Dino

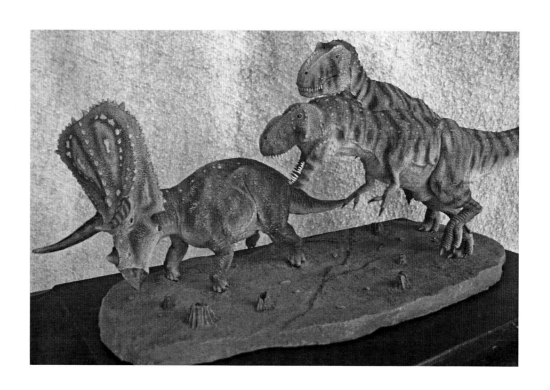

Dinosaur Sculpting

A Complete Guide
Second Edition

ALLEN A. DEBUS, BOB MORALES
and DIANE E. DEBUS

Foreword by Mike Fredericks

McFarland & Company, Inc., Publishers
Jefferson, North Carolina, and London

ALSO OF INTEREST FROM ALLEN A. DEBUS AND DIANE E. DEBUS

Paleoimagery: The Evolution of Dinosaurs in Art
(McFarland, 2002; paperback 2011)

Dinosaurs in Fantastic Fiction: A Thematic Survey
(McFarland, 2006; paperback 2013)

*Prehistoric Monsters: The Real and Imagined Creatures
of the Past That We Love to Fear* (McFarland, 2010)

Frontispiece: Perhaps the most persistent image of the dinosaur world involves a magnificent horned dinosaur and the most celebrated carnivorous dinosaur of them all: *Tyrannosaurus rex*. Public fascination with the theme stems particularly from two classic paintings made by Charles R. Knight during the early 20th century. Modern paleoartists continue the legacy, availing themselves of the startling imagery, modifying components in order to tell their own tales, as here in this 11"-long, 1/35-scale sculpture by Bob Morales (1999), showing a *Torosaurus* under attack, chased by two hungry tyrannosaurs. This original sculpture was molded and released as a model kit by Fort Duquesne Military Miniatures. In this book you will learn how to sculpt dramatic paleo-scenes like this, entirely from scratch! (Morales).

LIBRARY OF CONGRESS CATALOGUING-IN-PUBLICATION DATA

Debus, Allen A.
Dinosaur sculpting : a complete guide / Allen A. Debus, Bob Morales and Diane E. Debus ; foreword by Mike Fredericks. — 2nd edition.
 p. cm
Includes bibliographical references and index.

ISBN 978–0–7864–7205–5
softcover : acid free paper ∞

1. Modeling. 2. Models and modelmaking. 3. Dinosaurs in art.
I. Morales, Bob. II. Debus, Diane E. III. Title.
TT916.D43 2013 796.15—dc23 2013030167

BRITISH LIBRARY CATALOGUING DATA ARE AVAILABLE

On the cover: Tyrannosaurus rex model by Antonio Peres Vieira Filho

Manufactured in the United States of America

*McFarland & Company, Inc., Publishers
Box 611, Jefferson, North Carolina 28640
www.mcfarlandpub.com*

To Kristen and Lisa, who were amused back
in their early years by Dad and his new, unusual craft.
—Allen A. and Diane E. Debus

To my Lord and Savior, Jesus Christ;
to Eddie and Virginia, my dad and mom;
and to my late high school art teacher,
Eugene R.A. LaPlane, who showed me
I am truly somebody special.
—Bob Morales

Table of Contents

Foreword

by Mike Fredericks

When two talented sculptors decided to combine forces in 1995 and write a how-to book on sculpting dinosaurs, it was a highly original idea and one very well received by dinosaur fans around the world. I like to think I had a hand in that union, as I also had had an original idea only a few years earlier when I began publishing a magazine for dinosaur enthusiasts and fans named *Prehistoric Times*. My magazine featured art, science and tons of nostalgia regarding the realm of prehistory, as it still does today. Probably the most popular aspect of the magazine is the beautiful artwork of prehistoric life and animals shown within its glossy pages. My magazine became rather a "patron of the arts" affair and muse for both paleoartists of two-dimensional art and artists of three-dimensional sculpture. It wasn't long before prehistoric animal model kits and sculptures, many that were created and perhaps inspired due to the existence of the magazine, became an increasingly favored feature of *Prehistoric Times'* format, reflecting a theme dear to my heart throughout much of my life.

Before I had the skill and confidence to build my own model kits (my dad would build them for me), I loved models and miniature dioramas. In fact, within my childhood family album is a photograph of me at about age eight sitting next to a group of built plastic dinosaur models, including my ITC skeletal *Tyrannosaurus rex*. Below the picture, my mother wrote, "Mike's most prized possessions, his models." As I got older, I built many model kits (without my father's help) and even won a few trophies for those I entered into various contests. I even became a professional model builder (architectural, engineering) for a few years for a couple of companies. I have always loved the miniaturized form of things and can appreciate the tiny details in a well done piece.

During the early 1990s, a few artists who loved prehistoric animals were discovering the method of sculpting their subjects in clay, baking it until hard, making a silicone mold from their sculptural prototypes or "masters," and then casting resin copies of the original sculpture for sale, often in the form of model kits. As editor of *Prehistoric Times* magazine I began reviewing many of the prehistoric animal models that artists were making in their own homes, studios or garages. Sculptors were sending their work to me for critique and review, advertising their latest resin model productions, artists such as Bob Morales and Allen Debus.

Bob initially made his sculptures to be sold through Mike Evan's company, Lunar

1

Models and later through Dragon Attack. Meanwhile, Allen and Diane Debus formed their own small business, Hell Creek Creations, launching several of their own original resin cast models. During their formative years, Bob and Allen had also sculpted many one-of-a-kind sculptures and dioramas using polymer clay prior to the time when they began replicating some of their unique creations. In those early years Bob was particularly prolific as a producer of original polymer clay sculptural dioramas that were molded and later cast for others to purchase. Their models are getting tougher to find now, but back in the day anyone interested in paleontology became familiar with their work as commonly shown in *Prehistoric Times* magazine, and many purchased copies of their prehistoric animal creations. Through my magazine, given their mutual interests, the artists of this new book met and became long-distance friends.

So, when they announced their original *Dinosaur Sculpting* book, revealing all their tricks of the trade, even people who never considered creating their own prehistoric animal model wanted a copy of the book, to at least find out how difficult it might be to give it a try. The book quickly sold out and is now a sought-after collector's item. I remember participating in a modeling convention in Pasadena, California, where I had a table selling and promoting *Prehistoric Times*. Bob Morales also had a table where he was selling his model kits as well as a thick stack of their then-new book. Well, I can guarantee you that the authors would love to have another stack of those books today. If you can even find copies for sale, they sell for very high prices. New prospective paleoartists who came along too late in the game have had to go either without or pay exorbitant prices.

But what Allen, Bob and Diane have compiled herein is even better than their original *Dinosaur Sculpting* book (1995), and much preferred to simply putting that first version through a second printing. They have more to say now, offering instructions and more visuals that will greatly enhance this completely new edition — tailored for new generations of those who also yearn to become dinosaur sculptors.

Writing many chapters of this book was business as usual for Allen, who has written several books on prehistoric animals, as well as numerous articles for magazines including many for my own *Prehistoric Times*. Anyone interested in dinosaurs, whether you actually want to try your hand at sculpting or not, now has a gold mine of information that will inform, instruct and even entertain. And if you're anything like me, it will definitely rekindle your childhood love of prehistoric animal sculptures, miniature dioramas, model kits and dinosaur paleoart.

Mike Fredericks has been the editor of *Prehistoric Times* magazine since 1993.

Introduction: The Circle of Life

The cyclical nature of life's history is an unexpected wonder. Charles Darwin glimpsed this fact when he wrote in the conclusion to his *The Origin of Species*, "There is grandeur in this view of life.... Whilst this planet has gone cycling on according to the fixed law of gravity, from so simple a beginning endless forms most beautiful and most wonderful have been, and are being evolved." Three decades earlier, Darwin's friend Charles Lyell's cyclical view of geohistory was caricatured by Henry De la Beche in a cartoon titled "Awful Changes." Therein, a certain "Professor Ichthyosaurus" pontificates, ironically, to his pupils — from a future Earth millions of years hence when the climate, environment and characteristic fauna of the Mesozoic Era have returned — on that geologically older and extinct class of primitive fossil creatures excavated from the rocks, known as Man — *Homo*. Lyell (and De la Beche) weren't far from the mark; in its largest sense, geohistory is cyclical.

Earth scientists of varied disciplines have noted that the age of multicellular animal life on our planet is, or will be, in astronomical terms, a relatively short-lived affair. Animals will be doomed to extirpation within the next, remaining, "mere" half billion nurturing years of the Sun's twelve-billion-year lifespan. This is because as solar luminosity steadily increases, warming the planet toward extreme temperatures, the "essential nutrient" of our planet — carbon dioxide — will be increasingly consumed in chemical weathering and bio-geochemical processes to a critically low level, decreasing its atmospheric concentration and thereby preventing growth of plants. Without plants, multicellular animals must perish. Thereafter, Earth would neither seem familiar, nor habitable.[1]

Life, beginning with single-celled organisms over 3.5 billion years ago, flourishing with seemingly ceaseless, yet improbable successions of famous and popular paleontological forms (trilobites, giant dragonflies, fin-backed reptiles, pterodactyls, dinosaurs, ancient birds, magnificently horned primitive mammals, early horses, saber-toothed felines, giant and woolly rhinos, mastodons, hominids and even mankind), will peter out in forthcoming millennia, the Earth first returning to an early Paleozoic type of world and then inevitably to a hellish, Neo-Precambrian timescape where the only life is microbial, and even that deeply submerged within the cooler bowels of our (then unrecognizable) planet. So over a billion years, multicellular animal life emerges, waxes, and then inevitably wanes; a cyclical pattern of somber symmetry. Worse, the heyday of Earth's maximal biomass happened about 300 million years ago. So we're already on the downslide into organismal oblivion. As the fossil record reveals, nothing lasts forever. Therefore, whether or not Earth is the

only planet capable of supporting such a multitude of evolving multicellular forms through-out its allotted one-billion-year span, the host of fossil forms paleontologists have described should seem very special and intriguing. For these strange and wonderful creatures of the past vanished, sometimes mysteriously, only hinting at the inevitable — at what will happen to species of our present day.

Perhaps the most famous and magnificent pairing of restorations showing the evolution of animal life during the Phanerozoic Era were painted for Yale's Peabody Museum by Rudolph F. Zallinger, titled "The Age of Reptiles" (1947) and "The Age of Mammals" (1963). These influential murals convey impressions that there is an inevitable progression of vertebrate life forms from lower to higher (or from ancestral forms to more derived and complex), as recorded in the fossil record, and also that smoldering volcanoes are apparently the bane of life, having doomed the dinosaurs at the end of their reign, while also inter-rupting critical stages in the history of mammalian dominance. Not discernable to admiring eyes, however, is a presumption in Zallinger's murals that the atmospheric compositions in which these animals of the past thrived were essentially identical to today's, decidedly an incorrect notion. Not only did climates and environmental conditions differ and evolve through the ages of both reptiles and mammals, so too in complementary fashion did atmos-pheric concentrations of oxygen and carbon dioxide. Further, during several mass extinctions, poisonous hydrogen sulfide became more highly concentrated in the ocean-atmosphere sys-tem.

But Zallinger was merely striving to portray the heroic proportions of the dinosaurians, the magnificence of the "conquering" mammalian lineage, and overall the majestic handi-work of strange evolutionary forces resulting in these imposing creatures "from so simple a beginning." No, Zallinger wasn't attuned to life's macroscopic cyclicity, but then he was illustrating what geologists and astronomers would consider a slice of time, a mere 400 or so million years — only a fraction of the total age range of Earth's organic forms that have already evolved, or will come to fruition. A mere 1/24 of Solar time.

So (although this is a concept largely lost on modern paleoartists), due to astronomical and biogeochemical forcing of the ocean-atmosphere system, animal life will evolve and continue to run its fateful course in a rather cyclical fashion, ultimately perhaps not unlike how Darwin and Lyell originally perceived.

If life's destiny has been cyclical, so has been the most fortunate fate of this — our first and until now — our last book. You see, like life, books may also have a cyclical history. The first, self-published edition of *Dinosaur Sculpting* appeared in the spring of 1996.[2] A resounding labor of love, the one thousand printed copies sold like hotcakes. We've since seen copies offered for sale on Internet sites at prices exceeding $2,000, quite a markup from the original $19.95. Really! Was our book *that* valuable? We were certainly pleased with the publication, especially when we learned that it had been officially recognized by the (former) U.S. Dinosaur Society, mentioned in their 1996 *Everything Dinosaur* product catalog following review for accuracy by professional paleontologists. If you have the old edition, keep it! It's a collector's item.

Many kind and considerate souls wrote after receiving *Dinosaur Sculpting* and putting it to good use, thanking us for instructing them about how to begin what would otherwise seem to be most complicated and difficult sculpting projects. *Dinosaur Sculpting* satisfyingly helped our readership — our pupils, if you will — achieve lifelike expressions in their pre-

historic animal recreations. *Dinosaur Sculpting* also proved a boon companion to Mike Fredericks' *Prehistoric Times*—a visually captivating magazine especially devoted to dinosaur figures and often paleosculpture. Mike even included a picture reference to our book in the "Paper Dinosaurs" chapter (p. 193) of his *Dinosaur Collectibles* (1999), coauthored with Dana Cain. Our 1995 booklet opened doors not only for us but also for many readers. And we anticipate that this new volume will open doors as well, particularly for those who need an introduction to the exciting, mentally stimulating world of paleosculpture.

Subsequently, Allen co-edited a periodical named *Dinosaur World* (1996 to 2000, nine issues) that was certainly friendly to dinosaur sculpture and sculptors. In the years between 2000 and 2010, Allen (once with Diane) wrote three other books for McFarland, each delving into forms of paleoimagery (both in literature and visual art). Allen twice gave popular presentations on the history of paleoart and how to sculpt lifelike prehistoric animals at the Burpee Museum of Natural History's annual Paleofest (2003 and 2004), and gave another at a meeting of the South Texas Geological Society, called "Sorting Fossil Vertebrate Iconography in Paleoart," in September 2003. So now, after quite a hiatus, it is appropriate for the authors to return to the forge where our original volume was first fired—dinosaur sculpting! Our hope is that this edition will inspire a new generation of dinosaur sculptors.

Much has transpired in the "dino-verse" since publication of our first edition. Draft portions of the first edition's main text were written by Allen aboard a Metra commuter train in two spiral school notebooks. Bob enhanced the text with many loose handwritten pages, snail-mailed to Allen and Diane from California. These pages were then committed to a 11/2-inch-thick laptop PC at home, relying on then-state-of-the-art Wordperfect 5.1 software. Amy Ceisel expertly took our fledgling manuscript and 120 photos, within six months converting it all into a real, printed book. An exciting affair for the authors!

During the mid to late '90s, we made a definite impact on the world of avocational paleosculpting with our limited 1st-edition booklet (only 1,000 copies). Here, with our new *Dinosaur Sculpting* guide, we convey our thoughts and techniques on the subject in repackaged format, appealing to new generations of young paleosculptors. Would this book never go out of print!

This time around, besides adding new material to each chapter, Allen contributed new portions to this introduction, provided a wholly revamped chapter 2 on the history and meaning of paleoart, and likewise shared responsibilities to varying degrees with Bob in the subsequent, hands-on crafting of chapters—the meat of this book. Diane rounded out the overall manuscript in certain ways, performing many tasks to help this product seem as seamless as possible.

This new edition was drafted with the latest Hewlett Packard laptop, replete with Microsoft Word, a cool printer/scanner operated thru "wifi," and many gizmos not completely understood by the authors. This, combined with the ever-mounting array of blogs, tweets, message board postings and sundry, assorted dino-phile Web sites certainly made our re-immersion into this topic a most daunting challenge. Like before, we're here mainly to offer insights, approaches and, above all, encouragement on how you may sculpt your own dinosaurs. Like before, we're aiming for beginners, on up.

And if you are inclined toward that latter purpose, now there is considerably more to comprehend about the science and restoration of prehistoric animals—especially dinosaurs. For instance and notably, several months following publication of the first edition, discovery

of the first feathered dinosaurs, as they were heralded, from China was reported, thus fueling what Allen (with Diane) later referred to in *Paleoimagery* as the "feathered dinosaur revolution." And while, many years before, Zallinger affirmed that artists would never know the true colors sported by dinosaurs (the colors in his painted murals were speculative), today using refined and sensitive chemical technologies, scientists can actually determine colorations in certain well-preserved fossil species.

While over fifteen years ago the most comprehensive compendium of dinosaur names and descriptions was Donald F. Glut's popular *New Dinosaur Dictionary* (1982), today readers' knowledge of the old and ever multiplying new wave of dinosaur genera is vastly facilitated by Glut's *Dinosaurs: The Encyclopedia* (constituting the original volume published in 1997 with seven meaty supplemental volumes). It has been more challenging (and expensive) keeping up with the many considerable developments in dinosaurology than ever before; concepts are well captured in an engaging college textbook, *The Evolution and Extinction of the Dinosaurs* (2nd ed., 2005). *Prehistoric Times* magazine is an excellent resource, the preeminent and most economical means for laymen sculptors to follow the latest news impacting the modern world of paleoart.[3] Also, for paleoimagery's historical background (if readers may forgive a well-intentioned plug), *Paleoimagery: The Evolution of Dinosaurs in Art* (2002) remains a great general reference, offering considerably more perspective beyond chapter 2's context. We also highly recommend you follow paleoartist Tracy Ford's long-running column, "How to Draw Dinosaurs," published in *Prehistoric Times*, as well as frequently referring to Gregory S. Paul's *The Princeton Field Guide to Dinosaurs*.[4]

The book before you borrows significantly from our first edition although it is also expanded, reflecting the latest scientific developments and understanding. For completeness, we have added several chapters, such as on molding, casting and finishing your pieces, not dealt with in the earlier edition. There are more photos, shuffling the deck a bit while substituting new examples of in-progress, how-to shots. Herein, you'll see photos of several of our favorite personal creations totally exposed, stripped down to their underwear, so to speak — all exposed in bare metal and glistening aluminum foil. This time, Allen's outline of paleoimagery's rich history is considerably broadened, offering a message.

If you're like us, then you enjoy living in the past (as Jethro Tull wrote), and so, accordingly, welcome to the dinosaur world once again. Thanks to the arduous and patient work of scores of paleontologists and earth scientists, dinosaurs (that is, visual life restorations and skeletal reconstructions of them) and their prehistoric brethren are instilled within modern culture; they've become highly recognizable and emblematic pillars of modern society. Dinosaurs are mainstream fixtures. Dinosaurian hype has reached an unprecedented level, the richness of which cannot be properly conveyed here. If you're reading this book, however, you're already surging on that wave. You have an inherent need — a yearning — to build your own original dinosaurs, like those you see in books and magazines, but you don't know quite how to begin, right?

Collectively, this book has been crafted from some 35 man-years of dinosaur sculpting experience. There's an easy way and a hard way to learn. Bob and I learned how to sculpt dinosaurs the old-fashioned, hard way, from scratch, taking the barren road with minimal instruction and guidance. By reading this book, you can have the direct benefit of our experiences. We'll explain which techniques work best using appropriate examples. Overall, this

is an A to Z affair; we'll address everything from buying your polymer clay to casting and painting finished pieces that you have sculpted according to your own designs. However, as you may already realize, there may be many methods you may conceive, alternatives to techniques explained herein. This is clearly not an "our way or the highway" situation. We're just trying to get you started; creativity goes a long way toward enjoying personal satisfaction and success.

Even if you don't plan on creating your own restorations and dioramas, by seeing how it's done from the beginning stages, you'll gain a deeper appreciation for how science and art blend in the restoration of extinct life forms, creatures that you can now make in your own home at minimal expense and with maximum pleasure. Or, if you've already dabbled in dino-sculpture with discouraging results, build your road to success using our techniques. It is never too late to learn how.

So why would anyone ever want to sculpt dinosaurs? Not so fast! That question will be answered in the course of addressing the matter of how it's done.

Paleontology, the study of prehistoric organisms, is a visual science. Photographs can readily be taken of nearly every living organism, even if one has to link the camera with a powerful microscope. However, no camera can resuscitate the bones of an extinct vertebrate. This is a task for human intellect and artistry. One wonders, if Michelango were alive today, might he be a dinosaur sculptor?

Paleontologists, scientists who study prehistoric organisms, routinely work with a grave handicap. They have never seen living examples of their specimens. Think about the magnitude of that statement. This implies that, with few exceptions, all those beautiful renderings of fossil vertebrates that we have become so accustomed to, including dinosaurs, aquatic sea monsters and winged pterosaurs, may be entirely conjectural.

Pessimistically, yes, there is a great deal of guesswork involved in breathing life into those ancient creatures. However, after over 200 years of intensive study, conducted by many dedicated scientists, much conjecture has been replaced with factual evidence, forming a solid foundation for sculpting prehistoric animals.

Although it is said that a picture is worth one thousand words, no scientific restoration of an imagined paleo-scene may be fully comprehended without a written caption describing what the artist or scientist intended to convey. Whereas it is the responsibility of the artist to visualize and create the prehistoric vision for others to behold, it is that of the scientist to guide the artist and provide narrative representation of the scene.

Skeletal reconstructions and life restorations of fossil vertebrates serve complex, interrelated purposes: to aid paleontologists in describing and analyzing extinct species, to communicate their ideas to other colleagues in visual form, to convey examples of biological evolution, and to promote public comprehension in the realm of prehistoric natural history.

Beyond such uses, and more in tune with our theme, restorations can also be considered artistic when expertly done, even if the restoration is of a daring, speculative nature (such as raptors known as dromaeosaurs, some of which sported feathers, attempting to fly) or involves a controversial theme (such as horned dinosaurs sprinting swiftly over the plains like modern buffalo).

While many facets of this fascinating hobby will be addressed, a book of such brevity cannot possibly be considered an end in itself. It is presumed that the reader is either inter-

ested in, or has some basic knowledge of paleontology. There is a glossary at the end of this book. You can quickly acquaint yourself with unfamiliar terminology by referring to it.

We won't cover the evolutionary relationships of the various kinds of organisms scientists have deciphered in their exploration of life's history. However, an account of this majestic tale — the pageant of life, may be found in *The Book of Life*, edited by paleontologist Stephen J. Gould. Another is Richard Dawkins' *The Ancestor's Tale*. And Glut's aforementioned mammoth dinosaur encyclopedias present the latest information concerning dinosaurian phylogeny, or the evolutionary relationships between dinosaur genera. We won't describe all the ways in which fossil vertebrates have been described and classified taxonomically by scientists.

This is primarily a book for hobbyists and is especially friendly to beginners who yearn to realistically craft their own dinosaurs and prehistoric animals. Here we stress the term *beginners*, for although this edition is considerably expanded beyond the first edition, this volume also remains a "complete beginner's guide." We aim to inspire you and to instill in you the passion and burning desire to sculpt prehistoric animals. Readers need not be art student majors or enrolled in university art programs to profit and gain knowledge from this book. However, some of you may be interested in becoming professional paleosculptors. Our methods may not suffice for techniques practiced by sculptors working closely with scientists. Careful museum work often requires sculpting a miniature skeletal reconstruction of the dinosaur before adding muscle, flesh and skin. Our techniques will not be quite as exacting, while still leading to marvelous results. Your "skeletons" will merely be composed of armature wire and a molding polymer clay (we prefer Super Sculpey). Yet eventually, you will produce convincing results of museum-quality appearance, allowing further personal advancement. We're just getting you grounded.

And so, accordingly, here are the ground rules for use of this book:

1. Suggestions will be offered on how to sculpt several groups of prehistoric animals (primarily dinosaurs and other Mesozoic vertebrates such as plesiosaurs, pterosaurs and fossil birds), using certain species for illustrative purposes. With few exceptions, we'll emphasize prehistoric life as viewed by modern paleontologists. Become as intimately familiar as possible with the nature of dinosaurs you intend to sculpt before you leap into your project. This exercise may save considerable heartbreak later. Studying your subject animal will enable you to gain useful insights concerning its locomotion, form, and even psychology.

2. Discussion is devoted to figures that can be and have been produced using a variety of clay based compounds, such as plasticine, Super Sculpey, Fimo and Cernit. These materials are available at hobby, art supply and craft stores. We will not discuss other sculpting media, such as balsa wood, wax, stone or how to weld metal into dinosaur shapes. Directions for baking will only apply to polymer clays, such as Super Sculpey, Fimo and Cernit. However, because the authors most often use Super Sculpey in making their own creations, the term *polymer clay* will often be considered synonymous with this product. Super Sculpey is made by Polyform Products Company of Elk Grove Village, Illinois, but is no longer directly available to consumers through them. You will find Super Sculpey and other Polyform products at a number of crafts stores such as Michaels, Jo-Anne Fabrics, Hobby Lobby and A.C. Moore. Directions for the general use of Super Sculpey and other

products may be found online at the Polyform Products website. Polymer clay products such as these set to hardness when baked inside a regular kitchen oven (according to manufacturer's recommendations, typically at temperatures ranging from 250 to 275 degrees F). But under no circumstances should you ever use a microwave oven to heat your sculptures, because we will be showing how to use steel, copper and aluminum wire to build armatures, which cannot be safely microwaved. You risk fire, or at least damage to your microwave oven, if you attempt to bake a polymer clay sculptural object in a microwave oven.

3. Our focus will be on aiding with planning stages of your own original projects, using concepts presented here. Of course, you may be able to improvise using materials that we didn't discuss, and you may even think of better ways to accomplish desired goals. This is exactly the sort of thinking we wish to stimulate. By all means, feel free to creatively go beyond anything we've stated or demonstrated here. In this book, after outlining the basic recipe for building a miniature dinosaur, we'll offer more specific tips and illustrated guidelines routinely germane to sculpting certain kinds of dinosaurs and groupings of other prehistoric animals. Ultimately, in a later chapter this will translate into a particular chosen example describing the modeling of a prehistoric sea reptile, Bob Morales' *Liopleurodon*, so readers can see how our techniques all fit together in an A-to-Z project. With exception of this *Liopleurodon* material, we aren't offering cookbook suggestions on how to specifically reproduce any of the original designs illustrated here. But we absolutely do want readers to avoid the pitfalls, stumbling blocks and psychological dread experienced by the authors in starting out so many years ago from scratch, feeling our way along without friendly help or suggestions, without any reference material or guide explaining how to begin. Although techniques for sculpting individual dinosaurs will be presented, complexity can be added to your design by adding additional figures. Each chapter of this book builds on the preceding chapters. Simply combine what you have learned in different chapters to design a striking scene showing duckbills and horned dinosaurs converging by a river bank, for example — maybe with a hungry raptor lurking behind shoreline vegetation. By the end of this book, you'll know how.

4. No matter how hard we try, this book cannot substitute for the general knowledge base that is needed before you initiate your sculpting projects. For instance, although constructive criticism of your art should always be welcomed (with a "thank you" — no matter how severe the "compliment" may be — no reason to be defensive about something that is meaningful to you, constructive and that you enjoy doing), you wouldn't want to commit what would be generally regarded as obvious errors. For example, after laboring methodically on a carefully crafted model of the plated dinosaur *Stegosaurus* posed in mortal combat with the great carnivorous dinosaur *Spinosaurus*, the last thing you would want to be informed of is that the two genera missed each other in time by sixty million years and that they lived on separate continents! So strive to learn about each creature that you plan to sculpt before you begin. The many references in the bibliography will get you started. You don't need to read all these references. But at least be comfortable with the subject matter before you begin.

6

gh drawing skills can be of service to aspiring sculptors in the planning and
,n stages, you don't have to be a great illustrator in order to have splendid
alts in the sculpting arena. We'll show you how to base your preliminary designs
,n photos and sketches of reconstructed skeletons, which should be oriented in
particular ways that will suit your needs. However, those who would like to
enhance their dinosaur-sketching talents should obtain a copy of *Draw 50
Dinosaurs and Other Prehistoric Animals: The Step-by-Step Way to Draw Tyran-
nosauruses, Woolly Mammoths, and Many More* by Lee J. Ames. You might be able
to find a used copy on Amazon.com or another online used book store.

Remember, the ultimate goal is to produce a striking sculpture. Your sketch, when
finished, should not be an end in itself, but rather the beginning or an accurate
plan for construction of a three-dimensional figure. Strive to visualize your com-
pleted projects three-dimensionally, from every viewing angle (including mirror
images), in design stages to avoid engineering difficulties later on. Don't compro-
mise your artistic license by sculpting two- instead of three-dimensionally.

6. Don't be alarmed if we sometimes use the term *dinosaur* rather loosely. The name
dinosaur ("fearfully great lizard"), although strictly applying to hundreds of fossil
vertebrate genera from the Mesozoic Era, will sometimes be used broadly in general
references to prehistoric animals that can become sculpting subjects in your tal-
ented hands. Reasonably up-to-date sources that will aid you in correctly using
the scientific names of prehistoric animals are noted in the bibliography. All gen-
erally accepted prehistoric animal names have been indicated in italics.

7. The emphasis will be on making one-of-a-kind pieces. However, for this edition
we've added some hopefully helpful words on how to mold and cast pieces. You
should know beforehand, however, whether this will be your intention, because
armature building must be compatible with a planned molding process. Our per-
spective will be on how to cast resin replicas from sculptural prototypes made in
polymer clay (e.g., Super Sculpey); we won't deal with bronze or plaster, for
instance.

8. We will emphasize the sculpting of miniature models. Most of our dinosaur figures
are less than two feet in overall length — or in their greatest dimension. Of course,
in this size range, it is entirely possible to sculpt a life-sized dinosaur hatchling or
even an adult prehistoric bird, such as *Archaeopteryx*.

9. You are advised to read the entire book before you begin sculpting your first
dinosaur, to gain an appreciation for the range of possibilities and get your thoughts
brimming, and so you can best anticipate how you'll proceed. Knowledge garnered
may keep you from making time-consuming and frustrating mistakes later on. It's
easy for beginners to get frustrated, but don't let it get you down! Chapter 6,
devoted to sculpting bloodthirsty theropods, outlines all the techniques that are
needed for sculpting any of the animals discussed in this book, and is therefore
quite detailed. Subsequent chapters will refer to techniques already previously
outlined in this (and other) chapters. Chapter 15 walks you through an actual
sculpting process from the bare beginning. We wish to minimize redundancy, so
each chapter builds a foundation for what is to follow.

10. Although there's no set rule here, to facilitate the work of beginners, where deemed

beneficial or otherwise practical, we've rather subjectively subdivided the several chapters into basic and advanced techniques. Naturally, beginners should begin with the basics.

11. We highly recommend reading this book in its entirety before starting. Then practice, practice, practice!

Sculpting is largely a process of self-discovery. You often learn how to overcome particular difficulties in the desire to create something new and aesthetically pleasing. Don't limit your skills and strategies to only those that are discussed here. You may need to invent tools for special tasks when a situation calls for it, if what you need can't be purchased. Always look for fresh approaches in design and try to conceive your own novel techniques for accomplishing these challenging projects.

Rely on your imagination while sculpting, and sculpt images that enhance your ideas. If you are bored with your design, it probably won't turn out as well as others that really fired you up. Be creative and inspired. Unless you are tapping that artistic fount that has excited animal artists since Stone Age times, your project will become frustrating (for the viewer as well as the creator). Don't just sculpt what others have already done; create what your imagination conjures naturally.

You should also feel encouraged to further your studies in paleontology through reading books and magazine articles. Alternatively, attend museum exhibits and lectures to learn more about dinosaurs. There are references in the notes for certain chapters to aid in your quest for knowledge.

Take a "safari" to your neighborhood zoo. Observing living animals in zoos or even in pet stores—or your own pets—may provide valuable clues concerning the probable appearance, movement and muscle structure of dinosaurs and other prehistoric vertebrates, especially those thought to be most closely related in an evolutionary sense.

The kinds of sculptures you can make may be ranked according to degree of complexity. Those having the simplest structures are recommended for beginners or those unfamiliar with or just learning the properties of polymer clay. For instance, your dinosaurs can be made free-standing, without need of any supporting base. Models referred to as "one of a kind" (not intended for molding and casting afterward) or "single figure—simple base" are commonly made. Only a smoothly sanded wooden base is needed to support your individual dinosaur.

A second, slightly more advanced kind of model is referred to as "multiple figure—simple base;" in this, two or more individual dinosaur figures may be sculpted over a sanded wooden base. Usually, such designs will not involve physical contact between any of the sculpted figures (or contact of the underlying armatures). The model base may be painted or stained after all figures have been baked. Examples illustrating this form of sculpture will be provided in forthcoming chapters.

More elaborately designed model bases may be made to enhance the appearance and quality of your work. The construction of bases has little bearing on the accuracy of your prehistoric figures. However, a sensational model base will nearly always have people raving about your work. Techniques for creating impressive, yet complex, model bases for single- or multiple-figure designs will be addressed in a subsequent chapter. If you aren't handy or lack the tools, locate a woodworking contractor who can fashion beautiful bases, according

to your specifications, for a fee. A professionally made base can make a great model seem even more spectacular. Along the journey, we'll show you several examples.

Finally, figures can be sculpted interactively, such that a single interlocking armature can be designed for one or more figures that are physically contacting one another. Although this is not our emphasis, advanced techniques for creating such armatures will be touched on.

By now, some of you may have become apprehensive. But don't worry, by the time you've finished these introductory lessons, you'll feel like a professional. Doubtless you'll be so thrilled, no matter what the outcome on your first attempt, that you'll want to start another.

And another...

And that's the proverbial "circle of life" in action.

Okay, let's first take a look at the sculptural process, followed by the history of paleoimagery, emphasizing paleosculpture, before getting started on *your* first dinosaur creation.

1

Recipe for a Dinosaur

In the misty gloom of an ancient landscape, a terrible confrontation has been staged between two gigantic dinosaurs. The elephant-sized, three-horned *Triceratops* squares off against the most fearsome predator to have ever walked the earth, *Tyrannosaurus rex*. Huge muscles strain. Thick dinosaur hide bleeds. Deafening cries bellow from parched throats, and the air is electrified with ground-thudding, tooth-gnashing, and tree-splintering sounds. A battle to the death! The death cries of an imagined victim (which one — a gored carnivore, or a slashed bull?) fade into oblivion...

Charles. R. Knight's famous mural of the late Cretaceous dinosaurs *Tyrannosaurus rex* and *Triceratops,* exhibited at the Field Museum of Natural History, is wondrously captivating (however dated it may now seem, scientifically). Chances are that if you're enthusiastically reading this book, you may understand how Knight's restorations and those by other contemporary dinosaur artists can so easily lure one into prehistory.

Now project your mind into the Mesozoic world, because the most important tool you will need to create dinosaurs in realistic settings is your very own imagination. In this chapter, an overview of the entire sculpting process will be presented. In later chapters, we will address more specific and particular techniques that will be helpful in sculpting various kinds of dinosaurs. Time for creativity. First, bone up on the facts concerning the dinosaur you intend to make. Reading about dinosaurs, and visits to a natural history museum exhibiting dinosaur skeletons, will certainly help. (If possible, try to discern which bones are real, and which are plaster restorations of bones that have never been found.)

Few of you may know that many of Charles R. Knight's most famous canvas restorations began as miniature sculptures. Throughout his career, Knight would sculpt miniatures simply to judge the pattern of shadows as he imagined his subjects in primeval settings. Not all artists who sculpt in miniature have the intention of scaling their work into full-sized bronze, concrete or fiberglass dino-monsters. Knight's twenty or so prehistoric animal sculptures were never reproduced as full-sized models. Nor was Benjamin Waterhouse Hawkins' set (circa 1860) of miniature models of prehistoric animals sculpted full size (although Hawkins' earlier life-sized "antediluvial" monsters still haunt the Crystal Palace grounds at Sydenham, England). However, both artists' small sculptures were available for sale to schools and collectors of long ago. These rare pieces are pricey today (as perhaps yours may be too someday) (figure 1–1).

Other premier "dinosaur" artists, such as Michael Trcic, Ely Kish and Marcel Delgado, also have specialized in small-scale sculptural representations of prehistoric animals. Kish,

No. 302–308. **Restorations of Fossil Reptiles,**
Pterodactyle, Megalosaurus, Iguanodon, Labyrinthodon, Ichthyosaurus, Plesio-
saurus dolichodeirus and *P. macrocephalus.* They are reduced (one inch to the
foot) from the gigantic models in the Crystal Palace, London; constructed to

No. 302. PTERODACTYLE No. 303. MEGALOSAURUS.

scale by B. Waterhouse Hawkins, F. G. S., F. L. S., from the form and proportions
of the fossil remains, and in strict accordance with the scientific deductions of

No. 304. IGUANODON. No. 305. LABYRINTHODON.

Professor Owen. Preliminary drawings, with careful measurements of the origi-
nals in the Royal College of Surgeons, British Museum and Geological Society,

Nos. 306–308. ICHTHYOSAURUS WITH PLESIOAURI.

(Figure 1–1): Original advertising for miniature sculptural replicas of Benjamin Waterhouse Hawkins'
models exhibited on the Crystal Palace grounds at Sydenham, England, appearing in Henry Ward's
Catalogue of Casts of Fossils from the Principal Museums of Europe and America (1866).

however, is primarily known for her landscape paintings of Canadian dinosaurs, while Delgado's
creations, after becoming animated into full-sized splendor on the silver screen, have captivated
many a youngster. Kish's exactingly accurate sculptures are used primarily as references and
images for her spectacular paintings. Delgado's sculptures, based on Knight's paintings, appeared
in America's most colossal and classic dino-monster movie, *King Kong* (RKO, 1933), and
threatened Professor Challenger and other intrepid explorers of the *The Lost World* (1925).

More recently, special effects masters for the 1993 movie *Jurassic Park* used computer software to create the virtual reality of an entire flock of sprinting ostrich-like dinosaurs, known as *Gallimimus*. Intriguingly, the effects were made on the basis of a miniature statue of this dinosaur.

Obviously there are many uses beyond simple display purposes potentially waiting for your handiwork. But don't scoff at the display option. Let's face it, we have been equipped with binocular vision to observe a three-dimensional world. Even the greatest two-dimensional restorations are but windows into the past and lose something in perspective when compared to a carefully executed sculpture (miniature or full scale), which has the power to project the viewer into its immediate surroundings. Guests to your home may even thank you for being invited to see your handiwork.

Fellow dinosaur sculptors, it is nearly time to commence: But first, let us offer one further word of inspiration. Some years ago, one of us (Allen) compiled a list of artists who have restored prehistoric animals. The list, emphasizing professional artists who may have worked under the watchful eye of scientists at one time other another, grew to over 400 names even before the now-defunct U.S. Dinosaur Society's emphasis on "dinosaur art" swelled the ranks. Today, this remains a significant core community.

The selling prices for this kind of artwork can be phenomenal. During the mid–1990s paleo-sculptural heyday, we received extreme offers of well over $1,000 for some of our original pieces, representing as much as a 100-fold increase over the material cost. Of course, your work must be well done, and you must strive to emulate paleo-sculptors like Knight and Waterhouse Hawkins (of whom more will be told in chapter 2), who infused their subjects with life and majesty.

So why not join us, even though making a bundle of bucks shouldn't be your immediate objective? The main reason: Dinosaur sculpting can be a mentally stimulating hobby. Your imagination, in fact, is the most important tool needed for sculpting dinosaurs and other prehistoric animals. Always remember, however, to fuel your imagination with scientific facts, and fortify your creativity by observing nature.

Throughout the rest of this book, in all examples presented we will be referring to creatures that can be fashioned from polymer clay, typically Super Sculpey. Although baking represents one of the end stages in dinosaur modeling, it is appropriate to discuss baking along with a few additional tips on how to use polymer clay, before proceeding to the overview of how to approach your sculpting projects.

1. Super Sculpey, for example, responds more evenly than regular Sculpey to lightly applied pressure, allowing sculptors to produce finer details in their pieces. Also, Super Sculpey bakes to a suitably hard finish, which is to our advantage. If you've ever had the opportunity to compare regular white Sculpey to tan-colored Super Sculpey, you'll realize what we mean. Regular Sculpey, a white variety also manufactured by Polyform Products, may be used to harden or densify the interior of your sculptures, or to fill in around bodies made out of Styrofoam or aluminum foil, usually part of a multi-staged baking process. (An obvious advantage is that regular Sculpey is less expensive than Super Sculpey. The two kinds are compatible, even though the recommended baking temperatures differ slightly.)

2. Always keep your spare supply of Super Sculpey protected in a sealed plastic bag

so that it won't dry out. Stiffer Super Sculpey may have been allowed to dry on the store shelf, and will not yield as easily to your fingers. Test the pliancy of the material with your fingers prior to purchase.

3. Although directions on the Super Sculpey box suggest that sculptures be baked at 275° F for 15 minutes, a lower baking temperature of 250 degrees F may also sometimes suffice. Also, let your model cool slowly in the oven after turning off the heat for an hour (or even longer). Place a sign on the oven that reads "CAUTION — DINOSAUR IN OVEN," so that your house chef doesn't crank up the heat at dinner time, burning your model in the process, or pile a roast in on top of your creation. (For safety reasons, children should not be allowed to operate the oven.) Larger sculptures may require a baking time of up to 30 minutes. Gas or electric ovens will both do the job, although electric ovens tend to be somewhat more accurate in temperature. Directions for use of regular Sculpey as printed on the package label slightly differ from this discussion. If your sculptures are made from *both* regular and Super Sculpey, follow the instructions for the use of Super Sculpey. *Remember, it is imperative that your sculptures as designed must be able to fit comfortably inside your kitchen oven.*

4. There are chemicals in Super Sculpey that may vaporize during heating and will routinely coat your hands while sculpting. This is unavoidable. Read the directions on the Super Sculpey packaging. These compounds are not to be ingested, so please wash your hands after using Super Sculpey and before eating. Ventilate properly while baking your models, and to avoid overheating in the oven. (Disclaimer: if you use Super Sculpey according to our instructions, then you must assume the relatively minor risk of exposure to these compounds.)

5. So as not to create the possible graver risk of any domestic strife, try to keep Super Sculpey shavings and lumps off of the floor and carpet. (It may be difficult to remove them later.)

6. In the finishing stages of sculpting, rubbing alcohol (isopropyl alcohol) may be brushed on to smooth out finger prints and rough spots. However, let the flammable alcohol evaporate completely from the surface of your sculpture prior to baking. Otherwise, after baking, rough areas can be smoothed using a small piece of finely graded sand paper.

7. Never attempt to apply or bake Super Sculpey in excess of one inch thickness. If you do, the interior of the sculpture may not heat to an acceptable temperature and the exterior may crack later. Generally, the thicker the layers of Super Sculpey, the longer you must bake your model. Use filler material in the interior of pieces, such as Styrofoam or aluminum foil, to create an air cavity within. Sculpt in thin layers, baking interior sections at 250 to 275° F prior to adding outer layers. Each successive layer may be baked separately; polymer clay sculptures may be baked multiple times without damage. The exterior finish should always be less than one-half inch thick.

8. Maintain a clean work area. And, as always, *safety first.*

Okay, okay... Open your boxes of polymer clay. Let's see what the generalized overall process of sculpting a dinosaur entails.

First, imagine how your dinosaur will appear three-dimensionally. For instance, will

the animal be striding, bellowing, chewing or charging? Selection of a pose through positioning of limbs, tail, head and feet will play a vital role in determining how animated your creation will seem. Scenes that tell a story prove to be most captivating.

The history of dinosaur paleontology may be characterized in the terms of the analogies scientists have made between dinosaurs and living animals. Currently, in the era of warm-blooded thinking, scientists often refer to avian and mammalian traits in restoring dinosaur bones. So an afternoon trip to the zoo may be inspirational. Observing elephants, giraffes and rhinos will provide a sense of body movement in the Mesozoic giants. The locomotion of ostriches and emus may mimic that of their carnivorous ancestors.

After making suitable comparisons with living animals, try to imagine a setting in which your animal may have lived. Then envision the animal as he (or she) may have existed in that paleoenvironment. Roughly sketch the animal.

Next, draw your idea as accurately as possible, devoting attention at this early stage to body proportions (figure 1–2). Good planning here will really pay off later. Most valuable at this phase are published dinosaur skeletal reconstructions. A basic approach is to simply outline a picture of the skeleton you are using as reference on tracing paper.

For projects requiring advanced skill, start by drawing the bones to model scale. Sketch the skeleton schematically, two-dimensionally, and then lightly pencil in muscles and flesh. You may wish to reconfigure the skeletal orientation for the poses you are intending to create. If you are so inclined, sculpt the muscles first. (Paul's 2010 *Princeton Field to Dinosaurs* often presents speculative restorations showing how the large muscles were most likely attached.) Muscle scars on original fossilized skeletons offer some clues as to the nature of dinosaurs' muscles. Otherwise, just remember than muscle placement in dinosaurs is similar to that found in corresponding anatomy of humans, modern mammals and living reptiles.

Photographs of dinosaur skeletons will help you in deciding how wide the animals should be, but "think thin." Generally, known dinosaur trackways are narrow, even if their

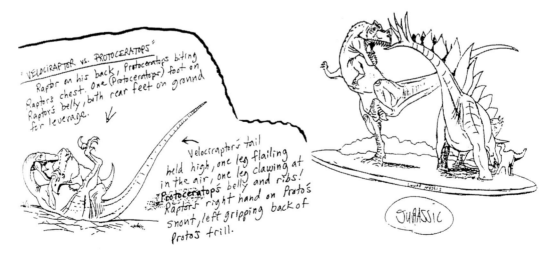

(Figure 1–2.): Two of Bob Morales's sketches for sculptures: at left, *Velociraptor* fighting *Protoceratops* near the latter's (conjectural) egg nest, and at right a *Ceratosaurus* combating a plated *Stegosaurus*— a design based on a Robert Bakker restoration. Prototypes of both sculptures were molded and offered as cast reproductions by Lunar Models during the 1990s (Morales).

bellies — especially those of herbivores, may have been capacious and wide. By carefully observing the artistry of other experts, you may avoid positioning your dinosaurs in unnatural or impossible poses. But originality counts too!

Techniques for preparing a sturdy armature can vary according to the availability of materials. Some individuals have elevated the construction of metal and wire-formed "naked" dinosaur skeletons into an art form. But you don't have to be as elaborate when polymer clay or modeling compound will be applied over your armature.

In the simplest case, when creating one-of-a-kind sculptures, a wooden base is selected (preferably one inch thick, placed inside an oven to minimize any warping of the wood), upon which a metal wire "skeleton" may be securely fastened. Tools and materials that prove helpful during this stage include pliers, wire cutters, coat hanger wire or perhaps even less-rigid aluminum or copper wire if your armature is less than six to nine inches in length, and a hand drill with an assortment of drill bits. Be advised, however, that securely fastening the wire skeleton to the wooden base may make the ensuing sculpting rather cumbersome.

Try to make the armature as sturdy as possible, using heavier wire to form the legs and backbone, *unless you intend to mold your sculpture.* (See chapters 15 and 17 for more on techniques germane to molding baked polymer clay sculptures.) Thinner wire will suffice for the arms and neck. Larger bodies, especially the range of 12 to 24 inches, will require stiffer wire to bear the added weight of Super Sculpey that will be applied over the armature (figure 1–3).

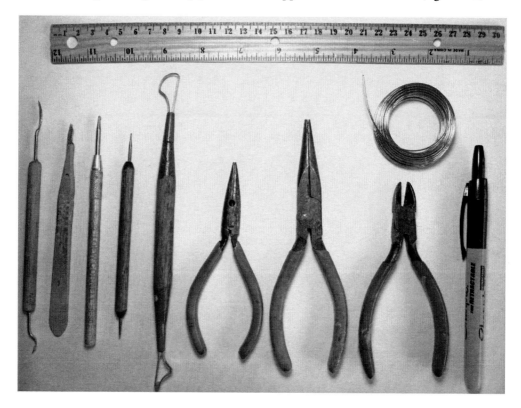

(Figure 1–3): A variety of basic tools sculptors may wish to keep handy for the work outlined herein. This particular array includes sculpting tools (including two examples of ball-tipped tools), a scalpel, needle-nose pliers, copper wire, a ruler and a marker (Debus).

Insert wires into holes drilled into the base, and bend the wire into a preferred orientation, according to your chosen skeletal design. (If you want to eventually reproduce your creation as a resin cast, after making a mold of the original Super Sculpey piece, then it is best to only use aluminum or copper wire. This is because it may be necessary to cut your original model into several sections prior to molding; softer wire can be cut far more easily than steel coat-hanger wire. Also, the armature must then not be already permanently bonded to the wooden base in any way.)

Prior to planning your first masterpiece, you should become generally familiar with the handling and baking properties of Super Sculpey. *Kids, if you use Super Sculpey, let your parents operate the oven at the correct temperature when it is time to bake your pieces, using a timer. Also, ensure your entire model will fit inside the oven before it is built.* You will also need a set of sculpting tools (some of which you can even make yourselves), as described in later sections, to create effects in the soft, unbaked surface of your creation.

To save on material cost and lighten the weight, cover the metal armature with Styrofoam that has been carved into a body shape. (Alternatively, aluminum foil can be used.) Then, begin sculpting with polymer clay to make a thin jacket surrounding any Styrofoam (or foil) you may have used, before adding a second coat of overlying "flesh." See figure 1–4 for procedural details.

Short metal rods, nails, pins or even thorns from bushes may be embedded into the dinosaur body to support assorted appendages such as horns, teeth, clubs, spikes or crests, although other techniques will be discussed later. Wire mesh from an old window screen can be used effectively to fan out the shape of a horned dinosaur's crest, or a fin-back lizard's (pelycosaur's) "sail." Just staple it in place. You'll be amazed when you cover these items with Super Sculpey and see what effects are possible. We'll cover this technique more extensively in chapter 12.

Getting the skin texture to look right is one of the most challenging matters faced by dinosaur sculptors. There is no single way to do the job correctly, and beyond the tips offered in the various chapters of this book, you may have to rely on intuition.[1]

Over a century ago, paleontologists speculated that the skin of dinosaurs, which were perceived as ancient but gigantic reptiles, resembled the scaly skin of modern reptiles. So Hawkins intricately sculpted reptilian textures on his Crystal Palace *Hylaeosaurus*, *Iguanodon* and *Megalosaurus*. In the intervening century and a half, several dinosaur fossils bearing exquisitely preserved skin impressions have been discovered, thereby relieving some of the guesswork involved in restoring the appearance of dinosaur skin. Nevertheless, there are alternatives.

Sculptor David Thomas has had success using cloth pressed on figures made out of Super Sculpey. Thomas related this experience after one of his sculptures swelled slightly during the baking process:

> I have used Sculpey and Super Sculpey, but I think they swell a little when they are baked. I did a New Mexico Whiptail Lizard for the New Mexico Museum of Natural History in it, and I sculpted the basic lizard, baked it and then carved it to get the definition back. Then, when the shape was right, I coated it with a very thin layer of Super Sculpey and pressed into it a cloth with a fine weave that left a scale-like impression. I sculpted the skin folds with a small sculpting tool through the cloth and baked it. The result was that the lizard had thousands of tiny scales all over it. I used single strands from copper electrical wire for the fingers and toes with a small lump of Super Sculpey at the joints. Then I painted it. People wouldn't believe it was

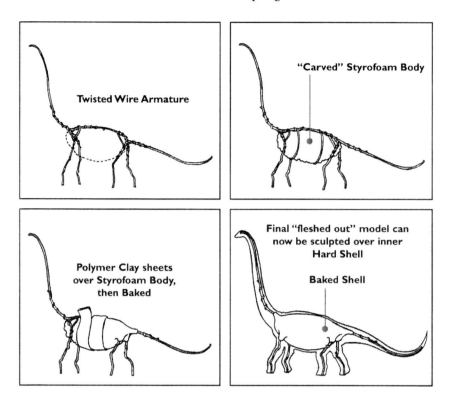

(Figure 1–4): A general overview of the sculpting process using polymer clay. *Upper left:* A twisted wire armature can be used as the "skeleton" for any sort of restoration. *Upper right:* Use of filler material such as Styrofoam (or aluminum foil) wired to the armature can result in material savings cost and reduce tendencies for the polymer clay to crack as your model cools after baking. *Lower left:* After filling in the body cavity of your armature with suitable filler material, you may wrap sheets of polymer clay over this material; the clay can be striated with a sculpting tool so that the next, outer layer of polymer clay will more readily adhere to the internal core. This internal shell should be baked according to manufacturer's instructions. *Lower right:* After the inner layer of polymer clay has been baked, then the dinosaur exterior can be clothed or "fleshed-out" properly (Morales).

sculpted. One visitor, a taxidermist, asked who had mounted it, and when he was told it wasn't mounted he nodded and said, "Freeze-dried!" It was a lot of fun. People would rap on the glass to see if they could get it to move![2]

Actually, in our experience, polymer clay may sometimes slightly shrink during the baking process.

Vertebrate paleontologist Donald Baird related a strategy used by sculptor Carl Beato, who sculpted dinosaurs for the Carnegie Museum in 1940, before the invention of polymer clay. Beato used liquid rubber to make impressions of the skins of various stuffed or pickled reptiles in the herpetology department, then pressed the patches of rubber onto the surfaces of his plasticine models. Baird lightheartedly stated, "Of course, there's a gross scaling (no pun!) error involved, but the results were highly realistic." Perhaps similar approaches could be made after the underlying body mass has been formed in (baked) Super Sculpey.

The effect of wrinkly skin can be accomplished by adding thin rolls of Super Sculpey into the body areas, where flesh may have hung loosely. Scaly skin texture can also be sim-

ulated by impressing a wad of wire mesh or lace fabric gently into the surface of your dinosaur. (Remove these "etching" materials from the surface of your dinosaur before baking.)

Striations lightly added using the sharp end of a sculpting tool can also create the effect of leathery dinosaur hide. After baking, textured surfaces that appear too rough can be smoothed using finely graded sand paper.

You can also rely on plastic to facilitate the effect of realistic skin folds and wrinkles. A thin sheet of clear plastic (a sandwich bag is fine) may be placed over the surface of the sculpture. Then, a thin pointed or curved sculpting tool can be used to create skin folds. Simply impress the tool into the Super Sculpey through the sheet of plastic. Use a lump of Super Sculpey to practice first. Polymer clay "shreds" may be entirely avoided using this technique which will hereafter be referred to throughout this book as the "baggie trick"[3] (figure 1–5).

You may want to peel the plastic away from the sculpture after every two or three wrinkles have been inscribed. This will help you avoid inadvertently altering other fine details you may have already added, such as other skin folds and scales. Experiment with different thicknesses of plastic for achieving a variety of textured wrinkles and folds.

The advantage in using clear sheets of plastic over the sculpture is that skin folds and wrinkles will not need to be smoothed over or otherwise cleaned up, as would probably be necessary if the same details were sculpted directly into the Super Sculpey. Engrave many

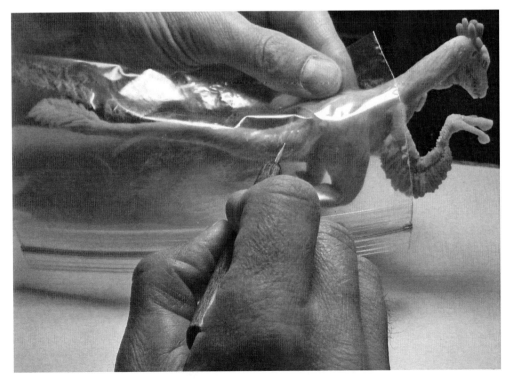

(Figure 1–5): Demonstrating the simple "baggie trick" on an as-yet-unbaked *Troodon* in the making. (To see the final sculpture from a similar angle, see figure 13–13) (Debus).

details, such as tiny wrinkles around the eyes, jaw line, nostrils, and add fine wrinkles and folds wherever they are needed. Using the baggie trick, individually sculpted scales can be formed in this manner, especially for those crucial facial details. Give it a try on a spare lump of Super Sculpey to familiarize yourself with the technique before approaching your model. The results may amaze you!

We will not advise on the use of real feathers in your work, which certainly could be done. Rather, in chapter 13, we'll outline how to make sufficiently convincing and more durable dinosaur feathers using polymer clay, supported whenever needed with a suitable pair of armature "wings." Our techniques will also facilitate your sculpting of pterodactyls and Cenozoic birds, such as the large, flightless creatures known as terror birds, several of which were taller than men, as well as those intriguing feathered dinosaur genera. Sculpting details on pterosaur wings essentially relies on the same initial preparatory stages, although the process is less complex because while pterosaurs possessed only fine hair insulation — relatively simple to sculpt — they didn't grow bird-like feathers. While the wing structures of birds and pterosaurs differ anatomically, fortunately the methods for sculpting them using polymer clay are essentially equivalent, at least during the initial stages of the sculpting process.

While it may be possible to fit certain life-sized Mesozoic bird and pterosaur models made from polymer clay into a kitchen oven, this wouldn't be possible for, say, a full-sized *Hesperornis*, or any of the larger pterosaur genera such as *Pteranodon*. Generally, however, you'll find that many Mesozoic birds may be sculpted at half scale to full size. Most pterosaur, Cenozoic terror birds (e.g., *Andalgalornis, Titanis, Phororhacos*), the Eocene *Diatryma* and feathered dinosaur sculptures must be scaled down in size to be oven-ready.

Make sure you know which skull opening corresponds to the eye socket on your animal. Many dinosaurs and other archosaurs had an enlarged opening in front of the eyes known as the antorbital fenestra, and a third opening directly behind the eye socket. And some more derived dinosaurs evolutionarily reduced or entirely lost the antorbital fenestra. Research sufficiently so that you avoid placing eyes in the wrong places.

You may want to study your completed work for a couple of days *before* baking it in case last-minute refinements are found to be necessary. No need to rush — be patient. It is far easier to modify your sculpture before, rather than after, baking it. *Before baking* your model, always examine its inverted image in a mirror to spot asymmetrically shaped areas in need of correction.

After baking, sometimes it is disappointing to see that hairline cracks have developed. You can easily make repairs using plumber's putty, Milliput, Wonder Putty, Spackle compound or pre-mixed tile grout, available at local hardware stores, or you can seal the cracks using more Super Sculpey and bake again. Cracks can also be sealed with minimal amounts of Duco Cement, Super Glue or Five Minute Epoxy, applied *lightly* with a paint brush (let your model cool slowly first in the oven after turning the heat off). Once painted over, no one will notice that the areas have been retouched. (Avoid rebaking the model after adding any other sort of material to the finish or base of the model, such as Spackle, grout, paint or adhesives.)

After the model has cooled but before administering any necessary repairs to hairline fractures, per the above, place it where it may be examined. You may decide that further changes are still needed, which may easily be done by adding more polymer clay and rebak-

ing, carving, or even grinding off unwanted material with a dremel tool. This self-critique process should continue throughout the sculpting process. Just remember, nobody ever gets it right the first time.

Also recognize that with few exceptions, as stated in chapter 13, no one knows what colors dinosaurs had. So feel free to speculate, but also refer to the *Dinosaurs Past and Present* volumes, and David Norman's book, *The Illustrated Encyclopedia of Dinosaurs* (1985) for ideas.[4] Acrylic paints work well for a variety of cases, especially the model base and any rocky matrix or ecological surrounding you are striving to recreate. A blend of Testors solvent-based paints and oil paints can be used to create interesting effects on your dinosaur figures. Some models can be painted with bronze-colored spray.

If mistakes are made along the way (that carving or adding-to won't fix), don't despair. There's always room for improvement. Rather than bemoaning your mistakes, credit yourself for the things that were effectively done. Then, next time, vow to improve your mastery of the good techniques you've learned, while avoiding ineffective practices. While sculpting, don't rush, and work only when you are rested. It may take several weeks before the sculpture is completed to your level of satisfaction, so don't lose patience. Get in the habit of patiently moving your arms *slowly* while sculpting so figures and structures under construction are not accidentally ruined by wayward fingers and elbows.

While most often sculptors must resort to pictures in books offering skeletal diagrams that can be re-scaled and reoriented appropriately to your needs, here's an opportunity to refer, hands-on, to near-genuine fossils. Professionals begin their task by measuring actual bone specimens of the animals they intend to restore. Amateurs ordinarily have limited access to these. In the mid–1990s it was still possible to purchase affordable resin or plaster casts of certain historically significant fossil specimens. One of us (Allen) was fortunate to buy casts of both the Berlin *Archaeopteryx* (resin), and of *Pterodactylus* (plaster), greatly facilitating life-sized sculpting of these two marvelous Late Jurassic creatures. Some of you may even eventually be granted permission to study museum fossils up close as a preliminary step in commissioned model making. Amateur paleontologists may be so impressed with your work that they'll request custom sculptures from you to display alongside reconstructed skeletons of that same animal, displayed in their collections (as turned out to be the case with Allen's lifesized Permian reptile, *Captorhinus*, exhibited adjacent to its genuine reconstructed skeleton in Dave's Down to Earth Rock Shop and Museum in Evanston, Illinois).

Finally, take heed of William Stout's "10 rules for being a paleoartist," and James Gurney's "10 rules for accuracy in dinosaur restoration."[5]

2

An Overview of Paleoimagery

by Allen A. Debus

Two centuries ago, dinosaurs and their prehistoric brethren made a second appearance on Earth with the unexpected discovery of fossilized teeth and bones. Initially, dinosaurs were entwined with the mysteries of geologic time. The "abyss of time" prompted both wonder and fear in those who imagined its deepest recesses. A century later, dinosaurs came to symbolize Man's absolute and self-righteous domination of Nature. Dinosaurs also represented extinction, anything that was unsuccessful or destined for termination. During the late 1950s, dinosaurs were thought to have been generally stupid, sluggish, cold-blooded creatures. Then by the 1970s, dinosaurs became symbolic of evolutionary success. Today, some dinosaurs are popularly viewed as quick, agile, even brainy animals that almost certainly maintained social organization within roving herds, bands or flocks. Some speculate that certain species may even have aspired to civilizations of their own, as yet unrecorded in the fossil record.

Most recently, dinosaurs have empathetically been considered superior beings, because had it not been for an accidental catastrophe of apparently cosmic proportions, they would still be ruling Earth. Controversial theories and proposals for the final extinction of dinosaurs are debated and perhaps partially accepted in light of new evidence, further indicating how successful dinosaurs were as a long-lived group of organisms. Most incredibly, on the scale of geological time, conventional dinosaurs outlasted our genus, *Homo*, by a factor of seventy-five to one.

More so than for any other group of animals, extinct or extant, dinosaur "persona" and popular portrayals have evolved. Understandably, their scientifically restored appearances have also changed remarkably since the 1820s. Why did this all come about? How was this reflected in a dizzying paleoart array, especially for our purposes — paleosculpture? And moreover, what does it all mean?

Dinosaurs (and other prehistoric animals) acquired a two-fold purpose reflecting scientific advancement through contemporary forms of paleoimagery. Broadly speaking, they introduced perspective on time's sequential vastness, offering "life through time" conceptual knowledge, which, since the late 1950s, transformed into hard-science analysis of modern environmentalism during a rapidly evolving "dinosaur renaissance" period.

Here, the bimodal history of paleoimagery's two main, general themes will be briefly outlined while, for our more immediate purposes, emphasizing paleosculpture's development

at certain junctures. According to this analysis, broader, popularized components of paleoimagery's growth and development since the 1850s — shortly after which the profession is said to have "matured"—will be characterized as a two-stroke engine cycle fueled by man's visionary expectations and, ultimately, global concerns.

For purposes of discussion, *paleoimagery* refers to the varied kinds of visual-art renderings of prehistoric life, many of which may not have been overtly prepared to illustrate scientific reasoning, or otherwise may not qualify as paleoart. While paleoimagery sometimes may simply be intended to entertain, *paleoart* is more focused artwork intending to show or demonstrate rhetorical aspects, hypotheses or theories concerning prehistoric life, having an intended scientific goal or purpose; "paleoartists" are typically yet not exclusively (modern) museum artists and talented paleontologists who complete paleoart portrayals. Paleoartists, who work with bona-fide paleontologists, are usually at least highly informed about their subject matter, have been professionally trained in anatomy, and are not considered laypeople.

Restorations are usually lifelike renderings of prehistoric animals, often depicted in idealized, correct paleoecological settings. Depending on the intention and data with which it was prepared, this kind of paleoimagery may also be considered paleoart. In the case of prehistoric vertebrates, *reconstructions* are often skeletons reassembled from bones, illustrated on paper, modeled in miniature or constructed from original bone. Missing skeletal elements are often inferred when fossil remains are incomplete. It is usually necessary to reconstruct the skeleton, however speculatively, prior to completing a life restoration. (Quite often the terms reconstruction and restoration are used synonymously, but here I've deferred to William E. Swinton's definitions.)[1] In sculpting miniature prehistoric animals, we will routinely rely on skeletal reconstructions prepared by other paleoartists.

But there's also the *skeletal restoration*, in which the paleoartist draws a silhouette of the animal's restored body outline around a skeletal reconstruction. Today, skeletal restorations are nearly ubiquitous, appearing in many popular publications as well as those intended for scientific discourse. Sculptors should take notice of these excellent and informative illustrations. Sometimes the paleoartist will darken bones that have been discovered as fossils — the basis of the reconstruction — leaving unshaded the missing bones, which are inferred from other similar genera where those bones have been studied. (Alternatively and depending on the convention used, undiscovered bones may instead be shaded in the skeletal reconstruction.) Such speculative inferences allow paleontologists to commission whole skeletal reconstructions made of resin or plaster representing dinosaur genera that are only partially known on the basis of fossils, or even from composited individuals. (Symmetry also helps. If an upper arm bone is only known, say, from the right side of the animal, then the missing upper arm bone from the left side must be its mirror image, and therefore can be sculpted to round out a skeletal reconstruction.)

In the first edition of *Dinosaur Sculpting*, we encouraged readers to relate "stories" in sculpture. Rather than sculpting a solitary animal just standing still, perhaps you, the artist, can deftly show how this animal, say, defended its nest from intruders, instead (presuming it was oviparous). But powerful stories may also be told in the restoration of a controversial creature, simply in choosing details of integument and immediate setting. For example, how a fossil avian or presumably feathered dinosaur (e.g., the Triassic *Protoavis*) is restored would necessarily be founded on a particular set of ideas about what this animal was and

what it represents, evolutionarily. If your *Protoavis* is restored possessing bird-like qualities (e.g., feathers, which were not found in the original fossil), perched on a tree limb with wings outstretched, certainly to some this might read as a bold statement concerning how birds originated, astonishingly, 75 million years *before Archaeopteryx*, while also implying that they evolved flight capabilities "from the trees down." Ultimately, the restoration could prove controversial, especially when a competing hypothesis or conflicting theory exists, say, concerning the evolution of flight and origin of birds. Likewise, if your fossil "bird" is sculpted in a running, ground pose, feathery wings stretched forward, this may stir ire from another camp. But beyond controversy, to the enlightened, as we'll see shortly, paleontologically founded or themed "stories" that can be reflected in paleosculpture can also be absolutely mind-bending. Such visuals and the stories they tell have sometimes significantly impacted scientific discourse.

While the persuasive or influential power of well executed paleoimagery in restorations and even CGI-animated recreations featured in prehistoric animal documentaries (e.g., 1999's *Walking with Dinosaurs*, BBC) has been sensed at least subliminally or subconsciously among viewers of this art, only recently has the rhetorical nature of such paleoimagery and paleoart become of scholarly concern.[2] So readers should be aware that more so than before, savvy observers of your sculptural renditions may now question details perhaps unwittingly or tacitly woven into your design, seeking to decode or understand the complexity of your technical ideas —*your* hypothesis. Albeit communicated nonverbally in your sculpture, details of your design will often suggest or even explain certain theoretical ideas concerning prehistoric life. We're often walking a tight rope with our subject matter, because in creating accurate-looking life sculptural restorations of extinct animals, paleoartists must subjectively blur interpretive fantasy with bits of reality. Remember, the less iconic — or nontraditional — the portrayal, the more cerebral decoding is required by audiences.

A single prehistoric scene or sculpture of a solitary, extinct animal posed in a realistic setting would rarely lend itself to instilling distinct impressions of life through geological time. Aside from Rudolph F. Zallinger's ingenious mural masterpieces, his Age of Reptiles and Age of Mammals displayed at Yale University, usually a *series* of individual painted or sculpted recreations displayed chronologically in a book, publication or museum space would be necessary to convey the flow or pageant of life's history. Conversely, the single scene or restoration effort is where paleoart began as a discipline during the late 18th century. Paleoart is essentially visual paleobiology, recreating with nuances and measures of speculation the life appearances of long-extinct organisms, typically vertebrates and of course or especially dinosaurs. For a century until the late 1950s, however, artists and paleontologists endeavored to further illustrate how these organisms related to one another more so in time, as opposed to space. Not only were such depictions publically edifying, but culturally they were reassuring as well to those who otherwise would misunderstand or harbor fears of the deep past. True — throughout this period paleontologists relied on various forms of paleoimagery (usually published in scientific journals) to convey and debate paleobiologically oriented ideas, but on a popular layman's level, it seemed the sexiest or "where it's at" part of prehistory was all about battling dinosaurs and especially the age-to-age evolution of prehistory through time's long corridors.

This balance began to shift during the mid–20th century, however, when modern *Homo* peered into the mirror, performing a reality check, only to realize that his worst

enemy was himself. To some it seemed inevitable that we would end up like the dinosaurs after all, a profound conclusion having many ramifications in fiction, film and, generally, the world of paleoimagery. From the early 1960s onward, paleobiological aspects of paleoimagery came to the fore, supplanting the relevancy of life-through-time interpretations, while stressing more scientifically valid reassessments of how dinosaurs and other prehistoric animals lived and died. By the 1970s it was clear that certain kinds of dinosaurs had more in common, not only genetically with modern birds, but also, metaphorically, with man, than prior generations of paleontologists could possibly have imagined. Dinosaurs were not only objects of a refined science; they became a cultural template (or totem) for modernity.[3] As opposed to the earliest days when paleoartistic speculation in science was *verboten*,[4] paleontologists now welcome conjecture and creative license in paleoart—as long as the visual component is well defined with a story or caption, because it allows us to frame a wider range of falsifiable hypotheses from which to move forward with our science of the past ... and our future.

Paleoimagery's First Traditionalized Phase— "Life-Through-Time"

Most (but not every) exemplary form of paleoart was invented by the late 19th century.[5] Most, but not every example of paleoart may be represented on an ideological cladogram (figure 2–1) showing affinities between different, conceptual styles of expression, or what the author or artist hoped to convey. The establishment of a new paleontological art category symbolizes innovation in understanding the nature of prehistoric animals.[6] By the mid–19th century, individual fossils, prehistoric animal skeletons, life restorations of dinosaurs and even scenes depicting several extinct animals interacting in idealized settings had been achieved by artists. From an early historical stage, however, it was also clear that the Earth had witnessed not one but several geological ages, each of which was characterized by unique, discrete sets of fauna and flora. In fact, in the field, characteristic (or "index") fossils could even be used to identify strata from each of the known, different ages of Earth.[7]

Thus, scientists and artists sought to restore each respective planetary stage, replete with vertebrate life—thought to be the dominant kind—signaling each geological formation, visually, for public edification. It only made sense to present these restorations in chronological succession, that is, regardless of one's theoretical understanding or belief as to what happened exactly in between each painted setting or sculpted tableau, triggering the mysterious waning of one (previous) stage and allowing the onset of the next with its unique and representative fauna. For instance, overall, it appeared that fishes, amphibians and early reptiles had evolved during the Paleozoic Era, or age of "early or old life"; more advanced reptiles (dinosaurs, pterodactyls), early birds and mammals had evolved during the Mesozoic Era, or time of "middle life"; and more advanced mammals, birds and humans evolved during the Cenozoic Era, or time of "new life." Today scientists recognize that the three aforementioned eras, constituting a "Phanerozoic Era" (or time of "obvious life"), had durations, respectively, of approximately 290 million years, 190 million years and 65 million years. (And the Earth's total planetary age has been measured through various means to be a staggering 4.6 billion years.)

As stated by Stephen J. Gould, "The establishment of a time scale, and the working

Diagram Illustrating Artistic "Clades" of Intellectual
Paleontologic Expression
Allen A. Debus (1997)

(Figure 2–1): It is possible to sort the various kinds of fossil vertebrate iconography in artistic "clades" according to the nature of scientific ideology such diagrams were intended to convey. Node 1: " Early observations of vertebrate fossils, in this case fossil shark's teeth" — Conrad Gesner's 16th century *glossopetræ*; Node 2: "Early Vertebrate Fossil Reconstruction" — Juan Bautista Bru's 1790s reconstructed ground sloth; Node 3: "Fossil Vertebrate Restoration" — Baron Georges Cuvier's 1812 restoration of the soft part anatomy of a Tertiary mammal; Node 4: "Early Scene from Deep Time" — The first recognized "scene from deep time" — detail from De la Beche's 1830 *Durior antiquior*; Node 5: "Sequences of Scenes" — Josef Kuwasseg's 1851 dinosaur scene; Node 6: "Projecting Theoretical Geology," in this case the recent Ice Age — Detail from Isabelle Duncan's 1860 conceptualization of the Ice Age extinction boundary; Node 7: "Evolutionary Iconography" — A detail from Othniel C. Marsh's 1879 "ladder" of equine evolutionary progress. Most examples of fossil vertebrate iconography can be lumped into one of these categories. (For more detail, also see chapter references cited in note 6 to chapter 2) (A. Debus).

out of a consistent and worldwide sequence of changes in fossils through the stratigraphic record, represents the major triumph of the developing science of geology during the first half of the nineteenth century.... Such a spectacular success had to be accompanied by a maturing iconography committed to representing the past as a series of successive stages rather than a single undifferentiated past contrasted with our present world."[8] This ambition and tradition which presided for a century (circa 1850s to 1950s), popularized geology and infused geological with evolutionary knowledge. Besides some of the fantastic movies of the past, like RKO's *King Kong* (1933), it is this time-dimensional, visual component that most likely lured many of us into the highly romanticized paleontological field.

And such visual display has a time-honored history, which perhaps many of you are unaware of. A significant, early unveiling of prehistory's enchanting nature was delivered in the form of a publication by an Austrian paleobotanist, Franz Xaver Unger, who enlisted the artistic talents of landscape painter Josef Kuwasseg. According to Martin J.S. Rudwick, "The team of scientist and artist embarked on the most ambitious project of its kind yet undertaken."[9] The result was a book whose title (translated by Rudwick into English) was *The Primitive World in Its Different Periods of Formation* (1851). Kuwasseg completed 14 lithographed scenes, highlighting key geological formations then known to science, that were explained in words by Unger. Two additional scenes, picturing the Silurian and Devonian formations, complemented an 1858 edition. Due to Unger's academic background, plants rather than animals generally predominate in most scenes. Contrary to Charles Lyell (mentioned in the introduction to this book), Unger interpreted Kuwasseg's succession of portals of prehistory as a portrayal of a *directionally evolving* Earth (rather than a cyclical, recycling planet), where volcanism and mountain building altered planetary climate and atmospheric composition, leading inevitably toward current conditions.

Kuwasseg's beautiful restorations of essentially alien landscapes ranged from the "Carboniferous limestone" to the "Period of the Diluvium" (Pleistocene). A more familiar scene showing the "Period of the Present World" ends the chronological sequence. Organic forms shown in each scene were founded on fossil evidence, although there was considerable speculation as to their living structure as well as the arrangement of, say, ancient forests. Reptiles and amphibians do appear in Mesozoic scenes, yet with exception of a trio of quadrupedal, horned *Iguanodon* in the Wealden, Lower Cretaceous scene, their presence is rather subdued. Of the Wealden fauna, Unger stated, "Unfortunately, since only a few bones, teeth, and fragments of the jaws of these animals have been discovered, it has been necessary to trust to imagination for the greater part of the work of their restoration, but we shall have less and less occasion to have recourse to its aid; for as new discoveries are made, less difficulty will be found in divining approximately or ascertaining accurately the physiognomy of these strange beings."[10] His assertion proved absolutely correct. And unwittingly perhaps, Unger and Kuwasseg fashioned a magnificent template for paleoartists following in their steps — institutionalizing the organic framework, misty jungles and other striking, idealized settings, which others would populate with hordes of prehistoric beasts (yes, even in RKO's *King Kong*).

Perhaps the most important 19th century pioneering paleoartist was Benjamin Waterhouse Hawkins. Despite their obvious inaccuracies, his life-sized dinosaur sculptures at Sydenham England are known to all paleophiles. His lesser-known, small-scale sculptures are sought by collectors and museum curators. Considerable scholarship exists on Hawkins,

far too much to recount here. It will suffice to say that, given the contemporary *zeitgeist*, Hawkins' aim was to restore in chronological succession the impressive vertebrates from Periods of prehistory as then known to scientists, both in his native England and later in America. This ambition is exemplified in plan diagrams documenting positioning of the Crystal Palace statues, which are arranged chronologically upon strata according to geological age. By 1860, Hawkins also painted six colorful scenes showing "struggles of life among the British animals in primeval times," issued as educational, lithographic wall posters. These scenes ranged from the European Liassic to the Pleistocene, featuring by-then familiar subjects such as ichthyosaurs, plesiosaurs, quadrupedal iguanodonts and megalosaurs, paleotheres, giant ground sloths and glyptodonts and woolly mammoths.

Today, in the United States, Hawkins is revered mainly for reconstructing a skeleton (that to a large extent was sculpted from scratch based upon incorrect notions) and several plaster replica plastotheres of what is often referred to rather erroneously as America's first dinosaur, *Hadrosaurus*, a life-sized in-the-flesh restoration of which was to be a centerpiece of New York City's ill fated Palaeozoic Museum. At that time, Hawkins was able to declare, "The interest in the remains of ancient animal life which Geology has revealed within the last century is worldwide, and almost romantic in its influence upon the imagination, and ... there can hardly be a question as to the advantage of representing these remains, clothed in the forms which science now ventures to define. The restorations which were committed to my charge in the Crystal Palace Park at Sydenham, were the first efforts of the kind ever attempted, and their acknowledged success, both in commanding the cordial approval of scientific men, and also a large measure of public appreciation, encourages me to hope that a similar enterprise may meet with equal favour on this side of the Atlantic."[11]

Again, scholars probing into this episode often neglect that Hawkins intended to organize not only the Palaeozoic Museum as a life-through-time exhibit, but following that unfortunate debacle, displays intended for the Smithsonian and for Princeton University's Guyot Hall as well.

The Department of Geology and Geophysical Sciences at Guyot Hall is marvelously endowed with artwork by the 19th century's two most magnificent paleoartists, Hawkins and Charles R. Knight. Between 1875 and 1877, Hawkins completed 15 (or possibly 17 — it's unclear) marvelous framed oil paintings on canvas portraying the transformation of the planet and its prehistoric life, ranging in geohistorical, global context from the Silurian to Pleistocene periods. The paintings are rarely reproduced, so an itemized listing may be informative. The titles of the surviving paintings are in order: "Silurian Shore at Low Tide," "Devonian Life of the Old Red Sandstone," "Carboniferous Coal Swamp," "Triassic Life of Great Britain," "Triassic Life of Germany," "Early Jurassic Marine Reptiles," "Jurassic Life of Europe," "Cretaceous Life of New Jersey," "Tertiary Mammals of Europe," "Glacial Epoch in Europe," "Pleistocene Edentates of Patagonia," "Attack in Pleistocene England," "Pleistocene Fauna of Asia," "Irish Elk and Palaeolithic Hunters," and "Moas of Prehistoric New Zealand." For decades, the paintings adorned walls in Nassau Hall's geological museum. More recently the paleontology exhibits were dismantled and Hawkins' paintings which had fallen into disrepair were placed in storage.

Besides his Crystal Palace and Palaeozoic Museum statues, Hawkins also sculpted small replicas of prehistoric animals — of the scale and kind that this book will guide you in designing and hand-crafting. Five of these, miniatures of his Crystal Palace specimens, were

offered for sale, as in Henry Ward's 1866 *Catalogue of Casts of Fossils: From the Principal Museums of Europe and America, with Short Descriptions and Illustrations.* On pages 80 to 81, (items nos. 302 to 306–308), Ward printed illustrations of Hawkins' "Pterodactyle," *Megalosaurus, Ichthyosaurus* with *plesiosauri, Iguanodon* and *Labyrinthodon*, which then may have been purchased for a sum total of $30. (See Fig. 1–1.) These fabulous miniature models, constructed "in strict accordance with the criticism and sanction of the highest scientific authorities" at a one inch equals one foot scale, had been offered to collectors in England during the 1850s as entrepreneur James Tennant advertised in a July 1860 sales pamphlet. Hawkins' then museum quality, scientifically accurate, miniature sculptures were exhibited in museums over a century ago, as rather surprisingly remains the case today at some venerable institutions. Molded recasts of the original *Iguanodon* and *Megalosaurus* held in private collection were offered for sale during the 1980s. Dr. Donald Baird who had a longstanding fascination with Hawkins' work, provided this information, adding "three-dimensional models tend to have more impact than flat pictures, even in color."[12]

Another early explorer — surveyor-visionary of life through planetary time was Edouard Riou, who collaborated with chemist-physician and popular writer Louis Figuier in completing twenty-five portrayals of Earth's geological ages for 1860s editions of *The Earth Before the Deluge* (1863 to 1867).[13] According to Rudwick, Figuier realized from the outset that his book would be especially attractive to the general public, especially younger readers. So, drawing from successes experienced by Unger and Kuwasseg a decade before, Figuier enlisted Riou to portray dramatic, idealized scenes from deep time, which would be described chronologically in his forthcoming popular geology book. The intrepid collaborators began their sequence with "Condensation and Rainfall on the Primitive Globe" and ended with scenes of Flood events as then perceived. (After all, with the connotative "Deluge" in the title, Riou simply *had* to illustrate it.) Riou wasn't a sculptor like Hawkins, yet his illustrations of fighting dinosaurs and aquatic reptiles remain cited and popular even today. Riou went on to illustrate the 1867 edition of Jules Verne's *Journey to the Center of the Earth*, which may be viewed also as a life-through- time paleontological adventure, founded significantly upon Figuier's influential *Earth Before the Deluge*.[14]

By the time Riou and Hawkins completed their master works, according to Martin J.S. Rudwick, the genre of making scenes from prehistory had "originated, emerged and consolidated."[15] Already, by the 1880s, the field of paleoart image-making had matured to the extent that most of the geological periods known today had been portrayed in the form of idealized (yet always largely hypothetical) landscapes. Furthermore, Rudwick concludes, "Riou's sequence of pictures for Figuier established the genre of scenes from deep time throughout the Western world. Later nineteenth-century versions of such scenes were clearly modeled on Riou's, and their influence has continued, however indirectly and unrecognized, throughout the twentieth century. They themselves were modeled on Kuwasseg's earlier sequence for Unger, and on other precedents.... The idea of portraying a sequence of scenes finds its precedents in the ... ancient tradition of biblical illustration."[16] What follows traces the further development of paleoimagery expression in portraying life through successive stages of geological time, that is, until general dethronement of this popular theme during the height of the "dinosaur renaissance" wave.

During the late 19th century, Hawkins' American contemporary, Henry Ward, popularized paleontology by selling casts of Ice Age mammal skeletons —*Megatherium* and

Glyptodon— to museums while promoting his business with a life-sized restored woolly mammoth sculpture that prominently appeared at industrial trade expositions and world's fairs during the latter 19th century. Through Ward's efforts, many Gilded Age patrons became acquainted with the idea of a formerly living prehistoric fauna. Curiously, however, in America, life restorations of prehistoric animals were frowned upon by serious-minded evolutionists such as Othniel C. Marsh, due to their speculative nature. Marsh and his scientific nemesis — visionary paleontologist Edward D. Cope, who in 1897 would mentor the young Charles R. Knight — contributed mightily toward bringing fossil treasures from New Jersey and, later, the American West, eastward to New Haven, Philadelphia, Pittsburgh, Washington and New York, where they were fervently studied.[17]

Contrary to Othniel Marsh's philosophy, during the 1890s and the early 20th century, paleontologist Henry F. Osborn led a reformation in paleoart at the American Museum of Natural History. As opposed to Marsh, he realized the inherent value of constructing museum displays for public edification, hiring talented artists and artisans to erect monumental skeletons of extinct animals, fueling the imaginations of museum patrons and financiers alike. Osborn directed the creation of marvelous paleontological displays including dinosaurs mounted in lifelike displays (which in assembled form appeared sculptural in their own right) exhibited near mural paintings and sculptures showing contemporary visions of how these extinct animals had appeared alive. By the 1910s, Osborn recognized that the most meaningful prehistoric fossil bone exhibits within New York's American Museum of Natural History were those accompanied by Charles R. Knight's artwork — painted watercolors.

Inspired by Osborn, paleoart fervor soon swept the country as the Smithsonian, Yale University and other august institutions followed suit with their own visually striking displays of ancient life. By the 1910s through the 1930s, America's fossil vertebrate treasure trove inspired a new generation of European paleoartists as well, notably German sculptor Joseph Pallenberg, Austrian paleobiologist Othenio Abel, and Czech artist Zdenek Burian. It was during the early phases of this period that museum paleontologists such as the artistic Osborn began wielding the persuasive force of paleoart far more confidently; that is, paleontologists came to believe that restorations were suitable for expressing scientific ideas — a time corresponding to America's paleoart reformation.[18]

During this earlier time, however, although modern paleontological museum displays and institutions were still rather uncommon or were unfamiliar to the general public, there were a growing number of popular paleontological publications (both magazine articles and books) available during the later 19th and early 20th centuries. The most lavish productions from this period were authored independently by Rev. Henry Neville Hutchinson and Henry R. Knipe. Hutchinson astutely sensed that following Figuier's book, by the early 1890s, there was a "scarcity of popular works in Geology at the present time."[19] And so he began writing a series of geological books outlining the succession of vertebrate life through the ages (e.g., *Extinct Monsters* (1892, 1893 eds.), culminating with his *Extinct Monsters and Creatures of Other Days: A Popular Account of Some of the Larger Forms of Ancient Animal Life* (1910).

Targeting popular audiences, Hutchinson quaintly reflected non–Darwinian evolutionary perspectives on the workings of evolution. Arguably, the most enduring outcome of these productions is Hutchinson's recruitment of artist J. Smit, who marvelously illustrated invertebrate and vertebrate animals of the Phanerozoic Era, beginning with monstrous sea scorpions (Eurypterids) of the Old Red Sandstone (Silurian) through giant mammals of the

Pleistocene. Hutchinson's and Smit's splendid "imagetexts"—illustrations with extended, highly informative chapter-length captions—formed a template for what would follow in the early to mid–20th century, with popular books such as those by E. Ray Lankester, Henry F. Osborn, Othenio Abel, W. Maxwell Reed, Charles R. Knight, and Joseph Augusta either already in the works or waiting in the wings.

Henry Knipe's two fabulous entries, *Nebula to Man* (1905) and *Evolution in the Past* (1912), are tour de force efforts to outline geological history. *Nebula to Man* is a lavish affair, a coffee table–sized volume with over 70 tinted and colorful plates, grandeur for the eyes to feast upon, featuring (mainly) the artistry of J. Smit and Alice B. Woodward. The annoying aspect of *Nebula*, however, is that Knipe elected to write this book in rhyme, making it a difficult and occasionally infuriating read. Regardless, it was Knipe's aim to convey the entire geological history of the globe, illustrating interesting, characteristic or dominant forms of life representing each of the major periods as then known. *Evolution in the Past* succeeds as a more traditional affair (thankfully dispensing with poetry), while again offering a more updated perspective on life's majestic history. Unlike his contemporary, Hutchinson, Knipe adhered to the Darwinian paradigm, hence the term "evolution" in his book title. *Evolution* featured over 50 illustrations, predominately plates by Woodward. Knipe's geological journey thrust readers from the dim uncharted Cambrian seas into territory unexplored by Hutchinson's books—savage prehistoric men portrayed as evolutionarily ancestral to modern humans. Until recently, there has been little interest in these popular works, or the manner in which Hutchinson and Knipe chose to portray life's history.[20]

By the early 1900s, the *succession* of prehistoric vertebrates known to science became increasingly exploited in a variety of ways. One early, little-known example is a series of thirty collectible cards (19 cm by 27 cm) issued by the Kakao-Company, Theodor Reichardt of Hamburg-Wandsbek. These came in an embossed, hard-cover binder titled *Tiere der Urwelt*. The prehistoric life shown in each of these cards was restored by artist F. Long. A descriptive sheet explains each restoration, with creatures ranging in geological age from the Pleistocene back to the Devonian Period—represented by an armored fish, *Pterichthys*, absurdly walking on land. The set was evidently popular in Germany, for shortly afterward additional series of cards featuring prehistoric life illustrated by other artists such as Heinrich Harder were also published and distributed.

By the early 20th century, the aforementioned Osborn became America's foremost vertebrate paleontologist. Yet Osborn had an unusual leanings in evolution, entrenched in Edward D. Cope's neo–Lamarckianism, while departing significantly from the Darwinian camp. Osborn fostered the since-falsified idea of orthogenesis, a theory that the (genetic) germ-plasm of organisms was predisposed toward certain trends, which eventually would lead to extreme traits or conditions deleterious to organismal health and continued evolutionary development. Common examples were the saber-teeth of felines such as *Smilodon*, the brow horns of the Pleistocene "Irish Elk," or the enlarged, massive horns of "titanotheres" (i.e., brontotheres) and the coiling tendency in a Mesozoic clam—*Gryphea*. Osborn, audaciously seeking to elevate his prominence to a Newtonian level, invoked metaphysical chemical factors and energies that would cause evolutionary trends. Thus, today, Osborn's amply illustrated *The Origin and Evolution of Life* (1917) is a sumptuous yet curious affair. *Origin and Evolution of Life* proceeds in chronological order, presenting many restorations of prehistoric animals while outlining successive changes in the fossil record through geological

time, while assigning causes of these evolutionary events to laws — several of which Osborn invented.[21]

Like Knipe's books beforehand, Osborn's *Origin and Evolution of Life* was published during a period when several artists were producing variously designed paleoart that could then be availed collectively for books and magazine articles. So while Charles R. Knight's prehistoric animal restorations are featured, his masterful work is not exclusive. Contemporary Austrian paleobiologist and artist Othenio Abel, author of a lavish 1927 life-through-time paleontological tour, *Lebensbilder aus der Tierwelt der Vorzeit: Zweite Auflage*, printed in German, may be regarded as Osborn's European scientific and scholarly equivalent.[22] And W. Maxwell Reed's *The Earth for Sam* (1929), intended for younger audiences, with its many chapters outlining Life's majestic history illustrated by a potpourri of talented artists, proved immensely popular for a younger generation of mid–20th century dinophiles.[23] *The Earth for Sam* was reissued as late as 1960, during the embryonic stages of the dinosaur renaissance.

Synchronously, by the 1910s, paleontologists and assorted paleophiles were wrestling with the causes of characteristic life-through-time changes observed in the fossil record. No doubt inspired by contemporary paleoimagery, one such enthusiast was the revered American writer Edgar Rice Burroughs, whose trilogy of 1918 novels, *The Land That Time Forgot*, *The People That Time Forgot*, and *Out of Time's Abyss*, involved peculiar science fictional evolutionary, somatic changes (founded upon Ernst Haeckel's since-falsified Biogenetic Law), occurring throughout an individual's lifetime within a mystic, romantic "lost world" setting. The pseudo-evolutionary growth cycles experienced by organisms in Burroughs' lost world are wrought by mystic, cellular-controlling forces, perhaps not unlike Osborn's orthogenetic ideals. In 1917, another writer, Charles H. Sternberg, a paleontologist protégé of the imaginative Edward D. Cope, also wrote a science fictional time-travel story leading in three life-through-time sequences from the Late Cretaceous to the Late Permian.[24] And in his 1923 silent 40-minute film documentary titled *Evolution*, directed by Max Fleischer and scientifically supervised by Edward J. Foyles of the American Museum of Natural History, sought to reconstruct and restore Earth's prehistory, leading from its misty nebular formation to mankind's origins. Several scenes and spliced shots of dinosaurs (stop-motion animated, skeletal reconstructions and statuesque reconstructions — including those by sculptor Joseph Pallenberg) appear to help tell the tale of the pageant of life in Fleischer's quaint yet still entertaining film.

Charles R. Knight's preeminent artistry and mural painting (especially a sequence of 28 mural paintings completed during the late 1920s for the Chicago Field Museum's former Hall 38, fondly known as the "dinosaur hall") set new, refined standards for portraying life's history. By the time Knight arrived at the Field Museum (then the Chicago Natural History Museum) to paint murals for its new fossil hall, he'd gained considerable expertise in restoring and painting magnificent prehistoric scenes replete with reptiles, dinosaurs, scores of prehistoric mammals and ancient men, particularly for New York's American Museum of Natural History. But the Field Museum murals were to become his magnum opus.

Now, given that during the previous half century geologists had increased their knowledge of Earth's geological history, Knight was able to perceive how the steaming early Earth had appeared — before life, not long after its formation. Another Precambrian scene witnesses the dim Proterozoic Era at a time when single-cell plants may have developed. Knight's

idealized Paleozoic scenes of the Ordovician, Silurian, Devonian and Permian periods followed, leading to Mesozoic time. Next, a single Triassic scene segues to four Jurassic murals, and then four Cretaceous scenes. Among these latter eight murals are four of Knight's most popular and atmospheric prehistoric animal restorations. Dinosaurs in these murals include restorations of aquatically inclined *Apatosauruses*, a pair of *Stegosaurus*, herds of *Edmontosaurus* and *Parasaurolophus* and ostrich dinosaurs accompanied by armored "*Paleoscincus*," and the epic battle between *Tyrannosaurus* and *Triceratops*— Knight's most time-honored, popular painting. The Tertiary and Pleistocene periods are amply represented, with the Pleistocene prevailing, having eight associated mural restorations reflecting a global view and a tendency toward a "pull of the recent."

Besides his Field Museum murals and the many renditions of his work copied by other artists for various media, Knight's magnificent life-through-time artistry appeared for decades, although in other original forms. His popular book, *Before the Dawn of History* (1935), captured many of his Field Museum restorations with several "imagetext" additions to round out the presentation.[25] Knight was a gifted writer; his expertise in restoring prehistoric scenes shines in descriptions of each painting (published in black and white). His colorfully illustrated article "Parade of Life Through the Ages," published in *National Geographic Magazine* (February 1942), was another magnificent foray into the life-through-time theme, once more delving into time's abyss, from the Cambrian Period to mankind's Bronze Age—shown replete with hunters spearing an Irish Elk.[26] Knight also prepared a smaller-scale display of 28 test paintings made preliminar to the Field Museum murals, which as mentioned previously are displayed at Princeton University.

Of all the pioneer paleoartists and paleosculptors producing contemporary life-through-time paleoart mentioned here, for the purposes of sculpting dinosaurs and other prehistoric animals in miniature—the focus of our book—Knight is highly significant. Later in life, rather like Hawkins, Knight conspired to build life-sized dinosaur statues with his younger compatriot, Louis Paul Jonas, who, instead, constructed famous life-sized dinosaurs for the Sinclair Refining Company's exhibit at New York's 1964/65 World's Fair. (Knight did sculpt a life-sized reclining lion, displayed and cast in bronze at Princeton.) But also like Hawkins, Knight sculpted miniature prehistoric animals, many of which were made available for sale, replication and distribution. In cases where his subject animals were no longer alive, negating the direct study of their movement, expression and demeanor, Knight intended his small-scale statues to facilitate canvas paintings. Having a three-dimensional restoration handy aided in judging illumination, light and shadow in painted prehistoric scenes. Even today plaster casts of many of Knight's beautiful sculptures are displayed in museums (figure 2–2).

Little has been written about Knight's magnificent sculptures, and so here is the opportunity for a bit of elaboration. Like Hawkins and the Ward Catalog beforehand, Knight's miniature sculptural renditions were also molded, cataloged and made available as plaster casts to students and universities. While I have seen twenty-five different prehistoric animal sculptures firsthand in museums or in photographs, his range of studies probably extends considerably beyond. For instance, while in 1982 Glut and Czerkas indicated that Knight sculpted "a series of primitive elephants ... followed during the early years of the twentieth century by a similar series of Miocene- and Pleistocene-period horses, duplicates of which went out to museums across the nation," I have seen only one such primitive horse (the

(Figure 2–2): Two examples of Charles R. Knight's sculptural artistry, in miniature–plaster replicas of his original sculptures —(*top*) the Pleistocene saber-tooth cat, *Smilodon*, (*bottom*) *Triceratops* (A. Debus).

Eocene "Eohippus") displayed, and four distinct types of extinct elephants (two types of mastodonts and two mammoths) reproduced in books or exhibited. This body of sculptural work witnessed may be categorized thusly. Of the miniature sculptures witnessed, Knight made four sculptures of Paleozoic fin-backed reptiles, ten dinosaur sculptures, ten paleo-mammals and one Neandertal Man statue. While appearances of these models may not seem quite so accurate today in several respects, anatomically speaking, under contemporary standards they were state-of-the-art, based on then-current scientific knowledge as often conveyed by men such as the eminent Osborn.

By the 1930s, sculptural representations (both life-sized and miniature) had become all the rage. Paleoart was an accepted staple at most museum institutions featuring paleontology displays. And paleoimagery increasingly wove its extraordinary spell on the American

public. Perhaps Knight's models and paintings had much to do with it, coupled with Osborn's ideologies, but also, psychologically, quite possibly the art of making miniature stop-motion sculptural puppets of dinosaurs built with moveable armatures seem absolutely gigantic on the silver screen was even more influential.

In the mid–1920s, movie-makers had been experimenting with stop-motion animation special effects for about a decade, but in creating the dinosaurs that appeared in First National's sensational silent film *The Lost World* (1925) and later RKO's *King Kong* (1933), they set an unstoppable wave in motion. (Knight's powerful artistic influence on Marcel Delgado and Willis O'Brien — masterminds behind those two sensational films — is well documented.) Here was a new, innovative way to enjoy *animated* prehistoric life, and the key to success began with sculpting miniature dinosaurs. Besides Knight, who couldn't possibly satisfy demands from every museum globally, other paleo-sculptors began testing their talented hands in the art of miniature dinosaur model- and diorama-making either for museum display or the film industry, including Vernon Edwards, Charles Whitney Gilmore, Willis O'Brien, Marcel Delgado, one Prof. Amalitzky of Warsaw, Erwin S. Christman, Richard Swann Lull and the young Ray Harryhausen (who later in his career relied on Arthur Hayward's talents).

But while miniature sculptures of individual prehistoric animals were enormously captivating and profitable — much as Benjamin Waterhouse Hawkins had proven decades earlier, and Josef Pallenberg much later — static, sculptural and statuesque life-sized 20th century prehistoric creatures proved even more mind-boggling. Better yet — why not make the life-sized prehistoric sculptures move on their own, growl, flash their teeth, feed, swivel their extended necks, and roll their eyes; and unveil them logically and, traditionally — that is, as understood by an adoring public — exhibited in a life-through-time format? Now here was an experience the public would never forget!

Although perhaps not directly inspired by First National's sensational 1925 silent film *The Lost World*, based on Arthur Conan Doyle's 1912 novel, George Harold Messmore and Joseph Damon's "The World a Million Years Ago," a motorized, animatronic display of life-sized prehistoric animals, which opened at the Chicago World's Fair in late May 1933, certainly stoked the imaginative fire and interests of those who'd witnessed dinosaurs on the silver screen in major motion picture productions. Messmore and Damon's electronic, "robotic" dinosaurs were the latest invention resurrecting prehistory. For their grandest exhibition, at the Chicago World's Fair, they presented 150 different kinds of waterproofed papier-mâché and cloth-skinned animals, about 15 of which represented extinct genera.[27] Additionally, there were four species of cave- or apemen and a giant prehistoric gorilla (likely inspired by *King Kong*, which opened three months earlier). The most famous of these was the 49-foot-long "Brontosaurus," made during the mid–1920s, erroneously attributed to the Triassic Period in a souvenir postcard description.

All these were housed inside a 150-foot-diameter metal half-globe building representing Earth and showing continents and oceans on the exterior. To keep audiences flowing, 700 at a time, patrons moved past jungles and animals wallowing in swamps, constituting several insular dioramas, along a motorized beltway or concourse. By June 1932, it was planned to provide earphones along railings so that spectators could listen to recorded growls played on disk records by behind-the-scenes technicians and hear educationally oriented descriptions of the animals in each display, but it is logistically difficult understanding today how

this might have been arranged while continually moving along a beltway. Besides "Brontosaurus," chief attractions witnessed within the globe were strange-mouthed *Platybelodon* (a "shovel-tusked" Pliocene elephant); *Tyrannosaurus rex* posed adjacent to its traditional nemesis, *Triceratops*; furry mammoths; a woolly rhino; and *Stegosaurus*, erroneously assigned to the Cretaceous Period in company advertising.

While displays were rather admixed, or congregated within the close quarters of the planetary globe, each individual diorama offered glimpses into successive stages of life's history, ranging from the Late Paleozoic Era to the Late Pleistocene. Additionally, there were six separate dioramas portraying early stages in the evolutionary history of man (i.e., from the time of the giant gorilla's Ice Age through Cro-Magnon Man) situated along the main arena on the globe's outer wall. There were two additional prehistoric displays at the Chicago World's Fair, but Messmore and Damon's creations, reflecting a general life-through-time tour sequence, were the most ambitious. In the gift shop, patrons — such as my grandparents — purchased lead-cast or brass prehistoric animal "toys," which were miniature sculptures of some of the larger recreations on display.

As recounted by Francis B. Messmore in 1997, in 1934 the World a Million Years Ago exhibit was moved to another location, although now isolated from the globe housing. Using a time-honored "river of time" metaphor, the "new show was called Down the Lost River to the World A Million Years Ago."[28] Now visitors were carried in boats across Northerly Island's lagoon to see the recreations. After the fair ended in 1934, The World a Million Years Ago creations toured the nation, notably appearing at the 1939/40 New York World's Fair and in other countries as well until the 1970s, when they were retired in various locations. But, thanks to Hawkins and later Messmore and Damon, the theme of illustrating life's vertebrate history in the form of life-sized statues arranged in geologically ordered settings has persisted until the present day.[29]

Greatly influenced by Knight and Willis O'Brien, between 1938 to 1940 a young and precocious Ray Harryhausen began an unfinished, experimental stop-motion film, amounting to 20 minutes of footage, titled "Evolution of the World." However, Harryhausen's viewing of Disney's *Fantasia* (1940) would quell further interest in completing his "Evolution." Harryhausen recalled, "I had begun *Evolution* before I saw Disney's *Fantasia*.... Of course when I saw the picture, I realized that it was all quite inane to continue, because he did it all in *Fantasia*, in the sequence 'The Rite of Spring,' and so beautifully."[30] That is, if the mass dying of dinosaurs in a drying lake bed can somehow seem beautiful. While most might simply remember the dramatic yet anachronistic battle between *Tyrannosaurus* and *Stegosaurus* from this Technicolor cartoon, Disney conveyed Earth's life history in a mesmerizing 22-minute sequence from primordial stages through the end of the Mesozoic Era, concluding with the dinosaurs' fiery, cataclysmic extinction. "Rite of Spring" was directed by Bill Roberts and Paul Satterfield.

Following Disney's highly praised (yet, even by contemporary standards, not entirely scientifically accurate), animated production, it might have seemed that nothing could further project the public along a life-through-time paleontological journey more artfully or capably. Evolution was certainly a *zeitgeist* then, as demonstrated in a science fictional yarn titled "The Isle of Changing Life" by Edmond Hamilton, published in the June 1940 *Thrilling Wonder Stories*. The story concerns a lost island in the South Pacific where natural radium deposits have kept life from evolving the way it was "supposed to" for millions of

years.[31] But with radium removed, all the stages of life's history are repeated, from primal protoplasm through a dinosaurian age to menacing cave people, all in a single day. This evolutionary process is far more rapid than illustrated in Burroughs' earlier, masterful trilogy. Hamilton's sci-fi tale is little known today, bowing to more dramatic visual representations of the day. But in the life-through-time arena, even Disney, and perhaps Charles R. Knight himself, was soon eclipsed by another artist, this time Rudolph F. Zallinger.

Zallinger painted what may be considered the quintessential life-through-time pictorial emblem of modernity, a colorful 110-foot long, 16-foot high mural at Yale University's Peabody Hall, titled "The Age of Reptiles," completed in 1947. The mural spans some 300 million years of geological time and evolution, incorporating idealized scenes of accurate-looking dinosaurs and other prehistoric animals representative of the major geological periods, from the Devonian to the Late Cretaceous. Trees and foliage representative of each successive transition and smoldering volcanoes subtly subdivide the ages in this mural. The great dinosaurs and reptiles inhabiting the mural do not seem active as dinosaurs have been lately depicted, but stand as solemn, statuesque titans attesting to their former grandeur. In the captivating mural, time's immensity moves from right to left. There is no "river of time" to sail along, but mind-roving viewers cross representative tree markers, cleverly creating a somewhat discontinuous journey from one period to the next. Transitions are imperceptible, not in the least jarring. If there's any irony, perhaps fostered by the mural's deceiving title, it's that at first glance, to the uninitiated, it would appear that all these animals lived together at the same period prehistory. Animals from different continents are seen together in the overall composition.

Unlike *Fantasia*, horror is not unveiled or unleashed in "The Age of Reptiles." And as opposed to Knight's misty romanticism, Zallinger's style may be called static realism, albeit of monumental scale. Whereas Knight's painted dinosaurs seem verily and momentarily active—one may anticipate their next moves—Zallinger's seem statuesque, even sculptural, appearing as mythic gods that have alighted on Earth. And, given the skeletal armatures displayed below Yale's great mural, "The Age of Reptiles" takes on three-dimensional ambiance, as reconstructed bones of many of the painted animals stand erected directly below their restored figures, projected in colorful landscapes (offering even further visual depth, receding into the wall). Seen correctly, the mural's perspective uncannily penetrates into the exhibit hall where observers stand, onto the vividly painted surface, and then magically transforms beyond into the wall itself. Zallinger's "Age of Reptiles" has been often reproduced through the decades, especially in pages of *Life* magazine (September 7, 1953) and in a volume, *The World We Live In* (Time Inc., New York, 1955), which may be regarded as one of the 20th century's most significant life-through-time representations, that is, published in book format, perhaps following the tradition of Kuwasseg, Hutchinson and Knipe.[32]

In *The World We Live In*, a major portion of "The Age of Reptiles" is shown, although in reverse order (such that, the "flow" of geological time progresses from left to right). This very similar yet slightly different version of the mural, a smaller (82½ inches by 12⅛ inches) preliminary scale cartoon, is also merged with an additional recreated Silurian terrestrial landscape by James Lewicki preceding the Devonian age. Prior pages in this chapter of the book present restorations of successive evolutionary stages, offering glimpses of marine life from the Late Precambrian (painted by Antonio Petruccelli) to the Silurian (painted by James Lewicki). Furthermore, introductory sections within this volume capture primeval

stages in Earth's development painted by prominent space artist Chesley Bonestell, beginning with his harrowing view of a red-hot, molten, primordial Earth with a swollen, asteroid-pocked Moon threatening the horizon. But this magnificent life-through-time pageant doesn't terminate with Late Cretaceous smoldering volcanoes, as Zallinger's artistry continued to mesmerize through a Mammalian Age.

Relative to his famous dinosaurs, few people are as familiar with Zallinger's restorations of prehistoric mammals and Paleogene birds. Zallinger extended the life-through-time sequence in *The World We Live In* in a subsequent chapter titled "The Age of Mammals" (originally published as a *Life* feature, Oct. 19, 1953), with its several colorful fold-out pages every bit as triumphant in scope as "The Age of Reptiles." This time Zallinger moved the flow of time from the Paleocene Epoch (at left) into the Pleistocene (at right), over a 75-million-year span. (Geologists had not yet hammered down the duration of the Cenozoic Era, now established at 65 million years.) Prehistoric men are not evident in this painting. Herein, the animals likewise seem statuesque amidst the luxuriant foliage representing each epoch. Painted imagery seems to move seasonally from summer to winter, from the warm Paleocene and Eocene epochs toward the recent Ice Age. (Zallinger also painted scenes of modern mammals, appearing in the "Rain Forest" chapter.) Eventually, this 1953 test painting was considerably revised and expanded into a 60-foot-long mural, titled "The Age of Mammals," now exhibited along a smaller, less prominent wall of the Peabody Museum. Zallinger refined his new life-through-time mural from 1961 to 1967, when it was unveiled to the public. Although at first glance, subtle differences between the "Age of Reptiles" cartoon and the mural are noticeable, in the case of the two "Age of Mammals" studies one may discern more significant and obvious alterations. Positioning of the animals differs in several cases; the scenery and lighting in the 1967 version appears brighter.

Besides his Yale Peabody murals and paintings, Zallinger did many other prehistoric animal paintings, such as for Golden Books' *Dinosaurs and Other Prehistoric Reptiles* (1965, by Jane Werner Watson), a life-through-time tour confined to the dinosaurian ages for younger readers; Wiley Lee's *Worlds of the Past* (1971); and *Life* magazine's "Strange Creatures of a Lost World" (Jan. 26, 1959), featuring a magnificent, colorful fold-out spread with restorations of lively South American Pleistocene mammals. During the 1950s, beginning circa 1955, Zallinger's prehistoric reptile and mammal figures, appearing in *Life* and *The World We Live In*, were recreated three-dimensionally by Phil Derham and a team of sculptors, particularly Joe Ferriot, although as small sculptures converted into immensely popular plastic toys sold by the Louis Marx Company. These once-ubiquitous toys proved highly influential in fostering love and curiosity for the creatures of prehistory among a generation of young dinophiles, including many of today's prominent paleosculptors and paleoartists. Zallinger's work would inspire 1990s sculptures, such as Jeff Johnson's miniature "Age of Reptiles" diorama, formerly available for purchase by Alchemy Works in a limited edition as a set of resin casts.

Most likely, Zallinger's "Age of Reptiles" compositions influenced Australian geologists, as well as two artists—Donald Ross Cowen and Robert Quentin Hole—who produced a striking mural for the University of Queensland's (St. Lucia) Geology Museum, reminiscent of Zallinger's by-then famous precedent.[33] The Australian life-through-time mural was completed in 1951 and is also titled "The Age of Reptiles," with idealized scenes of depicted geological periods moving continuously from left to right from the Permian to the end of the Mesozoic Era. According to Kerry Heckenberg, however, while the "general approach

may derive from Zallinger's work, ... the look of the University of Queensland picture [suggested] that, while the artists had heard about the Peabody mural, they had not actually seen any images of it."[34] This may be because Zallinger's actual 110-foot-long mural had not yet been photographed from the Great Wall. Furthermore, the "Age of Reptiles" cartoon had not yet been published by *Life*. The dinosaur scenes in the Australian "Age of Reptiles" appear to be a blend of Knightian imagery, although recast in a Zallinger-esque tableau. Another wall mural titled "Life Through Geologic Time," showing stages in the evolution of life through time arranged in a vertical succession of rows ascending from the floor level as a stratified "layering," thereby mimicking the geological column, was completed for the University of Michigan's Exhibit Museum of Natural History in 1950, painted by Robert M. and Jane Mengel[35] (figure 2–3).

It is apparent that by the mid–20th century, the art and style of rendering life-through-time paleoimagery had become vastly sophisticated and traditionalized through a variety of media and "imagetext" formats. Zallinger's "Age of Reptiles" will never be eclipsed, although two memorable, yet far less publicized 1950s productions reveal how ingrained and lasting this image-making tradition had become. This time, newer, post–Zallinger, entries — a film titled *Journey to the Beginning of Time*, and Joseph Augusta's volume, *Prehistoric Animals* — came from Czechoslovakia.[36] Both were evidently inspired by the artistry of master paleoartist Zdenek Burian, who had been painting prehistoric animals since the mid–1930s. Paleontologist Joseph Augusta teamed with Burian, resulting in a series of highly sought books focusing on facets of prehistory. Yet of these publications, *Prehistoric Animals* (translated in 1960 into English by Greta Holt) would be their first and most widely known collaboration. Theirs is a brilliant blending of "imagetext," combining Augusta's vivid descriptions of life's gradual development from simple organisms, culminating in mankind. Sixty of Burian's magnificent plates follow chronologically, beginning with life in the Cambrian Sea and ending with a Pleistocene depiction of Neandertals hunting a Cave Bear family. Burian's rather impressionistic style certainly was favorable and influential among a younger generation of paleophiles, who absorbed the distinctive sense of life's flow through the long corridors of geological time, conveyed through *Prehistoric Animals*.

Journey to the Beginning of Time (or in Czech, *Cesta do proveku*, 1954), produced by Karel Zeman, included many splendid stop-motion animation scenes of prehistoric life. Many of Burian's paintings had been published or placed on display over a decade previously, before being assembled into the *Prehistoric Animals* compilation. Zeman and his special effects team must have known of Zdenek Burian before imagining their movie premise. In *Journey's* 1960 American release, following a visit to New York's American Museum of Natural History, four youths find themselves sailing down a metaphorical river of time flowing from the recent Ice Age back to the primordial ocean at the proverbial beginning of time. Along the way, the boys observe living herds and isolated prehistoric mammals, a flightless terror bird, dinosaurs, and pterosaurs, and visit a Coal Age swamp. Just as many of Willis O'Brien's and Marcel Delgado's sculpted, stop-motion puppets that were animated for *The Lost* World (1925) and *King Kong* (1933) were derived from Charles R. Knight's famous dinosaur paintings, wildlife animated from miniature sculpted puppets in Zeman's *Journey* appears highly influenced by or derivative of Burian's painted restorations — several of which later were collected in Augusta's *Prehistoric Animals*.[37] In the end, however, Zeman's *Journey* turns out to have been merely a dream.

As in the case of so many of the life-through-time depictions, and even though many of the finest examples were introduced during the Darwinian era, the American edition of *Journey to the Beginning of Time* ends with a kaleidoscopic, geologically chaotic representation of the biblical "Beginning." While psychedelic visuals attuned with odd music assaults our senses, a narrator reads passages from Genesis. As Stephen J. Gould noted in 1993, in life-through-time portrayals, commonly, one may identify the "ghost of Scheuchzer's biblical chronology haunt[ing] us still."[38] From 1731 to 1733, physician Johann Jakob Scheuchzer published *Sacred Physics*, containing many illustrations showing the history of the world, as derived literally from Scripture. Curiously, Scheuchzer sought to reconcile science with theology, therein incorporating numerous plates showing historical biblical stages of creation and history, adorned with fossils, typically "relics of the Deluge." As noted by Martin J.S. Rudwick and Gould, however, today, and apart from popular culture, paleontologists derive their history of the world not from biblical writings and theological beliefs, but from properly interpreted scientific evidence, particularly knowledge of geological events, fossils and, in the modern day, utilizing the latest tools of chemistry and physics to unravel knowledge of the deep past from the rock record.

In other words, today, we are privileged to exist in a dinosaur renaissance.

Paleoimagery's Second Sweeping Phase — "Dinosaur Renaissance"

Historically, however, in life-through-time depictions — most of which were prepared by artists prior to the 1980s rise of modern trace chemical analytical laboratory method-ologies, scientific evidence is translated into the form of extinct animals and plants known from fossils, restored as living specimens. A theological purpose, emphasis or unspoken meaning, subtext on the part of the artist or commissioning scientists, often underlay the pictorial depiction. For a century, from the day of Benjamin Waterhouse Hawkins' Crystal Palace statues to Zeman's *Journey*, culminated in a beginning that most viewers would have naturally considered providential or divine, life-through-time journeys experienced by the public often have been at least tacitly infused with theological undertones, with exalted Man triumphantly showcased at evolution's pinnacle.

However, during the 1950s, following two devastating world wars, that pinnacle began to erode; our increasingly secular focus on our future began to shift, psychologically, the outlook growing grimmer, perilous. Scientists recognized that the global population was swelling rapidly to predictably unsustainable levels, the natural environment was being pol-luted, resources were being depleted by human industry, and the atmosphere, oceans and soil were being repeatedly contaminated with radioactive fallout. Furthermore, as Cold War tensions heightened, we drew ever closer to nuclear Armageddon. Nervously, with such ominous factors coinciding, scholars, writers of fantastic fiction, script writers and movie producers found themselves preoccupied with a dire question: "Could Man cause his own extinction?"

It was during this period that dinosaurs, particularly certain fictional kinds, became increasingly metaphorical for mankind's dilemma. Their demise 65 million years ago sym-bolized our own possibly inevitable doom, our extinction, as well. It was also at this time that the pop-cultural paleontological focus on life-through-time imagery faded due to the

(Figure 2–3): Segment of a wall mural (painted by Robert M. and Jane Mengel in 1950) displayed at Exhibit Museum of Natural History of the University of Michigan, Ann Arbor, showing the Permian (at bottom) through the early Tertiary periods. This is a section of a mural intended to show the entirety of geological "life through time," one of numerous such examples and styles made over a two-century period (A. Debus).

harrowing messages paleontologists, geoscientists and others were broadcasting. With our very survival in jeopardy, general interest in the pageant of life no longer seemed quite as relevant. Was mankind's evolutionary ascendance truly so triumphant, given our aggressive nature and propensity for self-extermination? Forecasters and social critics of the human dilemma, such as the evolutionist writer Herbert George Wells, certainly did not think so. Here, in essence, was an embryonic beginning to the second major phase or cycle in pale-oimagery with associated "imagetext." With interest waning in traditional life-through-time depictions, paleoimagery's dinosaur renaissance wave was cresting. And so here, the meaning of this renaissance in dinosaur knowledge will be outlined as it took form in culture and paleoimagery during the 1950s through 1990s.

Paleontology's popularity, especially its visual appeal, has been high since the discovery of bones allowing early naturalists and fossilists to perceive ancient worlds preceding our own, populated by startling arrays of monsters deemed pre-historic. For a century, life-through-time sequences formed an organizing, understandable, if not comforting con-veyance allowing laypeople to comprehend geology's vital, visual language. Interpretations of certain scenes or discrete animals witnessed within the organized, traditional set of sequences varied according to one's sociological, cultural, or religious background, or to the extent observers simply were predisposed to become subconsciously awed by giant, scary-looking extinct monsters. Furthermore, prehistoric monsters meant different things to their restorers and observers alike during different historical periods. Yet paleontology's visual core has been utterly and irrevocably shaken since the beginning of what has been termed the dinosaur renaissance. During this current phase of paleoart, we find dinosaurs anthro-pomorphized more than ever before. Stories told in many forms of paleoimagery and asso-ciated "imagetext" melodramatically seek to warn mankind of shared, inevitable fates of extinction.

Just as for every book, readers have their favorite passages and chapters, analogously, during the heyday of pictorial life-through-time representations (c. 1850 to 1950), there always were certain segments in Earth's timeline, such as the Mesozoic and Pleistocene, or particular painted or sculpted prehistoric animal restorations, that most fired the public's imagination. Portrayals of prehistoric life in the traditional, life-through-time vein had cre-ated stars of certain interacting genera. For instance, Charles R. Knight's paintings of *Tyran-nosaurus* engaging *Triceratops* in battle steadfastly remain one of paleontology's most popular themes; restorations of America's iconic *T. rex*, *Stegosaurus*, fin-backed reptiles and our mastodon, recognizable citizens of the past, are always eye-catching. Furthermore, certain paleoartists were trend setters, those who would at certain historical junctures speak most for the genre of recreating extinct animals from fossils through their visual artistry. Yet it wasn't until the dawning of the dinosaur renaissance that scientists found themselves ques-tioning the accuracy of traditional or particular scenes, reconstructions and their inherent or implied messages (i.e., "imagetext"), within the framework of paleoart's older, time-honored life-through-time sequences.

Reverting to the Late Cretaceous terminus in Zallinger's astounding "Age of Reptiles" mural, our eyes feast on two huge Cretaceous dinosaurs — a pot-bellied *Tyrannosaurus* and its traditional adversary, *Triceratops* (figure 2–4). But ominously in the background, we also see lofty, smoldering volcanic cones, the largest and most dangerous (closest to the viewer) situated nearest the left edge of the visual time line. What killed off the dinosaurian clan?

(Figure 2–4): **Schematic diagram showing key elements from R. Zallinger's Age of Reptiles mural (exhibited at Yale University's Peabody Museum).** *Tyrannosaurus* **(left),** *Triceratops* **(right),** *Cimolestes* **(in between the reptilian giants), and in the background, ominously smoldering volcanoes. See text for details (illustration courtesy Mike Fredericks).**

The barely discernible image of a tiny mammal, *Cimolestes*, in the mural painting offers an alternative, supposing that somehow proto-mammals caused the dinosaurian extinctions. However, it is more likely that *Cimolestes*, merely suggestive of the little-known furry genera that were waiting in the wings opportunistically, to "inherit" Earth, was included symbolically. But Zallinger also offers a more visually compelling explanation. From observation of this mesmerizing mural, we are more tempted to conclude — as visually emphasized by Zallinger — that *volcanoes* were the culprit. Volcanoes — grim orchestrators of geological upheaval, major polluters of the ocean-atmosphere system!

Certainly, by the 1950s, learned men cautiously contemplated chemical contamination and degradation of the natural environment, eventually equating the demise of the formerly "superior" dinosaurs (ironic, especially considering how brainy several theropod genera had become), with humanity's apparently hell-bent course of self-destruction. Conceptually, just as voluminous volcanic eruptions could have conceivably exterminated the Late Cretaceous overlords, mankind could so easily self-destruct, literally, at the push of a button. Scholars certainly had good reason to question whether braininess was a misfortunate consequence of evolution.[39]

Many attribute the beginnings of the so-called dinosaur renaissance to late 1960s biologically focused researches of Loris Russell, John Ostrom and Robert Bakker, culminating popularly perhaps with Adrian J. Desmond's *The Hot-Blooded Dinosaurs: A Revolution in Palaeontology* (1975).[40] That April also saw publication of Bakker's *Scientific American* article, "Dinosaur Renaissance."[41] Dinosaurian revolution and renaissance: what was this all about?

Surely all we needed to know about dinosaurs and other prehistoric animals had already been captured in those magnificent life-through-time sequences, right? During a revolutionary period of sociopolitical unrest in America, science — even what was then considered a dead science like paleontology — was also moving forward, posthaste.

But by the mid–1980s, dinosaurs were coming alive like never before. Certainly, in the cultural realm, heightened interest in dinosaurs during and beyond the mid–1980s increasingly spawned televised dinosaur documentaries, which in turn fostered a need for more dramatic, visually appealing animated portrayals of dinosaurs and other prehistoric animals. Illustrating how far we've come since then, in 2011, a new 4-part serialized program relying on state-of-the-art, computer-generated special effects created by an expert team of paleoartists including paleosculptor David Krentz, using more than a dash of artistic license, was broadcast by the Discovery Channel, titled *Dinosaur Revolution*. The message contrasted with that of the early 19th century paleontologists and associated paleoartists who eschewed speculation. For as Thomas Holtz stated, "If we *don't* use imagination we'll never come up with new techniques and methods to unravel the world of dinosaurs." Although *Dinosaur Revolution* offered fresh wildlife stories featuring anthropomorphized dinosaurs, using revolutionary special effects to produce the visually striking paleoimagery — introduced through release of 1993's blockbuster, *Jurassic Park*—interestingly, the new series safely presented its vignettes and animal stories in a generally forward-moving Late Permian through Late Cretaceous, life-through-time temporal format. *Dinosaur Revolution* quite speculatively claimed that beyond outright luck and superior physiologies, dinosaurs' success could be attributed to their enhanced breeding and reproductive strategies and, possibly, parental skills. As the interviewed paleontologists stated, the dinosaur revolution (as of 2011, that is) was just beginning.

So have we moved beyond a dinosaur renaissance into a more highly refined "revolution"? And what is, or was, the original dinosaur renaissance? Was it limited to the fields of study initially defined by Bakker, refined through Desmond's adroit analysis? The early publicized stages in the ideological battle were waged over dinosaur physiology, whether cold- versus hot-blooded metabolism was more likely. In retrospect, this scientific controversy, spilling over into the public forum, had manifest implications for new paleoart and paleoimagery; ultimately, proponents of the warm-blooded camp emerged victorious. Desmond proclaimed that the dinosaur revolution centered on a controversial, early 1970s reclassification of modern birds as dinosaurs. (In 1986, bird-dinosaur kinship was fortified using cladistics, an organizational, statistical method comparing and associating key or diagnostic anatomical relationships, thought to be evolutionary in nature, among clades, such as genera.) Furthermore, savvy paleontologists also reasoned that certain dinosaur species may have been insulated with feathers, a prediction that was dramatically verified two decades later. Accordingly, during the 1970s through the early 1990s, before the discovery of actual feathered dinosaur specimens (besides winged *Archaeopteryx*), paleoartists took liberties in restoring theropodous dinosaurs adorned with feathers and plumage, both on canvas and in sculpture.

While between c. 1900 to the 1970s, Knight, Burian, Zallinger and a handful of others presided over the dominion of paleoart with bold, new scientific interpretations in public consciousness and a manifest destiny to re-explore sectors of the deep past chronologically, during the dinosaur renaissance's early visual stage (1969 through early 1980s), new distinguished artists, particularly Robert Bakker, Sarah Landry, Gregory S. Paul, Mark Hallett,

John Sibbick, William Stout, John Gurche, Dougal Dixon, Dr. Kenneth Carpenter and Douglas Henderson, seized the baton. And by the end of the 20th century, scores of additional paleoartists (notably Brian Franczak, David Krentz, Michael Trcic, Stephen Czerkas, Michael Skrepnick, Sean Cooper, Shane Foulkes, Tracy Ford and James Gurney) were producing more spectacular paleoimagery and sculptures than ever before, typically of warm-blooded, socially-sensible dinosaurs and, later, often, visually captivating feathered theropods.[42] As if we didn't know already by then, on its cover, the January 2006 issue of *Geotimes* declared "a dinosaur revolution." Several articles on dinosaurs appeared in this issue, although paleoartist Gregory Paul led the way visually with his overview, "Drawing Dinosaurs," emphasizing modern restorations, feathered dinosaurs and avian-dinosaurian ties.[43]

The dinosaur renaissance has surely evolved, first branching out considerably during the 1980s. While an early, mid–1960s component of the movement dealt with a theory of dinosaur physiology, factoring it into the manner of their probable extinctions, three decades later, neo-catastrophist extinctions theories continued to rely upon such metabolic data newly gleaned from geochemical analysis of fossil bones, coupled with other logical inferences. The dinosaur renaissance quickly encompassed fresh fields of inquiry, such as probable dinosaurian social behavior and reproductive strategies. New analytical tools, including the latest generation of computers and software programs, were employed inventively by paleontologists. New dinosaur specimens, corresponding to more new species than could have been conceived of half a century ago, were being discovered annually, globally. Accordingly, since the mid–1980s, evolutionary (phylogenetic) relationships among dinosaurs and related genera were refined using a computer-driven and validated form of "dinosaurian systematics" as well as "DNA-molecular phylogeny." The philosophy of thinking anew about dinosaurian dogma tumbled into reconsiderations of other prehistoric life as well. If paleontologists had been so wrong about dinosaurs for so long, then what else had they missed concerning other prehistoric vertebrates all these years? And how could these animals, in turn, be redrawn, sculpted or painted to exemplify new, reigning renaissance ideas?

In short, the dinosaur renaissance remains alive in spirit and encompasses a far wider spectrum of inquiry than originally entertained by 1960s and early 1970s instigators and pioneers. Laypersons, intent on keeping up with the latest discoveries, feast upon scores of new popular books and associated visual paleoimagery showing life restorations of new species in their idealized ecosystems. Under the dinosaur renaissance umbrella, rather than stagnating, the prehistoric past is continually being reconsidered and redrawn.

But while the term *dinosaur renaissance* implied at some level a scholarly rebirth in thinking (generally but not exclusively) about dinosaurs *per se*, this rather ill-defined, if not otherwise open-ended movement meandered onto a parallel track: rebirth in considerations over mankind's fate in light of the dinosaurian demise. For by the late 1950s, once we comprehended what happened especially to dinosaurs, which on a pop-cultural level proved so endearing to imaginative souls and the young at heart, optimistically, it seemed we might also resolve our plight and secure the future. As one Peabody Museum scientist opined, "Clearly, a new life has come to the dinosaurs in recent years, one that is in some deep way much closer to our own."[44] Dinosaurs and man were not only becoming inextricably linked; in the persuasive realm of paleoimagery (including media traditionally viewed as science fictional), increasingly, dinosaurs were also taking on human guise.

Arguably, the core essence of the dinosaur renaissance movement began rather inde-

pendently, during the mid 1950s, a decade before the discovery and interpretation of *Deinonychus*, as the fate of our planet became reconsidered biogeochemically in light of major faunal extinction events. These studies translated into increasingly detailed reconsiderations of how particular groups of animals may have met their fates at extinction boundaries — particularly such as the Late Permian and Late Cretaceous — converging with other lines of inquiry, initially emphasizing researches into dinosaurian physiology. Subliminally triggered, perhaps, partly by Zallinger's famous "Age of Reptiles" mural with its ominous, metaphorical steaming volcanoes, early investigations characteristically focused on the role of volcanically emitted chemical pollutants. Thanks to paleoimagery, because of their by-then obvious overwhelming popularity relative to other prehistoric animal groups, dinosaurs occupied a preeminent share of the spotlight.

While extinctions theories of varied persuasion had been proposed between 1928 and 1972, a period that paleontologist Michael Benton labeled the "dilettante phase" of questioning the causes of dinosaur extinctions, later, especially during the late 1950s through early 1970s, several geologists suggested that high concentrations of toxic heavy metals may have exterminated the dinosaurs.[45] Several suggested that metals, such as selenium, silver, copper and zinc, could have been emitted during recurrent phases of heightened volcanic activity, thus poisoning dinosaurs and other organisms at major extinction boundaries. Others didn't implicate volcanoes mechanistically, yet believed that herbivorous genera could have eaten vegetation tainted with high heavy metals concentrations. Toxic doses of chemicals — heavy metals, carbon dioxide, even excessive oxygen emissions — reigned at the heart of the extinctions problem for decades as scientists pondered how these pollutants would have played havoc with dinosaurs' physiological and reproductive systems, viewed without consensus variously both as warm- or cold-blooded (or intermediate).[46]

Meanwhile and analogously, biologist Rachel Carson published evidence for widespread overuse of agricultural chemicals — insecticides known to have carcinogenic properties in humans and also to inhibit the ability of predatory raptor birds to raise young in eggs that were abnormally thin. In essence, we were insidiously imposing upon ourselves and endangered wildlife the harrowing fate that the natural environment had dealt to dinosaurs, resulting in their demise 65 million years ago. Some prominent paleontologists opined they didn't care about how dinosaurs had died, but instead how they had lived. So, correspondingly, many paleoartists of the time strove instead to depict how these "new" dinosaurs lived.[47] Yet, arguably, the most startling, fresh flavor of paleoimagery enlivened during the later 1980s materialized in the form of those artistic depictions derived from the astonishing asteroid impact theory's predictions. Paleocatastrophe imagery uniquely melded themes of visual paleontology restoration and reconstruction devised prior to 1900.[48]

Aside from volcanoes, when the famous asteroid impact theory of dinosaur extinctions — in essence a theory of an era-ending, global environmental and ecological disaster — went viral in 1980, visual artists, science popularizers and science fiction writers had a field day, introducing the new "imagetext" theme of paleocatastrophe, further supplanting the general interest in life-through-time depictions of prehistory. Beyond the gradualistic, epoch to epoch, period to period successional changes charted by prior paleoartists, surely there were just moments, mere seconds of prehistory, that were perhaps the most significant of all — such as when a 6-mile-diameter asteroid came suddenly out of the blue skies and collided with Earth. Science fiction had become stately fact. The visually arresting art of

paleocatastrophe took many forms, fueled intensively in culture particularly through scores of illustrations and paintings juxtaposing tyrannosaurs and horned dinosaurs with an impending cometary harbinger of doom soaring in the heavens above; other notable depictions showed the impact's aftermath (figure 2–5).

But also, most curiously, the new "what if?" science of luck, or contingency, founded upon circumstances in which the asteroid or comet instead missed Earth, spawned sculptural, pictorial or otherwise emergent science fictional representations of technology-wielding "dinosauroids," evolutionary descendants of brainy theropods that survived in the absence of a 65-million-year mass extinction. Furthermore, science fiction writers introduced brainy, metaphorical "warrior" theropods — supposedly long ago obliterated from the fossil record — capable of causing their own extinctions 65 million years ago through various means — e.g., nuclear war, ecological devastation, biocide or atmospheric pollution.[49] Not only was this nouveau art theme of paleocatastrophe closely allied to an evolving, increasingly hard science-driven dinosaur renaissance, but the movement had come full circle, demonstrating that through detailed studies of dinosaurs and their environments man could better understand himself as a natural species living on an indifferent (Gaian) planet cycling through a vast cosmos.[50] Psychologically perhaps, the art of paleocatastrophe was one step removed from "disaster porn."[51]

Particular instances within the fossil record's life-through-time sequence, generally corresponding to brief mass extinctions intervals, were demonstrated to be most instructive and of most relevance to the human condition. By the early 2000s, beyond what had been imaginable half a century before, enhanced dinosaur renaissance thinking fully relied on

(Figure 2–5): Jack Arata's stylistic composition, characteristic of the 1980s thru 1990s paleoart period, showing the K-T boundary comet (or asteroid) in the heavens above, following the curved wing of gravity on its inevitable collision course with Earth 65 million years ago (courtesy Jack Arata).

and prescribed use of highly sensitive chemical analytical tools, such as for detecting and identifying trace quantities of biomolecules in dinosaur bone, feathers and other fossils; stable isotope markers in dinosaur teeth to glean the probable metabolisms of their owners; instrumentation used to see inside fossil-bearing rock; as well as an assortment of key geochemical markers deposited in sediments supporting the likelihood of a 65-million-year-old asteroid impact (or other causative factors).

But geochemists were also using models founded in geological evidence combined with chemistry equations to show something extraordinary — that Earth's atmospheric composition had varied considerably since the middle Paleozoic Era. Their "environment-through-time" results, displayed graphically, demonstrated prolonged episodes when atmospheric carbon dioxide levels soared to over a dozen times higher than today. Furthermore, it was ascertained that dinosaurs, who like us were warm-blooded, had evidently evolved under more arduous conditions, when the oxygen content of the atmosphere was low, only 12 percent (compared to today's 21 percent). Such findings prompted new ideas as to why certain groups of vertebrates such as warm-blooded dinosaurs proved so successful, and why others succumbed to extinction — through time.[52]

While politicians and society spokesmen debated whether or not man's accelerating depletion of resources and industrial excesses were causing global warming through the emissions of carbon dioxide, which if left unabated could rapidly escalate to catastrophic levels, paleontologists documented evidence for *several* natural greenhouse conditions of the deep past deemed so severe that oceans became anoxic and the air turned toxic, laden

(Figure 2–6): Detail of sculpture made in polymer clay by Allen A. Debus, titled "Linked Fate?— Dinosaur and Man" (2012), showing *Troodon* at left and a fictional/hypothetical Dinosauroid. These two figures are posed analogously to those in the original Dale Russell–Ron Seguin composition. See text for details (Debus).

(Figure 2–7): "Linked Fate?—Dinosaur and Man" (2012), a one-of-a-kind sculpture by Allen A. Debus showing all three figures in this science fictional composition, bonded to a simple 17"-long wooden base. See text for further details, as well as note 57 to chapter 2 (Debus).

with poisonous hydrogen sulfide—the pervading smell of rotten eggs.[53] In a sense, life-through-time studies, aided by intrepid biogeochemists, transformed into a uniquely scientific and sophisticated, instrumentally fortified "paleontological renaissance" or neo-life-through-time perspective that can be newly exploited by paleoartists. Kuwasseg, Unger and Benjamin Waterhouse Hawkins would have been amazed.

Due to our undeniably precarious condition and the analogous fates (i.e., impending extinctions) evidently shared inevitably by man and dinosaur, visual artists and writers increasingly portrayed dinosaurs (both real and fictional) in an anthropomorphic (sometimes heroic) light. In retrospect, the dinosauroid or intelligent dinosaur theme proved most thought-provoking of all. Dinosaurs have come to reflect mankind's plight, which is why dinosaurs are so especially endearing today. They *are* us, or through the medium of popular culture have "evolved" into us. When properly interpreted, the dinosaur renaissance is as much about man as it is about dinosaurs and other prehistoric organisms and their paleoworlds.

The degree to which paleoart and paleoimagery is a form of rhetoric, or whether such imagery presents and documents scientific hypotheses, has lately become of scholarly concern. Certainly the best paleoart transmits ideas, even fantastic stories to be fleshed out in the mind. Controversial stories may be reflected in sculpture as well. Thus, perhaps the most profound case of dinosaur renaissance era paleoart, testing the imaginative limits, remains the 1981 sculptural rendition of the Dinosauroid sculpted by Ron Seguin under Dale Russell's direction.[54] Accordingly, for the purposes of this chapter, I offer a visual extrapolation of the Seguin/Russell Dinosauroid-*Troodon* pairing here (figure 2–6).

As paleoartist Mark Rehkopf stated recently, "Dinosaurs are the perfect science fiction ... parts of them are actual science fact, and the remainder is imagined fiction based on science speculation."[55] Accordingly, paleontological renaissance era considerations, reflecting the evolutionary transformation of paleoart's new and darker inner meaning, as outlined in this essay, are illustrated in a new sculpture titled "Linked Fate?—Dinosaur & Man" (2012) (figure 2–7).

Here at left we see the Late Cretaceous *Troodon*, restored as a feathered dinosaur,

thought to be so highly intelligent and cunning that, as scientists speculated during the 1970s, it might have evolved into an even brainier sort had the asteroid not fallen through Earth's skies 65 million years ago. Furthermore, as Dale Russell speculated, "If these presumably more intelligent reptiles had survived, their descendants might conceivably have continued to suppress the rise of the mammals, thereby preempting our own position as the brainiest animals on the planet."[56] In the middle is an image of the Russell/Seguin symbolic Dinosauroid, suggesting what *Troodon's* ilk might have evolved into, granted another uninterrupted 65 million years of evolution. Then at right is a stylized representation of a Late Cretaceous Warrior–Deinonychid descendant, a metaphorical, hypothetical dinosaur introduced in 1984 by paleoartist John C. McGloughlin, which — science fictionally speaking — using atomic weaponry caused the mass extinctions of 65 million years ago. Essentially, this menacing warrior *is* man.

The trio of figures were selected to modify, update and otherwise augment the meaning of the original 1981 Russell/Seguin ensemble, adding a darker unnatural dimension — the human specter. For while evolution could have proceeded much differently yet naturally in a parallel universe where the asteroid collision–caused extinctions didn't happen, thus obviating the emergence of mankind, man's probable self-imposed fate of extinction is increasingly felt as being shared metaphorically with that of the dinosaurs — so often deliberately anthropomorphized in dinosaur renaissance popular culture.[57]

Certainly, besides Seguin's and Russell's captivating *Troodon*-Dinosauroid pairing, there were numerous other life-sized, scientifically accurate sculptural renditions of prehistoric animals, usually dinosaurs, increasingly built by companies (e.g., Dinamation) or commissioned for museum institutions, materializing throughout the late 1970s and 1990s. For our purposes, however, by the mid to late 1980s, a few self-taught paleoartists began sculpting their own miniature dinosaurs and prehistoric animals in basement or garage settings. As Mike Fredericks relates, this self-reliant trend began in Japan (e.g., the Kaiyado Company), becoming ever more popular in the United States by the late 1980s, which is when authors of this book began their craft.[58] As a variety of plastics were more readily available and affordable by then to household consumers and hobbyists, it became possible to mold and cast prototype sculptures in one's home using household appliances, later offering casts and finished pieces to dinosaur aficionados and collectors.[59]

At first, only a few small companies engaged in this unusual line of business. Particularly following publication of *Dinosaur Sculpting's* first edition, and the appearance of a refined venue for advertising and promoting individualistic sculptural creations within the pages of Mike Fredericks's paleoart-friendly magazine, *Prehistoric Times*, the prehistoric animal sculpting and resin casting "garage kit" industry greatly expanded. A quick perusal of any recent *Prehistoric Times* issue will illustrate just how prevalent the hobby has become over two decades. Previously, museum patrons might only gaze wistfully through display cases at miniature sculptural marvels — so inspiring and convincing for their time — by stalwart paleoartists such as Knight, Christman, Vernon Edwards, Charles Whitney Gilmore, Richard Swann Lull, Maidi Wiebe, and George and Paul Marchand.[60]

Clearly, one no longer need be a museum artist to create museum quality sculptural replicas, or expend enormous amounts of personal capital purchasing paleosculptures made by others; that is, if you can make them yourself and for your own purposes — but you must still understand how and where to begin.

And this is where our book fits in.

3

Why Do it? Brainstorming Ideas and Exploring Themes in Paleosculpture

While much of this book emphasizes how to do paleosculpture, we should also fundamentally consider why anyone would want to embark on such an endeavor. After all, sculpting original dinosaurs is a rather unusual preoccupation. Besides, it takes considerable planning and time to do. Why not just read a novel, or become a couch potato watching sports instead?

First of all, you're probably already very interested in prehistoric animals and, generally, paleontology. As we know, paleontology — besides being a "historical science" — is also highly visual in nature. For various reasons, many of us were attracted to images of the extinct "paleo-zoo" at impressionable stages of our lives, in one form or another. Later in life, despite the various vocational paths and occupations undertaken, on some comforting, alpha-wave-generating level, many of us nostalgically yearn to relive that youthful, joyous, fascination.

You don't have to be a professional scientist or a trained paleoartist to enjoy paleontology, especially considering how prevalent this amazing field has become in popular culture during recent decades. And almost anyone with the proper spirit and resolve can learn to sculpt dinosaurs that seem sufficiently realistic to satisfy most people. For those who merely would like to get into the business end of paleosculpture, mainly to make a mint, we must caution you: paleontology generally won't make anyone wealthy. Numerous paleosculptors who have been interviewed for past *Prehistoric Times* issues have echoed this tune. So, instead, sculpt because you *want* to sculpt; because you have the passion and drive for it! Because you want to see what you can do and practice your skills. That will be your main reward.

Okay, but then what should you sculpt? The simple answer is "whatever you want." But here are some further thoughts. Think back to the core of your being and ask yourself what really attracted you to paleontology in the first place, what inspires or challenges you intellectually about it, what fires your imagination concerning dinosaurs and other prehistoric animals. That's how to get started. It's sort of like how many regard science fiction writing. Gee, another outer space or robot tale — surely it's all been done already, right? Well, if that were so, then why are hundreds of sci-fi novels and stories published each year? The possibilities are endless because human imagination knows no bounds.

Always strive for thematic originality. Thumbing through pages of *Prehistoric Times*—a magazine we highly encourage you subscribe to and obtain back issues of—it is truly amazing to see how many scientifically accurate sculptures of *Tyrannosaurus*, *Spinosaurus* and *Stegosaurus* have been produced and advertised during the past dozen years. That wasn't the case 25 years ago; when we started there were fewer practicing paleosculptors out there. Producing yet another eye-catching spinosaur or tyrannosaur in a running pose and with toothy mouth agape may be great practice (and likely a great selling product too), but wouldn't it be more exciting to try something entirely fresh and new? This is what comes from the inner stirrings of your soul, and—yes—your result may fly in the face of common sense and business sensibility. But so what? Be yourself.

We can outline good techniques, equipping you with the mechanical techniques and knowledge to build a dinosaur from scratch. But while it is truly difficult to dictate exactly what to do, perhaps we can briefly explain what paleosculptural themes we've fruitfully enjoyed and pursued over the years, some of which we've dabbled in hands-on, and then outline others that we've noticed or set on the backburner to explore some day.

Bear in mind that dinosaur sculpting differs from dinosaur "modeling." Dinosaur modelers usually take a finished cast that has been mass-produced in resin or plastic (i.e., in "model kit" form), assemble all the parts and paint it, sometimes placing the assembled model into a plausible diorama. Dinosaur modeling usually begins well after sculpting stages are done. Dinosaur *sculpting* is the term we reserve for constructing the original dinosaurs and other prehistoric animals entirely from scratch using wire, polymer clay, and other easily obtainable materials and tools, but mainly your imagination.

Oftentimes, modelers will customize their kits, altering poses, heads, etc., to suit their tastes, placing their own stamp of originality on things and sometimes improving upon the original sculptured pose. Of course the prototype, or *master* as it is sometimes called, can also be placed in a prehistoric diorama scene, even alongside mass-produced critters. While our emphasis is on the initiating, sculpting end of the process, in chapter 16 we'll also delve into some matters that would interest modelers as well. While dinosaur modeling is fun and challenging to do expertly even for yeoman modelers, and an activity that endeared many of us to paleontology at younger stages in life, the true joy of sculpting an original dinosaur is that you are making something that hasn't existed before. It's not someone else's creation but, for better or worse, your very own. That's our main reason for proceeding.

But surely there are other reasons to sculpt. Beyond having a hobby to share with family and friends, or simply amusing the kids, sculpting original dinosaurs is a useful, cathartic means of personal expression. Besides this, Allen, for instance, has had a long-standing fascination with the history of paleoimagery—questioning how prehistoric animals formerly were reconstructed and restored as known to science through the decades, and above all, why in such antiquated and outmoded configurations? So, during the early 1990s, for illustrative purposes, he began to sculpt miniaturized versions of several restored interpretations of the same dinosaur genus yet as historically understood, representing the ideological transformations. These figures were placed alongside one another on the same model base to show the quite dramatic differences in contemporary scientific thinking.

From this creative endeavor came Allen's "Historical Dinosaurs" series of original polymer clay sculptures. The models proved so enchanting to some at the time, that during the

early 1990s Allen authored several papers about them and the historical background concerning the older scientific interpretations, published in *Earth Sciences History* and newsletters of the former U.S. Dinosaur Society (*The Dinosaur Report*), the UK Dinosaur Society (*The Dinosaur Society UK Quarterly*), and the Western Australian Museum in Perth (*Dinonews*). Upon request, one such model ("Historical *Hylaeosaurus*") was delivered to the Crystal Palace Museum (Sydenham, England) and placed on display near Benjamin Waterhouse Hawkins' original lifesized concrete dino-monsters (figure 3–1). Another quite involved and challenging scale model — this time a recreation of Hawkins' late–1860s, never-completed "Palaeozoic Museum"— built in 1995, became the subject of another paper published in *The Mosasaur*; the model itself was displayed for several years in a plexiglass case within the dinosaur hall end of the Burpee Museum of Natural History in Rockford, Illinois.[1]

Many sculptors, however, are more interested in more graphic affairs concerning paleoimagery. Typically, sculptors gravitate to 3-D re-creations of any of our favored dino-monster movie scenes, such as sculpting static re-creations of the spinosaur vs. tyrannosaur battle from *Jurassic Park III* (2001) or the famous Kong vs. Rex battle from RKO's *King Kong* (1933). One enthusiastic paleosculptor, Jeff Johnson, recreated the famous Zallinger "Age of Reptiles" mural, which was made available in model kit form during the mid–1990s. Or try recreating the gist of famous dinosaur painted restorations, such as those by Knight (i.e. either of his two world-famous *Tyrannosaurus* vs. *Triceratops* scenes), or any of the

(Figure 3–1): Sculpture reflecting "evolutionary" stages in the body of scientific ideas concerning the British armored dinosaur *Hylaeosaurus*. The genus *Polacanthus*, at left, based on a 1905 skeletal reconstruction, was for many years (yet no longer) considered to be synonymous with the *Hylaeosaurus* (middle figure, after Richard Owen and Hawkins, 1854, and figure at right after George Olshevsky, 1979). Sculpture by Allen A. Debus, 1995. This particular sculpture was donated to the Crystal Palace Museum, where it has been exhibited. Model base is 22" long. For a look at the metal armature supporting this sculpture, see figure 16–6 (Debus).

more modernized restorations by Robert Bakker and Gregory S. Paul — the latter two artists being highly inspirational for maestro paleosculptor Bob Morales' paleosculpture.

For eleven-year-old Bob, dinosaurs were considered "tuff" (today's kids would say "cool" or "awesome") when he drew his first dinosaur picture, a line drawing of *Tyrannosaurus rex* copied from a science textbook. Two decades later during a visit to the Natural History Museum of Los Angeles County, Bob obtained a copy of *Predatory Dinosaurs of the World* by paleoartist Gregory S. Paul, who simply breathed life into dinosaurs. Inspired by this magisterial volume, Bob's creative energies were first fired by Paul's visions of the Mesozoic world's inhabitants. More than any other then-established paleoartist, to Bob, Paul's work made dinosaurs and exciting. Fully absorbed by this influential, mesmerizing artwork, Bob attempted his first dinosaur sculpture.

After doing sculpture after sculpture in polymer clay, honing techniques, it occurred to Bob that perhaps a model kit company might be able to reproduce his dinosaur proto-types. Scouting around, making contacts with "garage kit" model companies, most of which specialized in the manufacture and distribution of movie monster and science fiction–related model kits, brought Bob's talents to the attention of Mike Evans, who at the time piloted a company near Dallas named Lunar Models. When it came to the garage resin model-kit paleosculptural industry, Bob was perhaps the pioneer, and a most successful one at that (figure 3–2).

From his association with Lunar Models sprang a series of dinosaur diorama model kits, among the earliest of their kind, dovetailing with the onset of the latest phase of the dinosaur craze, when movies were being released on the subject of dinosaurs and many dino-related publications were spawned. During those heady days, Bob's talents and writings on the subject of sculpting his sought-after dinosaurs became familiar commodities among *Prehistoric Times*' avid readership.

Meanwhile, Bob formed his own company, "Dragon Attack!" that specializes in dinosaur sculpture, molding and casting of resin prehistoric animal hobby kits. As Robert Bakker once said, "Dinosaurs are nature's special effects," a motto and sentiment that continues to appeal to Bob's nature, as dinosaurs remain a pivotal element in his life, offering the means of a full-time career, the fulfillment of a fantastic dream for a young man sketching his first tyrannosaur.

Commonly, themes in paleoimagery fall into several popularized categories: restoring groupings of prehistoric animals (with plant life) that cohabited in idealized paleoecological settings; showing the evolutionary phylogeny of a lineage of genera, such as in demonstrating the evolution of horses, horned dinosaurs, or elephants; portraying the essence of "savage prehistoric nature," red in tooth and claw; or just showing some interesting natural history story concerning a particular individual prehistoric animal. Of course, there is also the conceptually simplest paleobiological theme of all, which is to show how the animal in question may have appeared in life, restored say, in a standing or walking pose. One sculptor interestingly chose to place his restored sculptures on a sculpted outline base showing either the U.S. state or the continent in which the animals was discovered. Restorations showing a "flesh" integument life restoration on one side, with reconstructed exposed skeletal elements on the other half of the body, known as "half restorations," are particularly instructive. Besides painted murals and paintings, miniature dinosaur dioramas often nicely accent natural history skeletal displays.

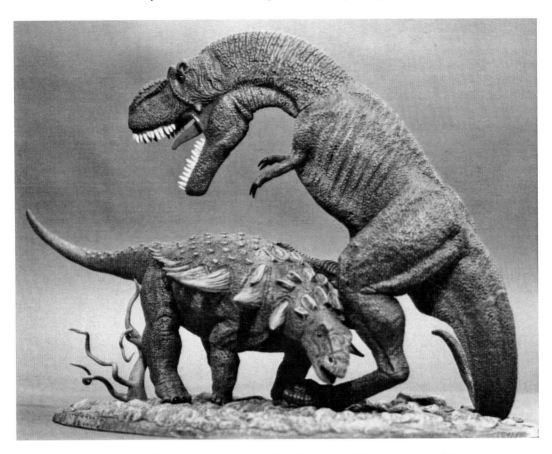

(Figure 3–2): The image of nature's armored tanks battling the mightiest carnivores of all time proves irresistible! Here the armored *Edmontonia* defends itself from an attacking *Daspletosaurus*. Sculptures in 1/35 scale by Bob Morales, 1994 (Morales).

It would be interesting to sculpt in miniature format the 1933/34 Sinclair dinosaurs exhibited at the Chicago World's Fair, or perhaps a grouping of tyrannosaurs — all on the same model base — constituting significant historical views of the genus. What kind of story do you want to tell? How about a scene showing a small, feathered theropod dinosaur, rather ironically in a standoff, devouring eggs laid by a prehistoric mammalian monotreme? Imagine a scene depicting foraging dinosaurs, a hungry dinosaur searching for its next meal, or perhaps a more serene scene showing an adult dinosaur nurturing its young. Read William Stout's 1981 book for ideas on the intricacies of how dinosaurs lived their lives for further inspiration, or watch any of those televised dinosaur wildlife documentaries, such as *Dinosaur Revolution*.

Or examine wildlife art made by sculptors depicting modern animals and try to imagine and translate such themes into a prehistoric setting populated with the analogous creatures of long ago. The possibilities are clearly endless, so it's up to you to decide.[2]

Let's move on![3]

4

Constructing Trustworthy Armatures

To the uninitiated, armature building may seem as difficult as arm wrestling. But that need not be so. You've got to twist the metal into a "skeleton," not letting the metal contort or wound you. A complicating factor to consider is that the intended dimensions of your sculptural figures are key; that is, they determine how the metal should be cut, contoured, bent, crimped or shaped. We outlined how to make armatures in chapter 1, and we'll delve into this recurrently in several subsequent chapters, particularly chapters 6 and 12. Given the importance of this step, however, some additional focused instruction will boost your confidence. So here are some tips and factors to consider when making armatures. Essentially, a properly made armature is the "skeleton" of your sculpture, and although of different media than clay is in its own right an artistic sculpture too.

From the outset, you must decide whether the figure to be made will be a one-of-a-kind piece or whether you intend to replicate it after molding the polymer clay prototype. Your decision will lead to proper selection of armature-making materials as well as to decisions about how the armature will be constructed. For instance, if you plan on eventually molding your polymer clay creation (i.e., after baking it properly to suitable hardness), then avoid using the hardest steel coat hanger wire for sections that will later be cut; instead use softer or thinner wire that may be more easily sliced through. Also, predetermine where sections of your polymer clay prototype will be severed to facilitate the molding process. Most importantly, the armature should be constructed as a free-standing figure, as opposed to being locked into a supporting substrate, such as a wooden base.

Alternatively, if you simply want to sculpt your dinosaur figure(s) without ever intending to mold or cast the original piece, then you are at liberty to anchor the armature within, say, a properly contoured, built-up, and sanded wooden base, one that may be baked in a kitchen oven along with the attached polymer clay figure(s). This technique has the advantage of setting everything out spatially on the display base, but requires careful planning as to positioning of all figures and structures in the display. (But you should always plan things carefully regardless.) By "attached," we mean that the wire legs or wire tail of the armature (usually coat-hanger wire) are sunk (i.e., embedded) into the wood. And we did *not* mean that they were bonded with epoxy to the wood surface (figure 4–1).

Then, after you bake this assembly, everything's done in one shot, sans any painting you will do. One possible disadvantage is that you may find it more difficult to sculpt the undersides of individual figures set into the base, because these areas may be harder to reach even with the nimblest of fingers. But, as a practical matter, these particular areas will not

(Figure 4–1): Armatures used for three stegosaurs, trees and other foliage. (See figure 16–1 for the final sculpted diorama.) The animal armatures are not free-standing. Legs for figures contacting the ground are embedded within the wood, thus holding the armatures in place. This was possible because it was not intended to mold any feature of the resulting one-of-a-kind diorama. The thick wooden base has been prepared as a final display substrate, prior to sculpting with polymer clay. (See text for further details.) Note the effort to form wire supports for plates in two of the figures. This was one of Allen's early creations, during the learning process; more efficient means than indicated here for sculpting stegosaurian plates — quite suitable for eventual molding and casting purposes — are described in chapters 5 and 8 (Debus).

be as readily visible to viewers anyway. On the other hand, an advantage is that you would not need to continually hold, manipulate and touch the (anchored-in) figures while you sculpt, excessive handling that could introduce unintended modifications to areas that have already been completed to your satisfaction. For example, figures 3–1, 9–2, 10–3, 11–5, 16–1, 16–3, 16–9, 16–10 and 16–13 show examples of one-of-a-kind dioramas sculpted using metal armatures that were entirely bonded into the wooden substrate prior to sculpting with polymer clay (also see figures 4–1 and 12–16). So, you see, this is one viable option.

Throughout this book we show several examples of both kinds of armatures and sculptures made both from one-of-a-kind armatures, as described above where the wire legs were lodged into a wooden base prior to sculpting with polymer clay, and also those that were made using free-standing armatures. So now let's move on to some tips on how to bend and twist that stiff, recalcitrant wire into structures that will serve as suitable frameworks for free-standing polymer clay sculptures. You must be wondering, "How does one get that wire to hold in place without it sliding around and over through the backbone (i.e., vertebral) wire?" Won't your sculpture collapse without a sufficient skeletal interior?

Yes, it would, but this need not happen. First, don't be anxious about it. This *can* be done. But be patient and begin with a drawing of your model. You will need wire cutters and a ruler and an indelible black marker. Place the sturdiest kind of wire you will use along a lateral view of your drawing, from the bend in the neck through the near tail extrem-

(Figure 4–2): A completed aluminum and metal wire armature for the extinct, rhinoceros-like mammal **Brontotherium.** Note the spines along the vertebral wire near the shoulder, the section of the armature that will be inside the head, and the peg pointing downward into the chest area just below the shoulder spines, which in a subsequent step will protrude into carved Styrofoam filler to lock this Styrofoam body into place. Means for carving Styrofoam for custom fitting into a wire armature are described in chapter 15. Attention to details on your wire armature will ultimately make your sculpture all the more accurate, proportionately. Note that this is *not* the armature used for Allen's **Brontotherium** sculpture, shown at bottom in figure 14- 5 (Morales).

ity. This will be your main vertebral wire, although it will not conform in its location exactly to the backbone as shown in a skeletal reconstruction of your dinosaur. Instead, it should ideally be situated a bit beneath the real skeletal backbone. This is because you will want it to be a bit more "centered" with respect to the abdominal area, where aluminum foil or Styrofoam filler will be placed. In a subsequent step, this filler will be further attached using thin copper or aluminum wire twisted into shape to hold the filler material (see, for example, figures 1–4, top right, and 15–12). Note that figure 1–4 shows the vertebral wire situated along the upper body surface of a brontosaur. This reflects Bob's preferred technique, although Allen generally places the vertebral wire lower into the body cavity, thus placing aluminum foil filler material above as well as below (i.e., surrounding) this wire. Bob tends to prefer and has perfected the use of Styrofoam filler, rather than aluminum foil. (If the head and tail will later be severed from the abdominal part of the body to make molds, then you can use armature wire that isn't as stiff, such as 18-gauge aluminum or copper wire, to support these body extremities.)

You want your creature to be properly proportioned, and your execution of the armature will determine whether this is possible. Gently bend the vertebral wire using pliers. Tinker and adjust so it conforms to the body outline shown in your drawing in all its subtle sin-

uosity. Now you'll need to attach legs (or flippers), and possibly if the animal is quadrupedal, arms. This is a critical step where sculptures either fail or lead toward the professional path.

The backbone needs something to stand upon, usually at least two sound legs. So (depending on whether the legs will also be severed from the body, that is, for mold-making purposes) choose either lower-gauge, less stiff wire that is easier to cut, or choose much stiffer wire such as coat-hanger wire to shape the legs. You may twist the upper end of the legs around where the femur joins the hip socket, using pliers. Make this connecting joint as tight as possible by clamping the leg wire down with the pliers over the vertebral wire. Do this for both right and left legs, ensuring that each leg wire curves a bit outward (and then downward) from the vertebral wire to allow for an intermediate abdominal region. Compare this assembly to your drawing.

Then, depending on how much the legs slip along the vertebral wire, you can tighten up the assembly further by doing two additional things. First take some of the lower, 18-gauge wire, twisting this around the leg joints using your pliers, pulling the thin wire taut. Then place a small blob of polymer clay, wedging it into the joint, around the upper end of both wire femurs and also around the vertebral wire. Don't use too much clay, just enough. Bake the assembly while it's standing upright on a temporary substrate, according to manufacturer's instructions, and let it cool. The oven-hardened polymer clay will firmly lock the legs into position at the hip and over the spine (figures 4–2 and 14–9). Then you may begin sculpting over the hip area by adding filler material and a coating of polymer clay (after you complete the rest of the armature).

Referring to figure 4–2, showing a carefully planned and executed armature skeleton, note that the vertebral wire is thicker, stronger wire than that used for the neck and tail. Also note that the wire used for the legs is thicker and sturdier, and that the legs are mechanically bonded to the vertebral wire by (1) using thin gauge wire to twist around and tie legs and arms to hip and shoulder joints, and (2) following the baking step, adding small oven-hardened polymer clay pieces surrounding these joints to restrict limb movement. The rear left leg appears longer than the rest because the leg "extension" or "peg" will be placed temporarily into a wooden or hardened polymer clay support to facilitate the sculpting process while the figure is conveniently situated in an upright pose. (However, technically, because of this peg extension, the armature cannot be free-standing, that is, on a level surface.) It isn't always necessary to use a peg projection as shown in figure 4–2, particularly when the figure to be sculpted is a properly balanced quadruped, as shown, for example, by the polymer clay prototype in figure 19–2 (where a peg was not used). Also, another peg is visible protruding downward below the shoulder spines. This downward projecting peg will later support a carved body of Styrofoam filler.

The primary difference between the armature illustrated in figure 4–2 and those shown, for example, in figure 4–1, is that the *Brontotherium* armature may be lifted from the temporary substrate and handled as needed during sculpting, while the stegosaur armatures as shown cannot be removed from the sanded wooden base because their limbs are locked, into the wood. Also, because the figures shown in figure 4–1 are wedged into the wooden base, there is far less need to use baked polymer clay to immobilize and hold the hip and shoulder joints in place, as in figure 4–2.

Once you've mastered how to properly join legs to the vertebral wire in a free-standing armature, then the process may be repeated for the arms of quadrupedal animals. In the

(Figure 4–3): Bill Gudmundson's free-standing ankylosaur armature. See text for details (courtesy Bill Gudmundson).

case of bipedal animals with diminutive forearms (e.g., *Tyrannosaurus*), sometimes one merely needs to add arms by inserting wire ends into the (partially sculpted) upper abdominal region, then sculpting over the exposed wire "arm" segment using polymer clay. Some small parts or body appendages such as fingers, claws, horns, spines, and "sails" etc., may require internal support wire, too. Advice on how to make these (with or without internal wire support) will be presented in chapter 5. Armatures for the wings of pterodactyls and winged Mesozoic avians are another matter entirely, as described in chapters 12 and 13.

Study Bill Gudmundson's free-standing armature for his quadrupedal "Ankylosaurus mutatus" figure, which frames its wide body in a rectangular metal skeleton (figure 4–3). Flexible, braided wire then is attached for legs, tail and neck. The joints and attachment sites for the limbs and appendages are bonded together using a polymer clay (although in Bill's case this is not Super Sculpey, but a fast-hardening two-component clay that hardens in air after blending). This is a very nicely prepared and carefully conceived armature.

Bob Morales further instructs armature-building in the case of a *Stegosaurus* sculpture (figure 4–4.) The heaviest gauge of wire is used for the main section, consisting of the head and neck, the body, and most of the tail. The tail end is snipped off with wire cutters, about two to three inches short of the very end of the tail tip. This is because a smaller gauge of wire is used so that the tail may be sculpted to a fine point. Using your reference illustrations,

(Figure 4–4): A view of Bob Morales' wire armature for a 1/20-scale *Stegosaurus*. See text for details (Morales).

make separate sections for the shoulder and legs, and for the hips and rear legs. Then, make a U-shaped notch where the shoulder section will be attached to the main head/body/tail section. Do this also for the hip section. Using one of the thinner gauges of wire (depending on the size of your sculpture), attach the shoulder section to the main body by wrapping the wire around and around the attachment point, also wrapping the wire around the upper parts of the shoulder and/or hip section, and also extending (i.e., coiling) this wire onto the main body section along the vertebral wire, toward the front or back, or both. The attachment should be pretty stiff and rigid, but if it isn't, either use more wire or use heavier gauge wire for this process. Once the shoulder and hip sections are wired into place, bake a walnut-sized piece of polymer clay into this area.

Finally, you should be apprised of two books offering advanced techniques for sculpting armatures suitable for stop-motion movie animation: Tim Brierton's *Stop-Motion Machining* and *Stop-Motion Puppet Sculpting*.[1] While procedures described in these references go far beyond the scope of this book, they may still be of interest to readers. Our intention here is to explain how to create *static* armatures useful for sculpting non-mobile prehistoric animals. But maybe someday you'll be in pictures!

5

Pre-baked Parts

What are "pre-baked parts"? Something you can simply add water to and stir? Not quite. One may bake smaller body elements (eyes, horns, plates, spikes, claws, etc.) of the dinosaur separately, thus hardening them and later adding them to the as-yet-unbaked dinosaur body. This technique is particularly useful for pieces that are relatively small and difficult to manipulate with your fingers unless they're hardened, or that should be first baked and sanded to sharpness prior to joining them to the body of your dinosaur.

You are *not* limited to baking your dinosaur sculpture only once—or only with everything intact, accounted for, mounted and arranged altogether upon the sculpt. Because these usually smaller parts are baked before the main dinosaur body is, we refer to them as "pre-baked." Usually, how-

(Figure 5–1): Bob Morales' *T-rex* hatchling sculpture stands 5½" high, not including the base upon which it is resting. The front-to-back measurement of the sculpture is 3½". The finished sculpture was painted with enamel paints. The interior of the egg was fashioned from a Styrofoam egg purchased at a crafts store, and thin aluminum wire was wrapped around it prior to adding polymer clay (which was anchored by the wire, rather like a technique described in chapter 15. The final touch was to glue the sculpture onto its wood display base (Morales).

64

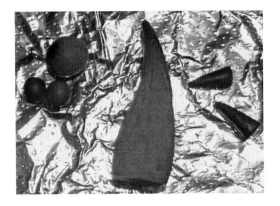

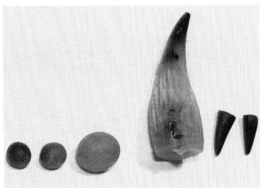

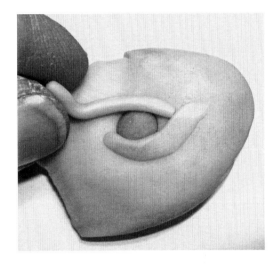

Left: (Figure 5–2): Sculpted eyeballs, a textured horn and a couple of teeth are shown placed on a sheet of aluminum foil, ready to be baked at about 225° F for about 20 minutes. The horn was made in much the same way as the teeth (as described in the text), but instead of being flattened it was textured on its lower end with a sharp dental tool (Morales). *Right:* (Figure 5–3): The baked example parts are now cooled down and ready to be inserted into the soft clay surfaces of the sculpture (Morales). (Figure 5–4): Using another lump of the clay, one eyeball is pressed into the clay, and ropes of the clay are rolled and then used to form the eyelids, upper and lower. Use your fingers, slightly flatten out the eyelids. A sharp, pointed tool may be used to sculpt wrinkles and folds on the eyelids (Morales).

ever, one will sculpt them *after* the main dinosaur body has been roughed out, so one may discern the proper dimensions of the horns, teeth, etc. And remember: you can indeed bake your prehistoric animal sculpture *several times* if necessary (but please try to minimize the number of times this is done).

This chapter is relatively short because we're merely introducing an important concept that will be reinforced in subsequent chapters with respect to more specific groupings of prehistoric animals. The following instructional bits were written with Bob Morales' 5½" tall *Tyrannosaurus* hatchling sculpture in mind (figure 5–1).

It's quite helpful to pre-bake eyes, teeth, claws, spikes, horns and other features that will be added to your sculpture. For example, in making realistic eyes, one can sculpt spheres of the desired size, say ⅛" in diameter, ¼" in diameter, or scaled properly to the particular size of the animal (figure 5–2). Why do this? Hardened pre-baked parts are much easier to insert into the areas of the head and jaws of the sculpture that are still soft, unbaked polymer clay. After the clay eyeballs are baked and allowed to cool, these hardened eyeballs can be pushed into the still-soft clay of the sculpture's head. The same is the case for the teeth, and for horns and spikes if your particular dinosaur or other animal sculpture has these features.

To make the eyes, simply take a piece of the clay and make two equally-sized

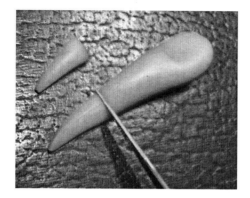

Top left: (Figure 5–5): A small piece of the clay is rolled into a "rope" and then tapered to a point, forming a sharp tooth (Morales). *Top right:* (Figure 5–6): The tapered tooth is flattened with a finger tip and smoothed out, then an X-Acto knife is used to cut it long enough to allow for insertion of the baked tooth into the gumline of the sculpture's mouth (Morales). *Left:*(Figure 5–7): After each part is pressed into a lump of polymer clay to saturate the surfaces with oils from the clay, the parts are pressed into this lump of clay, showing approximately how the teeth, horn and eyeballs can be pressed into the soft clay surface (Morales).

lumps (as close in size to each other as possible) and gently roll these pieces in your hand or fingers to make little spheres. Carefully drop these spheres onto a sheet of aluminum foil, trying not to get any fingerprints on them (but these may be removed with fine sandpaper after the eyes are baked and allowed to cool) (figure 5–3). Bake the eyes and allow them to cool. After sculpting the places where the eyeballs will be inserted into the head of your sculpture, carefully place each eyeball into where you've planned the eye sockets will be. Simply push the eyeballs into the soft polymer clay.

When the eyes are placed in the sockets evenly, so that they appear to be straight and horizontally aligned when you face the head, then roll a thin strip of polymer clay for the eyelids, and carefully lay this around the placed eyeball, using your sculpting tools to shape the eyelid into the head (figure 5–4). Refer to your photo or illustration references to help you to achieve a realistic shape for your sculpture's eyelids. You can project your creature's distinctive demeanor, depending on how the eyes and eyelids are fashioned.

Similarly, teeth, claws and horns may also be pre-baked. Examine, for example, how teeth were made for the *T-rex* hatchling. Take a small piece of polymer clay and roll it into a cone shape, tapering into a point (figure 5–5). Once this is done, place this cone-shaped piece on a sheet of aluminum foil and use your finger to slightly flatten it. Use your finger to lightly smooth out your fingerprints from this tooth. Cut the length of the tooth to approximately the size you will need for your sculpture, using an X-Acto knife, scalpel

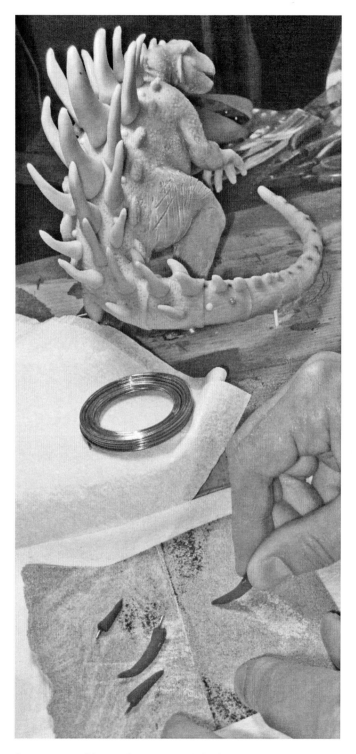

(Figure 5–8): Sanding spines and horns that were pre-baked in an oven during early sculpting stages of Allen Debus' fictional dino-monster named "G-Fantis" (2012). Note the numerous recurved spines adorning the monster's back and tail, which may be detached from the sculpt, pre-baked, and lightly contoured with a Dremel tool (after they harden and cool) to accentuate the creature's ruggedness (Debus).

or similar blade (figure 5–6). Always make a few extra teeth just in case some are lost or break during placement of them in your sculpture. Bake the teeth on the sheet of aluminum foil at about 180° F for about 25 minutes, just enough to cause them to solidify when they cool.

When you are ready to place your teeth in the jaws of your sculpture, first press the blunt end of each tooth into an unbaked piece of the polymer clay. This will place a tiny amount of the oil from the clay on the base of the tooth, helping it to adhere more readily into and onto your sculpture (figure 5–7). The teeth in the *T-rex* hatchling were made just this way; baked teeth were simply pushed into the gum line and laid flush with the lower jaw and lip.

Rely on this same process for creating realistic-looking spikes, horns, and claws, or scutes for armored dinosaurs, which we'll see more examples of later on in this book. So remember: the pre-baked method has the distinct advantage of preserving the shape and sculptural details of your creature's teeth, claws, horns, etc., prior to placement onto your in-progress sculpture.

Also, examine figures 5–8 and 5–9, documenting stages in the genesis of pre-baked parts (spikes and horns) in preparation for a fictional dino-monster named "G-Fantis."[1]

Now let's see how thegeneralities covered through these early chapters might apply to the most popular and endearing group of dinosaurs: the mighty and often vicious tyrannosaurs, raptors and horned ceratosaurs — theropods one and all.

You *know* you want to make one of these!

6

Sculpting Bloodthirsty Theropods

In the early 1960s, relatively few dinosaurs had been described. Often, too, the scientific names as then divulged to young paleophiles were assigned to scanty fossil remains, poorly known creatures. A quick count of genera listed in Edwin H. Colbert's *Dinosaurs: Their Discovery and Their World* (1961), a book then intended for laypeople, totals approximately 250 individual types. Half a century later, one finds nearly 850 "valid" dinosaur genera listed in Donald F. Glut's *Dinosaurs: The Encyclopedia, Supplement 6* (2010). Shortly, there will be 1,000 dinosaur genera! Expansion of paleontological surveying programs on the South American, African and Asian continents has certainly contributed to this swelling of the dinosaurian ranks.

While there were some three dozen or so meat-eating theropod genera known by the mid–20th century, including old standbys such as North America's *Tyrannosaurus rex*, the slighter *Allosaurus*, and "bird mimics" such as *Struthiomimus*, the list of theropods known to science has greatly expanded too. And while theropods are usually considered the Mesozoic's meat-eaters, this latter term is used in common parlance only, as not all birds eat meat.

With so many new theropod specimens available for study, naturally, detailed classification of discrete types (genera) has grown in complexity. In Colbert's day, paleontologists believed that theropods evolved from small and slender, Late Triassic "coelurosaur" ancestors, only branching into a second lineage known as "carnosaurs," which grew into the largest carnivorous dinosaurs such as *Allosaurus* and *Tyrannosaurus* by the mid–Jurassic. By 2011 the dim ancestry of theropods had been traced to a 230-million-year-old, Late Triassic, 4-foot-long ancestor named *Eodromaeus*, discovered in Argentina. In the 1960s, scientists were unaware of any feathered dinosaurs such as the specimens that have recently galvanized interest in paleontology and vertebrate evolution.

Since the mid–1980s, the systematics of theropods, a sub-branch of "reptile-hipped" dinosaurs, organizationally founded on cladistics, is far more sophisticated, yet seemingly complicated; theropods — all dinosaurs, in fact — are categorized into a hierarchy of clades reflecting evolutionary relationships, the details of which go vastly beyond the scope of this book.[1] The range of theropod types now is broadly split into evolutionarily related subgroups (or "clades") such as ceratosaurs, tetanurans, avetheropods, coelurosaurs, and maniraptorans, the latter a diverse category including both fossil and modern birds, and many feathered dinosaurs that have captured science news headlines lately. Such terms are defined in the glossary, yet rather incongruously, on the basis of cladistics, birds may be considered as a

unique flying (and running or diving) kind of reptiles. And some Mesozoic creatures that no doubt appeared quite avian were, anatomically, dinosaurs instead.

What is perhaps most instructive for our present purposes, however, is to know that with this embarrassment of riches in newly discovered theropods, or new fossil remains enlightening our knowledge of older dinosaurs that were poorly known before the dinosaur renaissance, for over a decade dinosaur sculptors have delighted in bringing to life dozens of new theropods (in addition to the old standbys). If you have any doubt, page through recent issues of Mike Fredericks' illustrious *Prehistoric Times* magazine, which at the time of *Dinosaur Sculpting's* (1st edition) publication was just getting off the ground. One doesn't only have access to a limited handful of well known theropods anymore!

So here, we'll outline trusty techniques for sculpting bloodthirsty theropods, the kinds that most evoke awe of the Mesozoic world. For ease and simplicity, this chapter will emphasize theropod dinosaurs and avian-dinosaurs appearing *without* feathers. Techniques we'll focus on here will immediately apply to the larger carnosaurs and derived coelurosaurs such as the Tyrannosauroidea grouping. But our basic methods will also work on maniraptorans, even though you as the sculptor must decide whether or not a feathery integument is in order for your creations. And always remember: even if you aren't a qualified professional paleoartist, you can still have a lot of fun designing your very own meat-eating dinosaurs in realistic settings. After all, this book is intended for those who simply want to get started in this fascinating field! But first you must do your homework, arming yourself with knowledge.

For reasons that perhaps only psychologists can explain, humans are fascinated with gore. Prehistoric animals have been portrayed in gory scenes since the late 1830s, when artist John Martin conveyed his perception of Mesozoic vertebrates as fiendish, bloodthirsty brutes. Those gory scenes still captivate us today, as in *Jurassic Park's* raptors. In fact, most sales of dinosaur toys and hobby models are of old *Tyrannosaurus* himself, arguably the classic flesh-eating theropod. For those who like their dinosaurian gore, red in tooth and claw, carnivorous theropods offer unsavory yet striking opportunities to depict the blood-curdling, tooth-slashing frenzy of Mesozoic times! (See figure 6–1.)

Besides Glut's masterful dinosaur encyclopedia volumes, in which may be found many useful, illustrated skeletal restorations — skeletal reconstructions enclosed by a restored body silhouette — readers may also wish to consult Gregory S. Paul's *Predatory Dinosaurs of the World: A Complete Illustrated Guide* (1988), and *The Complete T. Rex* (1993) by John R. Horner and Don Lessem. A general and recent volume having applicability to most chapters herein is Gregory S. Paul's *Princeton Field Guide to Dinosaurs* (2010), presenting many silhouetted skeletal reconstructions (often showing both lateral and dorsal views) as well as speculative restorations showing underlying muscular alignment in many dinosaur species. In your research, please don't ignore technical articles in *Journal of Vertebrate Paleontology*, *Nature*, or *Science*, where, especially since the mid–1990s, reconstructions often accompany descriptions of new theropod genera.

Then, to gain marvelous visual perspectives on movements evinced by these stately and sometimes powerful dinosaurs, there are numerous television documentaries, such as the BBC's *Walking with Dinosaurs* and the Discovery Channel's more recent *Dinosaur Revolution*, featuring CGI-animated representations of various kinds of theropods. While much has apparently been settled as to the appearances, physiologies and probable habits of many

kinds of theropods, by no means is there across-the-board consensus on every matter. We encourage you to research each and every dinosaur planned for sculpture beforehand to aid in your depictions. This will help hone what you intend to visually convey to your audiences. The more you know about your intended subjects, the better will be the result.

With theropods, we're working with a remarkable range of body types (morphologies). Some of the largest, bulkier types, whose heads grew larger, evolved increasingly smaller forelimbs, to the point of the hand/arm unit becoming vestigial, or possibly nonfunctional. On the other hand, many of the smaller kinds, especially those that were on their way to becoming most avian-like in appearance, evolved proportionally longer arms and hands that functioned with dexterity (figure 6–2). A lesser known group known as the therizinosauroidea had the largest hands of all. (See chapter 11 for more on therizinosaurs.) Theropod legs and feet were another matter. Ornithomimosaurs evolved proportionally

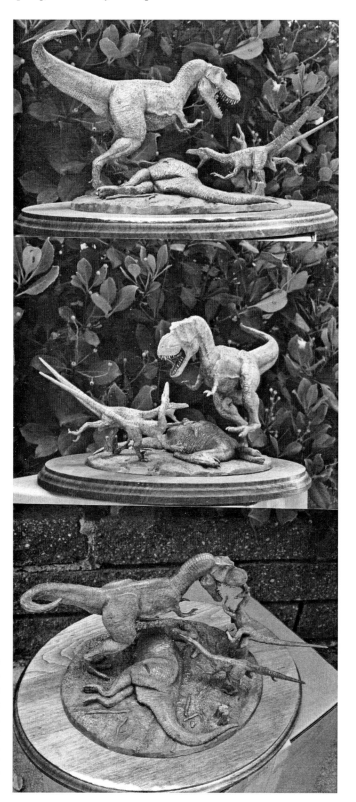

(**Figure 6–1**): **A host of hungry theropods converge, grappling for the spoils of savagery, in this case an unfortunate duckbill** *Parasaurolophus.* *Tyrannosaurus* **with prey and** *Dromaeosaurus* **at 1/35 scale. This rather complex diorama project was reproduced by Lunar Models as a resin kit. Sculpture by Bob Morales, 1993 (Morales).**

longer tibia and ankles, allowing faster locomotion, while the sickle-shaped, slashing sec-
ond-toe weaponry of the Deinonychosauria (e.g., *Deinonychus* and *Velociraptor*), used to
eviscerate prey, has become well established in popular culture.

Because *Tyrannosaurus rex* has become the iconic dinosaur, paleontologists zealously
strive to understand its functional anatomy, appearance and probable behavior. Although
in Knight's famous 1906 American Museum painting, *Tyrannosaurus'* teeth are concealed
within thin lips, today, most modern paleoartists like to portray Rex with a gator-like,
lipless mouth, menacingly flashing those six inch-long sabers (figure 6–3).

Were tyrannosaurs scavengers, or did they usually pursue prey—even dangerously
horned kinds such as *Triceratops*? Were those tiny arms used for hoisting up struggling,
living victims, the talons used like grappling hooks? Were they vestigial, useless limbs, or
did they somehow facilitate mating rituals? Didn't *Tyrannosaurus* crush the bones of its prey
in its powerful jaws and slicing teeth? It has been inferred that young tyrannosaurs were
feathered for insulation purposes; were even the adults similarly clothed in fine, colorful,
feathery down? How did the largest theropods sleep, rise off the ground, and reproduce?
These are all questions often debated yet for now cloaked in mystery, offering tantalizing
grounds for speculation in restoration.

Trackways of tyrannosaurs (and, generally, other theropods) are quite narrow; their
feet were "digitigrade"—meaning only the three forward-oriented toes met the ground, and
the heel was held high off the ground. Estimates of the maximal walking speeds of the
largest carnivores range from 4 to 8 kilometers per hour; however, some even consider the
4-km/hr value to be unrealistically high. Conversely, maximum running speeds of troodon-
tids and ornithomimosaurs may have been in the 40- to 60-km/hr range.

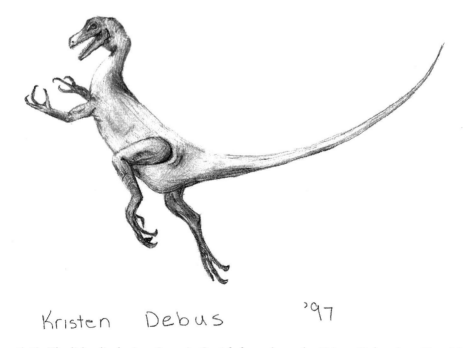

Kristen Debus '97

**(Figure 6–2): The lithe, lively, Late Jurassic *Ornitholestes* drawn by Kristen Debus (now Dennis),
after Charles R. Knight (courtesy Kristen Dennis).**

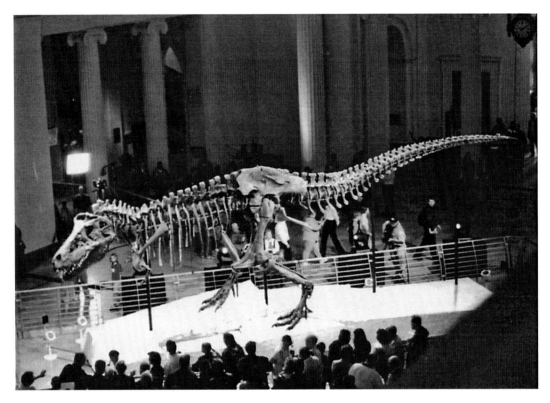

(Figure 6–3): The Field Museum's (Chicago) "Sue" tyrannosaur, photographed on its first day of public exhibition in May 2000 (Debus).

Don't confine yourself to simply sculpting *Tyrannosaurus* and its most closely allied Cretaceous kin (e.g., *Tarbosaurus, Gorgosaurus, Albertosaurus,* and *Daspletosaurus*). Aim to be original in selecting theropods for study. For example, instead of sculpting tyrannosaurs, which everybody does eventually, sharpen your skills with interesting, less frequently portrayed genera such as *Gigantoraptor, Baryonyx, Spinosaurus, Siamotyrannus, Carcharadontosaurus, Cryolophosaurus, Dilophosaurus, Acrocanthosaurus, Afrovenator, Carnotaurus, Balaur, Giganotosaurus* and *Syntarsus* (figure 6–4). There are the more slender "ostrich-running" types: the ornithomimosaurs, such as *Struthiomimus* and *Gallimimus* (CGI-animated for *Jurassic Park,* 1993). Or sculpt a *Bruhathkayosaurus,* which, if correctly identified from only a few very large bones, may be the world's largest theropod — at one time speculatively estimated to have been 65 feet in length![2] (However, read about this particular genus in the next chapter; it may be a sauropod instead.) For tips on how to make dandy-looking sails, as in the case of *Spinosaurus,* refer to chapter 12 on finbacked reptiles after reading this chapter.

Or if you'd prefer smaller, more slightly built theropod subjects, vicious "raptors" such as *Velociraptor, Troodon,* and *Deinonychus* have stormed public consciousness, largely thanks to *Jurassic Park.* However, a word of caution: those steely-eyed raptors are the very kinds of theropods that many artists today (sometimes using creative license) would adorn with feathers. For paleontologists have noted that more evolutionarily "basal tetanurans (e.g. coelurosaurs, therizinosauroids) bear more basal types of feathers, and more derived teta-

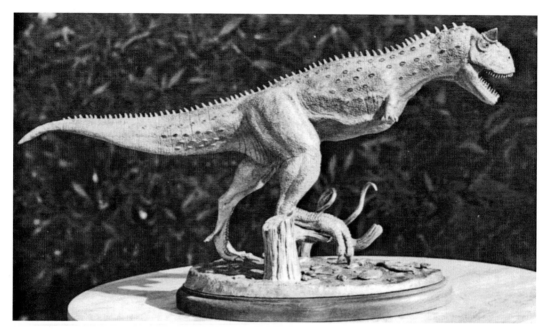

(Figure 6–4): A theropod, *Carnotaurus* at 1/20 scale — known from the Upper Cretaceous of Argentina — on the loose, sprinting over an ornately designed base (also shown at bottom in figure 16–11). Sculpture by Bob Morales, 1995, reproduced as a resin kit by Lunar Models (Morales).

nurans (e.g. oviraptorosaurs and deinonychosaurs) bear more derived feathers," a matter to be outlined further in chapter 13.[3] We'll save "ancient wing" *Archaeopteryx* and its more immediate, extinct evolutionary cousins for said later chapter.

Recently a 30-foot-long, Early Cretaceous tyrannosauroid, named *Yutyrannus* (meaning "beautiful feather"), was discovered in China. Remarkably, the fossil is shrouded with "shaggy" filamentous feathery impressions. So, besides the evidence and inferences concerning smaller ave-theropods, even larger sized, 1.5-ton theropods evidently displayed plumage too.[4]

Dinosaur artists restore theropods with pubic bones protruding noticeably below the pelvic area and, in the case of the bulkier genera, neck muscles bulging prominently behind the massive cranium. In order to remain in vogue with the current state of speculation, we encourage you to consider these possibilities in your own work.

In order to track down their food sources, theropods must have had well-tuned senses of sight, hearing and smell. They had binocular vision; respiratory turbinates preserved in the nasal passages of several genera indicate that theropods must have had quite reliable and acute olfactory senses. To what extent could they communicate with each other — congenerically, visually or through auditory means? And what messages did they relate? Were many of them sexually dimorphic?

Now imagine an ancient setting to pose your theropods in, a story that connects with the setting, and then be as creative as possible. Female tyrannosaurs were larger or more robust than the males. Pose your tyrannosaur battling an armored dinosaur, or alternatively, sculpt two albertosaurs disputing a discovered carcass.

Or consider other intriguing ideas.

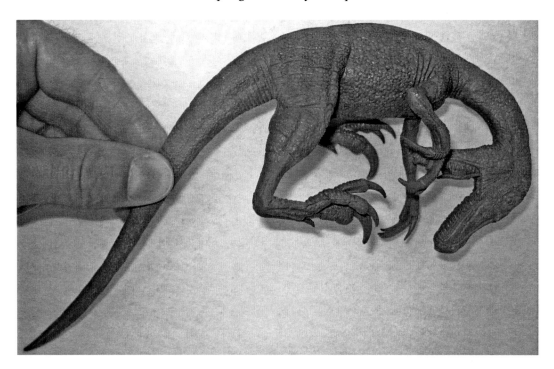

(Figure 6–5): ***Velociraptor***, posed defensively, warding off an attack by ***Protoceratops***, sculpted by Bob Morales for a 1993 Lunar Models resin kit (See figure 1–2 for diorama composition) (D. Debus).

Recently it was determined that an Early Cretaceous genus, the feathered *Sinornithosaurus* (the Chinese bird lizard, discovered in China), possessed venomous fangs situated in the middle and rear of the mouth. Paleontologists suspect that this turkey-sized predator principally hunted birds, first immobilizing them with venom. Shorter, sharp teeth at the front of its narrow snout may have been used to pluck off feathers from prey. The related, yet flying, spectacularly 4-winged and feathered *Microraptor* may have also been venomous. So what stories can you relate, sculpturally, founded upon these amazing scientific inferences and findings?

What did a theropod hatchling look like? It may be the case that raptorial theropods such as *Troodon* emerged as solitary hatchlings, whereas the young of *Oviraptor* were raised in nests from a clutch of eggs. Were they instinctively altricial or precocial?

Did theropods really "pack" together like wolves in bringing down prey? Could certain kinds of theropods swim, or did they ever fight over fallen prey and carcasses? Could theropods balance gingerly on a single hind limb? More evolutionarily derived theropods such as *Deinonychus* and *Velociraptor* possessed stiff bony rods in their tails, which can be seen in skeletal reconstructions. Their tails would have been far less flexible than the larger carnosaurs or tyrannosaurs. Raptors' stiffened tails functioned as counterbalancing beams for when they attacked intended prey, pivoting with slashing feet and grasping hands (figure 6–5). Generally speaking, of course, theropods did *not* drag their tails on the ground behind them.

We can't definitively answer or resolve these matters. However, if we have tempted you to read more about the science of specific theropod dinosaurs *before* you formulate an idea for sculpting, then our mission has been accomplished.

Here are some special tips for engineering the design of theropod armatures and sculptures, relying on basic commonalities of theropod shape. Please ensure that you're familiar with this entire chapter, referring to the accompanying photos, before beginning a theropod sculpture. Because these are the dinosaurs most of you will desire to tackle first, we've placed theropods up front as the initial chapter, outlining, in a general rather than dino-specific sense, all the steps involved. Subsequent chapters leading up to chapter 15 (which covers a specific A-to-Z sculpting example) will refer to or build upon the sculpting techniques and skills outlined here:

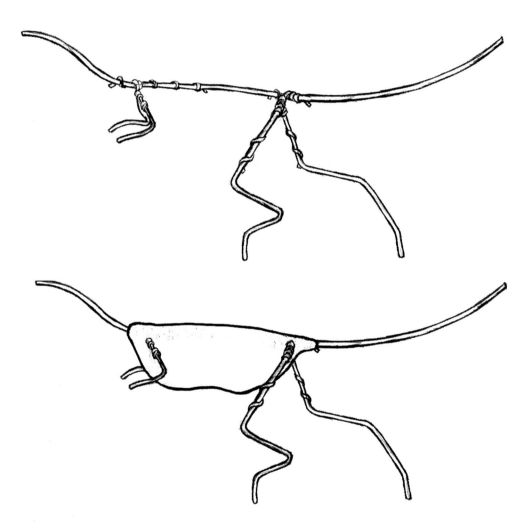

Top: (Figure 6–6): In this sequence of photographs (figures 6–6 through 6–10), the Upper Triassic, bipedal theropod *Syntarsus* comes to life before our eyes! First we see the twisted wire armature, not quite 7 inches long (Morales). *Bottom:* (Figure 6–7): Next, the abdomen is packed with filler material that is covered with a thin layer of polymer clay as indicated in the outlined polygon on this drawing. A foot peg may also be added allowing the sculpture to stand on a simple polymer-clay base (Morales).

Basic Techniques for Single Figure—Simple Base Design

First, please refer to figures 6–6 through 6–10, outlining the procedural steps in sculpting a Triassic *Syntarsus*, beginning with the armature-building stage. These visuals with captions will facilitate your understanding of the following discussion.

1. It is currently believed that theropods' vertebral columns were held more or less horizontally with respect to the ground. In mobile theropods, tails were not dragged behind in the dust, but were held aloft, swaying gently from side to side with every footstep. You should use a *single* segment of wire bent to represent the vertebral column, from tail extremity through the neck, and even the length of the skull. If

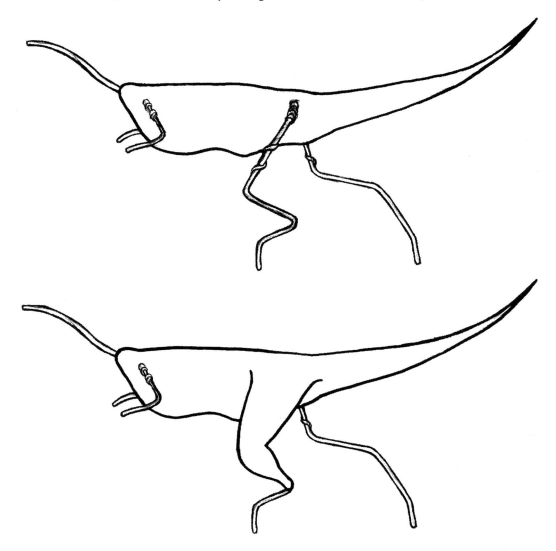

Top: **(Figure 6–8): More polymer clay is applied over the hip and tail areas as indicated. Note that very little polymer clay is needed to build up the basic body outlines, because *Syntarsus* was a thin, lively dinosaur (Morales).** ***Bottom:*** **(Figure 6–9): Finally one of the wire legs begins to receive a thin coating of polymer clay (Also see figure 6–15) (Morales).**

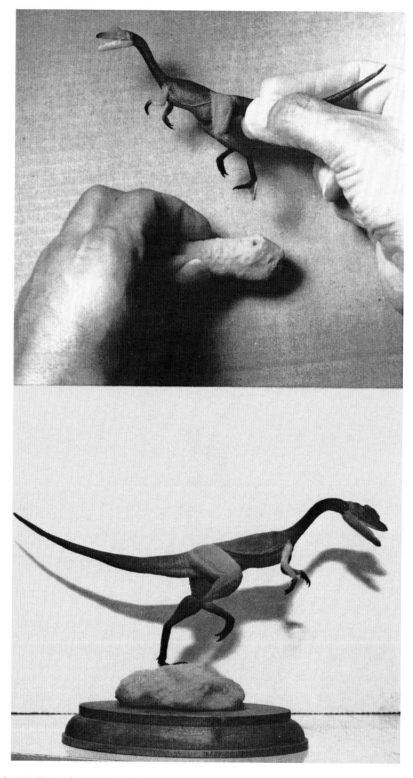

(Figure 6–10): *Top:* After a peg has been sculpted, it is inserted into a polymer-clay base. During sculpting stages, a non-stick agent such as Vaseline is used to keep the peg from adhering to the base. *Bottom:* The finished *Syntarsus* adorned with a unique crest on its head (Morales).

you're sculpting a dinosaur born of current renaissance thinking, avoid the temptation to insert the tail end of the wire into the wooden base, because we now know that dinosaurs were not tail-draggers. Your theropod model will most likely now be supported only by its feet, or by a single limb if it's walking, running or leaping.

2. Find a photograph or drawing of a skeletal reconstruction of the theropod you want to sculpt and outline the skeleton as a restored figure at your model scale. Otherwise, sketch an actual skeleton in a museum setting, or (with the author's and publisher's permission, as needed) photocopy a photograph or drawing of a skeleton using the copy setting that will result in the required size. Be exact! If you make scaling errors, especially in the case of a multiple-figure design, all the figures planned for a prehistoric diorama may not fit properly on the model base. Last-minute corrections may severely compromise your design and artistry. You don't want to wastefully go back to the drawing board after coming this far.

3. Particularly if the animal you intend to sculpt will be bipedal, the task of sculpting

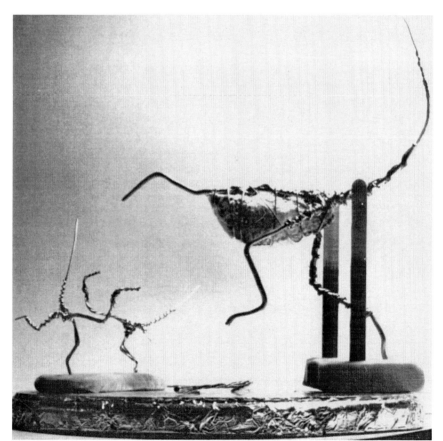

(Figure 6–11): Armatures for a pair of smaller raptors (left) are shown with an armature for *Tyrannosaurus* (right). Notice that all three armatures have been temporarily supported in lumps of polymer clay, illustrating that sometimes your armatures need not be firmly anchored or temporarily inserted into a wooden base during preliminary sculpting stages. The strategy illustrated here is preferred if your intention is to eventually cast replicas of the original figures. The final sculpture is shown in figure 6–1 (Morales).

can be simplified greatly if you anchor at least one foot of your metal armature in a sturdy, one-inch-thick block of wood (figure 6–11). So leave an extra two centimeters of wire extending below the level corresponding to the sole of your dinosaur's foot, where it will be standing on the wooden base. Remember to mark the position of the base of the dinosaur's foot with indelible ink. When you drill vertically into the wooden base and insert the wire, the mark should be visible just above the wood surface, with an additional two centimeters now embedded inside the wood supporting your metal armature. Measure accordingly, using a ruler. You can also mark the drill bit you are using so that it doesn't drill into the wood too far by wrapping a short piece of tape directly on and around the drill bit, measured up to the depth where the foot will rest upon the wooden surface. This way you won't drill in farther than, say, two centimeters. Always choose a drill bit matching the radius of the armature wire you plan to use for this support leg (usually ¹⁄₁₆", but sizes may vary).

Other, slightly more sophisticated methods, though, such as the peg structure — as in the case of the illustrated *Syntarsus* — or use of a V-wire frame for standing your armature upright are also illustrated here. But first, the legs must be joined to the vertebral column. This may be done by measuring the length of the leg, ankle and foot from your skeletal drawing. At the miniature scales most of you will be sculpting at, use the tighter centimeter and millimeter scales on your ruler instead of the side corresponding to inches. (With this said, in discussing wire and wood lengths to be employed in building armatures and base, below, or to simply provide a sense of familiarity, we will also occasionally discuss dimensions in terms of inches and feet.) As shown here, if your model will be molded later, you may only wish to sculpt with one leg *temporarily* supported in the base, so that the dinosaur can be readily removed from the base even after it is baked. **Do not permanently affix your dinosaur (or its armature) to a base if you intend to have it molded.** For more on this technique, refer to item 2 under the heading Advanced Techniques for Animating Theropod Designs, near the end of this chapter.

4. Figure 6–12 illustrates a sturdy base for your armature that will support your creation during sculpting stages.. This involves using a stiff wire bent into a V-shape as a stand for the rest of the armature. This wire extends through the support leg, into the pelvis, and finally up through the torso, neck and head. More flexible (and thinner) wires can be used and attached to this very rigid wire support in creating the other limbs and extremities. The V-shaped wire need not be attached to the base until the sculpture is complete. Later, the V-shaped wire may be concealed in a polymer clay base. The underlying wooden base may be stained and lacquered without having the sculpture in the way.

For theropod sculptures that are approximately one to two feet long, be sure to add about an additional 2.5 to 3 inches at the "hip" end of the wire used to form a leg. This additional length will be wrapped and twisted about the vertebral wire using pliers as explained in item 9, below. Sufficient length of wire should be allowed to represent the width of the dinosaur's pelvis. Your dinosaur leg should be angled slightly outward and downward from the vertebral wire. Theropod body widths will be discussed next.

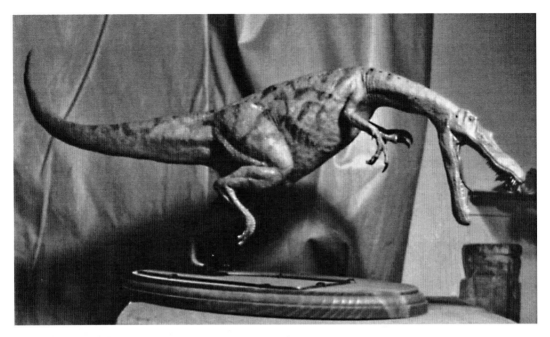

Top: Figure 6–12: *Baryonyx* at 1/10 scale, illustrating another means of supporting your dinosaur during the sculpting stages. Note the wire frame support attached to the base, which runs through the support leg and up through the pelvic section, body and neck (Morales). *Bottom:* (Figure 6–13): A top (dorsal) view of the inexpensive plastic *Tyrannosaurus rex* scale-model skeleton produced by Glencoe, which was reissued during the 1990s. At typical polymer-clay sculpt size (15" long and 8" tall), models such as this will help you proportion your original sculptures, and will help you "realize" the bones in miniature. Do not bake plastic models in the oven, however (Debus).

5. Theropods were surprisingly slender, lean, avian-looking animals, not chubby "godzillas." So keep them narrow at the hips. Skeletal reconstructions shown from a perspective raised above the skeletons will be particularly helpful in deciding how wide your sculptures should be (figure 6–13).

For the basic design, use our rule of thumb. If your theropod sculpture will be one foot long, from the tip of the snout to the end of the tail, then its width at the hips should not exceed 4.5 to 5 centimeters. A two-foot-long theropod should be no wider than about 9 centimeters at the hips, and so on. For further perspective, see how dinosaur skeletons are mounted in museum displays; check out those narrow pelvises, which of course were engirdled with sturdy muscles and sinew.

6. Wire support for tyrannosaur arms need not be joined to the armature's verte-bral wire, because their arms were relatively puny compared to their massive legs. (Remember, theropods were bipedal.) Wire-supported forelimbs may be physically pressed or pushed into the chest or shoulder area after leaving some extra wire at the furthest end from the clawed hands. Frequently, errors are made in assigning the correct number of digits to the forelimbs. For instance, *Tyran-nosaurus* only had two fingers, *Allosaurus* had three fingers, and *Ceratosaurus* had four fingers (and three claws). In the case of maniraptorans, or feathered dinosaurs, of course, the arms play a far more significant role, to be discussed in chapter 13.

7. Don't mess up your dinosaur's posture! Bend your wire using pliers to repro-duce the curvature of the vertebrae evident in your drawing (or properly scaled pho-tocopy). Leg and ankle joints should also exactly follow the pattern of your drawing. By holding your wire directly against the drawing, to verify that the wire will pass through your dinosaur's midsection, as you bend it, mistakes should be minimized. A good general approach to follow is that the wire contour used for the vertebral column should be scaled against the inner (lower) surface of the spinal column, definitely not against the upper surface, because otherwise the vertebral wire will be too close to the body surface. You can trace the position of the middle of the backbone directly onto your drawing to guide you later in bending the vertebral wire prop-erly.

8. Always clip with wire cutters. Don't use your teeth, which are not as sharp as thero-pod teeth!

9. Wire cut to form the legs may be fastened securely to wire representing your dinosaur's vertebral column by twisting it tightly around the region corresponding to the pelvic area in your drawing. You may need to simultaneously rely on two pairs of pliers to accomplish this task when using stiff wire (such as coat hanger wire). One pair will be needed to grip the leg wire at the thigh, and the other pair may be used to bend and turn the extra 2.5- to 3- inch length of wire around the pelvic area. First, using a felt-tipped pen, mark a spot corresponding to the acetab-ulum on the skeletal reconstruction drawing. The acetabulum is the round opening in the pelvis where the upper end of the thigh bone connects to the pelvis. In life it was encased in heavy muscle (figure 6–14).

Wire selected for use should always be "sturdy enough," a subjective guideline that will depend on the size of your creation. Smaller animals, say, less than 6 inches, can get by with thinner wire, whereas for larger, one-foot-long models, some stiff coat-hanger wire is recommended. Remember: you can always strengthen hip joints with polymer clay, pre-baked around the leg/backbone join too.

Twisting leg wire around the point marked on the vertebral column can be one of the most exhausting (if not temporarily exasperating) phases of sculpting a dinosaur. This is especially the case if you rely on thicker gauge, sturdier wire such as commonly available coat-hanger wire, which is more difficult to bend precisely. But take heart! This is perhaps the most critical stage in the process of crafting a dinosaur. Take your time, be patient, and don't accept an inferior result. You will regret it later if you do. Wear garden gloves if you are prone to

blisters. Sometimes a heavy-duty vice will help you to bend relatively inflexible wire. Persevere!

10. After your armature is completed, if your animal is large-bellied, wad up a section of aluminum foil, which will form the abdomen of your dinosaur. Tightly pack this material into what is becoming the chest/abdominal cavity. Using flexible, thin wire, tie the aluminum foil around the vertebral column wire, being careful not to let any of his inexpensive filler material become too close to what will become the exterior surface of your sculpture. The aluminum foil will remain inert throughout the baking process. (You can also use a carved Styrofoam chunk instead of aluminum foil for this purpose. Styrofoam will melt inside the body, and may also release fumes that must be ventilated. Ordinarily, we recommend using aluminum foil instead, but Styrofoam has its applicability too, as we'll see in chapter 15.)

11. Then, clothe or wrap your metal armature and body filler with a thin layer of polymer clay. You should bake this partially completed figure before adding subsequent layers of Super Sculpey, which will represent the skin or outer integument. When baked to hardness, this initial layer, or wrap, will lock the aluminum foil body in place, making it easier to work on the outer parts of your dinosaur. But *before* baking this inner assembly, however, striate the surface of this inner layer using a sculpting tool so that subsequent, outer layers will adhere or bond better to this inner core. To make suitably thin sheets of the inner clay wrap, flatten Super Sculpey using a rolling pin designated for such usage into thin sheets, then

(Figure 6–14): A dinosaur pelvis indicating the position of the acetabulum, or hip socket (shown at left). This is where the head of the thigh bone (femur) inserts into the pelvis, creating a ball-and-socket joint. The acetabulum is represented in the wire armature (shown at right) simply as a bend in the wire, from hip section to the leg (Illustration by Bob Morales).

slice these with a knife. Kids, remember to get Mom's permission before using her rolling pin or any kitchen utensils and appliances! Wash the rolling pin thoroughly with detergent when finished. Bake this initial layer according to Polyform's instructions, and allow the piece to cool before continuing.

12. Dinosaur eyes can be sculpted separately from the rest of the dinosaur body as pre-baked parts. Roll little balls of polymer clay gently between your thumb and forefinger. Fingerprints can be minimized by using a very gentle rolling motion, then dropping the soft eye directly onto a sheet of aluminum foil. The aluminum foil is then set on a cookie sheet, with edges raised into a border so the eyes won't roll off and get lost, and baked in the oven at about 230° F for fifteen minutes. The lower temperature and shorter baking time will solidify the eyes sufficiently for the next step.

 Then simply press the baked eyeballs into the soft dinosaur head, and sculpt the eyelids around the eyeballs with a fine-tipped tool. Depending on the size or delicate nature of your dinosaur's head, it may be necessary to gouge out a socket for the eyeball. This can be done using a ball-tipped sculpting tool to poke a hole where the eyes will be set. Eyelids can be made by applying a very thin rope of Super Sculpey above and below the inserted eyeball. Then, wrinkly details can be fashioned as eyelids, at the edges of the eyes (front and rear) and around the eyelids.

13. Claws and teeth may be made in a variety of ways, although if prebaked individually, superior results are possible. An alternative to prebaking theropod teeth (as discussed in the Advanced Techniques section of this chapter), depending on the size of your model, is to rely on pins or nails that have been cut to appropriate sizes using wire cutters. Bend these slightly before inserting them into your dinosaur's jaw. Use of a magnifying visor may facilitate the operation.

14. Theropod snouts, eyes and ears may be accurately placed, referring to photographs and illustrations of the skulls you're interested in. Study references by Paul, for example; Horner and Lessem relate further details concerning the skeletal nature of theropod skulls. As mentioned in chapter 12 of Robert Bakker's 1986 book, *The Dinosaur Heresies*, when it came to swallowing gobbets of food, allosaur skulls may have been remarkably snakelike. This implies that, while dining, the heads of allosaurs may have appeared quite unlike the shapes of their skulls, preserved in fossil form.

15. Sculpt a fleshy (not a forked, snakelike) tongue and add it to the crevice at the rear of the mouth prior to adding teeth. Remember to adequately flesh-out the powerful jaw muscles near the neck. Create the effect of a ridge of scaly protuberances by lightly pressing along the sides of the jaw (along the mouth margin), with a dental tool, or a ball-tipped sculpting tool.

16. Paint your model using basic guidelines presented in chapter 16.

Advanced Techniques for Animating Theropod Designs

1. If you wish to reposition the dinosaur figure in a pose markedly differing from the skeletal reconstruction you have found for your dinosaur, then you first

need to reorient the bones (usually on paper) into the desired pose. In your scale drawing, reorient the major bones (leg and ankle bones, vertebral column, including tail vertebrae) into positions you wish to sculpt. (If cut out from a photocopy, glue them onto a piece of cardboard.) You will constantly refer to this customized skeletal reconstruction, so don't lose this important diagram.

2. In creating dinosaur figures that will be replicated as resin casts (as opposed to one-of-a-kind pieces that will not be molded) a handy peg structure may be sculpted on an extra length of wire left exposed at the bottom of the support leg. A good example of this technique is illustrated in Bob's sequence of photos leading to a *Syntarsus* sculpture (also see figure 6–15).

 By now you may have noticed that the principles of building armatures are simple and relatively straightforward in every case. The only significant differences may be in selecting the thickness and strength of support wire, and the structure (type) of the support, dictating how the foot (and hence, sculpture) shall be poised or anchored, resting on the base. Furthermore, sometimes you may consider using peg-like structures if you plan on casting your pieces, or possibly a V-shaped, sturdy support wire.

3. To assist in fleshing out the body shape, excellent restorations of theropod musculature have been published in several books. Examine Gregory S. Paul's restorations showing musculature of the *Allosaurus, Albertosaurus (Daspletosaurus),* and

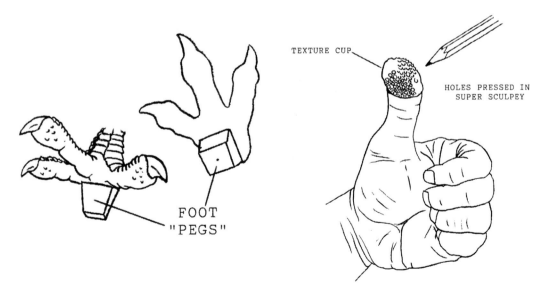

Left: (Figure 6–15): When a sculpture is intended to be molded eventually, and cast in resin, a foot peg can be shaped on a foot or feet. The peg can then be inserted into the unbaked polymer-clay base for a sturdy and rigid support. The cast replica would later be bonded to a resin base using Super Glue. The technique is demonstrated in figure 6–9 (illustration by Bob Morales). *Right:* (Figure 6–16): A tool for making dinosaur skin. When a piece of polymer clay is flattened onto the surface of your thumb, it takes on the shape of an inverted cup, hence the name texturing cup. Experiment with a variety of blunt tips of different sizes to press holes into the entire surface of the texturing cups (illustration by Bob Morales).

the *Velociraptor*, or Mark Hallett's restoration of the leg musculature of a *Tyran-nosaurus*. John Sibbick's restoration of the musculature of the *Deinonychus* is published on the jacket cover of David Norman's *Dinosaur!* (1991). Such restorations, published in references indicated in the bibliography, should be helpful to sculptors of theropod dinosaurs. Always remember, however, that such restorations are highly speculative in nature, although probably not too far removed from reality.

At the scale we're discussing, it would be impractical to individually sculpt all those muscles. However, in applying your first outer layers of polymer clay (over prebaked innards), try to follow the general form of bones and the larger muscle groups as you bulk out your dinosaur.

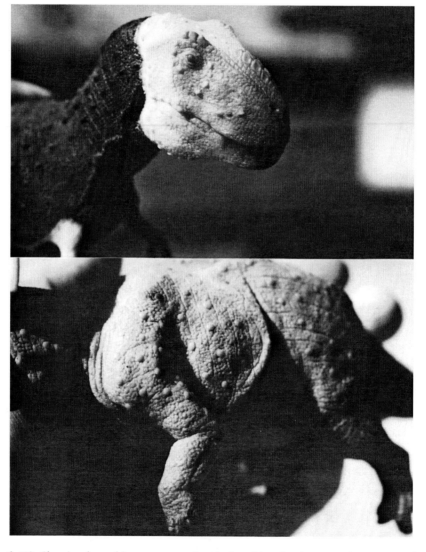

(Figure 6–17): Showing how skin texture can be nicely achieved using texturing cups on (*top*) the head region of an *Allosaurus* and (*bottom*) the body of a horned dinosaur. (Also see figure 7–8 to see how wrinkles, such as that shown on the horned dinosaur abdomen, can be made) (Morales).

4. As an alternative to using cut pins and nails for dinosaur teeth and claws, roll thin strips of Super Sculpey with your index finger against a clean, flat surface, tapering each end to a point. As discussed in chapter 5, slice each tapered strip, in succession, to lengths that are appropriate for your model scale. Curve each tooth and claw slightly and place them on a sheet of white paper prior to baking. If desired, slightly flatten your polymer clay dagger- or hook-shaped teeth using a finger. Place the soft teeth and claws in an aluminum foil tray and bake them *before* and separately from baking your theropod dinosaur model, according to Polyform's directions. Then, after the teeth cool, insert them gently into the unbaked jaws, feet, and hands of your theropod. These delicate structures will be fragile, so handle them with care. Remember to count the number of fingers and toes your dinosaur had accurately during the design stage. Even after baking, you can adjust to desired lengths by chopping teeth with the blade of a sharp knife or scalpel. Claw tips can be sharpened against a sheet of finely graded sand paper before inserting onto the feet or hands of your dinosaurs.

5. Mouths happen to be a critical feature of theropod heads! The most disastrous mistake one can make in sculpting a theropod is in not paying adequate attention to the appearance of the head. Give your tyrannosaur or ceratosaur a life-like toothy grin. If its mouth is closed, patterning its appearance after a modern crocodile's will give the proper effect. If the mouth is opened in a silent roar, it will be easier to insert those pre-baked teeth into the softer gums, made from polymer clay.

6. Perhaps more than any other feature that can be added to dinosaur sculptures, careful attention to skin details will most greatly impress your viewers. Fine skin details such as scales, pebbly skin texture, or a wrinkly skin surface can be accomplished using a variety of techniques. One may embed small dress pins — the kind with the tiny balls on one end — into your theropod's hide, either in a ramdom or system-

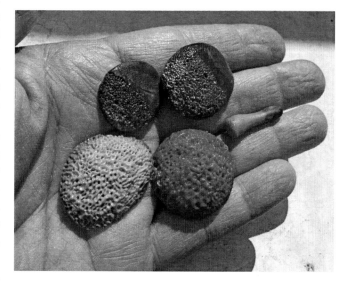

(Figure 6–18): A variety of texturing cups used by Bob Morales. After shaping texturing cups using your hands and a variety of objects (e.g., sculpting tools or other fine-tipped implements) to poke into the soft, unbaked Super Sculpey, bake the Super Sculpey according to manufacturer's instructions. Then after the oven-baked texturing cups cool and harden, lightly coat the surfaces of each with Super Glue, which helps keep the texturing cup from sticking later on to the unbaked sculpture that you will be texturing. One of the texturing cups is actually more like a texturing "stump" and is used to reach tighter areas of the sculpture (Morales).

atic pattern, to suggest the pebbly skin surface that some theropods, such as the South American *Carnotaurus*, may have had. In 2004, a tyrannosaur specimen, nicknamed "Wyrex," was discovered in Montana, apparently replete with skin impressions; the skin texture is knobby, pebbly.[5]

You may impress wire mesh from an old window screen into the surface of your dinosaur to create a scaly looking hide. A more sophisticated means of accomplishing the same result can be achieved by making several tools that will allow you to stamp the impression of scales (one scale at a time) or a pebbly surface into the skin of your dinosaur, as shown in a later chapter (figure 11–12). But if you rely on stamps, then make several of different rounded openings to vary the size of your dinosaur's scales.[6] Sharp ends of nails can also be embedded into the outer surface to create a spinier-looking skin texture.

But a very realistic skin texture can be created by making special tools, known as "Texturing Cups" (term registered trademark of Dragon Attack!). See figure 6–16. Place a marble sized piece of polymer clay on your thumb or finger and flatten the polymer clay so that it forms a "cup" around the bottom of your thumb. Then, using various pointed objects like pens, the back end of a paint brush, or any pointed tool you can imagine (although bluntly pointed objects will prevent bleeding!), inscribe holes in the entire surface of the Texturing Cup while it's situated on your thumb.

7. When this is done, very carefully peel the hole-covered piece of polymer clay away from your thumb, placing it directly on a sheet of aluminum foil. Transfer this onto a cookie sheet for baking. Bake the Texturing Cup at a temperature of 275° F until it darkens slightly in color. This will take up to 20 minutes. After allowing this texturing tool to cool, apply a thin coat of Super Glue over its surface. Allow the coating to dry. This seals the surface of the Texturing Cup so that it will not stick to the surface of your sculpture during use.

(Figure 6–19): Illustration by Bob Morales showing dewlaps on (top) a stegosaur and (bottom) a theropod. When sculpting a loose flap of skin or dewlap under your sculpture's throat area, you will need to decide whether a small or prominent dewlap will "dew." Some artists prefer a very small or almost non-existent dewlap. Dewlaps should be thin, but possibly wrinkly.

The completed Texturing Cup can then be pressed into and all over the body or head of your sculpture. Make several kinds of differing texture. You'll be amazed at the results (figure 6–17).

For different effects, gently rock the tool from side to side on your sculpture's

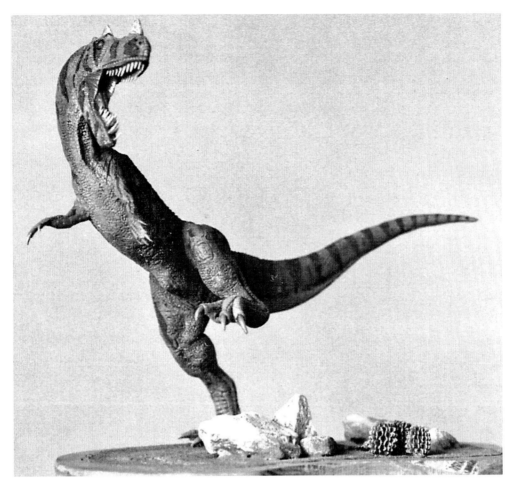

(Figure 6–20): Bob Morales' 1/35-scale *Ceratosaurus*, replicated in 1994 as part of a Lunar Models diorama. Also see figure 1–2 (Morales).

skin surface or even press it in a rotating motion or in a spiral pattern to achieve a multitude of scale designs and patterns. As with the skin fold techniques, try this technique first on a lump of polymer clay for practice. The outer edge of the texturing tool can be used to probe into those hard-to-reach areas, such as between skin folds or wrinkles. Differently sized Texturing Cups can be made, providing scaly skin texture in proportion to your model's size (figure 6–18).

8. Some theropods were adorned with other sorts of features and decoration, such as hornlets situated over the eyes and nasal horns. *Tyrannosaurus* had bony protuberances, one on each side, near the rear of the mouth (exterior), over the lower jaw. These can be realistically sculpted by shaping them out of polymer clay. Horns may be sharpened by slicing off unwanted bits with a razor blade before baking, or using a piece of sand paper after baking. Although there is little direct evidence for them, consider the possibility that some theropods had an iguana-like row of raised scales arranged along the dorsal side. Adding a dewlap, a loose flap of skin covering the throat area, can make a dinosaur seem more reptilian (figure 6–19). Also, the (ahem!)

exterior reproductive organ in all dinosaur genera may have been the cloaca, an opening situated at the base of the tail.

9. Philosophically, it would be most sound to sculpt your theropod over a miniature, accurately scaled skeleton of the dinosaur that includes all the major bones. However, now you would be building two sculptures — one skeletal, to be covered in a polymer clay life restoration. This is a much more highly involved process, considered beyond the scope of this book. However, if you would like to read more about how sculptors have succeeded in such or even more complicated scientific endeavors in miniature model-making, additional references may be of interest.[7]

10. Remember: seemingly minor touches can enhance your work. A simple twist of the neck, turning the head (with mouth open or closed) inquisitively, can entrance viewers (figure 6–20).

7

Sculpting Super Sauropods

Perhaps more than any other trait, most people are impressed by the huge sizes attained by certain dinosaur genera. In fact, to many, the word *dinosaur* symbolizes an animal of absolutely tremendous size. Of course, not all dinosaur genera grew to gigantic proportions. And their young necessarily started out relatively small. However, in the consideration of adult size, no landlubbers have ever exceeded the colossal dimensions of the sauropod dinosaurs. Sauropods, by virtue of their characteristic hip structures–being themselves "saurischians"—are closely related to theropods, discussed in chapters 6 and 13.

One must stand next to an erected sauropod skeleton (or a life-size sauropod sculptural restoration) to gain a full appreciation of the mighty bulk of the dinosaurian giants (figure 7–1). Most fully reconstructed museum specimens, however, do not fully represent gargantuan extremes of sauropod growth, which can otherwise be difficult to comprehend.

As nearly any youngster knows, sauropods were those truly colossal, ponderous dinosaurs — the ones with familiar names like Brontosaurus (or more correctly, *Apatosaurus*), *Brachiosaurus* and *Diplodocus*, or even *Mamenchisaurus*. Were they alive today, adult sauropods could easily peer into a third-story window, by virtue of their long, sinuous necks. Their gigantic limbs, when joined to bulky, muscular torsos, made their ridiculously puny heads seem poorly proportioned. Although years ago, scientists thought sauropods were primarily weak-limbed, aquatic animals, preferring to wade in swampy, marshy areas, now, thanks to Robert Bakker's late 1960s and 1970s reconsiderations, most agree that sauropods were terrestrial, adapted to drier, forested habitats.

Sauropods evolved from another related ancestral Late Triassic group known as prosauropods, sculpting tips for which will be discussed in chapter 11. And prosauropods, in turn, may have evolved from a tiny fellow named *Eoraptor*.[1] This pipsqueak basal form was discovered in Argentina. During the subsequent 30-million-year interval, evolutionary descendants of successful critters like little *Eoraptor* gained hold, seizing vacated terrestrial habitats through a process known as "opportunistic replacement."[2] And they diversified, and grew, and grew, and grew.

Sauropods no longer are perceived as clumsy, tail-dragging beasts, as restored by paleoartists in yesteryear. Their tails, held aloft so as not to be stepped upon by others in the herd, could have been used as whips, crackling supersonically and wounding emboldened attackers (figure 7–2). From fossil trackways, showing multiple roving or migrating individuals, preserved in parallel, it may be inferred that sauropod genera were most likely gregarious, as opposed to being solitary creatures.

Top: (Figure 7–1): Two skeletal casts of the Chinese sauropod genus *Mamenchisaurus*, exhibited at Chicago's Field Museum of Natural History, the one at right standing in tripodal position (A. Debus). *Bottom:* (Figure 7–2): The elephantine, 34-inch-long, 1/20-scale *Mamanchisaurus* sculpted by Bob Morales in 1991, conveying a stately expression of one of nature's grandest terrestrial creatures (Morales).

Nevertheless, debate persists over how high their elongated necks could actually reach. While for physiological reasons, paleontologists no longer suggest that their necks served an underwater "snorkeling" function, some now also claim on the basis of cervical bone morphology that sauropod necks could not have been elevated much higher than the position of their hearts. Blood pressure restrictions alone would have prevented the upward flexure

of, say, a *Diplodocus* neck into the treetops. So rather than feasting from leafy foliage aloft, such animals may have browsed no higher than 6 to 9 feet from the ground.

However, circumstances may have differed for *Brachiosaurus*, whose arms were proportionally longer than its hind limbs. This animal seems to have been anatomically designed for feeding some 40 feet off the ground. Did *Brachiosaurus* or the highly similar genus *Giraffatitan*[3] then have a gigantic, 400-kilogram heart and a vascular system equipped for sustaining systolic blood pressures of 630 mm (compared to 110 to 150 mm in humans and 320 in a giraffe)?[4] While some claim "No," the fact is that this impossible beast was quite real.

In spite of recent studies, creatures equipped with such elongated necks surely must have been capable of eating foliage from the treetops at least when necessary, if only for abbreviated periods so as to avoid fainting or cardiovascular complications. Lately, restorations of sauropods rearing upward to dizzying heights balancing upon their hind limbs and tail have proved popular (figures 7–3 and 7–4). Such "tripodal" posturing may have facilitated feeding, exerting prominence during intraspecific combat (e.g., mating ritual), or defending themselves and young from predators.[5] But logic contradicts tripodality's imaginative and visual appeal. For if sauropod blood pressures posed constraints on such behavior, with their tiny-brained heads soaring into the sky, then these dinosaurs might have fainted from diminished blood supply to their proportionally small brains, or their hearts would

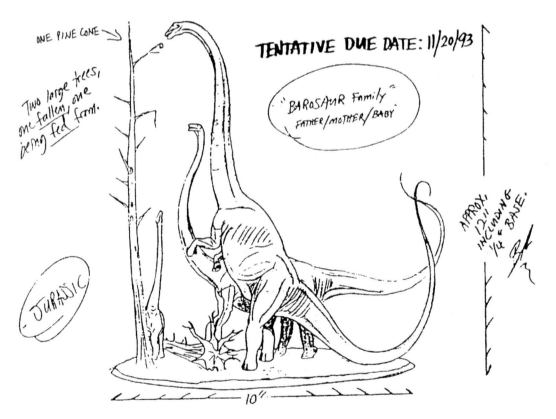

(**Figure 7–3**): Bob Morales' preliminary design sketch for a *Barosaurus* family browsing on the tree-tops (Morales).

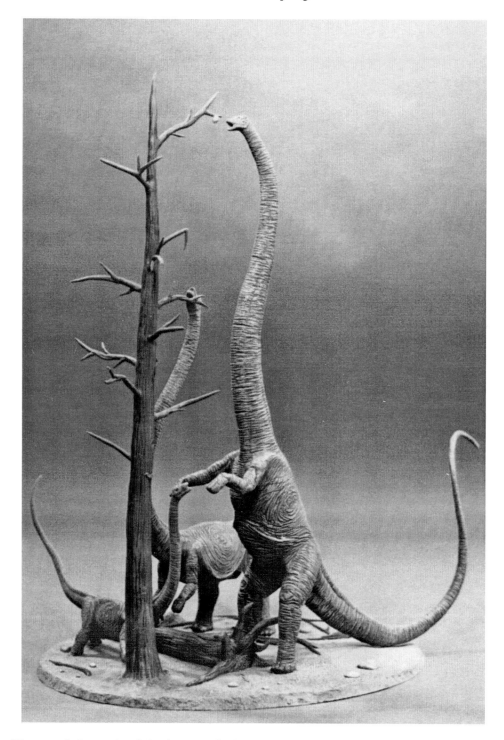

(Figure 7–4): Impressive skeletal mounts displayed at the American Museum of Natural History in New York, showing an adult *Barosaurus* rising into tripodal posture to defend its young from attacking allosaurs, fueled Bob Morales' imagination in creating this more serene scene (1994) of a barosaur family stripping the last foliage from a tree. The model is at 1/50 scale (Morales).

(Figure 7–5): An 18"-long, 1994 restoration of the *Cetiosaurus* by Allen A. Debus (with help from Kristen Debus). Contrast this restoration of the dinosaur with that shown in figure 16–9 (Debus).

have burst from added pressures resulting down below. And yet, males of the species may absolutely have needed to rear up in this position in order to er, uh ... mate.

Sauropods may have entered the Mesozoic world as pint-sized hatchlings, but growing perhaps nearly 20 pounds per day, rapidly escalated to immense sizes. In 1997, paleontologists discovered the first undisputed sauropod nest site; thousands of eggs were found. Sauropod embryos were found within some of the fossilized eggs, typically arranged with from 15 to 34 eggs per nest cluster. Fossilized skin impressions preserved on some embryos revealed a pebbly, stippled mosaic textural pattern. This titanosaur birthing ground, known as Auca Mahuevo, found in Late Cretaceous Argentinan badlands, proved that at least certain sauropods reproduced via eggs. The discovery dampened prior "dinosaur renaissance" speculations that sauropods introduced their young into the world via live birth. The widespread, possibly communally-guarded nesting ground underscored the gregariousness of this particular sauropod species; safety evidently existed in numbers. It is startling how tiny these creatures were at birth — that would eventually grow into nature's true giants.

You would be astonished to know just how huge they could become in adulthood!

For decades, the familiar genera *Diplodocus* and *Brachiosaurus* served as reference points for upper limits to growth with respect to the maximum lengths and weights (mass) attainable in terrestrial vertebrates. However, within the past decade, scientists have begun to realize that the term "upper growth limits" appears almost inapplicable when it comes to sauropods. The 90-foot long *Diplodocus* no longer holds the record for longest dinosaur. For example, consider *Supersaurus*—estimated to have grown up to 112 feet in length and 35 to 40 tons — or *Seismosaurus*—"the earth shaker," an immense, rival sauropod that grew to 120 feet in length![6] Although the mysterious *Bruhathkayosaurus* was formerly regarded as a theropod, if genuinely sauropod in nature instead, its dimensions would have stretched to 220 feet long with an estimated staggering weight of 175 to 220 tons!

During the summer of 1993, a fully mounted skeletal cast of *Brachiosaurus* was exhibited at Chicago's Field Museum of Natural History.[7] One may imagine how immense that

dinosaur was in life and sense how puny we humans are on the basis of relative size, when standing next to the Field's *Brachiosaurus*. But brace yourselves, a potential all-time record breaker, according to Gregory S. Paul, may have been the *Amphicoelias fragillimus*. Paul's estimates, based on a single fragmented vertebra, place this colossal animal far ahead of its class. *Amphicoelias fragillimus* may have been up to *twice* as long (nearly 200 feet long!) as an adult *Diplodocus*, standing 30 feet high at the hip. (Its shoulder height would have equaled the head-to-tail length of an adult allosaur.) Astonishingly, at 73 tons its weight may have exceeded that of the *Brachiosaurus* by up to three times.[8] More complete specimens attributed to newer genera such as titanosaurs *Argentinosaurus* (80 to 100 tons and 114 feet in length) and *Sauroposeidon*, in certain respects dwarfing former record-holder *Brachiosaurus*, strain the limits of the imagination as to sizes attainable in land animals.

How and why did sauropods grow to such enormous sizes? This remains a mystery, perhaps even a cosmic one. Is there a possibility that the strength of gravity at the Earth's surface may have been marginally less during the Upper Jurassic than it is today? It is possible that in a reduced gravitational field, vertebrates could have evolved and grown to sauropod dimensions, but of course, this remains sheer speculation.[9] Is sauropod growth a trait shared with other living reptiles, which grow slowly yet continuously through life? More likely, sauropods were genetically programmed to grow quickly. They reached sexual maturity in 20 years, having a life span of only a century. This contrasts with a former notion of giant sauropods growing at a slower reptilian rate, reaching maturity at a stately 60 years and living, tortoise-like, up to 300 years in age.

Reaching adulthood, sheer sauropod size may have aided their abilities to maintain body temperatures adequate for daily living through *gigantothermy*. Recent 2011 studies involving measurements of stable carbon and oxygen isotopes preserved in Late Jurassic sauropod tooth enamel have shown they lived at typical mammalian body temperatures: *Brachiosaurus*, 100.8° F; *Camarasaurus*, 98.3° F (figure 7–5). This does not necessarily mean they were metabolically warm-blooded like mammals and birds. But as adults their physiologies were clearly not crocodilian; sauropods were not sluggish and cold-blooded. The findings also shed light on their food intake requirements. Despite their weak-looking teeth, in order to rapidly grow to such great sizes they must have eaten continuously, cropping fibrous foliage, fermenting the compost in their capacious bellies.

Accordingly, elements of sauropod natural history merit consideration by dinosaur sculptors. Sculpt an adult sauropod in tripodal posture balancing on its sturdy tail (such as the adult *Barosaurus* exhibited at the American Museum of Natural History in New York), defending its young from a predatory attack. Or, despite the evidence from Auca Mahuevo, consider how a more speculative event, a sauropod live-birthing scene for a *different* species, may have appeared. The Chinese Middle Jurassic genus *Shunosaurus* wielded a small ankylosaur-like club at the tip of its tail, and Late Cretaceous *Saltasaurus*, known from Argentinan sediments, was studded with osteoderms, body armor. When threatened, sauropods may have cracked their whip-like tails against predators' limbs, perhaps even mortally wounding them with this defensive measure. Yet, most likely, great size in adulthood may have been sauropods' greatest survival adaptation, sparing them from considerably smaller predators. Stephen Czerkas has shown that sauropods such as *Diplodocus* bore vertical spines externally along the vertebral column, from the neck to the tail extremity.[10] *Amargasaurus* featured a more elaborate double row of cervical spines. Although according to convention sauropods

were limited to the Jurassic Period, it is clear that various genera of sauropods known as Titanosaurs persisted until the Late Cretaceous, quite a different faunal cast from the Jurassic's conventionalized usual suspects.

Sauropods were much stranger than many of us would have believed could ever be the case before the "dinosaur renaissance" era.

The following pointers will help you in sculpting super sauropods.

Basic Techniques for Single Figure: Simple Base Design

1. Unlike theropods, sauropods roamed Earth as quadrupeds. Actually, it is easier to construct an armature for a quadruped than for a biped, although more work is involved, twisting two additional strips of metal about the shoulder region of your armature. Fortunately, armatures for quadrupeds happen to be sturdier than those for bipedal poses. Tails should be waving aloft above the ground. However, you may daringly choose to position your sauropod with its arms and neck raised toweringly into the sky. In this case, the end of the tail can be anchored into a wooden base for added support while sculpting. To avoid sagging, use sturdier wire (e.g., coat-hanger wire) for supporting the backbone, neck and tail.

 Simply follow the directions and routine steps outlined in previous chapters for constructing armatures; however, in the case of quadrupedal poses, consider your sauropod's arms as two additional limbs that, depending on your design, may be anchored either permanently or temporarily while sculpting into a base (figure 7–6). Alternatively, under most circumstances with a quadruped — four paws on the ground — it is usually easier to handle and finish your sculpt if the wire supporting the tail and limbs isn't permanently anchored. Also, this strategy will permit molding of your piece later.

 Our rule of thumb for sauropod width is a follows: For a one-foot-long dinosaur, the width at the hips should not exceed 1.25 to 1.5 inches.

2. After your armature has been constructed according to your design, you are now faced with the task of sculpting over the wire "bones" and body made of either carved Styrofoam or aluminum foil. First, wrap your polymer clay around the exposed foil or filler material. Then clothe your metal armature and body filler with a thin layer of polymer clay. You may choose to bake this partially completed figure before adding subsequent layers of polymer clay, which will represent the skin. Sauropod abdomens should be barrel shaped.

3. The placement of sauropod nostrils can vary considerably. They aren't always at the end of the snout as one would ordinarily suppose, but sometimes near the eyes, at the top of the skull. Robert Bakker has even entertained the possibility that the genus *Diplodocus* had a fleshy tapir-like trunk, but today few scientists seem comfortable with this suggestion.

 So few sauropod skulls have been found that very little can be definitively stated about the probable restoration of the heads in certain genera. It has been suggested that sauropod heads were so tasty to predators (or scavengers) that they were gobbled up before anything else. This may account for why so many sauropod skeletons have been found in a headless condition, but no one has ever proven that

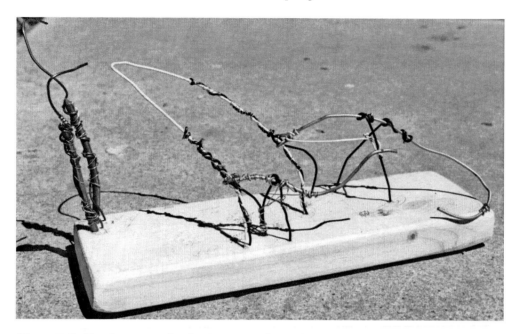

(Figure 7–6): Here is an example of an interactive figure design involving two sauropods. Can you envision mother and juvenile hungrily munching leaves from a nearby tree? The necks (and two forelimbs) of both dinosaurs are constructed of a continuous length of wire. The mother is attentively feeding her young. The twin upright structures at left will be sculpted into trees. This sculpture was designed as a one-of-a-kind display, in which the legs of both sauropods were securely anchored into the pre-sanded wooden base. Sculpting took place on this base without removing the armatures from their positions, as shown (Debus, 1990).

 sauropod skulls were a crunchy delicacy to carnivorous dinosaurs. (Their skulls may have just been fragile.) In the overall scale of things, sauropod heads were a relatively small body feature, meaning they're comparatively easy to sculpt.

4. Sauropods were equipped with sharp thumb claws. These can be prebaked and inserted into position as described in the previous chapter. Be forewarned, however. Some genera may not have had all their toes visible on the exterior of their foot. They may have been encased in leathery hide. So check some of the recent restorations of your particular sauropod for a "piggy"-counting session during the design stage.

5. It would be impossible to make full-sized *Diplodocuses* out of polymer clay, but you can still capture the essence of their gigantism in miniature, at typical scales of 1/25 to 1/100 actual adult size. Sculpt familiar reference points into your model base, such as waving palm trees, crocodiles, or plesiosaurs sunbathing on a primeval shore to indicate how huge your sauropods were when alive.

Advanced Techniques for Animating Sauropod Designs

1 To improve accuracy in bulking out your sauropod, it is always beneficial to examine published restorations of sauropod musculature (e.g., thigh and forelimb muscles). Take a look at the restorations of *Brachiosaurus* muscles depicted by John Sibbick

on pages 170 and 186 of David Norman's *Dinosaur!*, or Gregory S. Paul's similar restoration on page 32 of *Dinosaurs Past and Present* (volume 2) if you aren't certain.[11] Remember, soft-part anatomy is rarely ever preserved. However, with more than a tinge of conjecture, muscle attachments and insertions into bone can be identified from scars on fossilized bone and from comparisons made to other living vertebrates.

Don't be overly exact in sculpting muscles, because at your miniature scale it will be difficult to accomplish more than a suggestion or outline of where the major muscles were located and their overall pattern of growth. However, in all your restorative

(Figure 7–7): Working meticulously under the advisement of renowned paleoartist Gregory S. Paul, Bob Morales sculpted a highly accurate *Brachiosaurus*. Here are two views of the cut prototype, prepared for molding as the next step. *Top:* The tail has been removed from the left side of figure, and the neck removed from right, upper side of figure. *Bottom:* An instructive, clear view of a bulging brachiosaur belly showing skin folds and creases situated before the thigh region. As Bob recollects, "I made numerous changes to this sculpture. Greg Paul must have given me about 30 various things to add or delete during our project. To the best of my ability, through letters and phone calls, I finally finished the *Brachiosaurus* more than a year after getting the go-ahead." Also see figures 16–4 and 17–10, showing the final accomplishment — a resin cast resulting from this prototype (Morales).

work, you'll need to at least have an idea of the relative sizes of the muscles in order to adequately bulk out your dinosaur.

2. Now clothe your muscled out restoration with skin (figure 7–7). Should you graft on the leathery, wrinkled hide of an elephant, or a sleek, slippery dolphin-like skin texture? Or is a scaly, reptilian-looking skin surface more appropriate? Ideas concerning the appearance of sauropod skin have shifted considerably during the past century. During the years when sauropods were commonly regarded as semi-aquatic beasts, artists made their skin texture appear sleek and smooth, enabling their creations to slide through the waves that they supposedly swam through more gracefully. During the 1920s, Henry Neville Hutchinson (author of several popular paleontology books, including *Extinct Monsters*, 1893) criticized the appearance of skin depicted by artist Alice B. Woodward, in her restoration of the sauropod *Cetiosaurus*. In a letter to a colleague, Hutchinson stated, "I don't like her *Cetiosaurus*—with all that loose flesh. Aquatic animals do not have loose flesh hanging about like that." Evidently, Hutchinson had become so accustomed to regarding sauropods as water-dwelling animals that Woodward's analogy to modern elephants seemed inappropriate at that time. Ever since the 1970s, when paleontologists convincingly demonstrated that sauropods were forest dwellers, sauropods have been increasingly depicted with elephant-like wrinkly skin. That "slippery as an eel" skin texture that Charles R. Knight painted on his sauropods, typically posed as semi-amphibious swamp dwelling animals, is rarely ever resorted to today.

Of course, sauropods were no more closely related to elephants than we are to hypsilophodonts. Sections of fossilized sauropod skin impressions indicate that

their skin texture may have been relatively unwrinkled and covered in tiny scales or tubercles that would not have been overtly noticeable from a short distance away, perhaps not at the scale of your sculpted restoration.

To make wrinkles, roll thin short sticks of polymer clay, half an inch to two inches in length, lightly with your fingertip (figure 7–8). Then, before baking the animal sculpture, place these on likely places (abdominal area, in front of limbs, at flexed portions of the tail, etc.) over the body of your (nearly) completed sauropod. Using a sculpting tool, blend these rolls gently into the skin, creating a wavy, wrinkly effect; don't make it too prominent, though. Prebaked stamps of varying size can be used to lightly texturize the skin. Or make a special Texturing Cup suitable for scaly sauropod skin.

Wrinkles should also be added to

(Figure 7–8): **Rolling small lumps of polymer clay into thin strips that will adhere to dinosaur bodies, appearing as wrinkly skin areas and folded dino-hide (Debus).**

(Figure 7–9): *Paluxysaurus* (foreground) and *Sauroposeidon* (background), 2011. Restoration by Dr. Kenneth Carpenter of the Prehistoric Museum, Utah State University — College of Eastern Utah.

prebaked knee and elbow joints. But these should be made as a rather faint or subdued concentric series of circles or semicircles encircling the joint area. These wrinkles can easily be made with the sharp end of a sculpting tool. Rely on the "baggie trick" here as well when you apply either your pointed or tiny ball-tipped sculpting tool. According to recent thought, *Diplodocus'* nostrils were positioned more forward toward the snout than as previously restored (i.e., just before the eyes, on top of the noggin).[12]

Dare to dream and, above all think big! (See Figure 7–9.)

8

"Can-Do" Stegosaurs!

In the previous two chapters, we've offered guidance on how to sculpt representatives of the two great orders of what are known as saurischian dinosaurs, that is, the "lizard-hipped" grouping of genera. Now with stegosaurs, one of the most recognizable dinosaurian varieties due to their hallmark features — backbone plates and tail spikes — we're infiltrating ornithischian or "bird-hipped" territory. Don't let these terms conflate matters. Paleontologists believe that birds actually evolved from a lizard-hipped, theropod clade and not by implication from bird-hipped ilk.

The earliest (most ancestral) members of Dinosauromorpha were bipedal animals. Quadrupedalism, as later manifested in the great sauropods and creatures such as stegosaurs (which evolved from earlier, smaller forms of armored genera, all classified in a more encompassing clade named "Thyreophorans"- a subcategory of ornisthischia), evolved secondarily. As some of these species enlarged through geological time in an evolutionarily sense, graviportally, there were advantages to dropping down to all fours when walking. And so for example, in the case of those magnificent plated stegosaurs, one readily notices how the front limbs are generally much shorter than the longer hind limbs — creating an arch (or "roof") along the vertebral column toward the hips, a vestige of their former bipedal ancestry.

Although stegosaurs were bird-hipped, please do not adorn sculptures of plated dinosaurs with feathers — unless you are deliberately trying to create a spectacle. There is no evidence for it, and evolutionary theoretical notions are not supportive of feathered stegosaurians.

While generally few stegosaur genera are known, they remain one of prehistoric Nature's most celebrated, if not puzzling denizens. If fossilized stegosaurian plates look amazing to humans, just try to imagine how they must have seemed in the Late Jurassic world 150 million years ago! (See figure 8–1). Virtually everyone who loves dinosaurs yearns to sculpt their own stegosaur. And so here, we'll explain how you can do stegosaurs too.

The informal term "stegosaur" comes from the scientific genus name and the most familiar creature belonging to this clade, *Stegosaurus*, meaning "roof lizard" — referring to those plates (or "osteoderms") arranged along the animal's "roof" or spine upwardly arching toward the hips. Half a century ago, when dino-mania began to surge once more, there were only two stegosaur genera well known to Western culture; the other genus, the African *Kentrosaurus*, also particularly well established on basis of fossil remains, wasn't by any means a household name then (figure 8–2). Today, stegosaurian ranks and known specimens have swelled thanks to discoveries made in other countries, especially since flowering of the dinosaur renaissance.

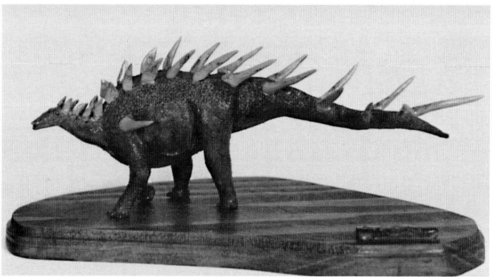

Top: Figure 8–1): Bob Morales' 1993 sculpture of the Upper Jurassic, North American *Stegosaurus*, showing the formerly regarded vertical arrangement of tail spikes. Sculpture at 1/10 scale (Morales). *Bottom:* (Figure 8–2): Allen Debus' 1997 sculpture of the Upper Jurassic, African *Kentrosaurus*, showing prominent left parascapular spine, unknown in North American stegosaurs. Model is 10" long (Debus).

While there are roughly a dozen genera known altogether (with a few known to 19th century paleontologists on the basis of scrappier remains), only a few are known from more sufficient fossils such as to enable reasonably complete life restorations, thereby minimizing the guesswork. (But there always will be intuition, inferences and guesswork in paleontology!) These are Chinese genera, such as the Late Jurassic *Tuojiangosaurus*. Another, the more ancestral (primitive or basal) *Huayangosaurus* dating from China's Middle Jurassic is something of an anomaly, in that–its hips are proportionally close to its front limbs (figure 8–

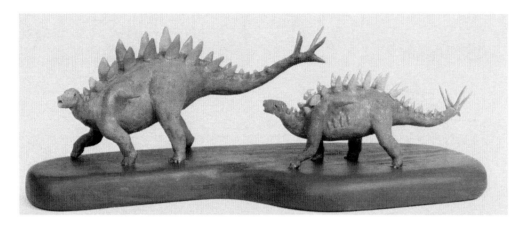

(Figure 8–3): Allen Debus' 1992 sculpture, "Plated Dragons," showing two stegosaur genera known from Chinese deposits, *Tuojiangosaurus* at the left and *Huayangosaurus*. Model base is 20" long (see text for discussion of these two genera) (Debus).

3). The earliest stegosaurs may have evolved from even more primitively armored (non-stegosaurian) Early Jurassic dinosaurs such as the British *Scelidosaurus*, or the North American *Scutellosaurus* (both of which are also considered Thyreophorans).[1] Curiously, stegosaurs weren't just a Jurassic phenomenon, as at least one genus survived until the Late Cretaceous.

But in attempting restorations of the other stegosaurs, sculptors may avail themselves of admittedly sketchier skeletal reconstructions published in journals, dinosaur texts and other encyclopedic references. Lately, the Internet has also become a valuable source of information and inspiration, offering artistic, pictorial suggestions as to how certain (or should we say, less certain) stegosaurs may have appeared in life, including, for example, fascinating genera such as "Yingshanosaurus," *Chialingosaurus, Lexovisaurus, Dacentrurus, Gigantspinosaurus, Paranthodon*, and *Wuerhosaurus*. When it comes to restoring those fabulous stegosaurs, many paleoartists simply want to get into the act, and now you may as well! Happily, recent additions to Late Jurassic stegosaurian ranks, such as the North American *Hesperosaurus* and *Miragaia*, discovered in Portugese sediments, are known from fairly complete material. In particular, paleontologist Steve Brusatte observed that *Miragaia* more or less resembled a long-necked sauropod with short plates.

Some of the species and generic names as well as systematics of stegosauria are in a state of flux, such that some of the previously assigned formal names are either considered of uncertain or doubtful nature, or have been lumped by certain paleontologists with genera known from more complete fossil material. This is a common circumstance in the annals of vertebrate paleontology, however.[2] (Don't wring your hands — just get used to it!) While you're always better off restoring a dinosaur known from a complete skeleton, you may enjoy speculatively creating interpretations of these lesser known types too.

What happened to the plated dinosaur that stayed out too long in the rain? It became "stegosaur-rust." Groan! Third grade jokes aside, let's cover a few aspects of (presumed) stegosaurian natural history before launching into techniques for sculpting these "rusty" and wonderful creatures.

The coolest and most obvious stegosaurian trait will always be their ostentatious osteo-

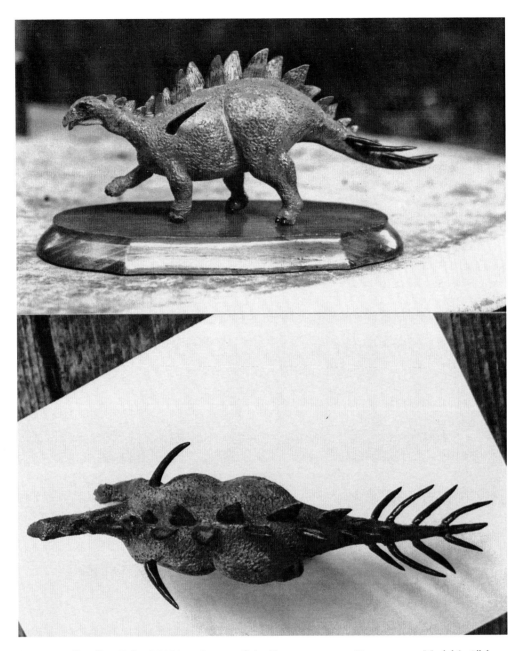

(Figure 8–4): Allen Debus' 2002 sculpture of the European genus ***Dacentrurus***. Model is 9" long (Debus).

derms, which may have made them "hot"—hot-blooded, as some paleontologists aver, or at least "hot-looking," that is to members of the opposite gender, possibly via sexual dimorphism. The story of discerning, scientifically and artistically, how *Stegosaurus'* plates were arranged in life is an often told tale, one that will interest most readers. (Some of those historically suggested arrangements and associated anatomical hypotheses are sculpturally depicted in chapter 16.[3] Let's take this opportunity to outline not only current thinking

concerning how those plates functioned, as well as the formidable array of spiky lances adorning the tail end, but also how they may have been properly situated along the vertebral column. From there, we'll address some of the other popular stegosaurs. Then let's get on with it and build one from scratch!

Despite how the plates appear in museum skeletal reconstructions, paleontologists believe that stegosaur plates were not physically attached bone-on-bone to the vertebrae (i.e., neural spines thereof), but instead were embedded within the skin above the backbone. This conclusion even prompted a bit of controversy concerning whether or not stegosaurs could rely on nerve centers to wag their plates up and down. Others, the consensus group, claim the plates were rather immobile. In other words, stegosaurs could not voluntarily raise or lower their plates for defensive, visual display or thermoregulatory purposes. Maybe they bounced a bit or jostled under gravity while the animal ambled along.

You've probably noticed bony channels and grooves running along the surfaces of *Stegosaurus'* plates. In life, these were filled with blood vessels. Osteoderm plates were quite vascular, meaning they contained a rich, internal network of blood vessels and therefore must have been sheathed in scaly skin or keratinous horn. Accordingly, the actual plate sizes may have been considerably (up to 20 percent) longer and larger in life and much showier than their fossilized bony remnants would otherwise indicate. (Ditto for those bony tail spikes, which in life were also covered in keratinous horn.) One may only imagine how vivid were colorations on their plates!

Some paleontologists therefore have hypothesized that the plates served as a means of radiating heat or otherwise regulating body temperature. When *Stegosaurus* got chilly, those plates absorbed solar heat; on hotter days, while cooling in shade, the plates efficiently radiated heat. In fact, controlled testing of models equipped with thermocouples in a wind tunnel has supported this idea. Interestingly, different symmetrical patterns of plates were tested in the wind tunnel. The most efficient *Stegosaurus stenops* plate pattern, however, was a (currently conventional) closely aligned, double-row, staggered or alternating array of ver-

(Figure 8–5): Sketch of the Chinese genus *Gigantspinosaurus*, having the largest parascapular spines of any known stegosaur (illustration by Jack Arata).

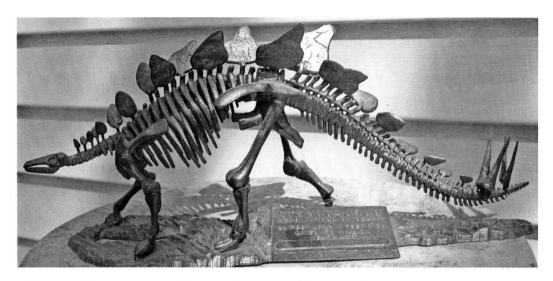

(Figure 8–6): An inexpensive plastic toy *Stegosaurus* skeleton model produced by Glencoe, shown in lateral view, accurately scaled after the American Museum's genuine specimen on display, may greatly facilitate the sculpting of a stegosaur. The model base is 11.5" long (Debus).

tebral plates, as opposed to the double-row, symmetrical arrangement. (Although it is supported by experimental evidence, as one may anticipate, not everyone concurs on the intriguing thermoregulatory plate function model, however.)

A trend that may be further authenticated as more specimens come to light is that smaller stegosaurs such as *Tuojiangosaurus* seem to have had a *paired* double row of osteoderms situated along the backbone—as opposed to the larger *Stegosaurus*' staggered (or alternating) double-row plate arrangement. Despite initial claims, per Gregory S. Paul's 2010 skeletal reconstruction, *Hesperosaurus*—slightly smaller than *Stegosaurus*—now also seems to have had the double row of alternating plates.[4] Recent discovery of a juvenile *Stegosaurus* suggests that rudimentary osteoderms enlarged proportionally during sexual maturity when they presumably became more important for inter- or intraspecific display, contests and behavior.

Following much earlier debate, for many decades of the 20th century, tail spines (also somewhat vascular in nature) in the most well documented species were conventionally regarded as four in number, all arranged in an angular, vertical orientation. While for *Stegosaurus*, as well as for *Hesperosaurus*, two pairs of tail spikes still seems to be the current formula accepted among most 21st century paleoartists, as a result of Kenneth Carpenter's researches, the spikes are usually oriented horizontally in restorations (rather than more or less vertically). This is because a splayed-out, sideways orientation may have offered more efficient defensive means from an attacking *Allosaurus* or *Ceratosaurus*, prompting *Stegosaurus* to swing its deadly tail weaponry. (To a lesser degree than plates, spikes angled outwards may have functioned in a thermoregulatory mode as well.)

To our knowledge, unlike the condition in *Kentrosaurus*, *Stegosaurus* and *Hesperosaurus* bore no protruding shoulder or parascapular spines, which in now-superseded paleoart were formerly and incorrectly attached to the hip region. *Huayangosaurus*, *Lexovisaurus*, *Tuojiangosaurus*, *Yingshanosaurus*, and *Dacentrurus* also bore large shoulder spines (figure 8–4). But

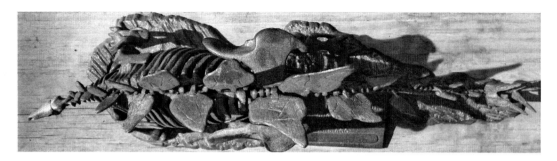

Top: (Figure 8–7): Same model as shown in figure 8–6, but viewed from a dorsal position. The maximum width of the model base, near the shoulders, is 3.5." (Debus) *Bottom:* (Figure 8–8): The armature for the *Dacentrurus* model shown in figure 8–4 has been covered with a preliminary, inner layer of polymer clay (covering aluminum foil within), that is striated using a sculpting tool, and then baked according to manufacturer's instructions. The striations will help the exterior coating of polymer clay adhere to the inner, pre-baked layer (Debus).

Gigantspinosaurus (a basal member of the clade) had enormous, formidable shoulder spines, quite thickened at the base, that paleoartist Tracy Ford believes were oriented upward over the spinal area and rearward (as opposed to low and rearward) (figure 8–5). Was this the correct condition for all stegosaurs brandishing parascapular spines? What's *your* interpretation? Tell us, that is, sculpturally. (See figure 8–6.)

Stegosaurus (comprising up to five species) is often considered the most "derived" of all stegosaurs, meaning more evolutionarily advanced. It was the largest known stegosaur, having the largest plates with the most enhanced, osteoderm-aided thermoregulatory mechanism. But how did the form, growth pattern and function of plates and spines compare across the spectrum of other, less popular stegosaurian genera?

Among the better known stegosaur genera, the smaller, more ancestral stegosaurs seem to have had an evolutionary preference for spines and overall spikiness, as compared to the flared-out osteoderms brandished in *Stegosaurus*. Porcupiney spines and spikes projected rearward in pairs along the latter part of the backbone, hips and tail of several genera, as in *Kentrosaurus*. In fact, it appears that, evolutionarily, spines became converted into plates.

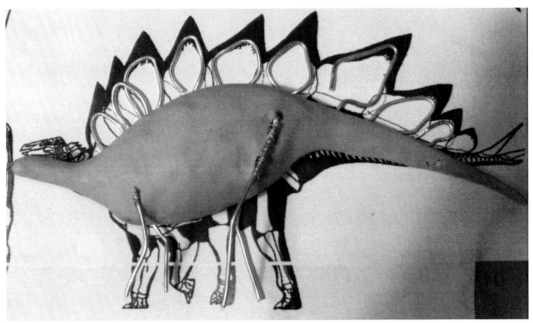

Top: (Figure 8–9): The exterior layer of polymer clay has been added to the *Dacentrurus* inner core shown in figure 8–8 (Debus). *Bottom:* (Figure 8–10): A *Stegosaurus* armature well underway, with polymer clay added to the abdomen, as well as along the cervical (neck) and caudal (tail) regions. This is a 1/20-scale creation made by Bob Morales. Note that in this case, due to the relatively large size of the sculpt, small metal armatures for each of the larger plates have been inserted along the spinal column, approximating the respective shapes indicated in a reference skeletal reconstruction (Morales).

As alluded to earlier, paleontologists claim that horn-covered spines, already quite useful for defensive purposes, increasingly took on another valuable function: modulating heat transfer and dissipation, eventually evolving into wider, broader plates along the neck, backbone and tail as known in several stegosaur genera. Eventually, among the larger genera, this secondary (thermoregulatory) function became obligatory.

While stegosaurs had horn-covered mouth "beaks" (or rhamphotheca), they also had

cheeks to retain food in their mouths while chewing. (Yes — they had teeth too, well suited for herbivory.) Furthermore, some genera, perhaps *Stegosaurus*, may have been capable of rearing upward in elephantine fashion on their hind limbs, resting tripodally upon their sturdy tails to nibble food higher off the ground on tree branches. In fact, life restorations of *Stegosauruses* standing tripodally go back to the 19th century.[5] Some paleontologists and paleoartists take things further, however, in suggesting that at least occasionally, certain stegosaurs *walked* bipedally rather than as quadrupeds. Except in *Huayangosaurus* and perhaps *Dacentrurus*, both of which had proportionally shorter hind limbs relative to front limb length, the considerably longer hind limbs of some stegosaurus, such as *Kentrosaurus* and *Stegosaurus*, suggest that quadrupedal walking would have been awkward. This is because their scrawnier front limbs would have had to scramble to keep up with the longer hind-limb gait. Hence, genera with proportionally longer hind limbs *may* have walked bipedally, an idea supported by trackways made by uniquely formed impressions of stegosaurian feet and toes, which seem to have been made by moving bipeds.

Now it's time to make a stegosaur body, equipped with a convincing set of those characteristic plates and tail spikes. To begin with, if you have one of those inexpensive, plastic *Stegosaurus* model skeletons (recently redistributed by Glencoe) at 1/25 scale, faithfully based on the reconstructed specimen displayed at the American Museum in New York, you may facilitate the armature building process for this dinosaur. In other words, your wire armature may be built according to the dimensions of the model skeleton (figures 8–7 and 8–8). (However, it's *never* a good idea to pile polymer clay over a plastic model, using the latter

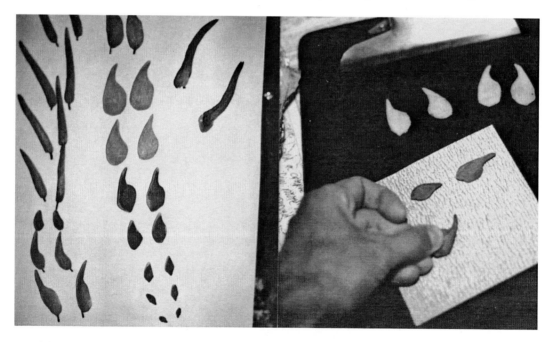

(Figure 8–11): *Left*: An odd assortment of pre-baked parts (plates, "splates" and parascapular spines) kept in relative order as they will be added to Allen Debus' *Lexovisaurus*. You can also write directly on the unbaked plates and spine of the stegosaur using a Sharpie felt marker, enumerating by code where each of the plates and spines should be properly positioned, respectively, on your stegosaur after baking. *Right*: Sharpening edges of stegosaur plates on finely graded sand paper (Debus).

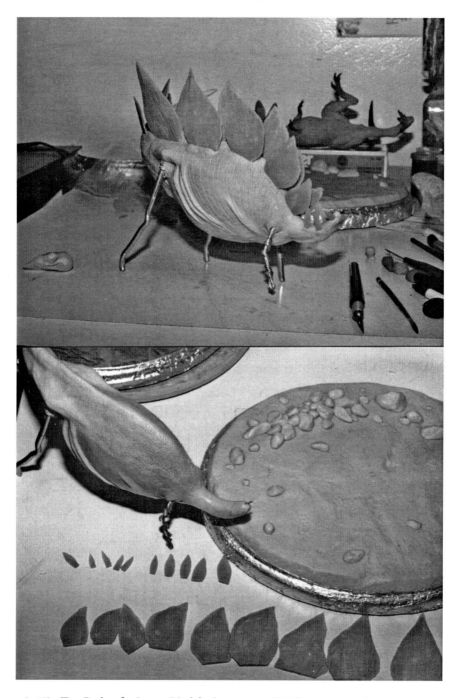

(Figure 8–12): *Top*: Body of a Lunar Models *Stegosaurus* (1994) creation well under way, showing how dermal plates are added along the spine. Check the size and appearance, and press the base of each plate into the soft, unbaked spinal area of the dinosaur, thus leaving an imprint of where each plate should be attached. *Bottom*: Stegosaur plates are best sculpted independently of the body and added after baking, as pre-baked parts. Plates of the stegosaur are kept in proper relative order after fitting them to the body of the dinosaur. Because this particular model was molded and cast as a Lunar Models production, the plates were not bonded to the final, baked dinosaur (Morales).

as an armature, because the plastic will melt in the oven — ruining your sculpture as well as releasing smelly, harmful vapors.) But if you don't have this plastic toy model, don't worry, because you'll find numerous paper reconstructions in books, journal articles, the Internet, etc., to rely on. (Or rely on photos shown here.) Use the plastic model as a reliable three-dimensional guide.

The most forbidding task is accurately sculpting all those osteoderms. After all, won't they all fall down? And what if they aren't positioned correctly — won't that look silly? Won't they appear as simple triangular shapes, jutting from the spinal column? We say, "No problem!" After reading further, you'll agree that *Stegosaurus* sculptures are not beyond the range of your abilities. (Osteoderms were easily separated from the rest of the skeleton after death.)

How many plates should your *Stegosaurus* have? The correct number is not known for any particular species. And with other genera, quite often many of the fossil plates and spines (or to borrow Tracy Ford's term, "splates") are missing. According to Stephen Czerkas, the correct number of plates for an adult *Stegosaurus stenops* is 17. Juvenile stegosaurs had fewer, shorter plates, and these may have even been cartilaginous (which would decompose more rapidly after death).

Dinosaur artists can't be expected to know more than scientists, however, so simply base your designs on published skeletal reconstructions. Two of the most accessible and highly recommended may be found in Gregory S. Paul's contribution to *Dinosaurs Past and Present,* volume 2 (1987).[6] Here Paul has restored the supposed musculature and even provided valuable reconstructions from a perspective immediately above the skeleton. Paul also reconstructed cross-sections through the rib cage. Such reconstructions, when reoriented into desired positions and scaled to model dimensions, can vastly simplify the process of dinosaur sculpting.

So here are our general (melded "advanced" and "basic") tips for sculpting *Stegosaurus* plates, the most distinguishing feature of this genus. Rely on the instruction in previous chapters for building and fleshing out the wire armatures. (But for a quick refresher, see figures 8–8, 8–9 and 8–10.)

1. For a one-foot-long stegosaur, the pelvic width should not exceed 2 to 2.5 inches. Stegosaur skin can be created using general guidelines outlined in previous chapters.

2. It may not be necessary to reconstruct coat-hanger wire forms for each osteoderm that are bonded, through laborious wire twisting, onto the vertebral wire. The risk is that you'll be off by several centimeters later, and things will quickly get out of control. Then, while making adjustments, you'll have to cut the forms anyway. Also, don't rely on flimsy aluminum foil to support a double coating of polymer clay; this may lead to serious sagging of plates later on. Instead, try this handy approach, as fortified by the accompanying illustrations:

 Draw *each* of the plates you wish to add to your sculpture, either on stiff cardboard or paper, to exact model scale. If you use cardboard, cut these plates out from the cardboard with scissors. If your plates were drawn on cardboard, coat them directly with polymer clay. (You may wish to leave a short length of cardboard projecting below the plate that can be inserted into the stegosaur's back.)

 If you used paper, cut out a double thickness of wire mesh from an old window

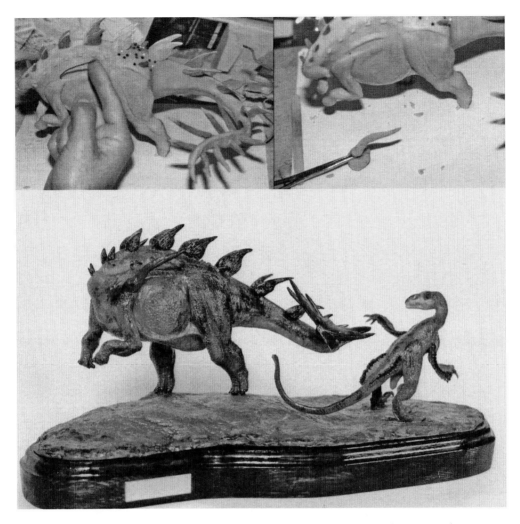

(Figure 8–13): *Top left:* Judging the positioning of the wire support for a left parascapular spine on *Lexovisaurus*. *Top right:* This support wire is curved properly to appear like a parascapular spine fossil. It took some time and attention to get that curvy swerve in the parascapular spine looking just right! After the spine is baked it can be positioned and embedded into the shoulder area of the as-yet-unbaked stegosaur. *Bottom:* In Allen A. Debus' final sculpture, "Tails — you lose!" (1998), the left parascapular spine is visible angling rearward and slightly upward in the dinosaur figure at left. Model base is 16" long. The model base was built up into a hilly prominence over the wooden base foundation using wire mesh and diorama-making techniques outlined in chapter 16. At the time this sculpture was completed, that is, during a very early stage of the dinosaurian "feather revolution," the paleoartistic concept of applying short feathered "wings" and tail onto maniraptoran theropod dinosaurs had not quite yet become cliché (also see figure 16–5) (Debus).

screen. Staple the pieces together. Flatten the staples by pressing with pliers, and cut the mesh to the correct shape of your plates with a scissors. Don't worry if the stapled sections do not exactly conform to your drawing. As polymer clay is used to completely cover the mesh, your paper sketch can be used as a guide for the intended shape.

It is unnecessary to provide an anchoring piece of wire, mesh or even a peg

(Figure 8–14): Design for a restoration of the most famous plated dinosaur, *Stegosaurus*, accurately portraying current scientific ideas concerning position of dermal plates and tail spikes (illustration by Bob Morales, 1995).

for insertion into the stegosaur's back. Left soft, the unbaked polymer clay dinosaur can have its plates and spikes (which by now you would have pre-baked) pressed gently into the spinal area, forming impressions or simple grooves provided in the stegosaur's back. This "spinal tap" technique is highly recommended for making stegosaur plates that are intended to be later cast in resin. The grooves impressed into the spine area mark where the resin case plates, or spikes, can be bonded later using Super Glue after the stegosaur body has been oven-baked separately (and cooled). However, only if you *are* planning to mold your model, before marking

the surface of the stegosaur's back, spread a very small amount of petroleum jelly thinly on the bottom edge of the sculpted osteoderms so they don't stick to the stegosaur's back.

3. Always make sure to keep your osteoderms aligned in order, respectively — one clearly marked row for each side (left and right) of the stegosaur. You can also write directly on the unbaked plates and spine of the stegosaur using a felt Sharpie marker, enumerating by code where each of the plates and spines should be properly positioned, on your stegosaur after baking. Don't glue plates (or "splates") into place until you are certain you've gotten the sequencing absolutely right!

4. Tail and parascapular spikes can be sculpted with relative ease. For added tail strength, cover a nail or short length of wire with polymer clay. If you are sculpting the African genus *Kentrosaurus,* there will be a relatively high proportion of spines compared to osteoderms.

5. It is easier to pre-bake each of the tail spikes separately before joining them to the tail of your stegosaur. After baking, you can sharpen the ends of spikes and edges of plates on sand paper before gluing them to the tail or shoulder areas of the fully baked stegosaur (figure 8–12).

Voila! Your osteoderms and splates are essentially done and properly positioned (figure 8–13). Spend most of your time striving for accuracy in the shape and symmetrical placement of the plates, and everything else will proceed smoothly.

See? Can-do! The rest is up to you! (See figure 8–14.)

9

Sculpting "Sharp-Looking" Horned Dinosaurs

In a science fantasy story by Harry Turtledove entitled "The Green Buffalo," field assistants working for paleontologist Othniel C. Marsh unwittingly hunt a live *Triceratops* that is stampeding with the buffalo. Later, they feast on its flesh (which tastes like chicken). A paleontologist who dines with them doesn't even notice the bones he's chewing on are the same as those his crew has been hammering out of the rocky hillside!

In a paleontology class years ago, one of us (Allen) overheard a graduate teaching assistant recall how he first became committed to paleontology. "I must have been about six years old, when I saw my first *Triceratops*, and became hooked forever!" See figure 9–1. Presumably, the teaching assistant was referring to a toy or one of Charles R. Knight's mesmerizing restorations rather than a live one. However, many of us know how pervading the image of those ancient horned bulls can be.

Most of us are familiar with the ever-popular restorations depicting what must have assuredly have been one of Nature's titanic struggles, *Triceratops* fending off a menacing *Tyrannosaurus*; that is, if such battles ever really did occur. The horned-dinosaur-versus-hungry-carnosaur theme became popularized a century ago by artist Charles R. Knight, who, at the time, was producing paintings for the American Museum of Natural History under Henry F. Osborn. The idea remains enchanting, as a number of similar scenes were painted by dinosaur artists during the 1980s.

So, of course, many of you would naturally consider sculpting such dramatic scenes, right? Be original —*don't*! First, it has recently been suggested that the brandished frills and horns of those great beasts developed later in life. Then, perhaps, their primary purpose may not have been to ward off predators, but during adulthood, to attract and put on displays for prospective mates. So, rather than dramatic, inter-generic war, they most likely reflected intraspecific love, that is, a proliferating sexual selection force driving procreative evolution in what is now western North America and was then the former subcontinental region known as Laramida, situated along the western edge of the Western Interior Seaway.

It's unlikely that tyrannosaurs ever directly confronted a healthy horned dinosaur. If (and this is a big "if") tyrannosaurs and their evolutionary cousins, the abertosaurs, were relatively quick, predatory hunters, wouldn't it make more sense to launch a surprise attack from the rear or side, rather than risking a most certain lung or abdominal puncture? (Reckless, incautious creatures are more prone for gene pool elimination and may not survive

(Figure 9–1): A miniature, 1/15-scale sculpture of a *Triceratops* skeleton sculpted by Bob Morales, 1994 (Morales).

long as a species in nature. Although their absolute level of intelligence is open to question, tyrannosaurs were one of nature's most successful land carnivores.) And if a large male three-horn were to sense impending danger, certainly a direct bull charge would have thwarted the tyrannosaur's head-on attack. But, as paleontologist John Horner believes, if tyrannosaurs were scavengers, then such confrontations would rarely have occurred.

Once in a while there may have been a titanic death struggle between *T. rex* and three-horn, but this most likely would have been the exception to the rule. However, the epic battle scene is a cliché. There are other scenes and numerous horned genera you can envision, though.

Imagine a duel between two bull torosaurs, fencing with their horns over a potential mate. Or a female centrosaur bellowing with rage as a flock of pterosaurs devours its unhatched eggs. Surely you can come up with excellent and original ideas for your own sculpting projects (figure 9–2).

While there were relatively few well-known horned dinosaurs during Charles R. Knight's heyday, today, the ranks of herbivorous, horned dinosaurs, also known as ceratopsians, have expanded fruitfully, facilitating their proper classification. There were the more ancestral, basal and geologically older forms, those smaller genera without the enormous frills and lacking prominent horns, such as the very well-established bipedal genus *Psittacosaurus*, which had "more than 100 long, bristle-like structures extend[ing] vertically from the top of the base of the tail ... homologous with the integumentary filaments seen in theropods such as *Sinosauropteryx* and true feathers present in *Caudipteryx, Microraptor*, and true birds."[1]

Among the larger, fancier, more derived forms, Ceratopsia is divided into two clades, known as short- and long-frilled ceratopsians: Centrosaurines and Chasmosaurines, respectively, all of which were quadrupeds. Centrosaurine genera include familiar names such as *Centrosaurus, Pachyrhinosaurus, Styracosaurus* and the time-honored *Monoclonius*. They were

Top: (Figure 9–2): Display of a *Torosaurus* skeleton in the Milwaukee County Museum provided inspiration for this hypothetical scene in Allen A. Debus' 1991 sculpture, suggesting a story — an encounter between a family of bull lizards and an intruding pack of raptors. Note that both mother and juvenile torosaurs (furthest at right) have been sculpted from a single armature. The model base is 20" long (Debus). *Bottom:* (Figure 9–3): Two *Pachyrhinosauruses* sculpted by Bob Morales (1995) at 1/20 scale. Also see figure 9–8 for a view of this sculpture while in progress (Morales).

large-bodied dinosaurs that bore shorter frills and sported prominent nasal horns with varying degrees of sharp, showy and bony epioccipital frill armament (figure 9–3). More recently discovered genera belonging to the short-frilled group include the similarly ornamented *Einiosaurus* and *Achelousaurus*. Long-frilled Chasmosaurines are even more familiar. Think of *Pentaceratops, Chasmosaurus, Torosaurus* and *Triceratops* (whose frill became secondarily shortened, although some now believe the latter two genera may be congeneric, with *Tricer-*

atops representing a more juvenile form of *Torosaurus*). The latest celebrated member belonging to this group, known from a peculiar, well-preserved skull, is *Kosmoceratops*.[2]

Sculpting horned dinosaurs demands careful attention to the head. It is critical to strive for symmetrically accurate spacing of the knobs on the bony frills and proper placement of horns over the eyes and snout. You don't want your creation to look like a mutant species! (Or one that would seem unattractive to a prospective mate; in natural selection, symmetry counts.)

For sculptors, one of the pleasant things about horned dinosaurs is that there are so many species (i.e., styles of heads) to choose from. Or, as William Service and William Stout stated so succinctly in their 1981 collaboration, *Dinosaurs: A Fantastic New View of a Lost Era*:

> These head-pieces evolved from a simple helmet designed to protect the skull and nape into an almost heraldic device of an era — a device for disemboweling the foe, dazzling and delighting the onlooker, and discouraging the competition.
>
> The angle of an animal's horns tells us something about its tactics against rival or predator. The bull and bison hook, the ram smashes head-on, while the goat and gazelle have two modes: a blunt, often ritualized blow to a rival's casque and a backward stab on the back or flank. The herbivore's defense need not be lethal, nor even successful every time, to register in the course of thousands of generations: a single puncture or gash may suffice. On the other hand, many styles of horns and antlers have flared, curved, spiraled and enlarged with more of an eye for attracting the female than for inflicting great damage. Although the proliferation of ceratopsian styles — the size and shape of the bony frill, the number and length and location of the horns — suggests an almost frivolous indulgence in the possibilities of genetic variation, the function of the apparatus was entirely straightforward. Yet the key to later ceratopsian success probably was proceratops' simple arc of bone, serving to spread the origin of the masseter (the muscle for chewing), which enabled the creature to exploit the availability of tougher, coarser vegetation with increased leverage.[3]

So you might, say, tackle your subjects "head-on."

Why sculpt *Triceratops* when there are so many more ornately adorned and interesting skulls to flesh out in sculpture? There are genera such as *Anchiceratops*, *Centrosaurus* and *Torosaurus*, with its famous nine-foot-long skull, delightful subjects in the hands of sculptors (figure 9–4). David Thomas' life-sized, bronze statue of *Pentaceratops*, exhibited at the New Mexico Museum of Natural History in Albuquerque, remains one of the finest dinosaur restorations ever done. Although *Triceratops* is one of our most popular and scientifically well-known dinosaurs, its head was relatively simple in appearance compared to that of *Styracosaurus* or *Pachyrhinosaurus* (figure 9–5).

It has been suggested that the crests of horned dinosaurs sported striking patterns of coloration for display purposes. Of course, this hypothesis has not been proven. However, your sculpture will appear even more decorative when the crests are painted elaborately.

Perhaps the most extraordinary dinosaur fossil ever found came from Mongolia's Flaming Cliffs in 1971, where scores of eggs attributed to *Protoceratops* were found in fossilized nests (figure 9–6). The new fossil, currently exhibited at the State Museum in Ulan Bator, Mongolia, caught two struggling dinosaurs, *Velociraptor* and *Protoceratops*, in their death throes while becoming engulfed in a sand storm. They were frozen in time for nearly 100 million years. One of the first sculpted restorations of this scene, a life-sized concrete sculpture, was placed on exhibit at the "Valley of the Dinosaurs" at Chorzow, Poland. This exhibit commemorates the Polish-Mongolian dinosaur expeditions to Mongolia's fossil beds,

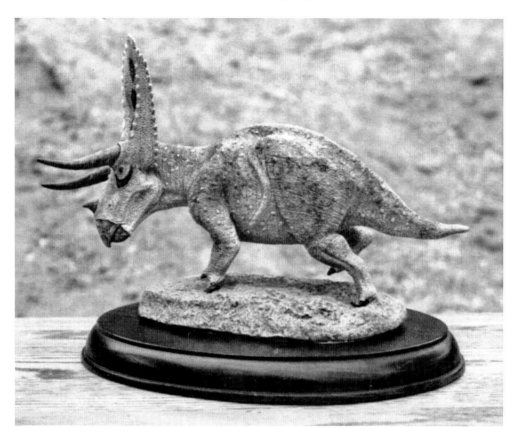

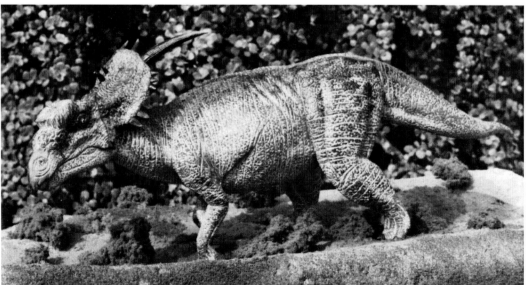

Top: (Figure 9–4): Bob Morales' *Torosaurus* sculpted at 1/35 scale, which was released as a model kit after molding the prototype. A detail of the unpainted skin texture was shown in figure 6–17, bottom (Morales). *Bottom:* (Figure 9–5): An alternate view of *Pachyrhinosaurus*, this time sans the impressive nasal horn, sculpted by Bob Morales in 1993. Compare with figure 9–3 (Morales).

(Figure 9–6): Drawing by Lisa Debus based on a Charles R. Knight painting showing a family of *Protoceratops* adjacent to a hypothetical egg nest (courtesy Lisa Debus).

taking place between the years 1963 and 1971. More recently, Bob Morales captured the moment expertly in a 1993 sculpture using polymer clay, although he added a putative nest replete with eggs.

Following the discovery of an *Oviraptor* fossil embryo (a theropod dinosaur) in an egg once formerly attributed to the ceratopsian *Protoceratops*, scientists reassessed the whereabouts of the latter's alleged nests. During the 1920s, scientists excavated fossilized egg nests in Mongolia which were then thought to have been laid by *Protoceratops*. At one nesting site, however, an adult theropod dinosaur was discovered, which was thought to be a hungry invader. The theropod was an oviraptorid (an "egg robber"), so named because it was inferred that one of its kind had been caught in the act of stealing *Protoceratops* eggs. Now it seems as if oviraptorid theropods merely guarded or even incubated their own nests, without committing acts of thievery. (For tips on sculpting oviraptorids, see chapter 13.)

However, clutches of completely articulated *Protoceratops* hatchlings have been discovered, sans eggs. These, if properly interpreted, may constitute former nesting sites belonging to this genus. Even though nesting sites haven't been discovered for other ceratopsian genera, due to former highly publicized interpretations concerning *Protoceratops* eggs, parrot beaked, horned or frilled dinosaurs are (also) still generally regarded as oviparous (egg-laying) animals. Although this is not a valid scientific argument by any means, their characteristic, parrot-shaped "beaks," reminiscent of modern parrots, also quite loosely suggest an (avian) egg-laying, reproductive habit.

Controversy lingers concerning the front limb posture of horned dinosaurs. Some scientists conclude that the front limbs of dinosaurs were bent outward slightly in a reptilian-looking "push up" position, whereas others think their strides were more mammalian in nature. A 1990s analysis of a ceratopsian trackway from the Laramie formation in Colorado favored the upright forelimb (mammalian) posture. We won't try to settle this postural matter here. Obviously, though, if you want to pose your centrosaurines or chasmosaurines in quick-footed running positions, a crocodilian-like front limb posture would seem awkward, because a sprawling motion won't create the impression of speed. The nature of front limb posture is linked to the warm-blooded question.

Some scientists believe horned dinosaurs could accelerate up to nearly 40 miles per hour, while others claim that such swiftness was not possible. Is it even possible that certain ceratopsians were able to rear up on their hind limbs and tail? You, the dinosaur sculptor, must decide what visual effects are important to project. You can even contrast these scientific ideas on the same model base (figure 9–7).

Here are some special tips to help you in the sculptural representation of horned dinosaurs:

Basic Techniques for Single Figure on a Simple Base

1. After deciding the nature of the pose, construct your armature using the instructions presented in previous chapters. Then, flesh out your armature (figure 9–8). Our rule of thumb for the width of a ceratopsian dinosaur is as follows: for a one foot-

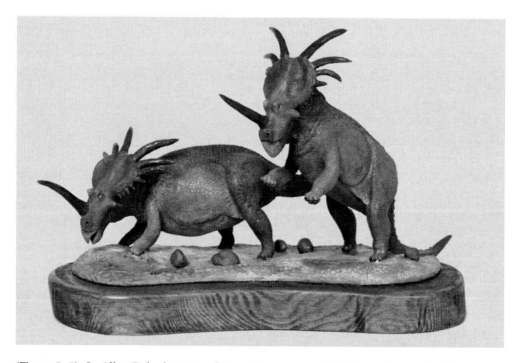

(Figure 9–7): In Allen Debus' 1995 sculpture, *Styracosaurus* bristles to the sound of an unseen intruder. Also see figure 9–8 for a view of this sculpture while in progress (Debus).

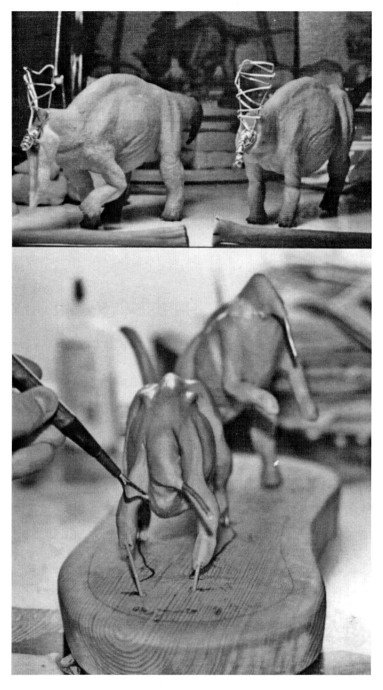

(Figure 9–8): Either wire mesh (not shown in this image), or twisted metal wire can be used to support those marvelous ceratopsian heads. *Top*: Bob Morales tackles the heads of his pair of pachyrhinosaurs (shown finished in figure 9–3) (Morales). *Bottom*: Allen Debus smoothing out the shoulder region of a styracosaur at a similar stage to his pair of styracosaurs (shown finished in figure 9–7). Note that these particular figures have been installed into their final destination, a smoothly sanded wooden base (in contrast to the two figures shown in the top of this image, which remain free-standing (Debus).

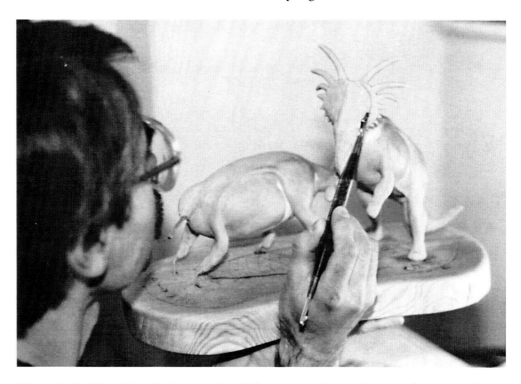

(Figure 9–9): Allen Debus begins sculpting frill ornamentation on his pair of torosaurs (shown finished in figure 9–7). This styracosaur head has been fashioned out of polymer clay applied over a wire mesh surface as described in the text. Wire mesh provides structural support for the frills of these styracosaurs (Debus).

long dinosaur (tip of snout to end of tail), the body width at the pelvis should not exceed 1.75 to 2.5 inches. By the way, this does not mean you must always sculpt a one-foot-long dinosaur. Scale your model according to your needs and tastes.

2. Those marvelous heads! It is vital to have a scale drawing (preferably a side view and from above) showing the skull with its characteristic cranial ornamentation that you will be animating sculpturally. There are many photos and illustrations of ceratopsian skulls available in scientific or popular references, including the Internet at such sites as Wikipedia, that will greatly simplify this task. With your scale drawing handy, imagine how the huge head should be positioned on the neck of your partially completed sculpture. Place a lump of polymer clay on the projection of the vertebral column representing the neck using your fingers, approximating the general form of a triangularly shaped ceratopsian head. (However, don't attempt to form the entire length of the frill.)

 Next, cut out a section of wire mesh from an old window screen and place it firmly into the lump of head you have started. (Practice caution, as the severed edge of the mesh could stab your fingers.) The wire mesh should approximately span the length and width of the ceratopsian frill, meaning that it will protrude out of the small mass of polymer clay over the neck. If your length of screen is too long, cut or taper it using scissors. Cover both sides of the mesh with polymer clay. Add further support to the frill by filling in neck muscles behind the frill. Routinely

check the angle of the crest relative to the midline of the snout, versus the same angle in your drawing (figure 9–9). Quite often in the early sculpting stages, the crest angle may have to be slightly raised or lowered. Sculpt the facial features situated in front of the crest. You may also proceed without the use of wire mesh, substituting wire and aluminum foil instead to create the crest armature. (We'll learn further inventive uses for window screen mesh in chapters 12 and 13.) Or you may support the neck frill with strands of copper or aluminum wire instead, as shown in figure 9–8 (top).

3. Ceratopsian facial features are challenging to sculpt accurately because of head shield curvature and geometry, all the while maintaining symmetry, in addition to projecting horns and knobby surfaces that must all be made systematically and symmetrically. The width of the mouth and the snout area of ceratopsian head shields should be thin when compared to the skull length. The mouth should terminate in a parrot-like beak. (Yes, ceratopsians had batteries of grinding teeth, but these were hidden in the mouth by the cheeks, so they won't have to be sculpted.) Ceratopsians may have inflicted deep gashes and wounds upon their foes with powerfully snapping jaws. Although herbivorous, an angered, combative *Triceratops* must have been an awesome adversary. Sculpt cow-like cheeks onto your ceratopsian's cow-like mouth.

The longer horns of ceratopsians may be strengthened by covering a short section of coat hanger wire with polymer clay. One uncoated end of the wire may be embedded into the head. However, you may have to curve the wire slightly, to an aesthetically pleasing contour using pliers before you add the polymer clay. Shorter horns on the frill will not usually require added support. Be advised that bony horn cores evident on ceratopsian skulls may not record the true length of the horns. Fibrous, keratinous sheaths covering the bony cores haven't fossilized. It has been estimated that in life, the overall length of ceratopsian horns may have been up to twice as long as indicated by preserved horn core. *Pre-bake* each horn, keeping them in proper order, and gently sand them to menacing sharpness before impressing them onto the unbaked head and frill — thus marking where they will fit after the entire animal has been oven-baked.

Advanced Techniques for Animating Ceratopsid Designs:

1. Robert Bakker and Gregory S. Paul have published restorations of ceratopsid musculature in their contributions to the first and second volumes, respectively, of *Dinosaurs Past and Present*, which should help you in improving the accuracy of body proportions in ceratopsians.[4] (Similar patterns of musculature may be generally assumed for the other large ceratopsians.)

2. The skin texture of ceratopsians is often restored with a leathery appearance. *Triceratops*, for example, was the size of an elephant, so the analogy may not be inappropriate. Wrinkly elephantine or rhino-like skin may be suggested to the viewer by pressing thin rolls of polymer clay onto the fleshy areas of your sculpture. Smooth the edges of these rolls into the body using a sculpting tool and the saggy baggy skin effect will look complete. Using the ball-tipped sculpting tool, or a tool having

a needle end, gently striate the body surface through a plastic baggie, producing an impression of crisscrossed lines (i.e., the Baggie Trick). Any excess material excavated by the tip of your sculpting tool, inadvertently clinging to the ridges, can be lightly sanded off later, after baking. Now your horned dinosaur's skin will appear leathery to the beholder after it is painted.

According to Gregory S. Paul, however, fossilized skin impressions reveal that ceratopsian skin sometimes had a reptilian, scaly texture. So, alternatively, consider adding large scales to your skin rolls by stamping or impressing scaly patterns into the hide using the advanced techniques outlined in chapter 6.

10

Sculpting Iguanodontian
and Duckbill Dinosaurs

History does repeat itself after all. The iguanodonts and dinosaurs loosely lumped together within the ornithopod clade, have a curious habit of becoming emphasized during revisionist or revolutionary stages in the history of dinosaur paleontology. During the 1820s and 1830s, *Iguanodon* became the focus of early scientific intrigue as British geologists pondered the mysteries of the newly discovered "antediluvian world." In 1858, Joseph Leidy described *Hadrosaurus*, which later gained fame as America's first mounted and exhibited museum dinosaur. *Hadrosaurus* was a herbivorous (although this is now less certain) genus dating from the Upper Cretaceous of Pennsylvania and New Jersey. Leidy claimed *Hadrosaurus* was bipedal, even though, until that time, it was commonly believed that all dinosaurs were quadrupedal (figure 1–1). During the late 1860s, under Leidy's advisement, Benjamin W. Hawkins proceeded to reconstruct *Hadrosaurus'* incompletely known skeleton, anthropomorphizing the final construct with fabricated collar and human-shaped hip bones (missing in the fossil) (figure 10–1).

Nearly a decade later, over 31 relatively complete *Iguanodon* skeletons were discovered in a coal mine shaft near Bernissart, Belgium. Studies conducted principally by Louis Dollo led to greater scientific understanding of the anatomy and posture in *Iguanodon* than any other species of dinosaur known to 19th century science (figure 10–2).

Then a century later, during the late 1970s, newspapers reported the discovery of a fossil embryo in Montana, belonging to a dinosaur at first tentatively reported as "Peeblesaurus" by the press. "Peeblesaurus" was later described by John Horner and Robert Makela as the duckbill dinosaur, *Maiasaura*, or "Good Mother Lizard." Its species name became *M. peeblesorum*, because the first specimens noted by Horner were discovered on pasture land owned by the Peebles family in northwest Montana. Horner estimated that hundreds of duckbilled specimens lay entombed at the Montana collecting localities. *Maiasaura*, the first genus of dinosaurs for which evidence of Mesozoic parental care was demonstrated, became paleontology's mascot as the 1980s escalated into a heralded "decade of the dinosaur."

As stated previously, duckbills and iguanodonts are classified as ornithopods, a great clade of herbivorous dinosaurs with Triassic origins and bushy evolutionary branching into the Late Cretaceous. Ornithopods comprised smaller, fleet-hoofed, possibly nocturnal creatures that lived in colder south polar climes as well as larger migratory beasts that visited Arctic regions. While the iguanodonts were more basal and perhaps more anatomically con-

(Figure 10–1): Allen A. Debus' oven-ready "Hawkins and His Hadrosaur" polymer-clay prototype (1996). This polymer clay sculpture became a Hell Creek Creations model kit. Unlike most dinosaur sculptures, which focus on prehistoric landscapes and dioramas, this one shows a restoration of a plausible historical scene in the art studio of the famous paleoartist, Benjamin Waterhouse Hawkins — standing at left holding a hadrosaur thigh bone. Hawkins restored his concept, mirroring ideas of paleontologist Joseph Leidy, of the Cretaceous *Hadrosaurus* discovered in New Jersey. Model base is 10.5" long. Compare this upright, bipedal hadrosaur stance with that shown in figure 10–3 (Debus).

servative, by the Late Cretaceous duckbills became far more differentiated, especially with respect to their heads and skull shapes. In particular, Lambeosaurines had an outstanding variety of head crests — analogous to those witnessed in the evolutionarily related ceratopsians — suggesting social structure among their herds, thriving romantic lives and perhaps hormonally driven sexual selection. The horse-shaped heads of iguanodonts and hadrosaurines, armed with batteries of teeth, were highly adapted for chewing tough foliage. Chewing food, singing songs and biologically reproducing is evidently what they did best! Because iguanodonts and duckbills had similar sizes, general body outlines and ecological roles, tips for sculpting these kinds will be outlined together here. (Another more diminutive yet historically significant ornithopod will be briefly addressed in chapter 13.)

Many iguanodonts and duckbills are well-established genera. Given that iguanodonts and duckbills have been commonly encountered in Cretaceous deposits throughout the history of vertebrate paleontology, one might naturally anticipate that such genera would be represented among nature's most startling examples of fossilization. This actually is the case. Besides entire nests of fossilized eggs, embryos, trackways and numerous examples of juvenile specimens, several fossilized duckbill mummies have also been discovered. These latter specimens offer rare glimpses into the near-life appearance of ornithopod dinosaurs, even pro-

(Figure 10–2): Skeletal reconstruction of an *Iguanodon* shown standing in conventional bipedal pose (courtesy Tanner Wray).

viding indication of the skin texture as preserved in fossilized skin impressions on the mummies. Soft-part anatomy in the abdominal region of a *Thescelosaurus* specimen was even reported, although this claim has been subjected to considerable scrutiny.[1] Looking further into the 21st century, will the first dinosaur to be successfully cloned from fossil DNA be a duckbill?

(Figure 10–3): Allen Debus' 1991 restoration in polymer clay of the *Hadrosaurus* shown as formerly considered, as an aquatic (note the webbed toes), bipedal animal, which supposedly hopped (incongruously) like a kangaroo. Sculpt is 4¾" tall (Debus).

The heads of the various iguanodont species known to science were fairly uniform in design. However, over geological time, the heads of duckbilled dinosaurs evolved into flamboyant splendor. Some of these heads grew long crest-like projections, which, as in the case of the genus *Parasaurolophus*, may (or may not) have been connected to the neck by webbing.

Others grew dome-like crests or more intricately designed bony protuberances. Were these features "trombone-like" adaptations for announcing themselves to attract mates? Did they provide a means of resonating vocally over greater distances (possibly with the added benefit of finding a mate)? Or did highly sensitive nasal organs extend through the interiors of such crests, allowing duckbills to catch the scent of distant predators? We may never know the answer.

Duckbilled dinosaurs owe their strange moniker to the fact that 19th century paleontologists made some analogies between the shape of the skulls of certain species belonging to this group and those of modern ducks. Despite the general resemblance in shape, the mouths of duckbilled dinosaurs were no more truly duck-like (or platypus-like) than are the beaks of ceratopsids to be regarded as parrot-like. These are merely examples of convergent evolution. Similarly styled or analogous adaptations are sometimes favored in organisms of differing ancestry because such features and anatomical structures have been selected for similar life functions.

Years ago, the mouths of duckbilled dinosaurs and iguanodonts were restored without cheeks. However, based on the latest evidence and interpretation, sculptors should add cheeks. The mouths of iguanodonts and duckbills characteristically ended in horny beak-like projections.[2]

Although until the mid–20th century, duck-

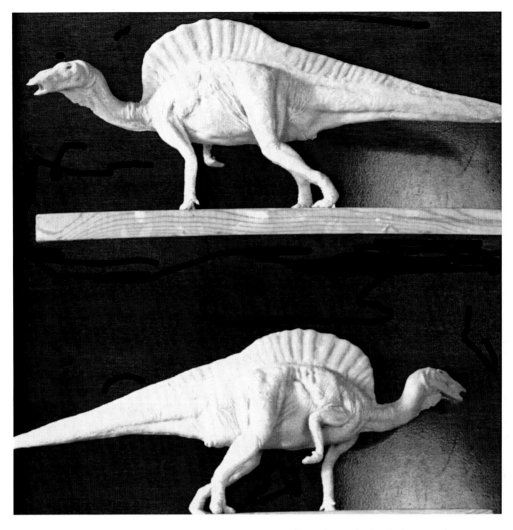

(Figure 10–4): Paleobiologist Dougal Dixon's sculpture of an African fin-backed iguanodont, *Oura-nosaurus*, in progress. As opposed to the 19th century view as restored in figure 10–3, the quadrupedal posture shown here is generally considered correct for both duckbills and adult iguanodonts. Note the crested sail (courtesy Dougal Dixon).

bills were thought to have been swamp-dwellers, they are now regarded as terrestrial, for-est-grazing dinosaurs. At an earlier time paleontologists entertained notions that hadrosaurs hopped about like kangaroos, a curious ideology that was quashed over 70 years ago (figure 10–3). It is possible that duckbills could swim, but they probably did not instinctively flee to the water when predators appeared, as formerly believed. When threatened, iguanodonts and duckbilled dinosaurs may have retreated from danger. However, on occasion, as when defending their young, they may have been forced to stand their ground. Adult duckbills may have heroically swatted their attackers with their heavily muscled tails, or kicked at nest invaders. After juveniles left the protection of the nesting ground, because they were still highly vulnerable to predation, skin camouflage may have represented their most efficient survival tactic.

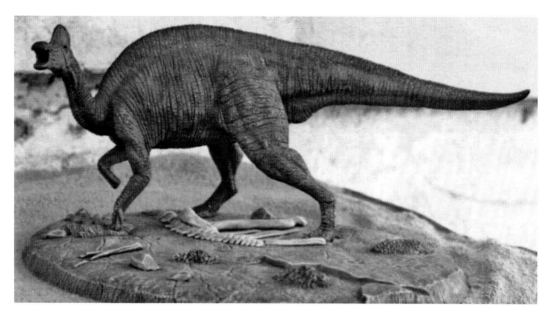

Top: (Figure 10–5): Bob Morales' duckbill *Hypacrosaurus* (1992). Note the vertical, wrinkly skin texture, which can be achieved using the "baggie trick" (Morales). *Bottom:* (Figure 10–6): Another skeletal reconstruction of the Cretaceous *Iguanodon*, in quadrupedal posture, conforming with modern views (courtesy Tanner Wray).

Several books and many articles have been published on the avian nesting habits of *Maiasaura*, which may kindle many ideas for sculpture. For a decade, *Maiasaura* was the hot dinosaur, but many other duckbills and iguanodonts await the hands of willing sculptors.

For instance, there are iguanodonts such as the fabulously spined African *Ouranosaurus* (figure 10–4), or the Australian *Muttaburrasaurus*. A Jurassic genus, *Camptosaurus*, may be an evolutionary ancestor of the iguanodonts. And there are Asian duckbills known to only the most ardent of dinosaur fanatics, such as the *Shantungosaurus*, which grew up to 49 feet in length, and *Tsintaosaurus*, with its curious spike projecting vertically from its skull (possibly nasal bones reoriented by crushing of the specimen after death, or alternatively a crest projection). The Romanian *Telmatosaurus transsylvanicus* is also known to have laid clutches of eggs. Apply what is already known of the *Maiasaura*'s social habits to other genera and, through sculpture, dare to indulge in moments of prehistoric drama.

Be assured, dinosaur sculptors, that because so many well preserved specimens have been studied, your most accurate sculptures will most likely be of duckbilled dinosaurs. Furthermore, from a design perspective, duckbills and iguanodonts are relatively easy to sculpt. There are no complicated horns, spines or plates to worry about in the final design. The mouths of certain species were filled with thousands of teeth. Fortunately, these will rarely need to be sculpted.

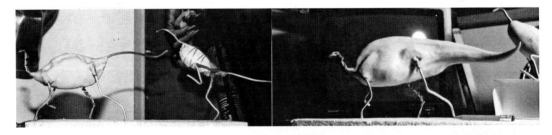

(Figure 10–7): *Top left:* A quadrupedally posed hadrosaur armature is fleeing from a bipedal, running theropod armature. The hadrosaur already has a coat of polymer clay surrounding a Styrofoam interior used to bulk up the abdominal area. *Right:* The hadrosaur is shown further along in the sculpting process. For a look at the completed duckbill, which happens to be a **Hypacrosaurus**, see figure 10–5 (Morales). *Bottom:* (Figure 10–8): Another view of Dougal Dixon's **Ouranosaurus**, although at an earlier stage of sculpted progress. Also see figure 10–4 (courtesy Dougal Dixon).

(Figure 10–9): Two reconstructed skeletons (*top*) of *Anatotitan* (a Cretaceous duckbill dinosaur — note their duck-shaped mouths) exhibited in New York's American Museum of Natural History, and the same specimens (*bottom*) as restored in a 1909 painting by Charles R. Knight. Images from H.F. Osborn's *The Origin and Evolution of Life: On the Theory of Action Reaction and Interaction of Energy* (New York: Charles Scribner's Sons, 1918), p. 222.

(Figure 10–10): Detail showing pair of iguanodont spiky-thumbed hands (center) and the sickle-clawed foot of an attacking raptor. For a view of the full sculpture by Bob Morales, see figure 11–7 (Morales).

Yet there are several characteristic features that merit closer attention. Here are our tips for sculpting iguanodonts and duckbilled dinosaurs:

Basic Techniques for a Single Figure on a Simple Base

1. Despite what Leidy and others may have thought years ago, adult iguanodonts and duckbills were most likely quadrupedal dinosaurs (figures 10–5 and 10–6). (Juvenile iguanodonts may have walked bipedally.) This is in contrast to all those restorations completed before 1970, in which the *Iguanodon*, as well as duckbilled genera such as the Trachodon (now *Anatotitan*) were usually posed in fully upright, bipedal form.

 Duckbills' backbones were highly arched over the hips. The heads were held horizontally, suspended on necks that were curved in a graceful "S" shape. The tail curved rigidly, outward and downward, toward the ground. It did not flex easily like a lizard's tail, or drag on the ground, however, because it was prevented from doing so by stiffening tendons extending along the length of tail vertebrae. Curve the vertebral wire of your armature accordingly to reflect this body plan (figures 10–7 and 10–8). Examine more recent skeletal reconstructions while avoiding older, pre-1980s imagery in which the backbone is often poised erroneously upright, and a limp tail is allowed to drag loosely behind on the ground.

2. In constructing your armature, first settle on an armature design based on a reliable skeletal reconstruction (figure 10–9). Follow the basic techniques previously described in constructing the armature.

Our rule of thumb for a one-foot-long (tip of snout to end of tail) dinosaur is that the maximum body width at the pelvis should not exceed 1.75 to 2.5 inches.[3]

3. Mistakes may easily be made in sculpting the hands of iguanodonts and duckbilled dinosaurs. Much of our present knowledge concerning the hands of iguanodonts stems from David Norman's reassessment of the function of this dinosaur's hand, which bore a thumb spike, now infamous in the lore of paleontology because over a century ago it was mistakenly considered to be a nasal horn. This thumb spike was evidently opposable, like the human thumb. It is believed that iguanodont hands were fully capable of grasping and manipulating tree branches, while used for support when walking. While striding, the spike was most likely angled inward, elevated from the ground (figure 10–10).[4] The spike may have also served a defensive purpose, but this may have been a secondary adaptation. Iguanodontians may have used their stiletto-like spikes as weapons, or to pierce into tough fruits.

However, duckbills were not equipped with opposable thumb spikes. Duckbill thumbs were not as prominent (or spiky) as the thumbs of iguanodonts. Their three fingers were "joined together in a thickened pad, [and] hardly had any way to function other than as a support while the animal was standing on all fours. Manual dexterity was not a hadrosaurid specialty."[5] The digits of the hand were covered by a padded hoof. The wrists bent downward when forelimbs were raised.

Duckbill and iguanodont forelimbs were thinner and shorter than their hind limbs. Isolated footprints and trackways indicate quadrupedal posture. Iguanodont hand prints have a characteristic half-moon shape; keep this in mind when decorating your diorama's terrain. The feet of duckbills and iguanodonts had three massive toes. Their ankles, like those of most dinosaurs with exception of sauropods and stegosaurs, were flexible and bird-like.

Advanced Techniques for Animating Duckbilled Designs

1. After you have constructed your armature, refer to restorations by Paul in cited references showing the probable musculature in the duckbill genera, *Corythosaurus* and *Hypacrosaurus*. Flesh out duckbill bodies based on Paul's or other similar restorations before adding skin texture. Sculptors may also wish to examine Mark Hallett's similar set of restorations for the *Iguanodon*.[6]

2. The scaly skin texture of duckbills is known from impressions marvelously preserved in a number of mummified specimens. The scales were small and assumed a symmetrical pattern. The mummies also bear evidence of frills made of skin, which extended continuously along the length of the vertebral column. According to Paul, wrinkly skin folds may have hung loosely and vertically from the duckbills' anterior regions (i.e., shoulders, upper arm and neck). As Paul heartily suggests, when it comes to dinosaur art and restorations, "We need to be daring and bold."[7]

3. Some smaller ornithopods, such as the mid–Cretaceous genus *Oryctodromeus*, may have burrowed, forming underground social dens.[8] Here's an unusual opportunity to jazz up the livelihood of your sculpted prehistory.

11

Sculpting Miscellaneous
Mesozoic Creatures

What were "miscellaneous" dinosaurs? We are merely reflecting the fact that herein, full chapters won't be devoted to each and every kind of dinosaur. So, in this chapter, general techniques for sculpting crocodilians and herbivorous dinosaurs — classified distinctively as prosauropods, therizinosaurs, hypsilophodonts, pachycephalosaurs and armored dinosaurs — will be outlined. (There are still other amazing kinds of dinosaurs, such as "ostrich-mimic" dinosaurs, herrerasaurs, heterodontosaurs, and armored scelidosaurs. Sculpting techniques for these types won't be specifically addressed here. But now that you've already read about similar or even more complicated body types and anatomical shapes, after researching them, your confidence in approaching these should be boosted as well.) See figure 11–1.

Dinosaurs addressed in this chapter is divided into basic and advanced sections, with respect to dinosaur types. Single figures on simple bases are relatively easy to create for the hypsilophodonts, pachycephalosaurs, therizinosaurs and prosauropods. We'll also discuss one important and popular group of marine reptiles, the plesiosaurs. Having already fortified your skills, sculpting non-dinosaurs such crocodilians and plesiosaurs should also seem relatively straightforward. However, even single-figure, simple-base designs involving armored dinosaurs are inherently complex, more time demanding, and should be regarded as more advanced (figure 11–2).

Ready? Let's go!

Basic-Design Crocodilians

A Florida fisherman recounted his experience of having a 12-foot-long American crocodile snatch a fish he'd caught on a hook; it was like a scene from *Jurassic Park*. "I'm just glad it wasn't my hand."[1] Why sculpt crocodilians? After all, this is a book addressing dinosaur sculpting, as opposed to modern animals. Aside from avians (birds), the only living archosaurs (a group that includes dinosaurs) are crocodilians. Many believe the basic crocodilian form evident today hasn't significantly altered in over 200 million years. After all, that "perfect" anatomical morphology and indolent, predatory/scavenging lifestyle saw them through their greatest ecological crisis, 65 million years ago — a doomsday for other archosaurs. And yet the fossil record indicates that especially during the Mesozoic Era, crocodilians were far more diversified, assuming many more ecological roles than is the case

SOME BASIC BODY SHAPES

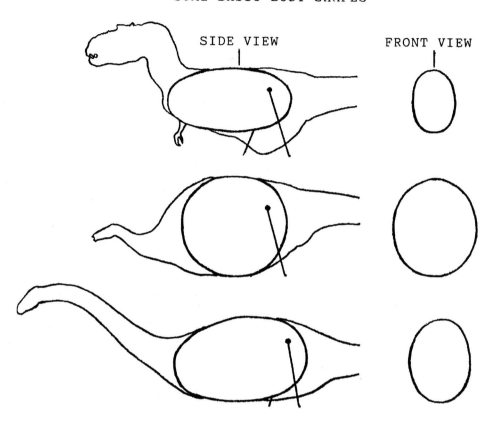

SIDE VIEW FRONT VIEW

(Figure 11–1): Body shapes of dinosaurs varied considerably, as is known from often-published dinosaur restorations showing lateral views. However, abdominal cross sections through the backbone show how different were the shapes of their torsos as well. From the top, tyrannosaur, stegosaur, sauropod (Morales).

today. If you choose to sculpt crocodilian forebears you'll be able to directly observe the movements, temperament and mien of modern species, unlike the circumstances with the long-extinct dinosaurs (aside from modern avians, of course). Thus, you may project or, rather, infuse the menacing aspect of a modern croc into, say, the armored, magnificently fanged, 20-foot-long Boar-croc (*Kaprosuchus*), a former inhabitant of what is now Africa's Sahara (figure 11–3). Never heard of that genus? Well, then you have to bone up on extinct crocs and their closest prehistoric relatives.

When dinosaur enthusiasts frame mental images of prehistoric crocs, most likely Raul Martin's startling painted restorations come to mind. Martin has painted scenes featuring 40-foot-long crocs, *Deinosuchus* and *Sarcosuchus*, in river settings dramatically attacking, respectively, *Albertosaurus* and *Suchomimus*. Here, Raul is simply portraying what crocs instinctively do to make a living. Decades ago, paleoartist Walter Ferguson's American Museum painting of *Deinosuchus* rushing a surprised young *Chasmosaurus* along a river bank long ago certainly fascinated the authors.[2] In such scenarios and contests, the crocs are the projected winners. While most paleosculptors will naturally be impressed with the

huge size of prehistoric crocs in comparison to adult theropods, for example, savvy sculptors may instead select recently discovered and peculiar fossil crocodilian genera formerly occupying niches and ecological roles now assumed by modern mammals.

A number of recent fossil croc discoveries dating from the Cretaceous have been made in the South American and African continents, pointing to the Darwinian "bushiness" of

Top: (Figure 11–2): An "armored tank" of the Upper Cretaceous, North American continent, *Euoplocephalus,* appears ready to smash Bob Morales' favorite coffee cup. Sculpture is 1/20 scale. Sculpture by Bob Morales, 1993 (Morales). *Bottom:* (Figure 11–3): Jack Arata's restoration of the 2-foot-long, Mesozoic "boar-croc," *Kaprosuchus* (courtesy Jack Arata).

their evolutionary lineage.[3] While they haven't achieved household-name status, paleosculptors should consider genera such as *Malawisuchus* (described as a weird, 2-foot-long, insect-eating croc that stood bipedally erect), *Simosuchus* (an osteoderm-coated, dog-sized, pug-nosed, burrowing vegetarian), *Anatosuchus* (a 3-foot-long, broad-snouted, fish-and-worm-eating duck-faced croc), and two 3-foot long species of *Araripesuchus*—*minor* and *rattoides* (respectively, a lanky-legged running, omnivorous croc, and a bucktoothed croc that may have burrowed for tubers), for possible sculpting projects. And a peculiar 7-foot-long Late Cretaceous croc, named *Armadillosuchus*, discovered in Brazil, was encased in armadillo-like body armor (figure 11–4). Such species only vaguely resemble the aspect and persona of modern gators and crocs, reflecting unanticipated lifestyles for their ancestry. As paleontologist Hans Larsson stated, "Each of the different crocs apparently had different diets, different behaviors. It appears they divided up the ecosystem, each species taking advantage of it in its own way." Paleontologist Paul Sereno added, "The most basic story these ... fossils tell us is that in the time of the dinosaurs, crocodiles filled in a lot of ecological niches later to be filled in by small mammals."[4]

The Mesozoic was certainly a heyday for the hardy crocs. A number of extinct lineages diversified over the course of geologic time from small Middle Triassic ancestors, on through the Tertiary Period.[5] Some larger crocodilians (e.g., *Metriorhynchus*) were adapted to marine environments, equipped with flippers and downturned tails sporting shark-like caudal fins—mimicking in body outlines the great ichthyosaurs of the Late Triassic and Jurassic periods. The genus *Teleosaurus*, a 10-foot-long, Early Jurassic Mesosuchian croc with a snout resembling that of modern gavial crocs, may be more familiar to paleoenthusiasts. However, it was rather far removed in an evolutionary sense from the Eusuchians—the group that modern gators and crocs belong to, which appeared by the Late Cretaceous and Eocene (e.g., gavials).

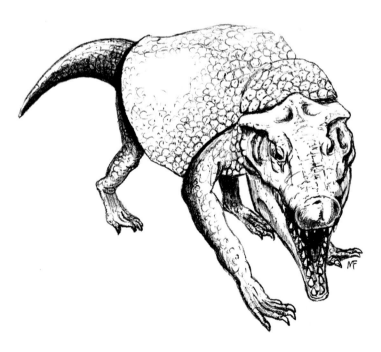

Unlike non-avian dinosaurs, crocs survived the world-sweeping mass extinction of the Late Cretaceous, 65 million years ago. As Paul Serano says, "Under the noses of the dinosaurs, crocs evolved into ferocious predators and pint-sized plant-eaters with a dual locomotor capability, best seen today in Australia's freshwater crocs. A distinctive survival

(Figure 11–4): Another unusually shaped Mesozoic crocodilian, *Armadillosuchus*, encased in armor as restored by Mike Fredericks (courtesy Mike Fredericks).

strategy had emerged that even a monstrous asteroid could not completely erase."[6] A life strategy possibly contributing to the survival of certain crocodilian genera that survived this ecological catastrophe may have been that, as in the case of modern crocs, some Mesosuchians and Eusuchians may have been able to live for months without eating. The Mesosuchians expired, however, by the Miocene. Eusuchians persisted, although they suffered global decline during the later Tertiary and Pleistocene due to climatic deterioration. Their endangerment during modernity may be attributed to pollution and encroachment by man into their natural habitat. Surely, if man were ever to disappear, an age of reptiles will dawn once more!

Be advised, fellow sculptors, that there were similar vertebrates, predating crocodilians by millions of years, dating from the Triassic Period, that resembled crocs yet were not of that lineage. These are named phytosaurs. One genus known from Europe and North America, *Rutiodon*, grew to 10 feet long and had a thin gavial-like snout equipped with sharp teeth. Phytosaurs differed significantly from crocs, however, in that the former had nostrils positioned just before the eyes, whereas nostrils in modern crocs are situated at the snout tip. Phytosaurs and Eusuchian crocs represent an exemplary case of parallel evolution.

Phytosaurs belong to a more ancient archosaurian category, formerly known as thecodonts. This is the formerly recognized clade from which, as many paleontologists suspected, dinosaurs emerged by the Late Triassic. However, thecodonts are no longer recognized as such because, in consequence of cladistics analysis, it was demonstrated that there are "no unifying diagnostic features that are uniquely shared by all members of the group."[7] But for our purposes there are many other Triassic genera, formerly lumped into the old thecodont category, allied to crocs, that sculptors may consider restoring to life with polymer clay as well.

For instance, there were heavily armored, quadrupedal, herbivorous aetosaurs such as the spiky-looking, 16-foot-long *Desmatosuchus*, anticipating the more familiar ankylosaurs of the then-long-off future, the Late Jurassic and Cretaceous periods. Or imagine the half-ton carnivorous, Early Triassic quadruped, *Erythrosuchus*. (No, we aren't showing examples of these here, but like the rest you can readily research them either online or at your library.) And there was an assortment of bipedal, bony-plated creatures such as the 13-foot-long *Ornithosuchus*, 2-foot-long *Euparkeria*, and 1-foot-long *Lagosuchus*, each of which was pegged at one time or another by paleontologists as representing the most anatomically advanced thecodontian form antecedent to the earliest dinosaurs — which also were bipedal, and pterosaurs.[8] It would seem, paleosculptors, that a kitchen oven would readily accommodate a life-sized, polymer clay *Lagosuchus*, nicknamed the "rabbit-croc" by Robert Bakker! Check out Bakker's dramatic restoration of this diminutive probable dino-ancestor, lithely leaping for a furry protomammal dinner, in his well-received *Dinosaur Heresies* volume.[9]

Modern crocs have osteoderms (bony elements embedded within the skin) and many extinct forms may have also. In sculpting fossil crocodilians and their closest extinct relatives, one will "graft" scaly skin (except in the case of the sleeker, marine *Metriorhynchus*), scutes, tubercles and even spines and armor. Scaly skin may be accomplished by deft use of the needle- and ball-tipped sculpting tools (minding the "Baggie trick"), as well as possibly stamps to be applied (dorsally) over the body surface. Depending on the scale, consider impressing window-screen mesh over parts of the unbaked polymer clay body as well. In the case of aetosaurs, refer to previous sections of this book discussing pre-baked parts,

such as sharp spines and bony nodules that will be embedded, protruding from your dino-monster's scaly hide. Instructions presented for ankylosaurs later in this chapter will analogously apply to armored aetosaurs.

Those once-ubiquitous prehistoric crocs may pleasingly accentuate a dino-diorama, as in the case of Allen's dioramas (figures 11–5 and 12–7).

Basic-Design Prosauropods

Prosauropods were precocious critters. They were among the earliest dinosaurs to evolve during the Upper Triassic, about 220 million years ago. A prosauropod bears the distinction of being the first dinosaur ever featured on a postage stamp, issued in 1958 when China commemorated the 1930 discovery of *Lufengosaurus*. From their numerous remains, excavated from a quarry at Trössingen, Germany, in 1921, *Plateosaurus* was the first dinosaur of the 20th century to become intimately understood. *Plateosaurus* was among the very first fossil vertebrates of the Secondary Period (Mesozoic Era) to be scientifically described in 1837. Nevertheless, this genus, now quite familiar to dinosaur enthusiasts, was not counted four years later in 1841 among Sir Richard Owen's initial tally of dinosaurians.

Prosauropods, dinosaurs probably ancestral to the sauropods of the Middle and Upper Jurassic, have been found on every continent (reflecting a state of low vertebrate endemism during that stage of Earth history due to continental aggregation, prior to major rifting and separation). The prosauropod general body plan is rather suggestive of miniature sauropods. *Plateosaurus, Anchisaurus, Riojasaurus, Massospondylus* and *Yunnanosaurus* all generally resembled one another in having relatively small heads affixed to elongated necks. Accordingly, their thicker torsos and long tails can be sculpted readily by referring to instructions presented in chapter 7. Our tip is, when in the initial stages of sculpting prosauropods such as *Plateosaurus*, think "mini-sauropod." Be advised, however, that there is a growing consensus supporting the notion of bipedal instead of quadrupedal prosauropods — particularly *Plateosaurus*.[10]

In the late 1940s, *Plateosaurus* became a more familiar bipedal dinosaur with the completion of Rudolf Zallinger's "Age of Reptiles" mural for Yale University, dominating the Triassic section of the mural (as underscored by a popular 1950s Marx

(Figure 11–5): A Cretaceous, South American croc splashing into a stream, as sculpted by Allen A. Debus, forming part of his 1993 sculpture, "Mating Call." The croc shown here is 9.5" long (Debus).

dinosaur toy). Since the 1970s, plateosaurs and most prosauropods have been regarded as quadrupedal (not bipedal) walkers. It is possible that plateosaurs could have foraged in the tree tops, after rearing up tripodally, resting on their tails (as shown in Zallinger's painting). Besides *Plateosaurus*, other prosauropods, such as *Lufengosaurus* and *Euskelosaurus*, may also have sometimes ambled about bipedally. To depict the current range of scientific ideas, you may wish to sculpt scenes showing at least two prosauropods, one standing upright browsing in the trees, the other strolling quadrupedally.

Although several years ago some scientists claimed prosauropods had carnivorous tendencies based on reanalysis of their teeth, they're now regarded as herbivorous. Quite possibly, prosauropods had cheeks to keep shredded vegetation from squeezing out of their mouths. Sculptors may wish to consult Gregory S. Paul's restorations of *Plateosaurus* before designing armatures.[11]

Most of the dinosaurs discussed in this book lived in the Jurassic and Cretaceous periods of the Mesozoic Era. Prosauropods, however, prospered during the Triassic. It is not our intention to imply that the Triassic Period was in any way less significant than later periods of Mesozoic time. In fact, evolutionary biologists might claim that Triassic events are worthy of even deeper concern. If only there were more deposits illuminating this great period!

Besides dinosaurs, the Triassic had luxuriant forests (one of which was destined to become the world famous Petrified Forest of Arizona) that supported thriving populations of armored aetosaurs and croc-like phytosaurs. The first true mammals comingled with the dinosaurs. While prosauropods roamed widely over an Earth whose land masses more interconnected than in the current day, winged vertebrates, such as the pterosaur, *Eudimorphodon*, and possibly even the first bird, Protoavis, soared through ancient skies.

In the wake of thecodontian extinctions, hot-blooded, bipedal dinosaurs scurried through wooded terrain. This was an age populated by an ever-increasing diversity of dinosaur species, many of which were ancestral to the later-evolving plated, armored and carnivorous forms humans delight in today. Argentinian fossils of eight- to 12-inch-long baby prosauropods, named *Mussaurus*, symbolize the vitality thriving, yet eventually extinguished, at the end of the Triassic.

As preserved through fossils dating from that time, we understand that the Triassic was a world alive with radiant splendor and evolutionary opportunity. For it was the dawn of dinosaurs, a spring-like presence that would continue for 150 *million* years! And yet it was also a prolonged time of reduced or reducing oxygen atmospheric content, a natural selection factor that may have benefited the earliest dinosaurs having superior metabolic systems.

We know (mostly) how it all turned out. Perhaps for the benefit of those who haven't yet taken a mental time-safari into the deep Triassic, you can imagine ways to capture the vigor of this younger world in your prosauropod sculptures.

Basic-Design Therizinosaurs

Tantalizingly little is known about therizinosaurs, one of our most mysterious additions to the dinosaurian ranks. Their general appearance has in the past suggested a prosauropod ancestry. Is it possible that therizinosaurs, known from Cretaceous deposits of Mongolia,

China, Kazakhstan, and North America, were descended through over a hundred million years of evolution from prosauropod ancestors? After all, both prosauropods and therizinosaurs were long-necked and herbivorous. Historically, the oddball therizinosaurs have not easily fit within the framework of traditional dinosaur family trees. They're more than a little mysterious, to say the least, but under current classification schemes therizinosaurs are theropods. But we've included them in this chapter because from a paleosculptor's perspective, they approximate the prosauropods in general body (and therefore armature) outlines.

Both prosauropods and therizinosaurs are correctly classified as saurischian (reptile-hipped) dinosaurs even though (not unlike the condition in certain derived theropods such as *Velociraptor*) therizinosaurs' wide hip bones have a rather distinctive ornithischian configuration (known as a pubic retroversion). In the case of therizinosaurs, pubic retroversion would have accommodated a wider and more massive belly, allowing vast quantities of vegetation to be digested.

Besides differences in pelvic structure, therizinosaurs are distinct from prosauropods in having a toothless beak (situated at the front of the mouth, before the teeth), four-toed feet, relatively short tails and in certain genera, such as *Therizinosaurus*, remarkably long forelimbs and three remarkably elongated clawed digits (figure 11–6). Astonishingly, in *Therizinosaurus*, the fossil claws measured up to 28 inches in length. In life, these may have been covered in horn-like sheaths (fingernails), that grew to even longer lengths. (Just imagine the size of its nail-clippers!) Depending on the scale of your sculpture, these extended claws should be individually pre-baked with segments of copper wire inside each finger. Whereas some prosauropods were fully quadrupedal, therizinosaurs were bipedal.

Previously, only the most awe-inspiring clan member, *Therizinosaurus*, was considered a theropod. Discovery of a relatively complete specimen, known as *Alxasaurus*, fortified the view that therizinosaurs may represent a natural grouping of advanced maniraptoran (so called due to their enlarged arms and hands) theropods. Yet uncertainty clouds conclusions as to whether they're an evolutionarily derived versus basal grouping. For our paleosculpting purposes, let us consider them a unique, intermediate, most likely theropodous form — herbivorous descendants from carnivorous antecedents, without addressing their phylogeny (evolutionary heritage) further.

Armatures similar to those for prosauropods will work best for therizinosaurs. The overall design will seem prosauropod-like (a strictly bipedal stance), although special attention must be devoted to those marvelously clawed fingers, the four-toed feet and the beak. A suggestion of the therizinosaur's unusual pelvic structure and the pot-bellied form will also make your sculpture readily discernible from those of prosauropods.

There are few sources featuring skeletal reconstructions of therizinoaurs, primarily because all the specimens are of a fragmentary nature. However, Brian Franczak's striking restorations of *Segnosaurus* and *Erlikosaurus*, for instance, will assist in visualizing how they should (or could) be sculpted.[12]

Therizinosaurs probably had cheeks. Superficially, their heads bore a general resemblance to those of prosauropods. Therizinosaurs were probably ponderous and slow-footed, so avoid swift running poses. It has been suggested that therizinosaurs may have had webbed feet, equipped for a semi-amphibious, fish-eating existence. (Alternatively, according to another claim, they may have been voracious ant-eaters.) Others claim that behaviorally,

therizinosaurs were "giant sloth-like."[13] These are speculative ideas that may spark intriguing, if not outlandish, sculptural designs.

Alternatively, imagine a confrontation between the Mongolian tyrannosaur, *Tarbosaurus*, and the "Freddy Krueger fingered" *Therizinosaurus*. What's *that* all about? (*You* "tell" us.) Dare to blend what is known about other Mongolian dinosaur genera with speculation concerning the natural history of those rare and mysterious therizinosaurs. Someday, you may be startled to find that *your* interpretations were correct!

Finally, the extraordinary Chinese therizinosaur, *Beipiasosaurus*, was a "hairy" guy with a seven-foot-long body. *Beipiasosaurus* had two kinds of fossilized feather impressions. As preserved today, these are

(Figure 11–6): The Mongolian *Therizinosaurus*, now considered by many paleontologists to be a theropod dinosaur. Bob Morales' sculpture was made in 1993. Today paleontologists might consider that its tail should be ⅓ shorter. Note the support frame structured into the dinosaur's armature, upon which it stands to facilitate the sculpting process (Morales).

downy, fiber-like feathers covering the body and tail; the tail feathers were up to seven centimeters long. *Beipiasosaurus'* second variant of stiff feathers, known as "elongated broad filamentous feathers," consisted of unbranched filamentous fibers that were up to six inches long. These filamentous feathers were intermixed within the downy layer. So now, the latest paleoart trend is that paleoartists are more generally restoring other therizinosaurs too, such as the 20-foot-long *Nothrorhynchus*, with furry swatches of feathers covering the body (despite lack of fossil evidence for this latter genus). For further tips on how to sculpt feathers on prehistoric animals using polymer clay, see chapter 13.

Basic-Design Hypsilophodonts

Hypsilophodonts were generally lightly-framed, cursorial (running), herbivorous (ornithopod) critters. Years ago, scientists used fossil evidence as a basis for restoring one genus, *Hypsilophodon*, as a tree dweller. There was even a suggestion that arboreal dinosaurs, thought to be ancestral to the *Hypsilophodon*, represented an evolutionary link between birds and dinosaurs. Therefore, weren't some hypsilophodonts, which were "bird-hipped" ornithischians, accustomed to living in trees? Well, ummm.

One of the best representations of *Hypsilophodon* as an arboreal creature was sculpted

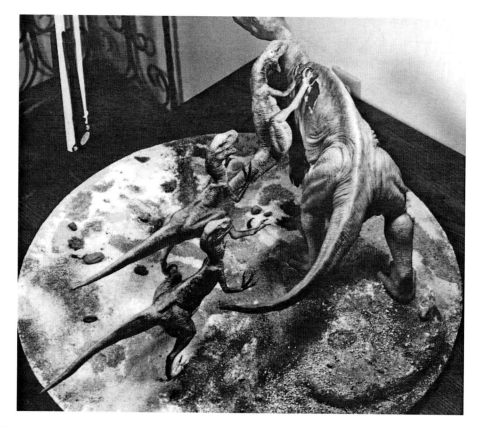

(Figure-11–7): Raptors attack *Tenontosaurus* in this 1992 diorama made by Bob Morales (Morales).

by Vernon Edwards in 1936. Since the early 1970s hypsilophodonts have instead come to be regarded as fast-running bipeds. Most theropod predators would have quickly tired, giving chase to these Mesozoic "gazelles."

Lately, however, paleontologists have also considered certain hypsilophodonts as *fossorial* or digging creatures. For the Middle Cretaceous genus *Oryctodromeus* was discovered within the "expanded distal chamber" of a sediment-filled "terminal burrow"; adult and juvenile specimens were associated within the burrow.[14] So it is quite likely that some hypsilophodonts like *Oryctodromeus* were burrowers, responsibly raising their young like modern prairie dogs do inside such underground dwellings, or dens. This prompts wonder as to whether these critters survived the K/T boundary extinction, at least for a while into the early Paleocene, hunkered down within their protective confines. Did they survive only to become fodder for the giant Eocene bird, *Diatryma*, several million years later?

Besides *Hypsilophodon*, there are several well-known hypsilophodonts, such as the North American genus, *Orodromeus* and the large 21-foot-long genus, *Tenontosaurus*. *Orodromeus* is known to have laid clutches of eggs in nests. *Tenontosaurus* may have been victimized by wolfish packs of early Cretaceous raptors, *Deinonychus*[15] (figure 11–7). Seize these two fantastic themes for sculpture!

A skeletal reconstruction of the *Hypsilophodon* by Gregory S. Paul may be examined in *The Dinosauria*. A reliable reconstruction of the *Tenontosaurus* was also published.[16] Wire

armatures and body filler (sectioned Styrofoam or crumpled wads of aluminum foil) should conform to the body plans suggested by available skeletal reconstructions.

It is proper to restore hypsilophodonts in running poses. Anchor only one foot into your model base. Suspend the other ankle poised over the ground in swift running form. (Use techniques for constructing armatures as suggested in chapter 5.) Always refer to your skeletal diagram for correct limb posture.

Hypsilophodonts were beaked animals, and they also probably had cheeks. Their tails, long counterbalancing rods, were reinforced by tendons, so don't sculpt their tails as if they were loosely dangling on the ground. The tail end of your vertebral wire should be suspended above the ground, and should not be overly curved, swooshing through the air in great loops. When the muscles have been suitably suggested or even to some extent fleshed out in polymer clay, graft on a scaly-looking skin texture using techniques described in previous chapters.

Often underrated as nonspectacular dinosaurs (because they were not ferocious, large or spiky-looking), hypsilophodonts are actually among the most intriguing of dinosaurs.[17] Of all the dinosaurs known to man, hypsilophodonts would have probably made the best pets.

Basic-Design Pachycephalosaurs

Pachycephalosaurs, "domeheaded" dinosaurs, are usually restored as a pair of males butting their thickly skulled heads together. Surely, their social lives also consisted of more meaningful activities. One wonders, were pachycephalosaur females truly impressed by such displays? Sixty-five million years before the invention of football (and aspirin!), the pachycephalosaurs apparently lived life on the edge.

Herbivorous, ornithischian domeheads, known principally from Cretaceous deposits in Canada, China and the western U.S., may be most closely related to the ceratopsian clan — the horned dinosaur lineage. The genus most frequently restored on canvas is *Pachycephalosaurus*. However, domeheads are infrequently sculpted. They were bipedal with relatively wide abdominal areas. Although no complete specimens are known, Gregory S. Paul has published a good pair of skeletal reconstructions of the genus, *Homocephale*.[18] Fortunately for us sculptors, Paul has depicted both side and dorsal views.

Naturally, one might expect that the most durable, and hence preservable, feature of pachycephalosaurs would be the thick, bony skulls. In fact, most domeheaded species are known on the basis of cranial material. The tails were rigidly reinforced by a network of tendons fused to bone (called ossified tendons).

If you sculpt domeheads, no one will question your originality! Use sculpting techniques outlined in previous chapters for constructing and fleshing out armatures. Because relatively little is known about their natural history and paleoecology, it won't take long to research domeheads. The skin texture may have resembled that of the possibly related ceratopsians described in chapter 9.

Here's a genuine opportunity to be creative!

Advanced-Design Armored Dinosaurs

Sculpting armored dinosaurs can consume as much time as it takes to do stegosaurs, possibly more. This is because so many details must be added to accentuate dermal spines,

ossicles and armored hide. Each kind of armored dinosaur may be distinguishable on the basis of its armor. However, with exceptions for *Pinacosaurus, Euoplocephalus, Ankylosaurus, Edmontonia* and *Sauropelta*, there are few skeletal reconstructions available in the literature that can be considered reliable.

Excellent restorations of the *Sauropelta* were published in Kenneth Carpenter's article "Skeletal reconstruction and life restoration of *Sauropelta* (Ankylosauridae: Nodosauridae) from the late Cretaceous of North America," and Gregory S. Paul's contribution to the spring issue of *The Dinosaur Report* concerning "Fat, really fat ankylosaurs."[19] These artistic paleontologists, respectively, included skeletal reconstructions viewed laterally (as seen from the side) and dorsally (as seen from above). Carpenter added three perspectives showing Sauropelta in the flesh (with body armor). Because of Carpenter's and Paul's thorough narrative and visual descriptions, *Sauropelta* becomes an excellent candidate for sculpture.

Through the years, Bob and Allen have restored several armored dinosaurs, including *Saichania, Hylaeosaurus, Edmontonia, Euoplocephalus*, and *Polacanthus*. Instinctively, one is tempted to pose these Mesozoic "armadillos" in mortal combat with attacking carnivores. Sculptures involving theropod-armored dinosaur confrontations certainly do stir the imagination (figure 11–8). However, before you create trickier designs staging combatants sparring at close quarters, try sculpting an individual armored dinosaur first as a test. This will help you acquire familiarity with the necessary details and their distinctive anatomical proportions. Your second effort will be noticeably improved, and that is the one to be showcased in a more spectacular scene.

Proportionally, armored dinosaurs were wide-bodied creatures (some of them really, really wide, as Paul remarks!). The legs and arms may have been upright, as opposed to sprawling. Armored dinosaurs may have scampered swiftly through wooded areas, their tails held aloft. (In older restorations, armored dinosaurs are depicted as sluggish, lumbering brutes with tails usually resting on the ground.) Armored forms known as ankylosaurs possessed bony clubs at the ends of their tails, which were distinctively featured. Other armored forms, collectively referred to as nodosaurs, lacked "war clubs."

The heads and eye sockets of armored dinosaurs were solidly protected by bone. There is little doubt what such adaptations may have been selected for: passive protection and defense.

Sculpting armored dinosaurs requires patience and skill. Armatures should be quadrupedal, and relatively broad at the hips. Nodo-

(Figure 11–8): The Mongolian armored genus *Saichania*, attacked by two vicious *Tarbosaurus*, showing a dorsal view of body armor detail. Full model length is 21". Sculpture by Allen A. Debus, 1991 (Debus).

Left: (Figure 11–9: Here, Bill Gudmundson's "Ankylosaurus mutatus" armature has been covered in appropriate places with crumpled aluminum foil. For a look at the preceding armature stage, see figure 4–3 (courtesy Bill Gudmundson). *Right:* (Figure 11–10): Apoxie Sculpt clay compound now covers the aluminum foil on the armature (courtesy Bill Gudmundson) *Below:* (Figure 11–11): Here Bill has added more definition to his sculpt by sculpting armor. For the final result, see figure 11–16 (courtesy Bill Gudmundson).

saurs had backbones that arched upward rather prominently toward the hips. As in stegosaurs and horned dinosaurs, their hind legs exceeded the front limbs in length. To conform with modern views, bend wire limbs of the armature into upright (as opposed to flexed), squat-looking angles. Place aluminum foil (or Styrofoam) in the body cavity as described in previous chapters. (However, for further options, see figures 11–9 through 11–11.) Suspend the end of the tail in the air above the model base. After fleshing out the basic body shape, legs and arms using polymer clay, begin working on finishing details. Start with those sideways-projecting dermal spines.

The lengths of each bony spine and osteoderm, their shape and pattern of distribution over the body, should resemble that of the genus you are sculpting as closely as possible. Examine photographs showing the fossilized armor before you become carried away with some wild and carefree spiky look. Try to be accurate as you add spines, while realizing that for some designs you must improvise due to lack of fossil evidence.

Bony spines may be either pre-baked and pushed into the softer unbaked body, or added in an unbaked condition. (However, we do recommend the pre-baked approach.) Contour these, but don't make them too cylindrical, too long, or overly thick, which is a common tendency. For longer spines, it may help structurally to roll strips of polymer clay around a short length of wire, but don't completely cover one end of the wire. Then, gently insert the uncovered wire tip into the (unbaked) body, which will anchor it into the body securely.

Relying on the Baggie Trick, poke tiny indentations around the surface with a ball-tipped sculpting tool where each spine joins the body. This will create the impression that those spines really grew from your dinosaur's body. Or you may stamp impressions of scales on your ankylosaur (figure 11–12).

Striate the bony armor along the back and tail according to the mosaic pattern of bony and plated areas preserved in fossils. Add small bumps and lumps of polymer clay that will appear as bony knobs (known as ossicles) after smoothing the edges with the ball-tipped sculpting tool.

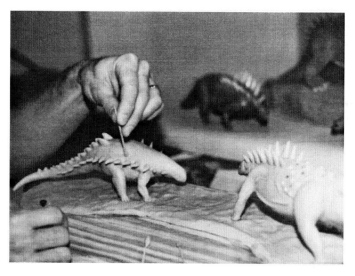

(Figure 11–12): Stamping impressions over the table-top back of an unbaked nodosaur is not too difficult after you have created your stamp. The end of the stamp shown here was fashioned into an appropriate shape decided upon by the sculptor. This polymer-clay piece was affixed to the end of a toothpick and baked in an oven at 250° F for 10 minutes. Then, the outer edge was sharpened against a sheet of finely graded sand paper. Before use, the polymer clay shape was epoxied to a toothpick. Cavities within the hollowed core of such stamps may have to be repeatedly cleaned during use with a fine sculpting or dental tool. Notice the dress-pin heads adorning the *Polacanthus* (at right), another ready means for creating a bumpy, nodular skin surface. While stamping may be done, the authors generally prefer use of the texturing cup technique for creating skin detail (Debus).

Alternately, the heads of nails or dress pins embedded into the back (with the needle end pressed into the body) and extending along the tail may also be used to create a surface that appears nodular, armored and spectacularly spiky. You'll need to shorten those pins, however. You can also add dried thorns from a rose bush into your armored dinosaur's hide for added realism.

Examine photographs of the fossilized war clubs carefully before you begin sculpting the tail ends of ankylosaurs. Armored dinosaurs didn't carry bowling-ball-like objects on their tail tips.

Finally, add a pattern of ossicles made from polymer clay on the head and situated around the eyes. A horny-looking beak will be the final touch on your Mesozoic "tank." Follow our advice, practice and you'll both be smiling!

Basic-Design Plesiosaurs

Over a century before Godzilla and Ray Harryhausen's prehistoric monsters of Hollywood menaced humans on the silver screen, plesiosaurs captivated human fancy with their hideous form. In fact, the earliest science fantasy tales, *Paris Before Man* (1861) and *Journey to the Center of the Earth* (1864), written by Frenchmen Pierre Boitard and Jules Verne, respectively, popularized the savage, nightmarish image of these sharp-fanged antediluvians.

Plesiosaurs were aquatic, flipper-powered creatures. The term *plesiosaurs* refers to both short-necked pliosaurs (such as *Kronosaurus*) and long-necked genera (such as *Elasmosaurus*). If one were to thread a snake through the body of a turtle, the strange result would vaguely resemble the body of a plesiosaur.

No one sculpted more life-sized plesiosaurs than Benjamin Waterhouse Hawkins. Hawkins' exhibit at Sydenham, England, features three species of snake-necked plesiosaurs

(Figure 11–13): An unbaked plesiosaur (left) and a mosasaur in the making, forming one section of Allen A. Debus' "Hawkins' Palaeozoic Museum" sculpture (1995). Note the exposed wire mesh on the right hind flipper of the plesiosaur (*Elasmosaurus*). The mosasaur will be immersed in polyester resin "water." (See chapter 16 for further details on creating the effect of water.) The finally sculpted reptiles may be seen at right in the lower image of figure 16–10 (Debus).

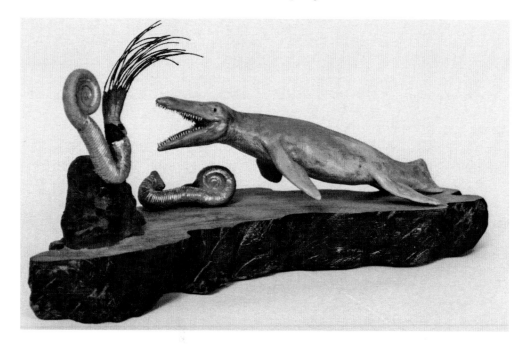

Top: (Figure 11–14): The Australian short-necked plesiosaur (a "pliosaur") *Kronosaurus*, was one of the Cretaceous high seas' most awesome predators. Like other Mesozoic aquatic reptiles, it may have dined voraciously on invertebrates, such as the (fictitiously designed) ammonoid shown here in Allen Debus' 1994 sculpture. The supporting rod for the *Kronosaurus* was drilled into the wooden base extending from the tail. The tentacles of the ammonoid were made from copper wire, painted red, onto which a thin veneer of 5-Minute Epoxy was applied to create a thickened, slimy look. The sculpture is 1/40 scale (Debus). *Bottom:* (Figure 11–15): A Cretaceous aquatic reptile, *Mosasaurus*, sculpted into a base designed like rolling sea waves. Exhibited at the University of Wyoming Natural History Museum, Laramie (A. Debus).

lurking through a marshy setting. During the late 1860s, Hawkins also had planned to sculpt an elasmosaur for the Palaeozoic Museum in Central Park, New York, a short-lived project that was never completed.

Fortunately, so many plesiosaur skeletons have been discovered that there is little doubt concerning their life appearance. You can confidently sculpt plesiosaurs by relying on photographs of reconstructed skeletons published in paleontology books.[20] Photographs of plesiosaur skeletons showing both dorsal and lateral views will provide three-dimensional proportions for accuracy in scaling.

(Figure 11–16): Chicago sculptor Bill Gudmundson's very nicely sculpted "Ankylosaurus mutatus" (2008). This 12"-long figure was sculpted not using polymer clay that would bake in an oven, but instead Apoxie Sculpt, a two-part compound that hardens in air within 3 to 4 hours. Gudmundson prefers using fast-hardening material because, he says, "I like working on small areas that will solidify so that I don't mess them up when I'm doing another part of the piece." Photographs showing in-progress stages in the creation of this model are shown in chapter 4. As you may suspect, the "Ankylosaurus mutatus" is a fictional beast, suggesting that the techniques outlined in this book may be applied to fictional dino-monsters, dragons and movieland monsters as well (courtesy Bill Gudmundson).

You must decide whether to sculpt your plesiosaur underwater, rowing through the waves or resting on land. A dry-land pose will be easiest because you will only need to suggest the presence of a sandy beach. Underwater poses are relatively easy to do, because you will merely be tempting the viewer to imagine the presence of water without actually having to do the impossible, sculpt water itself. Because as of 2011, paleontologists found fossil evidence of an embryonic plesiosaur within an adult, presumably female, specimen, it is now inferred that plesiosaurs gave birth to live young; so, contrasting with past paleoimagery, they may have rarely (if ever) mounted the shoreline.

If your plesiosaur will be half submerged, you need only sculpt the neck, part of the back and exposed portions of the flippers. The surrounding wooden or polymer clay base may be painted using blue shades to create a shimmering image. Testors solvent-based paints streaked with oil paints can cast a turbulent impression. Crescent shaped ripples, made from baked polymer clay, that are bonded to a wooden base before painting with fine, brush-stroke quantities of 5-Minute Epoxy, will accentuate the watery effect.

One of the pleasurable aspects to sculpting long-necked plesiosaurs is that those serpent-like necks can be oriented in almost any desired position. For instance, try coiling the necks of two grappling plesiosaurs around one another by twisting one armature wire into a spiral shape. Then, simply sculpt a second neck spiraling in the opposite direction.

The main armature wire, or vertebral rod, may lead from the neck, extending through neck and body, and emerge through a flipper on the tail into wooden support. Flippers may be made by twisting coat-hanger wire around the vertebral rod at shoulder and hip regions. Bend these into the shape of limbs where they shall emerge from the body and cover them with wire mesh cut into the shapes of "paddles" that can be covered with polymer clay (figure 11–13).

If your plesiosaur design involves underwater swimming, the end of the long armature wire may protrude through the end of the tail into the model base, or laterally through the end of a hind flipper into a "rock" made of wood, later covered with polymer clay, that has been screwed into the base. Wherever possible, try to disguise the presence of the supporting wire by joining the point where the armature wire emerges with some feature on your model base. Use sufficient quantities of body filler (Styrofoam and/or crumpled wads of aluminum foil) for these full-body "underwater" swimming poses (figure 11–14). Otherwise, your armature may sag under the weight of polymer clay that is applied.

After baking, the exposed wire end protruding from flipper or tail may be bonded into the wooden base by applying 5-Minute Epoxy to the exposed wire end. Insert this epoxy-coated wire into the drilled hole, allow the epoxy to bond to the wood (while supported in place by small blocks of wood or chunks of unbaked polymer clay), and shortly your plesiosaur will be firmly immobilized.

The teeth of long-necked plesiosaurs will be smaller and fewer in number than those of the short-necked pliosaurs, but they may be longer and more jagged-looking. Techniques described in chapters 5 and 6 may be followed to fill your plesiosaur's toothy jaws.

The skin texture of plesiosaurs can be sleek-looking, possibly with some flesh rolls added in appropriate places, such as where flippered limbs contact the body. In pliosaur genera, a possibility exists that a fluke grew along and above the tail vertebrae. Add a barnacle or two to the plesiosaur skin.

There were many other kinds of Mesozoic marine reptiles such as ichthyosaurs and mosasaurs (figure 11–15), for which sculpting techniques are not elaborated here, but may be sculpted by applying our techniques and philosophy. We have selected a short-necked plesiosaur, *Liopleurodon*, for which detailed, advanced sculpting considerations are outlined in chapter 15, "Putting It All Together, A to Z," which you may care to skip to next. And in chapter 18, Bob guides readers through the painting process of his 1/20-scale mosasaur: *Tylosaurus* (figure 11–16).

12

Sailing On to Distinctive Projects: Finbacks and Winged Reptiles

As you've already seen, this dinosaur-sculpting book takes readers beyond the dinosaurian clan, instructing how to sculpt other kinds of prehistoric animals — that is, besides dinosaurs. Therefore it's more logistical and appropriate, rather than following a strict clado-inspired, categorical phylogeny of species, for savvy sculptors to lump together different kinds of creatures, all of which can be created using highly analogous sculpting techniques, even if their genetic constitutions would seem to a paleontologist widely disparate. Accordingly, for this chapter, a commonality of method or theme will be how to rely on an old wire-mesh window screen to facilitate sculptural renderings of distinctive Paleozoic and Mesozoic beasts. And here we'll also outline how to sculpt not one but two distinctive kinds of spinosaurs.

Okay — you've got all the basics down by now, so let's try something new, different and interesting. Almost needless to say, by this stage, we're clearly delving into techniques that might seem advanced to beginners.

But don't be fearful.

Finbacked Reptiles

Let us now help you "sail" through sculptures of finbacked reptiles, long favorites of prehistoric lore, such as the carnivorous Permian *Dimetrodon*, a pelycosaur that is often mistakenly regarded as a dinosaur (figure 12–1). One way to make the webbing sufficiently sturdy is by using wire mesh (such as from a discarded window screen, cut so as to approximate the sail shape) for forming the pelycosaurian "sail." Sails shown on Allen's *Dimetrodon* and *Edaphosaurus* (figure 12–2) have such an underlying double layer of wire mesh support.

If you're planning a simple one-of-a-kind piece, attached permanently to the base, then you may drill several pieces of coat-hanger wire into your wooden base in order to structurally support the sail. This wire should be sandwiched or enveloped between two sections of wire mesh screen (figure 12–3). Slightly bend the coat-hanger wires such that their curvature roughly matches the outer "ribbing" on the contoured sail shape. Staple the two wire-mesh sections together surrounding the wire rods; flatten the ends of the staples using pliers. (Smaller designs will need less structural support for the sail.) Having wire mesh screen inside your sculpture will minimize tendencies for breakage of the delicate sail

Top: (Figure 12–1): Bob Morales' 12"-long, Super Sculpey *Dimetrodon* became a popular Lunar Models resin kit creation during the mid–1990s, after molding this prototype (Morales). *Bottom:* (Figure 12–2): Allen A. Debus' one-of-a-kind, Permian fin-back reptile, *Edaphosaurus* (1994). With a little patience and skill, impressively adorned spined lizards can be created in your own home. This 14"-long model sports a wire mesh sail concealed under a layer of polymer clay. Those crossbars adorning the sail were fashioned from clipped toothpick ends, embedded into the sail (Debus).

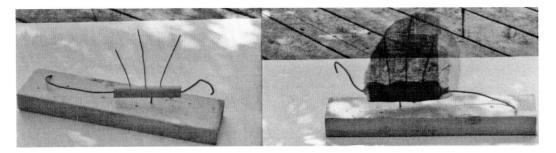

(Figure 12–3): Two early stages in the sculpting of a 12"-long **Dimetrodon**. A simple armature (*left*) subsequently incorporates wire mesh into the sail (*right*). Two strips of cut and contoured wire mesh are stapled together over three sturdy rods supporting the sail. Sail details including curved ribbing are sculpted at appropriate intervals over this assembly (Debus).

later on, such as when your pelycosaur is cooling (after baking in the oven). Ribbing on the sails can be sculpted over the screen, in turn, after this screen has been covered with a thin layer of polymer clay. Have your scale drawing handy to refer to, indicating proper positioning and contouring of each individual sail rib. One disadvantage of using this technique is that your sail may appear proportionally too thick, unless the model is at least 12 inches long. Another is that unless the animal with sail attached is free-standing (i.e., not mechanically bonded into the wooden base), it will not be possible to mold and cast later on. (Molding of Allen's free-standing *Dimetrodon* with wire-mesh sail support, as a single-piece sculpture, will be discussed in a chapter 17.)

Alternatively, follow Bob's steps for making sails that are thinner in appearance for smaller-scale models, as indicated in accompanying figures. These sculptures are also free-standing (i.e., armature not bonded to a wooden base), so they'll readily conform to molding eventually (figures 12–4 and 12–5).

First, sketch your sail to exact proportions, including sail ribbing, directly on the baked sheet of polymer clay. Then roll a lump of polymer clay into a ball shape. Flatten the ball somewhat by squeezing it with your fingers. Next, flatten it to piecrust thickness using the rolling pin. (And for safety, don't reuse this rolling pin or the board you were flattening the polymer clay on for food processing afterward unless you wash it thoroughly with detergent.)

Bake this flattened polymer clay sheet, but be careful not to use too high a temperature, in order to avoid warping the thin sheet of polymer clay. (Remember, no internal reinforcing support such as wire mesh has been added in this design.) After this has cooled, carefully place the sheet on a level surface. Then determine the height of the sail using the pelycosaur's body as a guide for proper sizing. Referring to your original design sketch, draw the shape of the sail directly on the baked sheet, including the vertebral spines and slight dips along the sail's upper margin in between each spine.

Place the sheet back in the oven on the aluminum foil and cookie pan once again and soften the sheet at 200° F for 10 minutes. Immediately after removing the sheet from the oven, for structural support, place it on a flat, wide piece of wood. Carefully cut out the shape, drawn on the polymer clay using an X-Acto knife. Be careful — kids, get your parent's assistance.

Now that the sail shape has been outlined from polymer clay (minus the ribbing),

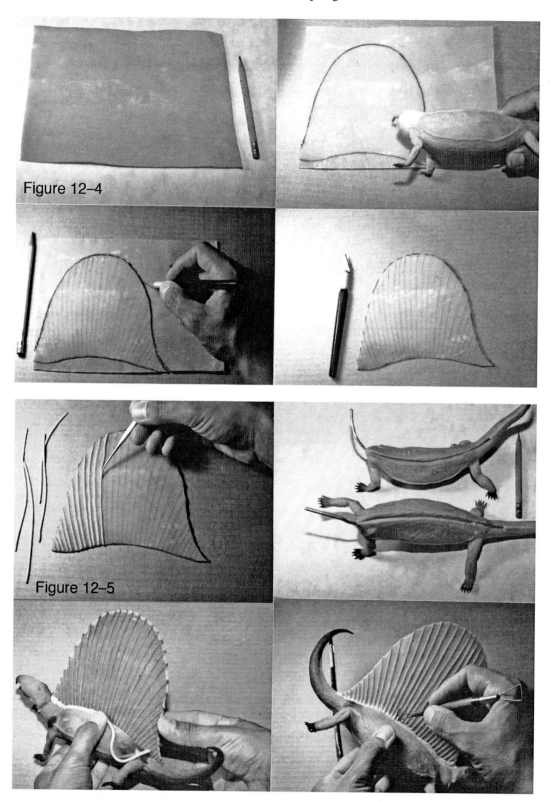

Figure 12–4

Figure 12–5

hold the sail gently against a sunlit window and lightly trace the vertebral spines on the opposite side of the sail, using a pencil. This will make both sides of the sail perfectly aligned for sculpting spines. Sail spines are created by rolling thin ropes of polymer clay and then adhering them to the sail, as demonstrated in the accompanying figure. Press a piece of soft polymer clay onto the surface of the sail first, in order to saturate the surface with the oils, which make it a bit tacky. This will help unbaked, bony sail ribbing stick to the partially baked polymer clay sail membrane. *Hereafter, only prepare one side of the sail at a time,* then bake the completed sail (including ribbing).

Given that your pelycosaur armature has already been constructed, with an as-yet-unbaked polymer clay body sculpted according to previous instructions, cut a groove into the dorsal spinal region of your animal that conforms to the shape of your sail where it will be joined to the spinal body area. The completed sail can now be glued into the groove (see accompanying figures) with Super Glue (after the rest of your *Dimetrodon* has also been baked). But if you are planning to mold and cast your creation as a multi-piece model kit, *do not bond the sail to the body using adhesive.* After the glue is dry, fill in the gaps at the sail base with more polymer clay. Bake one final time according to manufacturer's instructions.[1]

There are many intriguing theories for why finback reptiles had sails, and varied opinions concerning the appearance of the sails. We prefer the idea that their sails aided control of pelycosaurs' body temperatures. Those impressive sails may have also functioned in ways that we can scarcely imagine today, as visual displays during mating rituals.

Dimetrodon has the distinction of being the first fossil reptile for which the limb muscles were restored three-dimensionally. This restoration was prepared by Otto Falkenbach in 1922, under the direction of William K. Gregory. From studies such as these, coupled with the eventual discovery of pelycosaur footprints, it is generally thought that pelycosaurs moved with a sprawling gait. So, study the limb posture of crocodiles and alligators before sculpting pelycosaur legs. Don't get too close to live gators, though! (See figure 12–6.)

Dimetrodon's teeth can be made using techniques described previously (even though their lengths and shape and distribution in the jaws differed from the case in theropods).

Opposite top: (Figure 12–4): As opposed to using wire mesh, this technique may be best used for making sails, particularly if the animal in question, as sculpted, will be less than about one foot in length. *Upper left:* Using a rolling pin, a sheet of polymer clay is flattened to approximately the thickness of a slice of cheese, then baked on a sheet of aluminum foil. *Upper right:* Using the diameter of the *Dimetrodon's* torso as a guide, the height of the sail can be determined. In this case, for example, the sail is approximately three times the height of the *Dimetrodon's* torso. *Lower left:* An X-Acto knife is used to cut out the sail from the sheet of polymer clay. Remember to cut out slight dips between the upper margin of each spine, as shown. *Lower right:* A cut sail! A groove is cut along the spine on the *Dimetrodon's* torso for fitting the sail into along the backbone. Now the sail can be inserted into this groove on the reptile's back to check for sizing and positioning (Morales).

Opposite bottom: (Figure 12–5): *Upper left:* After rolling thin strips of polymer clay, at different lengths, each spine or rib on the sail is created by sculpting the strips onto the surface, as shown. Note the dental tool used, ideal for this purpose. *Upper right:* Notice the groove along *Dimetrodon's* spine where the sail will be placed, when the sail is complete. *Lower left:* The completed and baked sail is first Super-Glued into the groove on the figure's back, and the gap between the back and tail is filled in with a rope of polymer clay. *Lower right:* Using the type of tool indicated, the rope of polymer clay is shaped to blend the body and sail together. Support the *Dimetrodon* on its side, laying the sail flat on a clean cloth surface. Remember, using this technique, the polymer clay sail has no internal support, so handle it gently! (Morales).

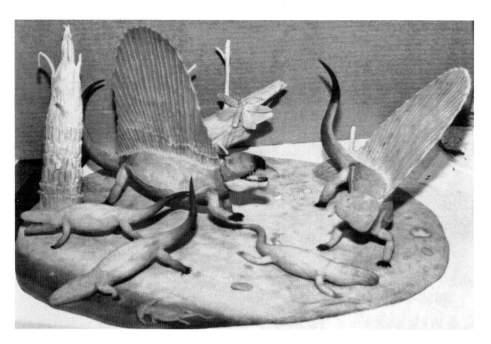

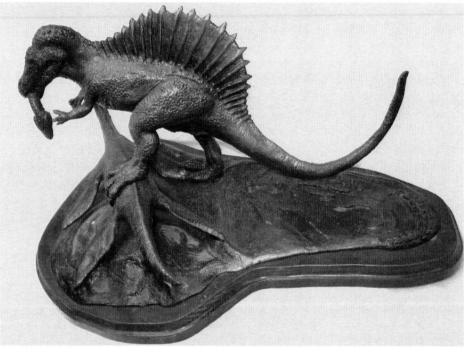

Top: (Figure 12–6): The completed sculpture resulting from Bob Morales's meticulous sail-management techniques, as sculpted in 1995. See figures 12–4 and 12–5 showing how the *Dimetrodon's* sails were made. This 14" by 17" diorama also includes three Permian amphibians (*Eryops*), one giant dragonfly and a dead tree trunk. Footprints litter the polymer-clay base (Morales). *Bottom:* (Figure 12–7): The prototype of Allen A. Debus' *Spinosaurus*, captured here in this 1996 sculpture titled "Spinosaur's Big Fish," was designed with a wire mesh internal sail support. This 14"-long diorama was sold as a Hell Creek Creations resin model kit. Note the croc swimming in the swampy water toward the spoils of war. This particular mounted resin casting is painted in faux-bronze, a technique described in chapter 16 (Debus).

Edaphosaurus, however, was herbivorous, with a deeper, more expanded abdominal area, and is usually depicted with a closed mouth, teeth not visible. As shown in the accompanying figure, *Edaphosaurus* had short, bony transverse crossbars situated horizontally across its prominent, vertically oriented neural spines. Assume that pelycosaurs had a scaly, reptilian skin texture.

Skull and skeletal morphology betrays pelycosaurs as distant forerunners to a vibrant lineage of (sail-less) paleomammals known as therapsids, which triumphed during the Late Permian and Triassic. Pelycosaurs were themselves quite abundant during the Late Permian, with several sail-less varieties known to science as well. Most paleontologists agree that, overall, pelycosaurian finbacks had a reptilian physiology similar to that of modern crocodiles.

Spinosaurs and Other Sail-equipped Dinosaurs

While *Dimetrodon* and *Edaphosaurus* sported quite prominent sails, that is with respect to their overall body lengths, certain favored Cretaceous dinosaurs known as spinosaurs grew much taller sails comprised of dorsal neural spines up to five feet long, although proportionally smaller relative to their bodies than in pelycosaurs. Other dinosaurs had sails as well, but none were as tall or impressive as those in the 40-foot-long African genus *Spinosaurus*, a theropod featured as *Tyrannosaurus'* anachronistic foe in *Jurassic Park III* (2001).

In designing *Spinosaurus* armatures, the sculptor must decide early on which technique will be used in crafting the

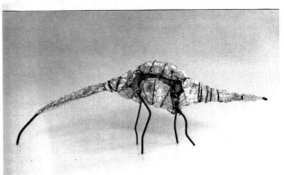
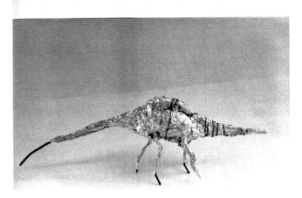

(Figure 12–8): A sequence of photographs outlining how a quadrupedal, humped *Spinosaurus* (per paleontologist Jack Bowman Bailey's 1997 theory) can be sculpted from scratch. *Top:* A wire armature matching the design elements and parameters is first fashioned from coat-hanger wire. Polymer clay is placed along the joints, where limbs meet the vertebral wire (which is wrapped securely around the backbone). Then this assembly is baked, locking the joints firmly into place. *Middle:* An aluminum foil jacket is placed within the abdominal area as well as along the neck and tail. Thin copper wire is wrapped about the foil to hold it into place. *Bottom:* More wads of aluminum foil are placed laterally within the abdominal areas to bulk up the body, and these are also held in place with thin copper wire (Debus).

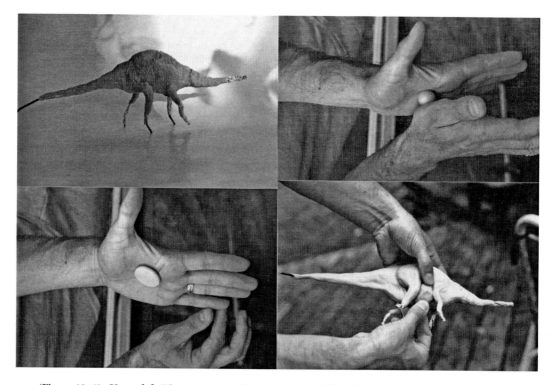

(Figure 12–9): *Upper left:* The armature with its aluminum foil jacket is covered with a thin layering of polymer clay that has been striated using a sharp sculpting tool so that exterior layers will adhere more tightly to the internal core. Then this assembly is baked according to manufacturer's instructions for 10 minutes and allowed to cool before further handling. *Upper right* and *lower left:* Your hands are the most important sculpting tool. *Lower right:* Squashed balls of polymer clay, warmed and softened by body heat, are applied to the sides of the abdomen so the animal won't appear emaciated (Debus).

prominent sail. Either of the techniques described for the pelycosaurs, above, will work for spinosaurs built in the 1/40-scale range.

Spinosaurus was formerly speculated to have had an overall facial configuration or countenance mimicking that of North American tyrannosaurs. However, by the late 1990s, following consideration of the evolutionarily related British *Baryonyx*, and *Suchomimus* from Niger (both of which bore shorter sails and were considered *piscivorous*—fish eating), a longer, sleeker and narrower, almost crocodilian skull morphology approximating that of these two genera (for which skull elements were known) became conventionalized for *Spinosaurus* instead.[2] *Baryonyx* (figure 6–12) was nicknamed "Big Claw," a moniker earned for the elongated, one-foot-long, curved talon brandished on its thumb. This claw may have facilitated fishing ventures, much like grizzly bears' claws help them to seize salmon. *Spinosaurus* also had an enlarged claw on the first digit (figure 12–7).

Alternatively, in 1997 Jack Bowman Bailey proposed that *Spinosaurus'* elongated neural spines supported a massive hump rather than a sail.[3] Accordingly, sculptural restorations of both hump- and fin-backed spinosaurs have been made, although the humpbacked varieties are considerably rarer.[4] So if you're intending to sculpt *Spinosaurus* with a fleshy hump rather than a sporty-looking sail, the set of accompanying figures will facilitate matters (figures 12–8 through 12–10). As you can see, armature-building and sculpting steps are

rather straightforward, with exception that instead of a window screen you may instead rely on crumpled-up aluminum foil strip, wadded to sufficient proportions for creating an enlarged hump region.

While fascination with Bailey's humpback suggestion has faded from mainstream, other dinosaurs besides spinosaurs are also thought to have sported either sails or heightened bony ridges situated along the spine. One such genus was the Egyptian iguanodont, *Ouranosaurus*, shown in figure 10–4 (which Bailey also considered to have been a humpback). The North American, Early Cretaceous allosaurid *Acrocanthosaurus*, also bearing tall neural spines yet not as tall as in *Spinosaurus*, has recently been restored with a bony-looking ridge protruding above the abdominal area. In earlier life depictions, *Acrocanthosaurus'* exaggerated spinal feature appeared either as a short sail or a "thick fleshy ridge"[5] (figure 12–11). *Megalosaurus*, the first carnivorous dinosaur to be formally described, has even been restored with both a dubious spiny sail and a humplike feature.[6] Finally, rearward-curving cervical (neck) spines on the elongated neck and extending along the backbone of the South American sauropod *Amargasaurus* have been interpreted as sail-supporting.

Structures such as bony ridges and full-fledged sails on these additional dinosaurian genera may be realistically accomplished using our window-screen sculpting strategy.[7] Because these anatomical features are lower and less prominent than in

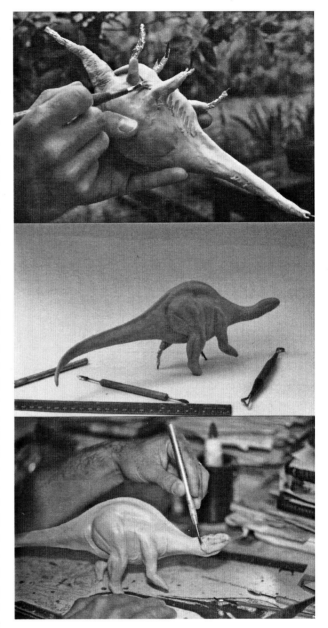

(Figure 12–10): Getting there! *Top:* Bulking out the body's underside. *Middle:* Notice how the hump is building up. *Bottom:* Fine details of the head and hands are typically the last to be sculpted. A photograph of the final humped, 14"-long *Spinosaurus* sculpture (1998) situated in a small diorama (not shown here) may be seen in Donald F. Glut's *Dinosaurs: The Encyclopedia*, Supplement 1 (McFarland, 2000), p. 332. This sculpture, alongside a finished casting of the finback *Spinosaurus* sculpture shown in figure 12–7, was exhibited at the University of Western Illinois, Dept. of Geology (Debus).

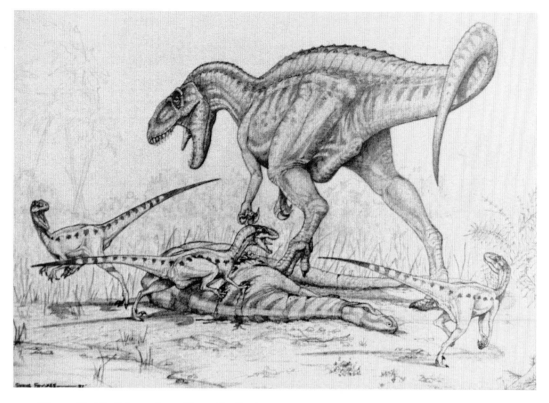

(Figure 12–11): Paleosculptor Shane Foulkes' 1997 restoration of a spine-backed *Acrocanthosaurus* and avian-like, although unfeathered *Deinonychus* competing for downed prey (Original art by Shane Foulkes; Debus collection).

Spinosaurus (i.e., when *not* interpreted as humpbacked in certain named genera) or finbacked Permian reptiles, however, it may be simplest to embed a either a single or double layer of screen into a thin strip of polymer clay adhering to the dorsal side of the armature's vertebral wire. Simply bake this screen into place and then sculpt over it according to your preferred design using fresh, unbaked polymer clay.

"Winging" Pterosaurs

Over a decade before any dinosaurs were formally described, in 1809 Baron Georges Cuvier published his interpretations of an unusual winged fossil species, referred to as "wing finger" or "pterodactyl," owing to its greatly elongated fourth finger, which supported a wing membrane (figure 12–12). By the mid–19th century, Benjamin Waterhouse Hawkins sculpted life-sized pterodactyls among his prehistoric menagerie at Sydenham. By then, pterodactyls, or pterosaurs (winged reptiles) had ideologically been transformed into the traditionally regarded, cold-blooded, bat-winged creatures — dragons of the air — imagined by contemporary scientists. But this view began to erode during the 20th century, such that by the 1970s, paleontologists carefully reconsidered the physiologies and life appearances of pterosaurs.[8] Today, pterosaurs are regarded as endothermic (warm-blooded) creatures once capable of active, flapping flight. Their wing membranes were reinforced with tiny fibers,

known as actinofibrils. To maintain a high metabolism, their bodies were lightly insulated with fur. From analysis of their brain cavities and enlarged eye sockets, pterosaurs must have had excellent vision; they were rather intelligent. For an unimaginably long duration — before birds got their big break at the time of the Cretaceous-Paleogene extinction — pterosaurs ruled Mesozoic skies.

Formerly and popularly held opinions of pterosaurs as leathery, bat-winged, demons of the skies assuredly are in error; pterosaur wings could not differ more considerably from those of bats! Extend your right arm. Now imagine that your pinky finger reduces in size to the point of vanishing, while individual bone segments on the fourth finger of your hand become greatly extended, maybe by as much as 2 feet in length each! This gives you quite a wingspan indeed. Then imagine a tough, tightly woven and durable skin membrane connecting the tip of your elongated finger to your abdomen (or possibly to your lower hip area or knee).

(Figure 12–12): Occasionally, it is possible to obtain plaster casts of real fossils from fossil dealers, such as this *Pterodactylus*, which upon examination will greatly facilitate the accuracy of your prehistoric life sculptures (Debus).

That would be the pterosaur wing, although as appearing incongruously attached to a human. But for a bat, the second through fifth fingers of the hand are each elongated, fanning out through the wing membrane. The pterosaur has one elongated finger, while bats have four extending through the wing membrane. So please don't refer to pterosaurs as "bat-winged," despite how 19th century science popularizers may have referred to them.

The first modern, or renaissance-era, restorations of pterosaurs (i.e., *Pteranodon*) perhaps didn't appear until publication of Desmond's *Hot-Blooded Dinosaurs*. Therein, Desmond championed the idea of the hot-blooded pterosaur.[9] Then, since the 1980s, life appearances of pterosaurs have been restored dramatically, based on the latest fossil findings. For instance, following 1975's unveiling of a giant Texas pterosaur, *Quetzalcoatlus*, with its approximated, colossal 40-foot wing span, Dr. Paul MacCready constructed a half-sized, animatronic model of this genus (18-ft wing span) that actually "flew," in 1986 (figure 12–13). A similarly sized *Pteranodon* "glider" with radio-controlled steering was also successfully flown in 1985. Based on a recently unearthed, well-preserved *Pterodactylus* fossil from Solnhofen, described in 1998, this genus (the genus first described by Cuvier) is now thought to possibly have had webbed feet, a soft-tissue crest used as a rudder, and a keratinous beak. The variety of pterosaurs known to science is staggering and, correspondingly, postulated evolutionary relationships have complexly expanded. Some pterosaurs must have been bona fide "terror-saurs."

Bob Morales' 1/35-scale diorama involving two furry, Late Mesozoic pterosaurs (*Quetzalcoatlus*) defending their hatchlings in an egg nest from a hungry *Albertosaurus*. The model base, replete with stream ripples, a sculpted-in nest of eggs, and mossy shoreline growth, measures 8" by 12". In the late 1990s, this sculpture was reproduced as a model kit by Lunar Models (Morales).

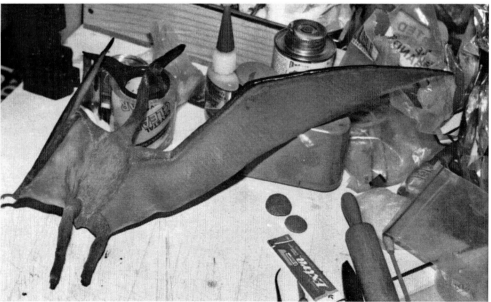

Top: (Figure 12–14): The body of the pterosaur, *Dimorphodon*, may have been clothed in a light layer of fur, as shown in an aerial view (*right*) of this life-sized sculpture. The wings of this creature were sculpted using essentially the same technique described for the *Dimetrodon's* sail (figures 12–4 and 12–5), meaning that no internal support structure exists within the pterosaur wing membranes. Notice (*top left*) the V-shaped wire support as described for use in chapter 6 (e.g., figure 6–12). Sculpture by Bob Morales, 1992 (Morales). *Bottom:* (Figure 12–15): An in-progress image of a late sculpting stage for one of the *Quetzalcoatlus* pterosaurs shown in figure 12–13 (Morales).

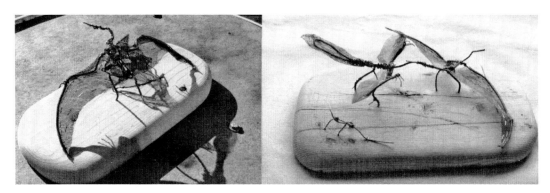

(Figure 12–16): Pterosaur wings may also be sculpted using a wire mesh from an old window-screen for internal support, as shown in these armatures created by Allen A. Debus, 1992, for (*left*) a life-sized *Pterodactylus* with hatchling, and (*right*) a half-sized *Rhamphorhynchus* (at right of image) being attacked by *Archaeopteryx* (1993) (Debus).

Glut lists over 110 different pterosaur genera in Supplement 4 to his *Dinosaurs: The Encyclopedia* (2006).[10] He organizes pterosaur genera into several clades, presenting many restorations of these creatures that will inspire sculptors. Collectively, pterosaurs are regarded as closest evolutionary cousins to Dinosauromorpha, the recognized clade including all dinosaurs and birds. Their lineage may have originated during the Middle Triassic, although the oldest, indisputable pterosaur, *Eudimorphodon*, dates geologically from the Late Triassic, about 75 million years before the oldest known (generally undisputed) fossil bird. Thereafter, gigantic and more diminutive genera enjoyed a cosmopolitan existence during the era of "middle life." Although equally as diverse during the Cretaceous Period, by contrast, birds may have been less numerous throughout the Mesozoic.

Not unlike Charles Darwin's finches, discovered during the H.M.S. *Beagle*'s anchoring at the Galapagos Islands, pterosaur mouths, teeth (or lack thereof in certain genera) and skulls were specially adapted to their lifestyles, reflecting food preferences (although 100 million or so years later, it is impossible to decipher exactly *which* food types some of these species fed upon) and survival adaptations. Such a great diversity in kind of pterosaurs will excite sculptors' imaginations.

Perhaps the two most famous genera are the North American toothless *Pteranodon* and toothy, Late Jurassic *Rhamphorhynchus*, with giant glider *Quetzalcoatlus* swiftly rising through the ranks over the past quarter century (no doubt thanks to Dr. MacCready's flight experiments) to the number three position. But first through publication of amply illustrated books intended for laypeople interested in prehistoric animals, and later through a host of Internet publications, a flock of additional pterosaurs became popularized. Strange-looking, yes, but well adapted for their vanished ecosystems, the world now greets South American, Early Cretaceous *Anhanguera*, *Pterodaustro*, *Tropeognathus*, the Late Jurassic Chinese *Dsungaripterus*—not to mention the German Late Jurassic *Ctenochasma*—each with distinctive facial features and specialized beaks, as well. Gregory S. Paul's life restoration of the North American *Nyctosaurus* displays an extremely long, sexually dimorphic crest that's simply to die (if not go extinct) for![11]

With so many distinctive kinds, sizes and wingspans, respective functional morphologies, flying abilities, dietary habits and presumed lifestyles, it is difficult to pin down a general pale-

obiology conforming to all the known pterosaur varieties, for our purposes. But, not in lieu of the checking you must do in planning your sculpture, a few facts might suffice. Most pterosaurs had five toes, with four held plantigrade when they crawled, walked or shuffled about on the ground. Although a controversial matter, the fifth toe may have been spread outward, supporting the lower, inner part of the wing membrane. As commonly seen in life restorations, some of the smaller species may have clung upside down, bat-like, from tree branches while resting or snoozing. While sitting upright on the ground in quadrupedal stance (on all fours), perhaps on a cliff ledge, they folded their long wing-fingers backward up over their shoulders. Some pterosaurs such as *Dimorphodon* or *Quetzalcoatlus* apparently could walk or even run bipedally, with wings folded back (figures 12–14 and 12–15).

Two key features of the wing to pay attention to while planning your sculpture are the pteroid bone controlling an anterior part of the wing, and the positioning of the rear part of the wing membrane. While the first three clawed fingers of the hand protruded from the wing, there was also a pteroid bone situated at the base of the wrist, which controlled the forewing (the *propatagium*) positioned between shoulder and wrist, levering its position when the wing was either extended or retracted for flight maneuvering. Meanwhile, the rear part of the wing (the *brachiopatagium*) generally is considered to have been connected from the wing extremity to the "side of the upper part of the lower leg," higher up than the fifth toe.[12] Tail bones in shorter-tailed genera such as *Pteranodon* may also have been encased within the wing membrane. Some seaside-dwelling genera may have been equipped with pelican-like throat pouches. The tail of the popular *Rhamphorhynchus* was stiff, not flexible, sporting a triangular membrane at the tip.

Many pterosaurs, possibly those having webbed toes, are restored as fishing animals, soaring high over the waves, while diving down to snatch fish in toothy jaws from the sea. Some pterosaurs may also have been carrion feeders; smaller species with narrow beaks, such as *Pterodactylus*, may have incongruously probed into the earth for worms. Paleontologists speculate (without confirmed evidence as of yet) that pterosaurs may have laid egg clutches, raising their young in the manner of birds. Although systematic terms for pterosaurs have been revised, generally, while the Rhamphorynchoidea generally suffered extinction at the end of the Jurassic Period, the Pterodactyloidea proliferated, diversifying into many forms that enjoyed the subsequent Cretaceous Period; nevertheless, despite their evolutionary longevity, all pterosaurs became extinct at the Cretaceous-Paleogene boundary (while some avian clades survived).

But now you can bring pterosaurs back, realistically "alive"! And here's an innovative way to do so.

The use of a discarded window screen will alleviate the task considerably if you're planning a one-of-a-kind piece. If you're instead planning to eventually mold and replicate the model in the form of resin casts, then you must either ensure that the prototype model with window-screen-mesh-supported wings can be molded as one piece (i.e., without cutting through the arms or wings), or resort to the optional technique described previously for the *Dimetrodon* sail *lacking* interior mesh support. (Of course, each wire mesh-fortified wing may be constructed separately and made to fit into a groove carved into the abdomen.) A little planning goes a long way here.

First, build the armature using techniques previously described for the basic dinosaurian body, positioning the long wing-finger segments into desired angles. Depending on the size

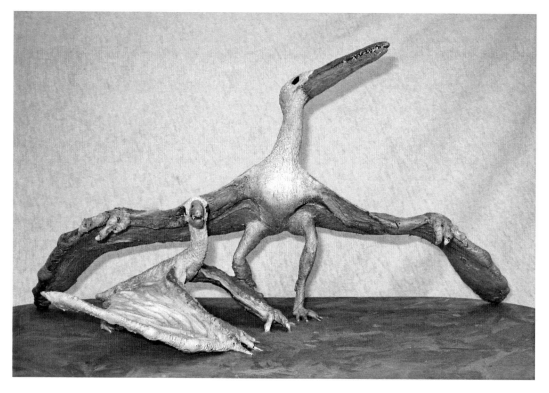

(Figure 12–17): Allen A. Debus' final, 16"-long *Pterodactylus* sculptural study (1992) corresponding to the wire armature shown in figure 12–16 at left, based on measurements and interpretations made from the fossil cast shown in figure 12–12. Wrinkles visible on the juvenile's wing were made beginning with the technique shown in figure 7–8, then applied as curved strips onto likely areas of wing membrane, and smoothed into the wing using a sculpting tool (Debus).

of your creation and after deciding whether any casts might be made later on, you may elect to use a window screen to support the wing membrane (figure 12–16). Larger models may benefit more from using the mesh for interior support than sculptures with smaller wings. (While you may be able to fit a life-sized *Pterodactylus* polymer clay sculpture into your kitchen oven eventually for baking, this will not be possible for an adult *Pteranodon*.)

Now you can wrap the wire mesh around each of your pterosaur's wing fingers — from each tip toward the knee joint in the armature. You can use a single piece that extends from one wing tip, over the vertebral wire, across to the other wing tip. After folding a window-screen section over the anterior length of each wire finger, staple the screen into place. Flatten the staples using needle-nose pliers. Remember to also use small pieces of mesh for the short propatagium part of each wing, which can be simply stuck into place along the wing-finger using thin rolls of polymer clay. The wing's wire-mesh contour may be trimmed using a pair of sturdy scissors. Simple armatures for the three short, clawed fingers protruding from each hand can be made by twisting short segments of copper or aluminum wire around the long wing-supporting finger, at the wrists. These short claws will be covered with polymer clay sharpened into claws, using sculpting techniques.

Add polymer clay over the screen along the wings. Press this down into place, smoothing it into a thin membraneous-like structure. Then you may add a wrinkly texture, depend-

ing on the degree to which the wings have been folded, by judiciously incorporating short rolls of polymer clay into the smooth wing surface along places where the skin would be bunched. Don't overdo the wrinkling or your pterosaur will appear too ancient (despite the fact that pterosaurs were exactly that)!

Add a furry coat to the skin surface of your pterosaur, both along the wing (*actinofibrils*) and over the body. This effect can be accomplished by lightly etching thin striations (through a plastic baggie) over the body using a thin-tipped dental tool. Short strokes (not long ones) will prevent your pterosaur from looking *too* hairy. Pterosaurs' eyes should be sculpted relatively large in size, yielding an intelligent expression.

Look out — they've come to roost! See figure 12–17.

13

Sculpting Prehistoric Birds and Feathered Dinosaurs "On the Fly"

While pterodactyls were among the earliest denizens of prehistory known to early "fossilists," by contrast, since 1996, the topic of prehistoric birds — especially the Mesozoic variety — has really taken off (and not quite unflappably)! Since the early 1970s, on into the mid/late 1980s following discovery of the dubious Late Triassic Protoavis, bird-dinosaur relationships were increasingly debated. What a contrast to what the authors experienced, growing up "dinosaur" in the 1960s, when there were usually only three Mesozoic birds generally known to aficionados and paleo-enthusiasts: the iconic Late Jurassic *Archaeopteryx*, the aquatic *Hesperornis*, and its fellow shorebird *Ichthyornis*, the latter pair dating from the Cretaceous.

Following discovery and reporting of the first fossilized, undeniably feathered, yet non-flying dinosaur in the fall of 1996 (*Sinosauropteryx*), however, and later a fine feathered flock of Mesozoic oddities, the study of the evolution of flight, feathers and relationships between certain theropod dinosaurs, extinct lineages of birds and modern bird clades has been profoundly galvanized. Like never before, Mesozoic birds and their evolutionary implications are a nerve center of vertebrate paleontology, also comprising a favored ideological realm for laymen. This is in utter contrast to one cultural historian's misguided 1998 prediction that when laymen realized popular dinosaurology had degenerated to the mere study of paleo-ornithology, interest in dinosaurs would wane considerably.

Today, however, at least one prominent paleontologist has shunned that time not too long ago when "extinct dinosaurs were considered by most as scaly and dull;" it was a "drab" period that — now that we have "solid evidence of their fluffy colored past" — most of us would not relish returning to.[1] An entire ecosystem seems to have been founded upon warm-blooded dinosaurs insulated with feathers. For, recently, giant fleas (0.8 inches long) have been discovered in 165-million-year-old sediments in China; these bugs are thought to have infested feathered animals particularly, because their legs seem specialized for grasping feathers.

Much of the evolutionary biology of birds, which assumed that they shared a most recent common ancestor with deinonychosauria, must now be carefully rewritten. Simply sporting feathers no longer does a bird make! Or does it?[2] Certain nonavian dinosaurs also had feathers, or at least in the more ancestral forms — integumentary, filamentous structures recognizable as proto-feathers. In 2006, Glut's Supplement 4 to his *Dinosaurs: The Ency-*

clopedia could boast a total of over 120 genera of Mesozoic birds then known to science, with the main flock dating from the Early through the Late Cretaceous. One memorable restoration in Glut's volume, by Todd Marshall, even showed an adult ("nonavian dinosaur") *Tyrannosaurus*, sans feathers, interacting altricially with a bushy, feathered juvenile.[3]

(Figure 13–1): Uncannily, a theoretical notion of how early birds may have appeared and flown as four-winged "tetrapteryx" species was predicted during the 1910s by William C. Beebe. The hypothetical creature shown here nicely corresponds to anatomical proportions of the *Microraptor* discovered nearly a century later, described as a four-winged feathered dinosaur. Image from H.F. Osborn's *The Origin and Evolution of Life: On the Theory of Action Reaction and Interaction of Energy* (New York: Charles Scribner's Sons, 1918), p. 229.

Skeletally, theropod dinosaurs may be distinguished from modern birds. As we've known for decades, in an evolutionary sense even modern birds are dinosaurs. However, since the 2000s, the term *dinosaur* carries added flexibility. It seems that birds evolved the means of winged flight relying on insulating feathers through a Darwinian process known as "exaptation," a moniker supplied by Stephen J. Gould in 1981.

A later, most startling discovery from 2003 was the 4-winged and most likely flying, gliding Chinese dromaeosaur, *Microraptor gui*, confirming a tetrapteryx (four-limbed) theory of flight origin suggested visually in Osborn's 1917 *Origin and Evolution of Life*[4] (figure 13–1). Until the onset of the dinosaur feather revolution, feather fossils had been only attributed to the dinosaurian *Archaeopteryx* 5 (figure 13–2). More recently, paleo-enthusiasts have been treated to cladograms showing the structural evolution and development of feathers throughout the biological history of theropods, leading to anatomically modern birds. However, it isn't proven that virtually all theropod dinosaurs possessed feathers at any ontogenetic (i.e., growth) stage. Or, as Don Glut professes, placing feathers on a dinosaur restoration is often a matter of "o-pinnion."

Think of those buffalo wings on your plate. Bird wings are supported mainly by fused (and therefore strengthened for flight purposes) bony elements on a greatly reduced wrist and hand, from which (in the case of flying species) individual, sturdy and long, aerodynamically designed flight feathers have grown. An irony of modern bird wings is that while their upper and lower arms are proportionally long (as in the case of the most evolutionarily derived theropod/maniraptoran dinosaurs), through geological time, their fingers shrank proportionally, that is compared to ancestral, nonavian dinosaurian forms. Those buffalo

wings are the cooked hands (otherwise known as the fused "carpometacarpus") of the chicken. But among prehistoric species, the design of hand bone elements — three avian fingers, digits, flexible wrist, degree of skeletal fusion — blurs into more ancestral *manus* morphologies as increasingly primitive flocks of fossil bird species approach dinosaurian (i.e., hand) forms, cruising backward into time.

Besides their wrists and hands, respectively, there are many other skeletal transformations and characteristics used by paleobiologists in establishing relationships between extinct

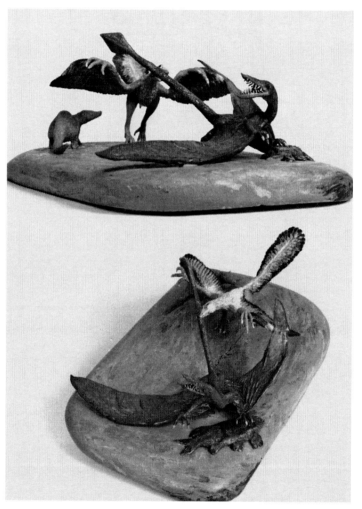

and modern birds that are also shared with maniraptoran dinosaurs. The matter of dinosaur–bird phylogeny is a highly fascinating and scientifically active if not volatile affair, representing a revolution in our understanding of vertebrate evolution. While beyond the scope of this book, you may bone up on this topic in Luis M. Chiappe's excellent and informative *Glorified Dinosaurs: The Origin and Early Evolution of Birds* (2007).[6]

With so many fossil birds and feathered dinosaurs to choose from, you won't quickly exhaust modeling opportunities or your creativity. Paging through Chiappe's book, for example, you'll find many genera of Mesozoic birds and fine feathered dinosaurs, relatively new to science or newly restored by paleoartists, that will seize your imagination. And be careful how you pose your creations — even if certain smaller dinosaurs bore feathers, this doesn't necessarily mean they could fly!

Bear in mind that more ancestral (or "primi-

(Figure 13–2): Hear the squawks and screeching? Scenes of the two Late Jurassic winged creatures, the pterosaur *Rhamphorhynchus* and the ancient bird *Archaeopteryx*, have long been popularized by paleoartists, although not quite in this fashion. In this 1/2-scale, hypothetical Late Jurassic scene, we notice a (non–Darwinian) evolutionary "ladder of progress" running diagonally across the base from a Coelacanth fish, to reptile, to bird and to mammal. Allen A. Debus' 1993 simple diorama is 15" long. The armature for this one-of-a-kind sculpture is shown at right in figure 12–16 (Debus).

tive") theropod dinosaur genera — particularly the coelurosaurs — displayed the most primitive type of feathery insulation. More structurally advanced and ornate-looking feathers begin to appear among the maniraptorans such as *Protarchaeopteryx*, which bore plumulaceous feathers not designed for flight. In fact, with exception of *Microraptor* and possibly the geologically older yet similarly feathered *Pedopenna*, most maniraptoran (feathered) dinosaurs — the group or clade inclusive of the more familiar *Velociraptor* and *Deinonychus* — didn't fly, at least well. The 75-million-year-old *Rahonavis* ("menace from the clouds") from Madagascar, viewed both as the most basal flying bird (next to *Archaeopteryx*) and as a transitional form between dromaeosaurs and avians, possessed sickle-shaped claws on its second toes; a crow-sized, flying nightmare! (figure

(Figure 13–3): Jack Arata's restoration of *Rahonavis* as a hypothetical flying dinosaur (courtesy Jack Arata).

13–3.) The recently discovered *Balaur*, known from Romania, outdid its popular evolutionary cousin *Velociraptor* in having not one but two toes equipped with sickle-shaped claws on each foot. In recent restorations, this newly described 6- to 7-foot-long, Late Cretaceous stocky-looking genus sports feathers from its noggin to the tip of its tail. The Early Cretaceous oviraptorid form *Caudipteryx* had true feathers but clearly didn't fly.

The bird-like nature of the toothless, nonavian oviraptorosaurs, included among the evolutionarily derived ave-theropods known as maniraptora, may also be of special interest to sculptors. Oviraptorid nests of the Mongolian parrot-headed genus *Citipati* were discovered in 1993; fossils of a parent overlay eggs arranged circularly, containing fossilized embryos belonging to the same genus. The adult specimen's arms, which presumably were feathered in life, are spread out over the nest, as if — like a brooding bird — protecting the egg clutch (figure 13–4). Did the parental reproductive instinct of sitting atop nests evolve in the lineage long before the arrival of modern birds?[7] Accordingly, paleoartists now enjoy adding feathers speculatively to their restorations of oviraptorids, such as the enormous, Late Cretaceous Mongolian form *Gigantoraptor*, which stood 2.5 times taller than an adult

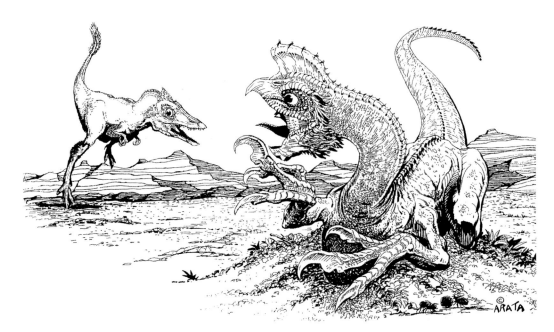

(Figure 13–4): Jack Arata's restoration of a hypothetical encounter between a feathered theropod (left) attacking a lightly feathered theropod oviraptorid (right), which is protecting its nest of eggs. See text for further details (courtesy Jack Arata).

man. Examine, for example, the astounding vignette featuring spectacularly feathered *Gigantoraptors*, animated using computer graphics for the Discovery Channel's 2011 sensational broadcast *Dinosaur Revolution*. In the 2007 scientific description of this genus, paleontologists suggested that, although perhaps not required for insulation purposes, *Gigantoraptor* may have "retained arm feathers ... from its ancestors, if not other types of feathers."[8]

The dinosaur "feather revolution," as dubbed in *Paleoimagery*, is in full swing![9] Recently, scientists determined coloration in Mesozoic creatures by chemically analyzing biochemical traces (e.g., melanosomes, color-bearing organelles) preserved in fossil feathers. This relieves guesswork in determining color patterns of feathers in certain extinct species of Early Cretaceous feathered dinosaurs such as *Sinosauropteryx*, or Late Jurassic "near birds" such as the peacock-sized *Anchiornis*, which is geologically older than *Archaeopteryx*. Restorations of the Chinese *Anchiornis* published on Internet sites resemble modern ground-running birds more so than traditional dinosaurs. However, an object of these restorations is to display the life color pattern as determined in feathers through chemical analyses of biomolecules preserved in fossilized feather impressions. Furthermore, in September 2011, scientists reported their analyses of numerous hair-like proto-feathers wholly preserved in Canadian fossil amber, sort of a "Jurassic Park-ish" affair. These feathers were attributed to a diverse assemblage of otherwise unidentifiable Late Cretaceous dinosaurs and birds. Pigmentation was exquisitely preserved within these feathers, offering another valuable window into the evolution of feathers as well as permitting biochemical analyses of their pigmentation.

Anchiornis— the first fossil species for which complete body feather coloration has been chemically determined — had black and gray plumage; its head crest is known to have been

reddish-brown. It also had "racing stripes" along its feathery legs, feet and winged forearms. Such a distinctive, complex coloration pattern — rather like a woodpecker — implies that, beyond the thermodynamic function of retaining body warmth in relatively small endothermic creatures, feathers had a visual display and communication function too. It appears as if coloration in dinosaurs known to have been feathered evolved first as an "among-feather" patterning in more ancestral types (e.g., the tail of the coelurosaur, *Sinosauropteryx*), later evolving into "within-feather" complexity among more evolutionarily derived genera, such as the maniraptora (e.g., *Caudipteryx, Anchiornis*). So, sculptors — choose your paint kit carefully when it comes to painting your homemade creations. Particularly these days, there's more to it than meets the eye.

A 125-million-year-old *Tyrannosaurus* 1.5-ton ancestor named *Yutyrannus* in 2012 was discovered with fossilized feathery patches. These filamentous feathers, as restored by Brian Choo, were surprising to find because the adult specimen was 30 feet long. So the theory that feathers were only required in smaller theropods for heat insulation purposes — due to smaller ratios between surface area and body volume — is challenged. However, during the Early Cretaceous, the part of the world where *Yutyrannus* was found may have had a cooler climate. In Choo's life restoration, the new theropod appears quite shaggy.

How does one go about sculpting bird wings and feathers? In spite of their different (yet homologous) anatomy, basic wire armatures for pterosaur and fossil birds can be constructed similarly. However, because with certain designs you'll be sculpting each feather individually, a short digression concerning feathers will be in order, shortly. But first, we introduce the *wing armatures*, which are, by design, fairly basic for flying birds.

Essentially, there are three kinds of avian wing armatures you might consider designing. The first kind, appropriate for a flying Mesozoic bird with wings outstretched, is the most elaborate and is of similar construction to the pterosaur wing armature described in chapter 12 (figure 12–16). Securing an old steel-mesh window screen to the wire or coat-hanger armature can greatly strengthen your wing, providing a structural base upon which you can later sculpt feathers.

To begin, construct your wire armature for the body according to your preferred design. Wrap individual segments of polymer clay around coat-hanger wire representing the backbone and tail, legs and arms, connected, tied or wound about each other, and then bake this assembly according to manufacturer's instructions. As described previously, this will help lock the twisted wire segments into place, forming a mechanical bond. Remember — if you plan on molding and casting your creation afterward, and the design is such that will require cutting of the original, prototype sculpture, then anticipate using softer or thinner-gauge wire than coat hanger wire for those sections that will be separated accordingly, because it will be easier to cut or saw through these sections later on. (However, resin casts can sometimes be made from a simple mold encapsulating the entire sculpture; in such cases, it is unnecessary to cut the prototype.)

Your armature will now most likely have long wire arms, corresponding to the tips of each spread wing. (One or both of the feet can be temporarily embedded into a wooden base for support.) Now fold a section of window-mesh screen over the coat-hanger armature wings, such that the top side of the mesh contacts the bottom underneath the wing; staple the mesh into place as close to the coat hanger rod as possible and along several sections of the rod, as you learned before in the case of the pterosaur wing. The mesh should

stretch to the middle of the body armature, or what will become the backbone (i.e., the vertebral wire) of your fossil bird or feathered dinosaur. Now trim the rearward edge of the window mesh with a sturdy pair of scissors so it is contoured like a wing, to your satisfaction.

Next, take a thinly rolled section of polymer clay and squeeze it into place along the length of the animal's tail, favoring the top side of the tail wire. *Before* baking this strip of polymer clay, embed a cut section of window-mesh screen into and along the tail, corresponding to the shape and width of the plumage that will appear in your final creation. If the mesh tends to slide over or roll from the top of the tail prior to baking, you may secure it into place using thin gauge steel, aluminum or copper wire twisted into place with needle-nose pliers. Bake this polymer clay tail armature according to manufacturer's instructions.

(Figure 13–5): A partially sculpted feathered dinosaur. Note the exposed wire mesh that will support feathering on the tail and wings. At this stage, the main body has already been baked once, thus bonding the visible wire mesh into hardened Super Sculpey (Debus).

If you plan on sculpting one of the recently discovered 4-winged dromaeosaur varieties of flying dinosaur, such as *Microraptor*, then you will also need to lay a wire mesh foundation for the pair of feathered wings appearing alongside the ankles. This may be simply done by folding a short section of window mesh around each ankle, then stapling the piece close to the coat-hanger-wire ankle bone. Trim the mesh to an appropriate contour.

Now you have constructed your basic armature suitable for sculpting Mesozoic birds such as *Archaeopteryx* or a feathered 4-winged dinosaur such as *Microraptor* or *Anchiornis* having fully outstretched forewings.

The second variation on the avian-type wing armature pertains to an assortment of non-flying theropod (Eumaniraptoran) dinosaurs (e.g., *Velociraptor*, *Troodon*, *Deinonychus*), where a short wing of complex feathers covering the arms from the shoulder to the wrists may have functioned for display and communication purposes (figs.13–5 and 13–6). Although often a conjectural matter, since the late 1990s, this feathery feature has become a paleoart cliché, and you should consider whether to add such feathers to

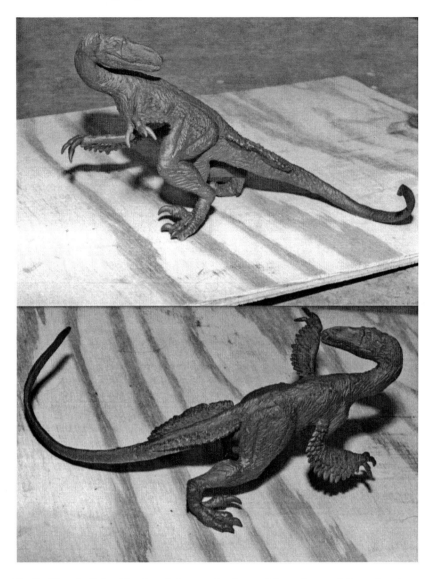

(Figure 13–6): Allen A. Debus' feathered theropod, advanced from the partially sculpted stage shown in figure 13–5. Here, sculpting is complete, the animal has been baked, and paint primer has been applied. From tail bend to clawed fingertip, the sculpt is 8.5" long. For a look at the final sculpture into which this dinosaur was incorporated, see lower image in Figure 8–13 (Debus).

your creations. Fortunately, this kind of reduced wing armature is much simpler to sculpt.

After constructing your basic coat-hanger wire armature per previous instructions (figures 13–7 and 13–8), then as in the case of the ankle-joint wings in *Microraptor* (described above), secure thin strips of window mesh closely to each arm, joining to the middle (backbone) part of the armature. You can stick or embed the ends of these thin strips into the polymer clay, locking the arms into place where what will be the twisted wire "shoulders" contact the vertebral wire backbone (figures 13–9 to 13–11). If your cre-

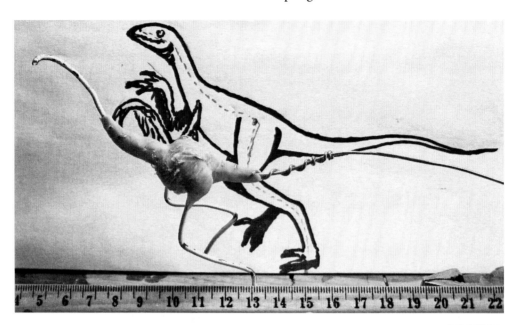

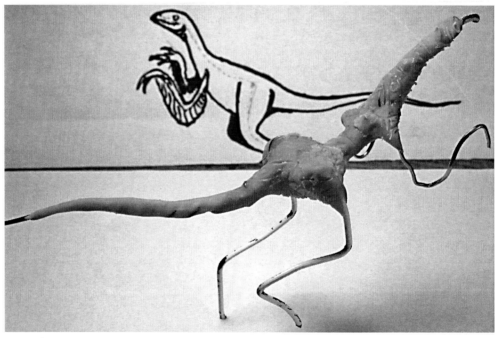

Top: (Figure 13–7): An early stage in the sculpting of a Late Cretaceous theropod, *Troodon.* The wire armature has been prepared and a block of hardened Super Sculpey further locks the hip joint and vertebral wire tightly into place, supporting and facilitating further sculpting over this construct. Note that copper wire was selected for extending the tail in case positional modifications must be made, while sturdier coat-hanger wire supports the rest of the frame. (During design stages it was decided not to mold this sculpture.) The leg support is resting temporarily in a wooden base. The ruler scale is in centimeters (Debus). *Bottom:* (Figure 13–8): Copper wire arms have been added (shaped per the simple preliminary drawing) and further hardened Super Sculpey has been applied over the armature (Debus).

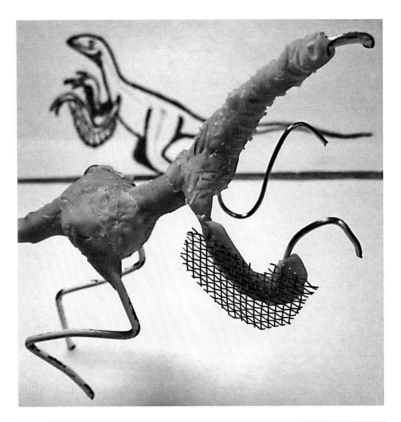

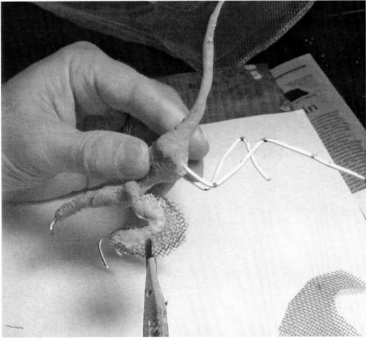

Top: (Figure 13–9): Adding a short wedge of wire mesh onto unbaked polymer clay, coating part of the right arm where it sticks nicely (Debus). *Bottom:* (Figure 13–10): Using a scalpel to add a thin layer of polymer clay to cover both sides of the wire mesh. Note the now-exposed longer left leg support segment, which rests inside the wooden base during sculpting (Debus).

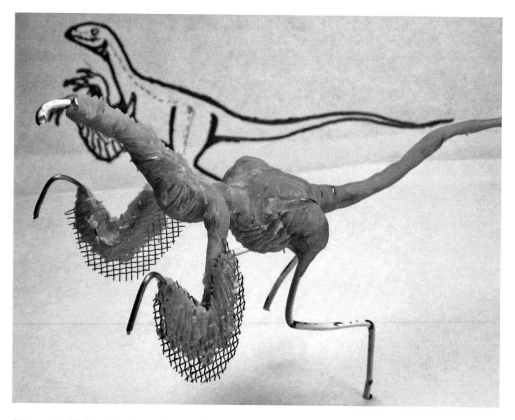

(Figure 13–11): Now both arms have a thin coating of unbaked polymer clay slathered over the wire mesh. Feathers, or impressions thereof, per the design drawing, may now be sculpted with care over this mesh using fine-tipped sculpting tools, a step that requires patience! (Debus).

ation's wings are longer than, say, 3 inches, carefully fold the mesh over the arm "bones" and staple into place. If you further desire your maniraptoran to be more fully decked out, resplendent with an eye-catching feathery tail, then follow the description for adding window mesh and polymer clay to the entire or select portions of the tail segment, as described previously in this chapter for supporting the sculpting of tail feathers. Bake this armature according to manufacturer's instructions. (See figure 2–6—figure at left.)

While modern birds do not evince hand-digit claws protruding from the front of their wings, this was probably not the case for Mesozoic birds and certainly not so for feathered maniraptoran dinosaurs, outwardly shaped like birds — such as the enigmatic Late Cretaceous *Mononkyus*. Such claws may have aided some smaller species, such as *Archaeopteryx, Scansorioropteryx* or other dromaeosaurs, in climbing or clinging to tree trunks (rather like the modern *Hoatzin* bird). For such ancestral forms, which would have had clawed fingers protruding from the feathery wing, you can tie three pieces (one for each digit) of thin gauge steel, aluminum or copper wire at the wrist portion of each wing, bent into the shape of digits, to be later covered in polymer clay during the finishing stages. Thin wire armature support for the clawed feet of your sculpture can similarly be fashioned at a later stage. Particularly if your bird or ave-theropod is relatively large — longer than 8 inches — its wings

will become heavily laden with polymer clay feathers. So remember to design your creation with a sturdy leg (made of coat-hanger wire) having an extended support rod that can be securely anchored within a wooden base for a one-of-a-kind model.

The third kind of avian wing armature covers the many kinds of flightless birds, especially those eye-catching giant genera thriving from the Tertiary through the Pleistocene periods. Armatures for such varieties may be constructed along the lines of the simple theropod design (chapter 6), although with considerably reduced tail segments. The wings on such species were vestigial, vastly reducing the complexity of the wing armature. Accordingly for these, you may simply embed a short section of window mesh into the body of the animal as you sculpt over the armature, allowing it to protrude slightly from the shoulder area, as shown in the photos for *Andalgalornis* and *Titanis* (figure 13–12). Then impressions of plumulaceous feathers — non-functional for flying — may be coated and etched over the mesh as you finish the sculpture's integument.

Now — onward to those tricky feathers. Brace yourself, for these are obviously advanced techniques.

There is considerable information about avian feathers for modern species available on Internet sites, for example at Wikipedia. So we only offer the basics here, sufficient to

(Figure 13–12): Allen A. Debus' 2001 miniature 6"-tall sculpture of the Tertiary flightless bird *Andalgalornis.* The vestigial wings were built up with polymer clay applied over both sides of properly contoured wedges of wire mesh, the wiry ends of which were firmly embedded into soft, unbaked polymer clay within the abdominal area. Sculpting of each wing then ensued after the wire mesh was in place (Debus).

(Figure 13–16): Restoration of the "ancient wing" *Archaeopteryx* by Kristen Dennis (2012), based on a sculpture by Arthur Hayward. Note the rectrices (feathers closest to the tail), remiges (feathers near the arms), and a series of shorter "covert" feathers (covering the flight feathers). See text for further details (courtesy Kristen Dennis).

get you started with your prehistoric projects. Birds' asymmetrically shaped flight feathers are grouped as either *remiges* or *rectrices*, the former corresponding to those on the wing, and the latter referring to those on the tail end. Wing feathers are further categorized as primary, secondary or tertial, depending on which part of the arm they're attached to, respectively. Primaries—generally 9 to 16 in number per wing, depending on the species—grow from the carpometacarpus (hand/wrist element); secondaries—generally 6 to 40 in number, again depending on the species in question—extend from the ulna, or lower arm; tertials are connected to the humerus, or upper arm. These are all considered "flight feathers" in flying birds because of their asymmetrically shaped vanes and orientation, facilitating aerodynamic lift and thrust when the arms are flapped. Additionally, several layers of covert feathers cover the flight feathers situated incrementally nearer the arms, both overlying and underlying each wing.

Rectrices are those long feathers attached to the tail bones (pygostyle) and the fatty bulb surrounding this area. Most modern bird species have six pairs of rectrices. In flying

birds, there is also an alula, which is an asymmetrical feather at the front of each wing, which can be levered by the bird's "thumb," facilitating maneuvering in landing.

Anchiornis had 11 primary flight feathers, with 10 secondary flight feathers on the arm, with an additional 12 to 13 flight feathers attached to its lower leg (tibia), and 10 to 11 such feathers on the upper foot (or metatarsus). Unlike *Microraptor gui*, *Anchiornis* is judged to have been, at best, a poor flyer, or glider. However, their long foot feathers make both genera unlikely candidates for habitual fast ground-running. In the more familiar case of *Archaeopteryx*, a number of excellent restorations depict the presumed wing and tail feather alignment, displaying primary, secondary and tertial remiges and an assortment of tail rectrices (figure 13–16). Both *Anchiornis* and its evolutionary cousin *Archaeopteryx* bore rectrices along their bony tails. Many dinosaurs that are known to have been feathered did not possess flight feathers. Their feathers are of the plumulaceous, downy or fluffy variety, functional for insulation and possibly visual display, but not supportive of flight. It has been determined, for example, that *Anchiornis* had both flight and plumulaceous type feathers. So before you place your sculpted, feathered Mesozoic creations in a perch setting, please verify current thinking concerning these genera beforehand (which could change "on the fly"). Even if, someday, *Veliciraptor* specimens are discovered adorned with fossilized feather impressions, *Velociraptor* did not fly!

Dinosaur feathers are turning up everywhere it seems, more frequently than one could have ever anticipated two decades ago. Filamentous proto-feathers have been identified on the tail segment of *Tyrannosaurus'* distant evolutionary cousin, the Early Cretaceous *Dilong*. The Early Triassic thecodont *Longisquama*, whose countenance graced the cover of the April 1975 *Scientific American* issue heralding Robert Bakker's "Dinosaur Renaissance," bore a very long, prominent double-row of feathers adorning its spine, which "may have served to break the animal's fall when it leaped from trees." Although among dinosaurs, feathery structures would seem to have been confined to the saurischian theropods, ornithischians such as the Chinese heterodontosaurid *Tianyolong* also sported feathers, or "elaborate integumentary structures."[10] And the basal ceratopsian *Psittacosaurus* possessed a row of vertical bristle-like filamentous structures ascending along its spine.[11]

Sculpting feathers from polymer clay is quite tricky and exacting; truly an advanced method. Sculptors often choose to make one-of-a-kind fossil birds and feathered dinosaurs appear feathery using real, cropped, cut and dyed feathers plucked from living birds (ouch!), instead of sculpting individual feathers. Other old-school sculptors prefer to ignore the feather revolution altogether, employing an ignorance-is-bliss strategy, pretending, as was thought back in the 1960s, that only birds had feathers, while dinosaurs did not. Then they stick to sculpting only dinosaurs. Looking at the numerous photographs and imagery displayed within issues of *Prehistoric Times* magazine, readers will readily notice that while paleoartists who paint or work on canvas often enthusiastically adorn their dinosaurs with an assortment of feathers, *paleosculptors* featured in this magazine are relatively stingy when it comes to adding feathers. An exception is Jerry Finney, as shown in his short article "How to Sculpt Prehistoric Animals."[12] In alignment with this trend, we have relatively few examples to show you, because they are admittedly difficult to do. Yet, in spite of inherent difficulties, shall we proceed?

For designs featuring flying prehistoric birds or maniraptoran dinosaurs, holding prominent wings outstretched, you must add individual feathers sculpted from polymer clay to

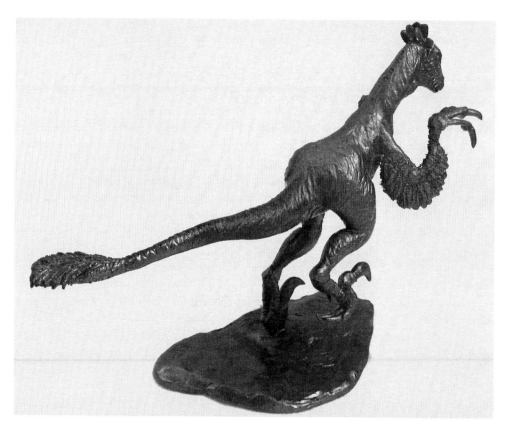

Top: (Figure 13–13): The finally feathered and faux-bronzed, 8"-long *Troodon* (2012) (See in-progress in figures 1–5 and 13–7 through 13–11.) (Debus). *Bottom:* (Figure 13–14): One of two highly detailed Pleistocene *Teratornis* sculpted by Bob Morales for his La Brea Tar Pits Saurian Studios diorama (also see figure 14–1) (Morales).

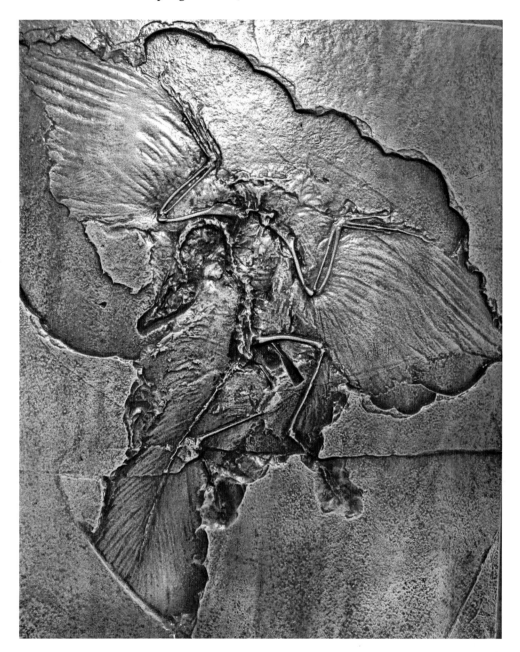

(Figure 13–15): Sometimes resin casts of genuine fossils, such as this exquisite resin cast of the original "Berlin specimen" of the Late Jurassic bird-dinosaur *Archaeopteryx*, can be obtained inexpensively. This particular fossil replica facilitated sculpting of the diorama shown in figure 13–2 (Debus).

the tops and bottoms of both wings onto the window-mesh screen armature. This will take time and patience, and it explains why most sculptors either avoid sculpting prehistoric birds altogether or prefer to go with the scaly, dull and drab, mid–20th-century versions of dinosaurs instead. But — face it, folks!— there's no easy way around it using polymer clay.

Examine a sketch of the bird (or maniraptoran) wing you intend to sculpt, and begin sculpting the primary feathers one by one. Keep them sufficiently thin (both in height and width), flattened on the mesh and not overly wide; strive to align the top part of the feather with its bottom half (underlying the mesh). Then move inward toward the body, adding the secondaries and then tertials. You do not need to extend each polymer clay remige feather all the way to the coat-hanger-wire rod. Remiges need only be sculpted to the portion of the wing (i.e., the mesh) where the first layering of coverts will begin. Again — think "thin" or your growing complex will become too heavy and may even collapse.

When remiges are fully accounted for, then sculpt the first layer of coverts, then other, successively shorter layers of coverts overlying each preceding layer. You may consider, for example, adding five layers of coverts to make the sculpture appear sufficiently bird-like. Then you can add layers of feathers along the spine, chest, neck and head of your creation — starting from the rear, working toward the head so that the feathers will appear to be overlapping headward (or anteriorally).

Tail feathers (rectrices) are usually a little easier to do, because there are fewer feathers to sculpt (figure 13–13). Your armature may already have a contoured wire-mesh slice embedded in a sliver of hardened polymer clay along the tail wire segment that you can smother with feathers, top and bottom.

Once the thin, flattened strips of polymer clay have been added onto the wings, tail and body, you should carefully striate or etch each individual strip with a thinly pointed sculpting tool, in order to create an impression of a feather-like vane and pennaceous filament. Use a light touch here. You can try using the baggie trick to avoid excavating polymer clay from the surface; however, if you use a sharp pin to create the fine striations required, the baggie may tear. Do the best you can, and later, after baking the sculpture, if little bits of excavated polymer clay adhere to the feathers, consider removing these, *lightly*, with finely graded sand paper, or brush them off using rubbing alcohol.

Feathers on armatures for eumaniraptoran dinosaurs and large flightless birds may be sculpted following analogous techniques. The smaller your design scale, however, the less detail will be needed on the individual feathers.

Don't get too frustrated. Remember — you are not trying to make an actual feather using polymer clay, down to microscopic detail. But to the extent possible, you are striving to create a realistic *impression* of feathers[13] (figures 13–14, 13–15, and 13–16.)

Study the photographs presented here and read up on birds.[14] Soon you'll be soaring successfully!

14

Sculpting Prehistoric Mammals — "Just Do It!"

Imagine a giant ground sloth mired in sticky tar, a fate suffered by many unfortunate victims slaking their thirst in water pooled over the impermeable asphalt. Its mournful cries draw two great saber-toothed cats. Slavering wolves and giant condors eye the helpless beast. On that sultry day, so many sunsets ago, the bloody banquet begins.

Charles R. Knight's preternaturally realistic paintings of prehistoric mammals leave us longing for the world of yesterday. It seems verily possible to step through his picture frames into the eerie, icy twilight of the glacial Pleistocene, or muggy buggy southwestern California when the great sloths reigned. It isn't difficult finding inspiration for sculpting prehistoric mammals. If you're still hesitant, we strongly advise watching the BBC's *Walking with Prehistoric Beasts* (2001), highlighting the evolutionary history of prehistoric mammals magically restored to life via the art of CGI (and other effects), as they once appeared — docu-dramatized for our viewing pleasure, during the Tertiary and Pleistocene periods.[1] Artful, fascinating stuff!

Mammals scored a number of important victories over the dinosaurs, both in the evolutionary sense and in the recent battle for popularity after humans, equipped with powers of reasoning, evolved.[2] Fossil mammals are not granted the same level of attention by paleosculptors as is afforded the dinosaurs. Curiously, many of the most popular (and hence most commercially viable — yet seldom sculpted) prehistoric mammals are more completely known, *scientifically*, than many of the dinosaurs, which are often restored with considerable speculation, on canvas or in three-dimensional model kit form. Paleomammals' musculature, soft-tissue anatomy and metabolic traits may be more confidently inferred from living relatives, relative to that of the more mysterious dinosaurs.

Be advised, fellow sculptors, that although prehistoric mammals haven't fared as well on the theme-park battlefield or even on the museum front (compared to dinosaurs), they remain fertile territory for your creative talents. With a nod to history, let's consider!

Historically and with varied success, sculptors have ambitiously popularized their haunting images of prehistoric beasts at life-size dimensions. Benjamin Waterhouse Hawkins had planned to restore a *Mastodon* for the Crystal Palace at Sydenham, before turning to Richard Owen's infamous trio of dinosaurs. Several mammals, including the great giant ground sloth, *Megatherium*, Irish Elk and great varieties of small tapir-like species, were restored on the Crystal Palace grounds. But regrettably, Hawkins never completed his

Mastodon. Hawkins also planned full-sized restorations of prehistoric American mammals for his never-completed Palaeozoic Museum. At the end of the 19th century, Henry Ward's life-sized Great Siberian Mammoth sculptural restoration was a principal attraction at the 1893 World's Columbian Exposition held in Chicago, not Hawkins's *Hadrosaurus* skeleton, as commonly believed.

Six decades before Dinamation's "Wild & Woolly" traveling exhibit, featuring an array of animatronically controlled prehistoric mammals, hit the road during the early 1990s, an assortment of equally fuzzy, mammalian robots greeted visitors at a wonderful attraction, "The World A Million Years Ago" at the 1933–34 Chicago World's Fair. After several show-ings around the globe, these were retired from service long ago. By the late 1930s, sculptor Herman T. Beck was sculpting life-sized, prehistoric saber-tooth cats and other contemporary mammalian fauna, which are displayed adjacent to actual tar pits on the La Brea grounds (figure 14–1).

Fantasy movie fans still rave about miniature dinosaur sculptural puppets that were animated to sometimes larger-than-life size in some of the vintage classic films such as *King Kong* and 1925's *The Lost World*. Prehistoric mammals (Kong excluded) rarely made the final roster in such classic film fare. One interesting test scene involving the magnificently horned *Arsinotherium* was planned for perhaps the most famous dino-movie that was never made — *Creation*.

Quick! Can you think of any exemplary prehistoric mammal sculptural restorations?

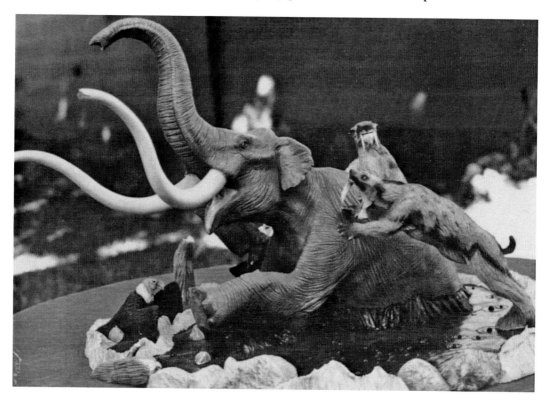

(Figure 14–1): Bob Morales' 1996 La Brea Tar Pits scene, showing an Imperial Mammoth, a pair of saber-toothed lion (*Smilodon*) and the Pleistocene vultures (*Teratornis*) (Morales).

Now how many full-sized dinosaur sculptures can you picture? Dinosaurs quickly win this contest, don't they? Why is it that widespread public interest in the prehistoric mammals infrequently seems to happen every half century, while dinosaur theme parks and expensive museum restorations continue to be financed and built? Although often neglected, relatively speaking, there remain quite a few striking examples out there, still every bit as prehistoric and inspiring as the more familiar dinosaurs.

For instance:

Outside the Palaeontological Institute in Moscow stand life-sized statues of a woolly rhinoceros and a mammoth. Sculptor Franz Gruss sculpted a handful of fossil mammals, including a cave bear, for his Saurierpark, situated in the Kleinwelka, Germany. Several life-sized fossil mammal sculptures, including the great beast *Indricotherium* (now formally *Paraceratherium*) reside at Thunderbeast Park located in Klamath Falls, Oregon — unfortunately now closed to the public. Much better (and accessible) Pleistocene mammal restorations reside on the Page Museum at the world-famous La Brea Tar Pits, outside (and within) the University of Nebraska State Museum in Lincoln, at the Wyobraska Museum in Gering, and on the Berkeley University campus. At the world-renowned fossil site of Big Bone Lick State Park, Kentucky, you can spy statues of several Pleistocene beasts that formerly roamed this territory. A life-sized *Brontotherium* sculpture resides with several other prehistoric mammals at Prehistoric World in Morrisburg, Ontario. Richard Rush's spectacular composite, half skeleton, half in-the-flesh restoration of the Perry Mastodon is exhibited at the Wheaton College campus in northeastern Illinois. A furry *Mastodon americanus* restoration stands guard at the New York State Museum, and a stuffed woolly rhinoceros, *Coelodonta* (with plaster cast of its death pose), preserved frozen in the ice, can be found in the halls of the Polish Academy of Sciences in Cracow, Poland. And yes, a fantastic restoration of the North American Ice Age sloth *Megalonyx* may be seen at the Iowa Museum of Natural History.

Tom Shankster's imposing, life-sized "terminator pig" sculpture (*Dinohyus*) greets visitors in Denver's Museum of Nature and Science. During 2010, a traveling exhibit dedicated to the evolution of elephants opened at the Field Museum; several life-sized sculptures of prehistoric elephants and felines fascinated visitors. One of the largest paleo-mammal sculptures is John W. Hope's life-sized bas-relief of the Baluchitherium, restored for New York's American Museum of Natural History in the early 20th century. However, perhaps the most expertly sculpted fossil life-sized mammals were sculpted by Erwin S. Christman for the American Museum, also during the early 20th century, and Frederick A. Blaschke for the Field Museum of Natural History during the mid–20th century. In particular, their brontotheres (formerly known as titanotheres) should inspire every paleosculptor.

On the miniature modeling scale, Charles R. Knight sculpted amazing renditions of many prehistoric mammals (figure 14–2), but these are generally unavailable to collectors. Quite recently, however, sculptor Sean Cooper of Paleocraft, who specializes in prehistoric mammals, has dazzled many hobbyists and collectors of prehistoric resin model kits with his remarkably keen eye (figure 14–3). Cooper is a highly talented sculptor who felt the lure of the Cenozoic world, carving a significant niche for himself.

In a 2002 interview, Cooper confessed:

When I became interested in reproducing my sculptures for sale, I noticed that there were many talented artists already sculpting and reproducing really good dinosaurs. Simply put, being new

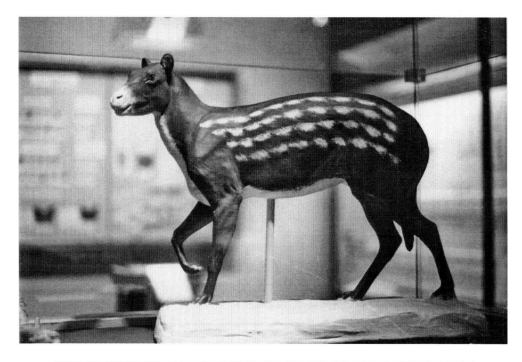

Top: (Figure 14–2): A sculpture of the Eocene "dawn horse," *Hyracotherium*, sculpted by Charles R. Knight, displayed in the University of Washington's (Seattle) Burke Museum of Natural History and Culture (A. Debus). *Bottom:* (Figure 14–3): Sean Cooper's 7"-tall *Indricotherium*, cast in resin (A. Debus).

to the field, I didn't want to compete with some of the superb dinosaur works that were already out there. Noticing that there were few reproductions of prehistoric mammals, which I find every bit as fascinating as the dinosaurs, I decided to focus on them.[3]

On the topic of sculpting prehistoric mammal miniatures, paleoartist John Fischner of Dreamstar Productions has insightfully stated:

The basic assignment is to go beyond what the subject looks like; all the way to who it is... I bent my steel armature to the basic proportions of the beast in a fully extended attack... If there are any short cuts or preparations beyond ... research, I don't know what they are... I just did it. The most terrifying monster of all for an artist can be the blank canvas or the empty work table. There will be some ideas that cannot be coaxed, designs that will not be inspired. The muse may never whisper. When this occurs, your choices are few. You can procrastinate, or even cancel or you can finish the piece. After repeated attempts, you may fail. Finally with several completed, self proclaimed failures you let someone else look at the work. Lo and behold, they love them all. The best defense against failure is more work. Just do it. Even if you don't know how it will turn out, just do it. Especially if you've never done it before; just do it. If the monster roars; attack! Art isn't for sissies. Just do it.[4]

While we must underscore the singular importance of thoroughly researching beforehand, certainly Fischner's "just do it" philosophy is appropriate for the tasks awaiting you. The message is clear. When it comes to paleosculpting, the timid either never get started, or never finish. We urge you to complete your projects! While many might say "why bother," we'd proclaim, "why not"?

Evidently, fossil mammals are under- represented sculpturally, in roadside theme parks, museum settings and even paleo-enthusiasts' individualized "dinosaur" collections, reflecting the public's preference for the more exotic and arguably mysterious dinosaurs. But your miniature models of prehistoric mammals need not be minor attractions. It seems that prehistoric mammals need a new public relations liaison. Who? You — the Prehistoric Animal Sculptor — can help by making them more familiar in sculpture. Nevertheless, as you research prospective genera for miniature sculptural restorations, certain exotic prehistoric mammals may especially inspire your creativity.

Don't worry about whether others will find your original prehistoric mammal sculptures more or less interesting than someone else's theropod dinosaur. Sculpt a critter that excites you, or it will turn out poorly. That's a rule that applies to any project, whether dinosaur, bird or mammal. Where do you begin? With something inherently interesting, of course! You say you don't like sculpting rat-like animals or prehistoric pigs? Not "sexy" enough? Well, don't. There are plenty of genera to choose from.

In fact, due to fossil preservational bias, a statistical phenomenon known as the "pull of the recent," there are many more fossil mammal genera known than dinosaur genera. Yet there are far fewer popular books concerning fossil mammals. Besides the Internet, references listed in the accompanying footnote will be helpful in getting you get started.[5] Museums or universities usually also have some fossil mammal bones on display. Make it a priority to see them.

Generally speaking, few realize that mammals had a good running start, way, way back in the Late Paleozoic Era, evolutionarily speaking, long before dinosaurs came to prominence. For instance, despite their reptilian mien, those Permian finback (pelycosaurian) reptiles discussed in chapter 12 were forerunners of paleomammals, quite paradoxically, as they are closer to humans in phylogeny than any dinosaurian. By the time of Mesozoic

dawning, primitive, ancestral protomammals had established themselves along several lineages. While the earliest varieties were not true placental mammals (i.e., our kind), during the Late Permian and in between mass extinctions episodes, therapsid creatures such as gorgonopsians, dog-faced cynodonts, strange dicynodonts (e.g., *Lystrosaurus*) and the Late Permian, bizarrely headed *Estemmenosuchus* enjoyed a warm-blooded lifestyle. But while their physiologies may have strayed toward the mammalian, skeletally their anatomy evinced traits of their more ancient reptilian forebears, such as a sprawling (rather than upright, pillar-like), quadrupedal gait. Although commonly restored as scaly-skinned creatures, that's not a foregone conclusion, as some of these animals such as the 200-pound, wolf-sized, Early Triassic and evidently quite ferocious carnivore *Cynognathus* possibly bore canine-like whiskers and were fully clothed in fur. As a group, pelycosaurs expired by the Late Permian, while the last of the therapsids persisted until the Middle Jurassic Period.

Questions have arisen as to why, if these mammal-like reptiles (e.g., therapsids such as *Moschops*) gained a foothold prior to the advent of dinosaurs, they were unable to maintain their supremacy beyond the Middle Triassic. This mystery has never been fully resolved, although certainly the vagaries of life (including ecological crises beyond organismal control), and innate anatomical and metabolical advantages that evolved within ancestral forms which eventually gave rise to early dinosaurs, are central to the issue. Beyond deterministic factors, there's always the intangible matter of pure chance, or contingency, too. While dinosauria grew steadily larger through geological time on their path to planetary dominance, the size reversal tendency toward diminutiveness in well-insulated mammalian (e.g., shrew-like) forms proved pivotal toward their survivability over an ensuing 150 million years. That they were not, perhaps, ecologically specialized and could burrow and perhaps hibernate for prolonged periods into their hidey holes when bad tidings erupted aboveground aided survivorship. A good thing too, because otherwise, we would not be here sculpting our predecessors!

By the Late Cretaceous, several groups of mammals had evolved, many of them insectivores including egg-laying monotremes, opossum-like marsupials, an extinct grouping known as multituberculates, and of course placentals such as us. All of these were descendants of genuine mammalian ancestors first appearing in the Triassic, which in turn had evolved from the earlier therapsids. Then — to the exclusion of many other contemporary species of fauna and flora — mammals finally had what amounted to a very good day — a mere moment in geological time — when a large asteroid plunged through our atmosphere 65 million years ago, allowing their warm-blooded descendants to inherit Earth. The history of life is, after all, a process of lucky survivorship coupled with quirky, selective elimination.[6]

For an unimaginably long time mammals of various bloodlines bided their time, pro-

Opposite top: (Figure 14–4): Showing a dorsal view of Allen Debus' two fighting *Arsinotherium*. Model base is 21" long (Debus). *Middle:* (Figure 14–5): Allen A. Debus' 8"-long, ancestral Oligocene rhino, *Subhyracodon* (2000), sculpted as a gift for paleontologist Donald Prothero. *Bottom:* Allen A. Debus' 11"-long, *Brontotherium* sculpture, dating from the Late Eocene, produced as a Hell Creek Creations model in 1998. Both genera were examples of primitive odd-toed ungulates. Free-standing armatures were used for both sculptures (note that the armature used for building the *Brontotherium* prototype shown here is not the one shown as figure 4–2, although something similar was used) (Debus).

liferating in the shadow of dinosaurs although perhaps often serving as prey to some. Regardless, despite their unheralded patience and heroic tenacity, few of you will be tempted to sculpt a shrew-like or rat-sized paleomammal nervously peering from a hidey hole, or even a squirrely critter hugging a tree branch, glancing toward the preternaturally luminous sky, an awful harbinger of doom. Yes — the asteroid of hope and change! Considerably larger forms evolved from those lucky survivors during the Tertiary and Pleistocene periods that you will doubtless be most tempted to sculpt. This — the heyday of prehistoric mammalian life — will most likely become the source or "strange attractor" of your inspiration.

One of the earliest creatures, dating from the Late Eocene, which would seem astonishing were we to witness one alive, was the 16- foot-long *Andrewsarchus*, a rather mysterious beast which had a 3-foot-long skull set with powerful bone-crushing teeth. An imposing terrestrial omnivore, it belonged to an extinct family of mammals known as Mesonychids, whence may have come the whale lineage (as formerly hypothesized, yet no longer generally accepted). Curiously, while it is often referred to as the largest land carnivore, only a portion of *Andrewsarchus'* skull exists with several intact teeth. Yet it is commonly restored with a bear-like body.

When it comes to paleosculpting, you must decide the species and the armature design, and connect that design to a story — an incident unrecorded in time. Test the limits! Be

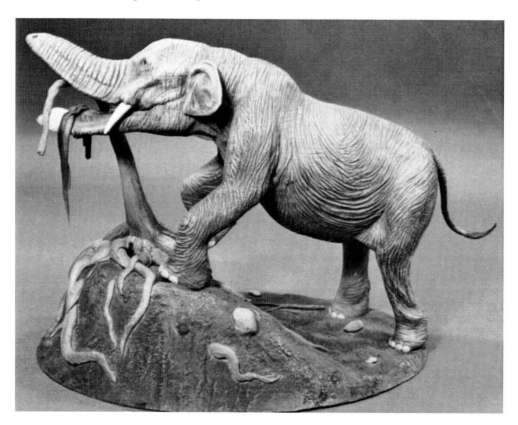

(Figure 14–6): Bob Morales' *Platybelodon*, an ancient "shover-tusker" elephant known from the Late Miocene of Europe, Asia and Africa. During the early 1990s, the prototype was reproduced as a model kit by Lunar Models (Morales).

creative and strive to do what others have not done already. Try a swimming *Zeuglodon* (now formally *Basilosaurus*), a 60-foot-long, tiny-headed Eocene whale, for example, chasing after prey.

Once motivated, you'll realize there are limitless possibilities. Typically, however, paleosculptors find the strange knobby horns of Late Eocene titanotheres, uintatheres, and those of twin-horned *Arsinotherium* tempting (figure 14–4). Unlike the condition in horned rhinos, their horns were made of genuine bone. North American *Brontops* and the Mongolian *Embolotherium*, (figure 14–5) for example, both stood 8 feet tall at the shoulder! (Fossil rhino horns consisted of tightly interwoven hair fibers, more prone to decomposition after death.) Proboscidea (elephants) are fairly easy to recognize when sculpted, but a host of paleo-elephantine species evolved through geological time on several continents, many with peculiarly shaped mouths and teeth. Besides the more familiar mastodonts and mammoths, there were deinotheres with downturned tusks and odd looking "shovel tuskers" such as *Platybelodon* (figure 14–6). The Plio-Pleistocene elephant, *Anancus*, known from southern France, had impressively long and proportionally extended tusks.

Rhinos came in all shapes and sizes, from the gigantic, 16-foot-tall, hornless rhino *Paraceratherium*, to the hippo-sized North American Miocene genus *Teleoceros*. The most remarkable rhino horn of all belonged to the *Elasmotherium*, an Ice Age genus thought to have been endowed with a magnificent 6.5-foot-long horn.[7] Through geological time, while rhinos suffered increasing waves of extinction, marked by decreasing diversity, the evolutionarily related horses (odd-toed ungulates) not only evolved to greater sizes but managed to hang on with greater persistence to the present day. Oddly shaped Miocene chalicotheres, clawed ungulates distantly related to brontotheres, horses and rhinos, would make another well chosen sculptural ambition (figure 14–7).

Armored glyptodonts with their armored shells and tails, reminiscent of the Late Cretaceous ankylosaurs and evolutionary cousins to Texas armadillos, were among the earliest fossil mammals to be scientifically described from South America. (In fact, Hawkins planned to sculpt a pair of glyptodonts for his Palaeozoic Museum menagerie. But it never happened.) Perhaps the most famous glyptodont, *Doedicurus*, wielded a spiky tail that looked like a

(Figure 14–7): Allen A. Debus' miniature, 1/12-scale sculpture showing *Moropus* (at left) engaging *Dinohyus* (the Miocene age "Teminator Pig"). The model base is 24" long; the animals were baked separately and subsequently (after cooling and painting) joined to the wooden base (atop the individual, thin Super Sculpey bases). The *Moropus* armature may be viewed in figure 14–9 (Debus).

(Figure 14-8): Three views of Allen A. Debus' Pleistocene scene (2001) involving the glyptodont *Doedicurus*, and two large flightless birds, *Andalgalornis* (at right) and *Titanis* (at left in lower two images). For considerably more, concerning this diorama scene, see "A Plio-Pleistocene Primer: Glyptomaniac with 'Big Birds,'" by Allen A. Debus in *Dinosaur Memories: Dino-trekking for Beasts of Thunder, Fantastic Saurians, "Paleo-people," "Dinosaurabilia," and other "Prehistoria"* (Author's Choice Press, 2002), pp. 191–220 (Debus).

medieval mace (figure 14–8). However, contrary to certain restorations, its tail was rather inflexible. Posterior tail vertebrae were encased in a bony caudal tube that restricted motion; the stiffened tail could, however, be swung using muscles in the caudal ring area near the rump.

For reasons lost in the echo of time, Cenozoic prehistoric mammalian fauna of South America and Australia evolved a parallel existence, although favoring marsupial lineages, relative to North America's, Europe's and Asia's placental-dominated fauna. Niches vacated by dinosaurs and pterosaurs 65 million years ago were surrendered to species that evolved into mammalian forms vaguely reminiscent of those found in northern regions, and at similar epochs in time. Giant, carnivorous killer kangaroos, marsupial saber-tooths (i.e., *Thylacosmilus*) and lions, rhino-sized wombats — it doesn't get any more exotic than this.

There are technical advantages to sculpting some forms of prehistoric mammals relative to dinosaurs. Because many of the most popular fossil mammals were stocky quadrupeds, their armatures will be robust, sturdy and relatively easy to construct. One can readily fill out their body cavities with aluminum foil or styrofoam. If you make casts of your sculptures later, you will find that demolding and finishing rounder and bulkier forms — such as giant ground sloths and toxodonts — may be less complicated than is the case with scaly or feathery dinosaurs and dino-birds.

The following highly generalized tips, observations and insights may prove helpful when it comes to sculpting prehistoric mammals:

Although they are perhaps a bit less available than the omnipresent dinosaurs, with a bit of patience you will find skeletal reconstructions of the species you are interested in or have a hankering to do. Having suitable reference material is always key. You may photograph museum mammal skeletons (both modern and especially prehistoric might be helpful), or directly rely on published photos. If you have pets — cats or dogs — observe how they move, slink, slake their thirst and interact curiously with their environment. Go to the library to find books and magazines (e.g., *National Geographic*) presenting wildlife photographs of living mammals to better understand their movements, because their posturing, motions, expressions, behavior and temperaments may be reliably or convincingly translated into that of their extinct ancestors.

To the best of your ability, draw your subjects effectively to gain familiarity with how the three-dimensional construction will look and proceed through all critical stages. These days, one may scan photographs, drawings or reconstructions into a personal computer and then size the images accordingly, to the scale of your intended sculpt. Keep that ruler handy as you go. And, ahem ... did we say *draw* your creature? Proper visualization is key. Sketching key stages of how the model will look, from armature construction to final form, before you begin sculpting, will frame your proper mental mindset for how everything should come together in sequence, successfully. And please (a special appeal to beginners), to avoid certain disaster, do not attempt to do everything in a single day! Practice patience.

After creating a two-dimensional design drawing that feels right, construct an armature using techniques outlined previously (figure 14–9). The savvy and talented Sean Cooper goes the extra mile in sculpting a miniature skull, including the teeth, of the beast he intends to create, which is oven "pre-baked" to hardness and added to complement a more elaborate-looking armature. Cooper states his favorite examples of paleoart are "sculptures, paintings and illustrations that depict dinosaurs and other prehistoric animals in ways they may

(Figure 14–9): The simple wire armature with a thin coating of baked polymer clay along the vertebral wire for the *Moropus* seen at left in figure 14–7 (Debus).

have appeared and acted within their habitat; the ones that give you a real vision of a working ecosystem."[8] The fact that we are more conditioned to seeing mammals in our everyday environment than reptiles may facilitate our ability to imagine how paleomammals interacted with their environment.

Breathe life, expression and fire into those old bones with polymer clay. Through your fingertips, those clumps of cold, hard Super Sculpey will be transformed into a living entity, revivified from the latest Ice Age or some even more remote time.

Many mammals have a hairy look, and this appearance can be expertly accomplished by gently striating the surface of the body using an appropriate sculpting tool, or with the broad edge of a scalpel. (Use the Baggie Trick when making these impressions.) Dense, hairy coats can be added as thin polymer clay rolls that are affixed to the body using sculpting tools and then more firmly striated with the sharp end of a sculpting tool. Lightly sand over the ridges later after the sculpture has been baked and hardened to create a matted look. Thinner layers of fur can be realistically suggested with lightly applied, shorter markings, achieved through use of a fine dental tool (as in the case of non-mammalian pterosaurs). Skin creases, folds and rolls can be added in all those saggy body places. Elephant-like hide can be enhanced using the Baggie Trick. A mechanical Dremel tool, deftly applied to oven-baked, hardened surfaces, can also be of service in creating furry ridges and tufts of hair during final sculpting stages.

Tusks and horns are relatively easy to make as pre-baked parts, using the techniques previously described for dinosaur teeth and armor, but should be relegated to a later phase of your project (after correct bodily proportions have been achieved to your level of satisfaction). Due to their recent existence in geological time and to their former global ubiquity, *Mastodon* and mammoth relics, including tusks, are relatively common as fossils and are found in many natural history museums. You should examine these before beginning. Pre-

bake those fangs, horns and tusks, sanding them to menacing sharpness, then insert them into the unbaked polymer clay hide of your beast. Ears and eyes may be pre-baked in this fashion. Make your animal roar and bellow!

Mammals have protruding ears and lips, and sometimes fleshy trunks. Until ancient cave art had been witnessed by the eyes of modern man, it was not realized that the great woolly mammoths grew layers of subcutaneous fat (humps) over their spines, as may have been the case with certain dinosaurs. Apply your knowledge of living mammals to flesh out these rarely preserved body parts in your sculpture.

Paleoart of the past on canvas, especially by Bruce Horsfall, Charles R. Knight, Jay Matternes and Zdenek Burian, should be consulted for inspiration. A book by Charles R. Knight, *Animal Drawing: Anatomy and Action for Artists* (1947), will help you in effectively and convincingly creating mammalian expressions.[9] Knight's instructional book emphasizes drawing techniques, but his ideas can be applied to sculpture. Knight, incidentally, expertly sculpted many fossil mammals, such as *Hyracotherium*, the "dawn horse" (formerly *Eohippus*),[10] *Smilodon*, cave bears, a Miocene rhino, the Irish Elk (*Megaloceros*, really a deer) and several genera of primitive elephants (figure 14–10). He would be considered a real trend setter, if only more of you would follow in his stead. Collecting plaster casts of Knight's

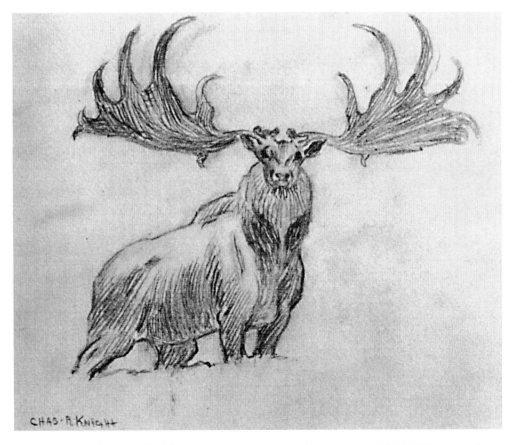

(Figure 14–10): **Charles R. Knight's preliminary sketch used for scaling up his Field Museum of Natural History mural painted during the late 1920s (A. Debus).**

prehistoric mammals would cost a fortune today. So, rather than living in the past, why not sculpt your own classy originals?[11]

Examine photographs of Pleistocene cave drawings made by ancient artists for hints as to how majestic mammoths and woolly rhinos may have appeared roving across the frozen tundra. After all, these were authentic life studies made by the real paleo-artists.

Prehistoric mammals have their closest relatives in living mammals. Zoo animals should be observed for their form of motion and temperament. Study modern mammals and project your observations into the form of their ancient ancestors. The study of paleomammals is a vibrant field, so do not take it lightly simply because dinosaurs are generally more popular today.

And despite the fact that living relatives of mammoths, giant ground sloths, etc., survived into modernity, in many respects, accurate depiction of fossil mammals through sculpture poses more challenges than is the case with those ever-popular dinosaurs. From Victorian times through the Flintstones' heyday, vicious saber-tooth cats have remained popular. A recently published book by Alan Turner, *The Big Cats and Their Fossil Relatives*[12] will facilitate selection of a fossil feline. Most people will recognize a saber-tooth cat as a cat only if it is imbued with feline expression. So, try to make your efforts as convincing as possible. Being even a little off the mark may prompt unwanted giggles. Remember — you'll want to sculpt a snarling, savage, saber-tooth from the Tar Pits, not Hanna Barbera's "Snaggletooth." (Remember John Fischner's advice?) According to current thinking, saber-tooth cats used their famous sabers conservatively so they wouldn't be broken during combat or while bringing down prey. The Tertiary and Pleistocene abounded with many other fearful genera of carnivores as well, besides felines.[13]

Finally, don't neglect our own 3.5-million-year history and lineage, for you can also sculpt fossil humans! In the case of Neandertal Man, however, you should be aware that older restorations were often based on fossilized specimens since proved to have been afflicted with an arthritic bone disease. So avoid sculpting your Neandertals dismally in the slumping, stooped posture frequently observed in older restorations.[14] Or consider sculpting the enormous, 10-foot-tall Asian form, *Gigantopithecus* (the "real" Kong), dating from the Middle

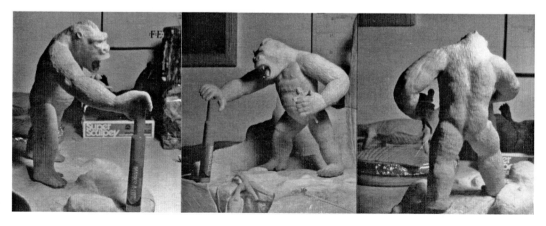

(Figure 14–11): Three views of Bob Morales' giant prehistoric ape King Kong, anatomically posed in a scene where the giant ape battles a vicious pterosaur on a cliff ledge, as in a scene from the 1933 RKO film (Morales).

(Figure 14–12): **A restoration of the woolly rhinoceros painted by Charles R. Knight.** Image from H.F. Osborn's ***The Origin and Evolution of Life: On the Theory of Action Reaction and Interaction of Energy*** (New York: Charles Scribner's Sons, 1918), p. 272.

Pleistocene, circa one million years ago (figure 14–11). A VHS videotape by Wayne the Dane Hansen, titled *Sculpting Monsters, Fantasy and Human Figures*, which unfortunately is no longer produced, offers a wealth of instruction on sculpting human figures in Super Sculpey. Perhaps you can find a copy on Ebay.

A wonderful assortment of prehistoric mammals — many never before seen in sculpture — are awaiting the hands of paleosculptors. Go "capture" one and bring it back alive!

Head to those happy hunting grounds of yesteryear (figure 14–12).

15

Putting It All Together,
A to Z: Sculpting *Liopleurodon*

Up to this stage, we've outlined general "how to do it" techniques in separate, categorical chunks, along the way suggesting which methods might seem more basic to beginners, versus those which are conceivably more advanced. We've offered basic or essential tips on how to make certain groupings of dinosaurs and prehistoric animals, while suggesting themes to explore in sculpture, how to pleasingly make details such as teeth and eyes, and how to make your miniature creations come alive in realistic settings. Now we'll swiftly put all these sculpting techniques together, sequentially, in Bob's prehistoric animal project — the giant, Late Jurassic, sea-roving reptile, *Liopleurodon*, which was not a genuine dinosaur but which lived during the Mesozoic.

Let's get started — showing all sculpting steps involved including those considered advanced.

When creating a dinosaur sculpture, you must be prepared. If you haven't already chosen a creature to sculpt, this is the first step. Dinosaur paleontology has a very wide fan base, and a variety of relevant resources may be found in libraries and bookstores and on the Internet. Observing drawings or sculptures made by other talented or innovative artists can be an inspiration.

Having chosen one of the many dinosaurs available for restoration, research is the next important step of the process. Research may sound pretty dull, but it need not be a tedious chore. Plus — learning is fun! These days, the first choice for seeking information is undoubtedly the Internet, and there are numerous credible sources of research material available online. In this case, typing "Liopleurodon" into a search engine presented dozens of sites with facts, theories, documentaries and articles, painting a clear picture of what a fascinating animal it was. For those who prefer the time-tested research methods, checking references in your personal collection and at your public library, observing plastic toy models of your dino-monster, or consulting magazines and trade publications (such as *Prehistoric Times*) will present a concrete depiction.

After acquiring necessary facts concerning *Liopleurodon*, one can begin to imagine the scale and features of the living creature. Known as the extinct "sea crocodile," it has been estimated at perhaps 40 to 80 feet in length! It had the hallmark features of an aquatic predator: four large flippers and a huge skull containing long, sharp teeth.

Beyond what fossils can provide, an artist's interpretation becomes necessary to hone

the details. Were all Mesozoic reptiles (both terrestrial and marine) sheathed in scaly skin? No one can say for sure, but in restoration work we must consider the living creatures we have today as well as the dinosaur's environment. Were aquatic reptiles covered in barnacles? Conjecture concerning the appearance of an extinct animal is an important step leading to an accurate portrayal. For example, many dinosaurs have been depicted with reptilian-like scales, bumps, ossicles and hornlets. Mummified skin impressions of duckbills, sauropods, and even one theropod, the *Carnotaurus* have been unearthed, providing fairly direct information. Again, it is acceptable to apply some creative license, but for a realistic result avoid getting too outrageous!

Focusing now on the *Liopleurodon*, one must assimilate research materials. Good reliable source photos and other visual information can be photocopied; do not be afraid of having the photo span more than one page. You can tape it together afterward. The more detail you have, the better. Two good plastic toy models that may be used for reference of the *Liopleurodon* are the British Museum's Invicta Plastics *Liopleurodon* and a small figure from Safari, Ltd. Obtaining these or models from other sculptors will make it easier to understand how much artistic license has already been taken in regard to restoring *Liopleurodon*. For instance, the Invicta and Safari models differ slightly in the creature's body bulk, flipper shapes and conjectured skin texture. Even with subtle differences, both were well crafted and there was no confusion about what they represent. Assuredly, prepared sculptors should feel comfortable with their designs even if your model doesn't equate fully with others.

The *Liopleurodon* sculpture featured here was a commissioned piece, constructed at 1/20 scale; it is about 26 inches long. This scaling was based on one of the largest known reconstructed fossil specimens.

After making photocopies, it may be helpful to use a permanent marker or pen to trace the outlines of the figure (sometimes edges do not transfer as well as we would like them to). From here, envision the model's swimming pose, because the model's armature will be assembled accordingly. Begin with scaled sketches that can be readily referred to, so you will not lose track of your original concept.

Have sufficient wire, polymer clay and sculpting tools handy. A basic checklist includes a pair of pliers, ruler or tape measure, a permanent marker, wire cutters and wire tools. Many hobby stores sell sculpting kits comprising an ideal combination of such tools, though the aluminum wire (available in different gauges, or thicknesses) will most likely be sold separately. If you cannot find these in a hobby shop, a hardware or art supply store would be your next best destination. There are also many Internet sites dedicated to providing art and sculpting supplies.

This *Liopleurodon* model was intended for a resin hobby-kit release. Such models need to be sectioned (cut) after completion in order to create molds of individual parts. In this case, all four flippers, the head and neck section, lower jaw and tail were to be sliced off for molding later on, and so aluminum wire was chosen for supporting these body sections. Aluminum is much easier to cut through than steel coat-hanger wire, yet still strong enough to provide stability to the limbs. For models that will not be sectioned, stronger wire is optional but recommended.

A word of caution: after cutting or trimming the aluminum wire, the ends of the wire can be very sharp. So when bending and cutting wire it is advisable to wear eye protection and perhaps even a pair of rubber surgical gloves that won't deter dexterity.

Wire of several gauges, or thicknesses, was selected. The thickest wire was used to fortify the neck, main part of the tail and body, serving as a one-piece foundation for placement and attachment of sections having thinner aluminum wire armatures. As previously mentioned, aluminum wire was used for the more delicate or smaller body areas, such as the flippers, the end of the tail, and to secure the pelvic section and shoulder section to the main body section (figure 15–1).

It's easiest to determine the length of wire needed for the head, neck, body and tail by simply placing wire intended for the armature over your scaled reference photos, prior to cutting (figure 15–2). Thicker wire should be cut an inch or two shorter than the entire length, so that thinner-gauge wire can be attached to support the more delicate, smaller areas to be sculpted, such as the tip of the tail. The basic curvature of the neck, spine and tail should be fashioned as seen in accompanying photos (figure 15–3). After this main support section is cut properly to length, wire should be cut for the following anatomical regions: the pelvis and rear flippers, the shoulder and front flippers, and finally, the lower jaw. Your wire armature needs to be a bit smaller than the finished sculptural dimension will be, since polymer clay will surround the armature, bulking-out your animal sculpture.

After shaping the head outline, body and tail from your scaled drawing, approximate the distance from the spine to the shoulder socket and slightly bend the armature wire there with the pliers. This will form the location of the shoulder. The same should be done for the pelvis and the hip bone. When these joints have been situated to your satisfaction, smaller gauge wire can be attached at a bend made in the shoulder area, and from there extended downward, all the way through the basic shape of the front flipper, ensuring that the flipper shape in the wire is smaller than the finished size of the sculpted flipper. After the flipper's armature is made, wrap the wire back around the thicker-gauge wire of the shoulder and the spine to secure it tightly in place. This same process should be used to complete the other flipper as well, anchoring it to the spine as the last step (figure 15–4).

This same technique can be repeated for the rear flippers and pelvic region, but take care to keep the size proportional: the front flippers should be slightly larger than the back flippers. Avoid finger cuts on sharp ends of the wire (figure 15–5).

Creating the basic shape of *Liopleurodon's* body (the ribcage and belly) can be done with scraps or pieces of used Styrofoam (figure 15–6). If you have packaging from DVD players, television sets or other household electronics, these will provide an ample supply of sculpture-quality foam material. This kind of Styrofoam tends to shrink more uniformly than the type that you might find at arts and crafts stores, which has a very rough and porous surface.

Styrofoam emits harmful vapors when heated to the temperatures you'll be working at, so it's very important to have good ventilation during the baking process. Some homes have fans above the stove that will minimize exposure to any harmful vapors that may be emitted. If a fan isn't available, make sure that doors or windows can be opened (weather permitting) so that fumes can escape.

With the wire armature complete, now it's time to carve the body mass out of a Styrofoam block. Mark the Styrofoam piece with a permanent marker while holding it under the ribcage area for measurements (figure 15–7). For the next step, make sure to work over a trash bin. Using a knife, carve the Styrofoam into its proper shape; start cutting down the length and then smoothing corners and edges (figure 15–8). Keep your reference sketch

or illustrations handy. It's advisable to label the top, bottom, left and right sides with your pen or marker. The Styrofoam piece should be slightly smaller than the finished parts to be sculpted over the foam. Hold the Styrofoam against your illustration; the outline of the body shape on your drawing should be visible. Carve or sand edges until you can just see the lines surrounding it.

Now that you've properly shaped your Styrofoam torso piece, you may focus on creating a shell, which will lead to a more detailed surface.[1] For smaller areas, such as the head, neck, tail and limbs, it isn't necessary to use Styrofoam filler. However, if your sculpture happens to have a very large tail or neck, Styrofoam may be used for the areas at the base of the neck and the base of the tail, but not at the ends of the neck or tail. This particular *Liopleurodon* sculpture's neck and tail areas were uniformly made of polymer clay, lacking Styrofoam innards (figure 15–9).

Before the finished Styrofoam body can be secured to the main wire armature, a groove or trench should be carved out of the Styrofoam body where its back will touch the aluminum wire spine. Place the Styrofoam body against the armature spine or vertebral wire, then use your marking pen to draw two parallel lines, one on each side of the wire armature spine (figure 15–10). Then repeat the process that was used when carving the Styrofoam body: carve the trench out on the back while holding it over a trash bin; make sure it is deep enough that the armature spine fits snugly into this groove. Another preparation step that may be useful is to extend some wire downwards representing attachment sites for the shoulders and pelvis. This wire can then pierce the foam body as you push it onto the armature spine to help hold it in place. Now you are ready to attach the Styrofoam body to the armature (figure 15–11).

Take the carved Styrofoam body and, using the small gauge of aluminum wire, attach one end of the wire to either the shoulder region or the pelvis, securing the wire by twisting it around this anchor point several times (figure 15–12). Wrap the wire around the foam body several times while holding the Styrofoam in its place against the spine; the wire will support polymer clay that will lie over the armature and foam. Once the wire is wrapped securely enough, harness the end to the nearest attachment point, whether it's the shoulder or pelvis area. To tighten the wire around the foam body, use two fingers to crimp the wire in several spots to give a snug fit of the "ribcage" wire over the body. Now you can start placing polymer clay over the body section.

You'll need a flat piece of board or plywood and a small rolling pin. A small piece of pipe can also be used as a rolling pin, a section about 6 inches long and perhaps ½ inch wide. Hold a plum-sized piece of polymer clay, kneading to soften it. Flatten this piece with your fingers and hands and then place the clay on your flat piece of board. Use your rolling pin to flatten out this piece of clay to a thickness of about ¼ inch. (The sheets of clay may be rolled thinner, depending on the size of your sculpture.) Repeat this several times, thinning several sheets of clay, which will be wrapped around the Styrofoam section and the armature, including the shoulder and/or hip section (figure 15–13). Slightly overlap these sheets on the body and blend the pieces together with your fingers. Create a fairly smooth surface; additional layers of polymer clay will later be applied over these initial sheets.

Press thin sheets of polymer clay onto and over the Styrofoam body surface. This will facilitate adhesion of polymer clay to the Styrofoam body and the wire armature. Excess

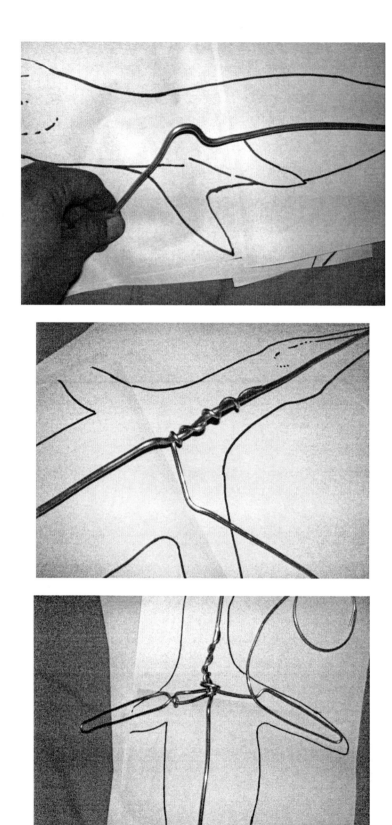

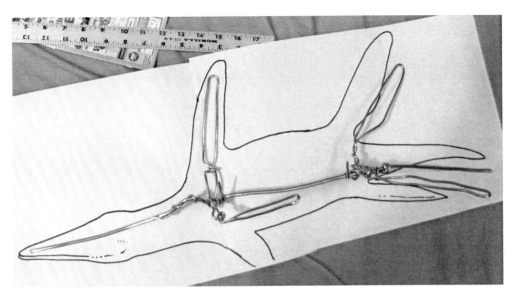

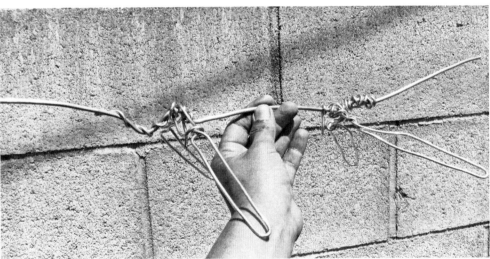

Opposite top: (Figure 15–1): The thickest gauge of aluminum wire is measured out, and bends or notches are made where the shoulder section and the hip section wire pieces will be fastened (Morales). *Middle:* (Figure 15–2): Once the main body section of wire is measured out and cut, at the point where the notches are in the wire, the wire shoulder section is fastened to the main body section with a thinner gauge wire. This is repeated for the wire hip section (Morales). *Bottom:* (Figure 15–3): Once the shoulder section is fastened with more wire, the armature is laid across the reference illustration to check for proper alignment and proportions (Morales).

This page top: (Figure 15–4): With the aluminum wire armature completed, it is placed along the reference illustration to check for accuracy in proportion and proper alignment of the hip and shoulder sections. Finally, a section of wire will be added to the head, to be used for the lower jaw. Next, a section of wire is wrapped around or attached to the areas of the shoulders and the hips, underneath, and the end of this wire is bent to point downward from the spine. Acting as pegs or rods, these extensions of wire will punch into the carved styrofoam body, helping to attach it to and align it with the armature (Morales). *Bottom:* (Figure 15–5): With the armature completed, we're now ready to make the carved Styrofoam body that will attach directly to the spine, hip and shoulder sections (Morales).

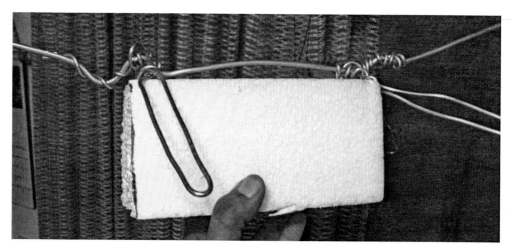

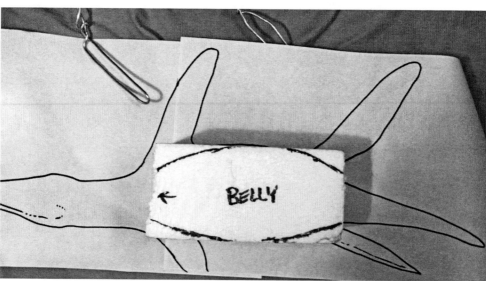

clay from these sheets, which extend over the shoulder and hip region, will be sculpted over the armature, anchoring the entire body section to the hip and shoulder areas. Once your polymer clay sheets are in place, take a sharply pointed object, such as a nail or dental tool, and puncture the clay in several places around the body. This will allow air to escape from the clay-covered Styrofoam body while it is being baked in your oven. If holes are not punctured in the clay sheets, air may become trapped inside of the body section. This would cause cracking of the hard shell. Neglecting to punch these tiny holes through the polymer clay sheets would also cause large bubbles to form in the body section, because air trapped inside will expand with the heat of your oven, much as a hot air balloon will inflate and burst if filled with rapidly expanding hot air (figure 15–14).

Set your home oven at about 10 to 15 degrees below the specified temperature on the Super Sculpey or polymer clay packaging. In this way you will be able to solidify the polymer clay without completely curing it. Generally speaking, the higher your oven temperature and the longer the item is baked, the more the polymer clay will shrink.

Place your in-progress sculpture on a cookie pan or baking sheet. Bake the clay-covered

Opposite top: (Figure 15–6): From a section of Styrofoam, a piece is cut to length, approximately the size of the hip-to-shoulder area (Morales). *Middle:* (Figure 15–7): Using a Sharpie pen or marker, the basic shape of the body is drawn directly onto the Styrofoam piece. This is done from all four views: top, bottom, left and right (Morales). *Bottom:* (Figure 15–8): It is strongly advised that the next two steps be done outdoors, with the Styrofoam being held over a trash can, and also for the best possible ventilation. The Styrofoam body section is carved carefully, using a household steak knife (careful please, sharp!). Carving more or less along the drawn-on lines, the basic shape takes shape (Morales).

This page: (Figure 15–9): "Why," readers may wonder, "are there matches in this photo?" When the Styrofoam body is carved and rounded as much as it can be, still retaining the rightly proportioned shape, wooden matches may come into play (outdoors only). Take the lit match and skim it quickly over the surface of the Styrofoam to melt and shape the body. But avoid lingering with the match too long or too near the Styrofoam, so as to prevent it from catching fire. Again, please be careful with the knife (as in figure 15–8) and with matches. Don't get injured! Safety first, and also see note #1 to this chapter (Morales).

Above: (Figure 15–10): Draw a line on the Styrofoam piece, on both sides of the aluminum armature spine so that a trench can be carved out, permitting a snug fit of the body onto the armature wire. This trench was contoured as closely to the curvature of the vertebral wire (i.e., spine) as possible (Morales).

Opposite top: Figure 15–11): A view of the carved Styrofoam body within the creature's abdominal area, testing for size (Morales). *Middle:* (Figure 15–12): Once the Styrofoam body is ready, it is attached to the vertebral wire spine with the thinnest gauge of aluminum wire available. The aluminum wire is wrapped around the length of the Styrofoam body, with the wire first fastened to either the hip area or the shoulder area. In this way, the aluminum wire acts more or less like ribs for the body. Using fingers (or needle-nose pliers), the aluminum wire is crimped into small twists. This snugs or tightens the wire around the Styrofoam body, facilitating placement of polymer clay over the body surface. Make many such bends until you feel that the wire is snugly fitting around the Styrofoam body (Morales). *Bottom:* (Figure 15–13): Using a small rolling pin or a piece of clean pipe, sheets of polymer clay are rolled to a thickness of about 1/16". Then the sheets are cut to desired dimensions and are wrapped around the Styrofoam/wire rib body. The sheets then are more or less blended together with fingertips or a sculpting tool so that a single thin layer of the clay surrounds the body. Poke some small holes in the clay after this step. The holes will allow trapped air to escape from inside the polymer clay coating, when the Styrofoam body is later subjected to oven heating. Make sure you have very good ventilation while polymer clay and Styrofoam are being baked in your home oven. under no circumstances should you ever use a microwave oven, because we are using aluminum wire, and you risk fire, or at least damage to your microwave oven, if you use it for this sculpture (Morales).

armature for about 25 minutes, which is enough for the heat to penetrate the thickness of the layered-on clay sheets enveloping the Styrofoam. During this initial baking time, the Styrofoam body will shrink, almost to the point of disappearing. (Again, the importance of having very good ventilation to minimize inhalation of the fumes from the baking polymer clay or Styrofoam occurs must be emphasized!) After 25 minutes, remove the hot cookie pan with the sculpture (using oven mitts, of course) and set it down on a marble kitchen counter or other heat-resistant surface. Allow the sculpture to cool down for at least half

Top: (Figure 15–14): Following the baking temperature and time instructions on the clay box, the armature and initial clay body shell are baked, and when the sculpture is allowed to cool, a hard shell is formed. The internal Styrofoam body will shrink away, sometimes melting down to a small residuum, and you may hear it rattling around inside the body area as you handle it. Next, a fresh lump of polymer clay is lightly pressed onto the surface of the baked shell, which places a small bit of the oil from the clay onto the surface, making for better adhesion of additional layers of the polymer clay (Morales). *Bottom:* (Figure 15–15): Adding more clay to the neck and tail areas of the sculpture, and an additional layer of clay over the body (not pictured here). The shape of the body, neck and tail are sculpted, with details added, in this case the scaly skin texture and various skin folds and random lines (creases) over the body. Small scutes are also added along the back, and larger pre-sculpted spines are inserted into the back, along the length of the spine (Morales).

an hour, but preferably an hour, so that it is possible to pick up the sculpture again for the next step.

With the body shell now cooling, obtain another plum-sized chunk of polymer clay, pressing this uniformly onto and over the surface of the hardened body/shell. Oils from the unbaked clay will help the next layer stick to the baked surface of the body. Once you have saturated most, if not all of the surface of your sculpture, repeat the process described above, flattening sheets of polymer clay with a rolling pin. Again, place your sculpture directly in front of your reference illustration or photo to check that the proportions are still correct. Adjustments can still be made at this point if, for example, the belly needs more bulk or contouring. Also, remember that some artistic interpretation is fine, because we are not certain exactly what these extinct animals looked like. Now place fresh layers of flattened polymer clay over the body shell as described above in the process for the initial layer (figure 15–15).

Now you may complete the sculpture, beginning with the body, then the neck and tail, next adding the contours of the muscles and the skin details, including wrinkles, ripples and the little horny bumps and scales. At this stage, when adding polymer clay that will form the exterior, it is a recommended to wear latex or surgical gloves and to avoid handling the model excessively. This is because heat emanating from your fingertips can soften unbaked polymer clay, smudging the details or leaving untidy fingerprints. Some surfaces that have been detailed with scales, for example, may need to be re-textured if they become obscured due to handling while the other side of your sculpture is being detailed. For this reason, make sure to pay attention to how and where you hold onto your model. After these details are completed, the model can be baked once more to finalize the body appearance before moving onto the next step, which is, in this case, sculpting the four flippers. Since the model has now been outfitted with textural, integumentary details in its soft clay surface, place it on a piece of cotton cloth to preserve these delicate features.

On to the final stages!

Pre-bake a series of short spines for the back, leaving them in the oven for about 25 minutes with the temperature set for 225° F (figure 15–16). Once the spines are removed from the oven and cooled, if they seem too long, use an X-Acto knife to trim them to the desired size. Press the base of the spines into a soft, unbaked piece of polymer clay to again saturate them with the oils, and insert them into the unbaked polymer clay back of the *Liopleurodon*. Carefully sculpt a small ridge or a type of cuticle around each spine so they appear as genuine growths.

After baking this final layer of detailed skin on the body section, allow it to cool properly. Next, you'll want to add flippers. Press a lump of soft polymer clay onto the surface of the attachment points. This will saturate the surface with some oils from the polymer clay. Work on one limb (flipper or paddle) at a time to completion, successively (figures 15–17 and 15–18). Blend the polymer clay onto the body surface, sculpting in the shape and contours of each flipper. Use texturing tools for this purpose. Then you may work on the head and lower jaw, thus capping the assembly. Here, other pre-baked parts such as eyes and teeth can be inserted into the polymer clay's soft surface with ease.

Once all the individual pieces are sculpted and assembled to your satisfaction, a final hardening bake performed at Polyform's recommended temperatures will finish the overall piece.

Congratulations — you've done it! (See figure 15–19).

But wait, if you're interested, there's a bit more.

With the sculpture completed, but only if you intend for the sculpture to be reproduced as a model kit, such as a resin kit, you must cut the sculpture in pieces or sections, which should be done in such a way that when a customer goes to assemble the resin kit replica, very little if any putty filler will be needed for the attachment points, or seams. The method relied on here involves a sharp X-Acto knife, preferably one with a long, thin blade. If you

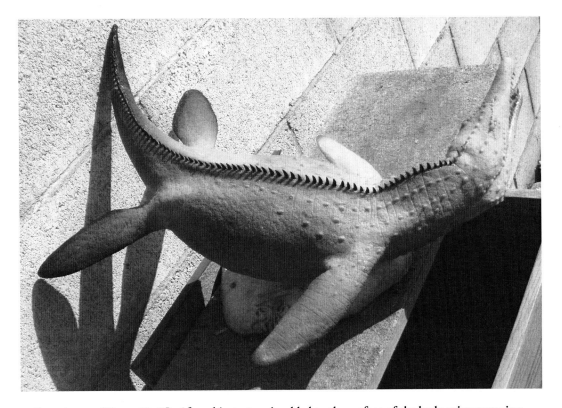

Opposite top: (Figure 15–16): After skin texture is added to the surface of the body using texturing cups, spines are added to the back, with each one sculpted and pre-baked first, and then cut to the desired size. After pushing each spine into a lump of still-soft clay, to accentuate adhesion properties on each spine, they are carefully pushed into the soft clay of the creature's spine (Morales). *Middle:* (Figure 15–17): One limb is sculpted at a time. This will help to avoid doing any damage to any previously sculptured area or limb. Each limb is finished, and the same process is used in sculpting the head and lower jaw. During the baking process, some cracks may form. Don't panic; these can be closed up by carefully placing a drop or two of Super Glue within the crack and holding each side of the crack together while the glue sets. Be careful not to get the glue on your fingers, and have a small, soft cloth handy to wipe up any excess glue. The glue will set quicker if you blow on it, and the still-warm clay causes a quicker bond as well (Morales). *Bottom:* (Figure 15–18): Details can be effectively blended in, forming a smooth attachment between the limbs and the body, and any other part of the body (Morales).

This page: (Figure 15–19): The completed 26"-long sculpture of the Liopleurodon, also known as a pliosaur. The darker coloring on some parts of the sculpture is typical when the sculpture is baked numerous times, and also when the clay in these areas is thinner. This doesn't harm the sculpture unless the temperature in the oven is too high, exceeding manufacturer's recommendations, which of course could burn the sculpture or cause cracking (Morales).

are a young person, please seek the help of a capable adult, as these knife blades will be very sharp and you risk cutting yourself severely.

At this juncture, your sculpture must be baked sufficiently, because if it isn't, the partially baked polymer clay will still be rather rubbery and pliable instead of brittle, even if it seems hard on the outside. Trying to cut a sculpture that is not baked thoroughly may result in pieces breaking or calving away from the edges, which will need repair later.

Begin by marking the sculpture on the areas where you will be cutting, such as inside a skin fold or wrinkle. The *Liopleurodon* was cut into several pieces: the four flippers, tail, head/neck and lower jaw. Some might choose to leave the legs or flippers in place, uncut, rather than separating them from the body, so that fewer silicone rubber molds will be needed, or to simplify model assembly. This may result in a more complex mold, due to undercuts on the legs and feet of your sculpture (with corresponding air vents, as needed).

Now, with the sculpture marked where it will be cut, place your handiwork in the oven once more on a soft cloth, in turn placed inside a cookie sheet or pan. Set the oven for 150° F. This lower temperature will soften the already baked clay sufficiently so that it can be cut with the X-Acto knife. Leave the sculpture in the oven for about 20 minutes. After carefully removing the sculpture and cookie pan from the oven, wait about 5 minutes and then lightly touch the surface of the sculpture to see if it has cooled off enough to handle while wearing rubber gloves. If the sculpture is warm, but not so hot as to hurt your fingers, then you can begin cutting the sculpture.

This is a soul-searching moment! And we feel your pain. Do you really want to start carving up the sculpture that you've labored so meticulously to create? But if you want to make sectioned model-kit replicas, then this really is a necessary next step. Okay—we're going in!

Begin cutting the sculpture, perhaps starting with the legs (or flippers), by stabbing the sharply-pointed tip of the blade into the wrinkle, fold, or fur texture, and be sure to insert the blade deeply, almost to the hilt if the sculpture is large enough. Small appendages such as very thin arms or tails will require that the long blade not be inserted quite as deeply into the baked polymer clay, so be careful. Also, when inserting the blade, if preferred, you may angle the blade to the right or to the left, which will create a concave area on one side of the sculpture's attachment point and a convex side for the other attachment point. Be very careful to follow the lines of the wrinkle or fold and take your time, patiently. You can always place your sculpture in the oven again at the reduced temperature to soften it for the cutting of another appendage—limb, tail, etc. Be very, very careful not to leave your fingers (or flesh) in the path of the knife blade. A sudden slip could mean a deep would, slicing into *you*! Always cut away from your body, not toward yourself (or any innocent bystanders). This cannot be stressed enough. (Bob has injured himself too many times, so you are forewarned.)

Depending on the size of the part that you are cutting, sometimes you'll find that the X-Acto blade will make contact with the wire armature inside, which is okay. Cut the piece completely around the circumference of this wire, ensuring that the termination of your cut or slice meets where your cut or slice began. If the knife cut is deep enough, you will be able to gently pull on the parts, separating the limb from the body, slightly. This will expose the armature and make it possible for the armature wire to be cut—which is our final major step.

Bob prefers to use thin coping saw blades to carefully slice in between the sectioned pieces. Wear a leather glove for this next step. *Carefully* separate the two partially separated parts of baked polymer clay, which have been cut sufficiently, just enough so that the blade will fit in between these parts, being careful not to cut or damage edges of the baked sculpture pieces. Saw the armature wire sufficiently so that you can wiggle the wire armature back and forth until it snaps, separating the two pieces. This is why it is important to use the softer aluminum wire for your armature, that is, if you plan to reproduce it as a model kit. So plan ahead, to the extent possible.

Once the arm, leg, or flipper (or other appendage) is removed with the X-Acto knife, you will be able to clearly see the cut ends of your armature wire. After any protruding wire is ground down with a Dremel tool (our next step), your two parts will fit snugly together, with minimal gaps, if any.

Dremel tools can be dangerous. Adult supervision is required; goggles are highly recommended — always protect your eyes!

To facilitate the moldmaking process (addressed in chapter 17, but for different prehistoric species), using the Dremel tool, grind the protruding sections of aluminum wire armature deeply enough so that if you place the detached sections back together, the armature sections will no longer contact each other. Once this is done, place some putty inside the small holes or gaps in the armature, smoothing the individual pieces. Trial-fit the sectioned pieces, confirming that each detached piece cleanly fits where it was formerly attached. You can also fill in the holes (where the cut armature wire was protruding) with more polymer clay and then bake the piece in the oven at a temperature recommended by the manufacturer for final readiness. But if you do this, then you must *also* place each of the other parts of the sculpture into the oven. Why? Because with each subsequent baking of the sculpture or individual sculptured pieces, a small amount of shrinkage occurs. So if, for example, a leg is baked by itself in the oven, afterward it may not fit quite as cleanly with the rest of the body it was meant to attach to, having shrunk a small percentage while it was baked. Repeat the process for all other limbs, tails, spikes, heads, jaws, etc., and your newly sectioned sculpture will now be ready for molding.

If so desired, after the mold-making process is completed, and if the original sculpture parts are in good condition, you may reassemble your sculpture prototype using Super Glue. By placing your sculpture pieces in the oven at the lower 150° F temperature, the surfaces to be bonded with Super Glue can be heated — allowing the reattached pieces to adhere optimally. At the higher temperature, bonding will be accelerated after applying the glue, so you'll have to work quickly and competently, quickly situating the pieces into their desired positions. Super Glue will adhere quickly on your skin, so be careful and time-efficient. Have a soft cotton cloth handy so that you can wipe away any excess glue that may seep out of the gap where the two pieces have been glued.

Then you're done, so you can now display your original sculptural prototype, nicely painting it. Many sculptors do not reassemble their sculptural prototypes after the first mold is made, however, because a second set of rubber molds may be needed when the first set has worn out.

16

A Word on the World
of Dino-Diorama Building
(Model Bases and Painting)

Landscapes of the West, as painted by 18th and 19th century master painters, have been referred to as "sublime," evoking "the overwhelming emotion produced by a glimpse of the infinite perfection of the divine, 'a sort of delightful horror, a sort of tranquility tinged with terror.'"[1] In the beginning, paleoartists who restored scenes from deep time strove to capture the majesty or sublimity of past eons, or moments in settings plausibly experienced by fantastic animals no man had ever seen living. Charles R. Knight's prehistoric landscapes, for instance, captivate us as we peer into time portals defined by the borders of his picture frames. While striving to recreate living likenesses of prehistoric animals in sculpture to the best of our abilities can be both pleasing and rewarding, many yearn to go one step further in placing these figures into imaginative settings representing past geological ages.

Building miniature dioramas can be a delightful exercise for those yearning to create living environments, staging scenes from deep time (figure 16–1). The possibilities are endless here, and so for practical reasons we'll merely offer starting tips on basic approaches you may try. We'll also explain how to use a few accessory items, which are not essential to the art and practice of sculpting but might enhance your dioramas. For skilled diorama builders — those who regularly design such scenes with resin casts made by other artists or who have model railroading experience — this chapter may seem rudimentary.

Fortified with knowledge of how to sculpt your own original dinosaurs and other prehistoric animals — rather than customizing or converting resin casts made by other paleoartists to fit into an otherwise original diorama design — now you may begin freshly by sculpting your own prehistoric creatures. Our suggestion is to structure your original diorama around your own specially designed prehistoric animal sculptures, instead of adapting elements in the diorama around someone else's sculpture that wasn't built specifically for your imagined scene.

Rather than converting someone else's sculpture with lots of messy putty and glue, and risking your flesh using X-Acto knives, sawing off limbs (the dinosaur's, not yours!), tails and heads to gain that perfect custom contour or body orientation, our recommendation is simply to minimize aggravation by beginning from scratch — your way, on your terms, designing your own models at correct sizes, idealizing proper poses and proportions per

220

(Figure 16–1): Two views (front and back) of Allen A. Debus' "Historical Stegosaurus" (1991), showing three early historical views of how paleontologists thought the plated lizard appeared in life. Model base is 22" long. This simple diorama includes two palm trees and two luxuriant cycads (Debus).

your diorama specifications. Effectively integrate an entirely original dinosaur into a customized scene. This way, your diorama may be uniformly planned and of integral composition.

Okay — remember, you've already read (and practiced) how to create many different kinds of original sculptures. You now realize that proper sketches (including measurements)

are crucial to success (figure 16–2). With diorama building, it is even more vital that you plan everything in advance (being careful as to details), visualizing how things will all come together. While many polymer clay sculptures or resin models cast from these prototypes may be displayed free-standing (without a base), most polymer clay sculptures made for display (even if molded) are mounted on a simple wooden base. The sculpture is painted (often faux-bronzed) beforehand, and the wood is nicely sanded and stained. The dinosaur then can be anchored or pegged into the wood, after carefully applying epoxy to the bottom of the foot (or feet); often a bit of armature wire can be left extending below one of the feet, which may be inserted into a hole drilled into an appropriate position on the wooden base. Epoxy may be lightly brushed onto the end of the wire prior to inserting into the drilled hole. (But don't use too much epoxy.) Five minutes later — allowing for the epoxy to set — voila! This is the simplest kind of display for your sculpture (other than having no wooden base whatsoever, allowing your sculpture to remain free-standing). These look professional and very nice, but hardly qualify as dioramas.

At a slightly higher level of effort and perhaps sophistication, another approach would be to add a suggestion of terrain underlying your dinosaur, inserted between the feet of the model or the belly and flippers of a swimming animal, but overlying any wooden base that is selected for sturdy support. While minimalists might simply paint the flat wood underlying the dinosaur in earth tone or watery shades suggestive of a prehistoric environment, you

(Figure 16–2): Bob Morales' preliminary drawing planning how his *Edmontosaurus* family diorama should appear. For the final sculpted and painted result, see figure 16–14 (Morales).

(Figure 16–3): Allen A. Debus' 1992 sculpture "Vanished Texans," featuring two giant pterosaurs (***Quetzalcoatlus***) resting atop a cliff while a curious sauropod, ***Alamosaurus*** (13"), gazes above the terrain floor. The peculiar rock formations and cave entrance were fashioned from various types of wood. Coatings of polymer clay were applied to the wood and were striated using a sharp-pointed tool to create a faux-stratified (limestone, sandstone and shale) ambiance (Debus).

may be more sophisticated. Terrain may be simple, but it can also become quite intricate. Keeping matters simple for the moment, consider how the ground upon which the dinosaur walks or moves would appear and then sculpt this using polymer clay.

Before discussing foliage and trees, keep in mind that one of the most alluring aspects of building dino-dioramas is that the sculptor may introduce two or more *interacting* animals

(one of which may be a corpse, perhaps partially submerged in a river). First consider that a story may simply be told with two animals on the same base setting without any other terrain or ground slab added. Neglecting momentarily the complexities of molding the pair later on if their figures are intricately joined, extending from a single entwined armature, if these animals are exhibited interacting then you have at least initiated a diorama in its own right. Simply posing *Triceratops* with its horns held menacingly low and forwardly directed toward *Tyrannosaurus* striding relentlessly from several inches away, fully counts as a diorama, for instance, even without any suggestion of added terrain on the model base. But wouldn't most of us prefer to enhance the sense of realism by adding elements suggestive of the paleoenvironment in which these animals interacted?

An imaginative story may even be told, depending on what terrain you select for your composition. There are numerous and heterogeneous kinds of materials and chemicals you may purchase and bring into play for diorama-building, such as those preferred by model railroaders or those who specialize in recreating military battle scenes in miniature. Some such approaches may be quite advanced and beyond the scope of this book. But for our purposes, we'll focus on relatively simple dioramas you may sculpt primarily using polymer clay and a few readily found, store bought or discovered items. Here, we seek merely to provide launching points for further ingenuity and creativity, which is the recurrent motif of our book. (See figure 16–3).

After reading this chapter, however, we encourage serious diorama builders to haunt hobby shops (in person or online) and crafts stores for other non–polymer clay materials (e.g., Celluclay, Durham's Water Putty, white glue, sandy grit) you might consider using to further enhance your diorama. (We also are not going to offer many tips on the safe and correct use of electric drills, sanders, saws and other wood-working tools. If you don't know how to use wood-working equipment or lack access to them, please rely on someone who can explain or do the work for you. As always, be safe!)

Here's how a basic diorama can be simply done.

Sculpting Cool Model Bases

You may sculpt a very thin base polymer clay that can be baked and bonded to the top of your pre-stained wooden base with epoxy. This base will necessarily be flat on its bottom side to conform to the finely sanded wood it will become joined to; the polymer clay base may be contoured, etched, or embossed with elements on the top side that suggest a prehistoric time and landscape. For instance, you can add three-toed footprints trailing behind the feet of your theropod; the sculpted bones of a partially buried or submerged prey animal; eggs from a nesting site; or traces of foliage, rocks, pebbles, or sand dune contours suggestive of a desert environment. Such minimal bases are relatively easy to make and add a feeling of realism or suggest a theme.

The illusion of footprints may be made simply by impressing the feet of a correctly scaled dinosaur model into the thin polymer clay base in the wake of where your polymer clay dinosaur will be positioned (figure 16–4). Then you can scour your backyard or driveway for small rocks and pebbles or sand that can be pressed into the polymer clay base, scattering them randomly around on the surface for authenticity. Super-Glue them into place. Bones may be sculpted or even borrowed from a model kit of another dinosaur skeleton model

Top: (Figure 16–4): Two views of a simple base terrain. A brachiosaur trackway was impressed into the polymer clay base (Morales). *Bottom:* (Figure 16–5): Building up a polymer clay base supported by wire mesh into a hilly prominence. (See text for further ideas and instruction.) For a look at the final polymer-clay base, see figure 8–13, bottom (Debus).

and Super-Glued into place (but *never* bake plastic inside an oven; add plastic elements only after baking). Hobby shops sell small bags of sandy grit that can be added to your ground as well. We'll offer some basic ideas for sculpting foliage later in this chapter.

If your sculpted polymer clay basal terrain will be thicker than, say, half a centimeter but less than three-quarters of an inch, then we recommend using two layers of polymer clay. The bottom of the lower half-layer will be flattened, shaped according to the contour of the wooden base it will be joined to. Then add a layer of old window-mesh screen over the top of the lower polymer clay layer. This will prevent cracking or breakage later on (figure 16–5).

Next, you can add a second, top, surficial polymer clay layer over the wire mesh, contoured to the design of your diorama story. Then bake your base according to manufacturer's instructions. (Note that as the polymer clay base cools after baking, when you remove it from the oven, it is wise to place it on a flat, inert surface and then cover the cooling base at both ends until it reaches room temperature with rather heavy inert objects — placed on top of a clean cloth — so that the polymer clay base does not warp or curl at the ends as it cools.)

Of course, dioramas may be far more elaborate. You can add rocky ridges and prominences made from polymer clay too. Polymer clay may be applied over small, custom-shaped wooden blocks joined to the base in order to create prominences. In such exercises, before fixing the dinosaur to a wooden base you may build a rocky ledge by slathering and contouring thin layers of polymer clay over wooden blocks that are correctly positioned according to your design (figures 16–6 and 16–7). On the wood surfaces, you can drill in several screws that are left raised (i.e., not fully screwed in). These will serve as mechanical bonds to grip the polymer clay into place. Sculpt or contour the polymer clay to appear rocky. You can impress rocks from your back yard, slivers of wood and other natural materials into the unbaked polymer clay to give an impression of horizontal or dipping rock strata. Then add these structures to the completed model or wooden base by bonding with epoxy, painting them accordingly. You may even wish to join or bond your dinosaur, pterodactyl or marine reptile to this raised or elevated sculpted feature. Or pose the animal climbing upslope.

(Figure 16–6): This is the armature setting for the completed scene shown in figure 3–1. Note the wooden block at center rear, which will be covered in polymer clay to create a hilly prominence for the 1854-style restoration of Benjamin Waterhouse Hawkins' *Hylaeosaurus*. The three wire armatures have been inserted permanently into the base. In this case, all sculpting took place with the armatures already securely anchored into the wood. In other words, there was no intention to mold and reproduce any of the individual dinosaur figures as resin casts (Debus).

(Figure 16–7): In this 1994 diorama (*bottom*) showing four historically significant restorations in the evolving idea of the theropod dinosaur *Dryptosaurus* (i.e., "Laelaps"), Allen A. Debus shows (left to right) a kangaroo-leaping bipedal phase of understanding, a restoration patterned after a 1897 Charles R. Knight painting, an 1877 perspective as envisioned by Benjamin Waterhouse Hawkins, and a modern 1980s view, after paleoartist Ely Kish. In the *top* image, we see the four wire armatures already sunk into the wooden base, including a rounded, contoured wooden block that will become a small hilly rise. Note the screws protruding from the rounded block that will form the hill. These will help to mechanically bond the thin layer of polymer clay that will be applied over the block. Because the model was so long, it had to be designed in two separate segments, the left-most portion comprising the two dino-figures at left and including the hilly rise. There was no intent to mold and reproduce any of these individual figures as resin casts, so this sculpture was designed as a one-of-a-kind item, with metal armatures anchored into their respective bases. The gently curving, combined wooden base is 21" long (Debus).

Wire mesh from window screens also offers a means of creating uneven or sloping terrain. However, for such bases you should begin with an already sanded wooden base that is cut correctly and that can be oven baked. (Always select wood for baking that is a hardwood, not a kind that will produce resin in an oven set to 275° F. The latter will tend to crack when baked and the gooey resin is messy and difficult to sand away later.) To avoid further possibilities of warping or cracking we recommend a wooden base of one-half inch to one-inch thickness.

Then, after designing the diorama and deciding where terrain will be sloping upon it, screw the mesh to the wooden base in the locations where it will be at base level. Next, partially drill screws into the wood at other locations to the correct heights/ (i.e., left raised, by not drilling them in all the way into the wood), where the mesh will be suspended above the wood. (Note this second set of screws will be positioned *below* the mesh after it is draped.) Then add clumps and rolls of aluminum foil to provide some support underneath the mesh wherever the mesh will be later draped over the second set of screws and underlying foil. Drape the mesh tightly over this lower assembly, securing it in place with screws drilled into the wooden base at its extremities.

Next, to lock the top side of the mesh into place, drill a few more screws through the top side of the mesh down into the wood, leaving them raised to proper elevations. (Note that the heads of this third set of screws will be positioned *above* the mesh, thus anchoring it into place.) Finally, using your fingers, coat the mesh with a very thin layer of polymer clay. Just smooth it into the interstices. Bake this assembly according to manufacturer's instructions. Then you can paint the raised and contoured polymer clay surface, add rocks and bond your dinosaurs into place. Any screws that might still be visible (at the extremities) should be covered with elements added to the diorama design (rocks, smoothed polymer clay, foliage, etc.). While such bases are usually one of a kind, such sloping, uneven base structures — even with rocks and pebbles strewn about — can also be molded. Lightly brush some epoxy over certain areas of the oven-baked, pre-painted sloping surface, then for extra texture sprinkle fine sawdust that will bond to the polymer clay, producing an interesting ground cover. Really pack the sawdust in densely, though!

Particularly large dioramas may be designed as broken into several wooden base segments and then baked separately, one at a time, before joining (figure 16–8).

As a final touch, consider adding four (one-sided) adhesive felt pads to the bottom corners of your wooden base (which doesn't have to be rectangular, by the way).

Diving into Marine Settings

If your design calls for partially submerged aquatic animals, or a pool where animals will be posed drinking, you have several options. And here we'll offer one additional tip concerning another kind of (dangerous) chemical that will be of utility in designing dioramas — "water." No, not real water, which would evaporate and leave a deposit, but chemicals that can provide the *illusion* of water in a dino-diorama. But first, how can you avoid using other materials, which can quickly add to the cost of diorama building?

Simply by sculpting a raised rocky- or sandy-looking prominence over a relatively flat surface (i.e., the wooden base) onto which some polymer clay ripples have been added by smearing thin clay strips onto the smoothed wood (then bonded into place after baking with lightly brushed epoxy) can suggest a tranquil river or lake environment (figure

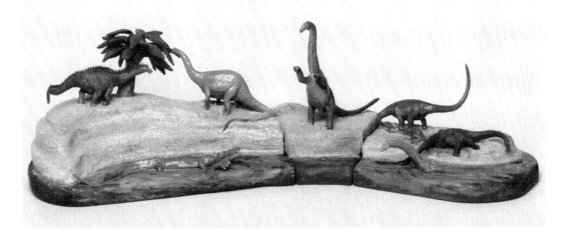

Top: (Figure 16–8): A complex diorama, this time showing stages in the creation of a modern reconstruction of how Benjamin Waterhouse Hawkins' planned Palaeozoic Museum would have appeared had henchmen of Boss Tweed's political empire not destroyed Hawkins' handiwork during March 1871, thus ending the venture. The overall diorama was too large (45" long by 20" wide), so it was necessary to break this into four separate segments, which individually would fit inside a kitchen oven. The development of two segments is shown here. These blocks with partially sculpted figures (left two images) were augmented by a third pertaining to the Cretaceous end of Hawkins' ill-fated museum. In the image at right, the first large block has been baked with figures painted, as a third (upper) block showcasing a long-necked elasmosaur is still in preparation. For a close-up view of the elasmosaur section, see figure 11–13. Note how it was necessary to build up various regions of relative topographical relief (hills and aquatic shallows), using techniques described in the text (Debus). *Bottom:* (Figure 16–9): Man's historical investigations into the study of the mysterious dinosaurs known as sauropods are commemorated in this large three-foot-long, three-piece sculpture. In this study by Allen A. Debus (1994), many contrasting scientific theories and opinions concerning how the sauropods appeared in life have been captured side by side. Ideas concerning the appearance and natural history of dinosaurs have been debated through 16 decades. Note how white limestone cliffs have been built up over a lower shoreline region of wood painted to suggest tranquil coastal waters. Also note the aquatic, crocodilian-like *Cetiosaurus* swimming in the seawater, exemplifying a mid–19th-century view that may be contrasted with the modern image shown in figure 7–5. The model was too large to be baked all together, so it was designed as three separate segments, each replete with anchored-in dinosaurian figures. The interpretation and meaning of this sculpture was conveyed in a short article by Allen A. Debus, "Mysterious Giants: Historical Sauropods," *The Dinosaur Report*, Spring 1994, pp. 8–9 (Debus).

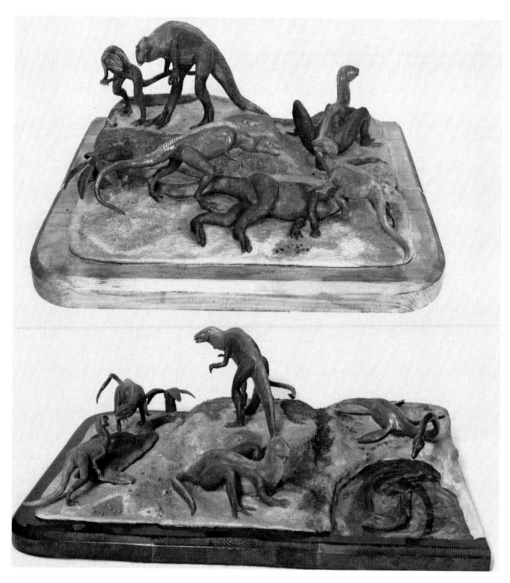

(Figure 16–10): The completed Cretaceous end of the sculpture shown in progress in figure 16–8, as sculpted by Allen A. Debus (1995). Note the subtle join linking the dinosaur-figure segment with the aquatic scene featuring an *Elasmosaurus* and a *Mosasaurus*, visible between the two wooden base segments shown in the lower figure (Debus).

16–9). Or, using polymer clay, you can also sculpt a series of oscillating stormy waves on a wooden base using the wire-mesh technique discussed for uneven, sloping terrain. Then your swimming animal, perhaps a mosasaur with neck and portion of back suspended above the water, can be sculpted from an armature protruding directly from the base (figure 11–15). In these cases, skilled painting will bring out the suggestion of tranquil waters or wave action in frothing sea foam. During a walk along a beach you might collect bits of coral, tiny seashells or starfish that would enhance a shoreline or underwater diorama setting.

You can also carve out or cut an irregular pond into the one-inch wooden base, or

create a shallow depression in sloping polymer clay terrain, fashioned to appear uneven. You can then cut out a polygon of clear, inexpensive, stiff plastic sheeting to cover this submerged area, bonding the sheet into position as a final step. Or, instead, you can pour a liquid polyester resin that sets to a hard transparent finish into these ponds. Clear polyester resin can be purchased at many hobby and crafts stores — but the fumes and heat generated during reaction can be dangerous. Ventilate! An advantage is that the resin can be tinted appropriately, and you can place setting objects (rocks, pebbles, foliage, animals, etc.) within

(Figure 16–11): **Two polymer clay model bases crafted by Bob Morales that will be suitable for resin model kits.** *Top:* Here is an example of a completely detailed base. The parched-looking terrain will become the habitat of some very thirsty dinosaurs. Note the suggestion of an egg nest at left. *Bottom:* This 8" by 10" model base has been adorned with a variety of objects — rocks, sticks, tree limbs and stumps — to create a realistic impression of an Upper Cretaceous landscape (Morales).

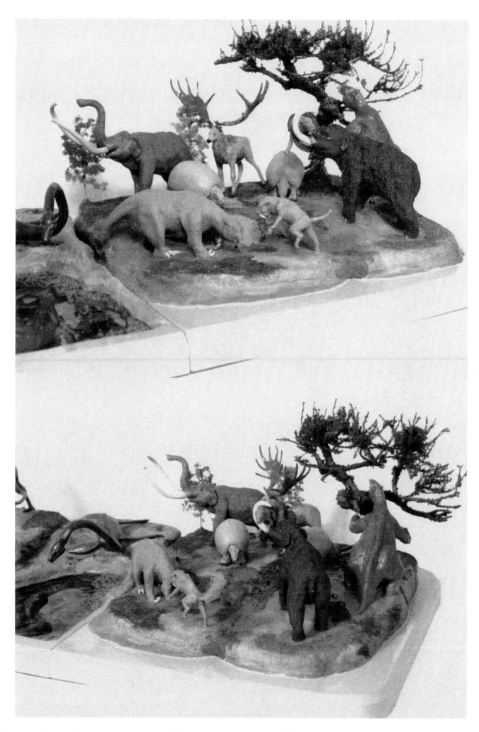

(Figure 16–12): Here are two views of the Pleistocene end of the Hawkins' Palaeozoic Museum model shown in figures 16–8 and 16–10, replete with fossil mammals. A giant ground sloth munches foliage from a desiccated and painted bonsai tree at right of image. The completed model (joined Cretaceous and Pleistocene segments) was exhibited in the Burpee Museum of Natural History (Rockford, Illinois) for several years during the late 1990s and early 2000s. For more about this particular diorama, see Allen A. Debus and Steve McCarthy, "A Scene from American Deep Time," *The Mosasaur* 6 (May 1999): 105–115 (Debus).

it. If you plan on using clear polyester resin, practice first on other materials before you use it on your carefully designed model to ensure that the polyester chemical is compatible with *all* the materials it will come into contact with or adhere to (figure 16–10).

Alternatively, large Styrofoam blocks can be carved to appear like cliffs in an underwater canyon without the use of any extra material to cast the illusion of real water other than a masterful, greenish, deep blue paint job; the cliffs can be lightly streaked with shafts of light filtering from the ocean surface. Of course, with such a diorama only the prehistoric animal sculptures must be baked in the oven —*not* the Styrofoam, which would melt.[2]

Sculpting Trees and Vegetation

You don't need a green thumb to sculpt trees and other types of vegetation for a dino-diorama (figure 7–4). It would be inappropriate and perhaps lame to sculpt dioramas consistently void of foliage, a barren landscape denuded of trees and other vegetation. Many species of dinosaurs and other prehistoric animals lived in lush forests and jungles, and probably avoided harsh, sun-baked deserts, where they would have become dehydrated and overheated. Herbivores needed something to eat! Sculpting scientifically accurate fossil foliage can be a tedious challenge. But even if you aren't a discerning paleobotanist, you can still make sufficiently suggestive foliage from polymer clay, coat hanger or copper wire, wire mesh and dowel rods. The information here will get you started, but you can also research restorations of vegetation existing in the periods and geographic locations you will be representing.[3] After all, plant life has evolved through the ages, too. Here are some tips to stoke your imaginative fires.

The simplest way to introduce vegetation into your diorama is to glue small twigs and sticks onto the polymer clay terrain. At the scale of your model, these will suggest the presence of logs or driftwood. But you won't be able to rely on this trick on each and every occasion. Or you can artfully integrate them into the polymer clay model base (figure 16–11). An old dried bonsai tree can also be rooted into the polymer clay base[4] (fig.16–12). Yet bonsai trees of an appropriate size and nature are rather difficult if not expensive to obtain. So beyond the integration of dried plants, how does one sculpt vegetation that will reasonably resemble Mesozoic or Tertiary trees and foliage? Usually the visual focus of your diorama will be the animals you have sculpted. But you should strive to add foliage that looks as realistic as possible. And so, accordingly, here are some ways you can sculpt plant life using polymer clay.

Depending on the scale of your model, palm trees and lower-growing cycads are fruitful diorama additions. Dead tree stumps and dessicated trees with withered limbs can also be artfully incorporated into the design. For such cases you will need to build armatures, but these are rather simple in nature. Cut wooden dowels will provide the main support.

For making a cycad, select a dowel rod that is approximately one inch in diameter, cut to one inch tall. Coat the rounded vertical cylindrical portion with an approximately one-third to one half- inch layer of polymer clay. The polymer clay thickness should be greater at the bottom of the cylinder and slope upward toward the more rounded top. Then drill several holes into the circular top, using a drill bit conforming to the thickness of coat hanger wire you will use to make the fronds and branches. (For example, see the cycads shown in figure 16–1.)

Then after clipping segments of coat hanger wire, bending each appropriately, staple

small sections of wire mesh (top and bottom, with the coat-hanger segment stapled in between) along portions of the bent coat-hanger wire. Trim the wire ends of each frond using sturdy scissors to a leafy shape. Then tamp in a thin coating of polymer clay covering the wire mesh with your fingertips. Using a pointed sculpting tool, to suggest the appearance of fern-like leaves, striate the polymer clay outward from the central wire shaft. Insert the exposed wire ends of each branch or frond into the holes that you drilled into the top of the cycad trunk or bulb. Cover the top of the cycad so the wooden armature is concealed. Then, using a ball-tipped sculpting tool, stipple the entire surface of the cycad bulb. You can either pre-bake the individual cycad fronds before joining them to the cycad trunk, or bake the complete cycad as a sculpted assembly. There were many kinds of cycads and plants that can be sculpted using this basic technique.

Or try adapting a real pine cone as the base of your cycad. Then you only need to add branches, bonded to this base with epoxy.

Armatures for palm trees may be made using this technique, analogously as for cycads, although the dowel used for the trunk will be taller. Leaf stems can be made as indicated above, and inserted into the top of your tree (figure 16–13). But you may also prefer to make palm trees that are more irregular, having less vertical symmetry. This effect can also be achieved using a dowel assembly, although you will need an assortment of rods having differing diameters. At the tree base, use a thicker dowel. Then have two (ore more) limbs protruding from the bottom base. These can be joined from bent coat-hanger wire segments. Create a tapering effect to each tree limb by using dowel lengths of successively smaller diameter, each joined by curving wire segments all the way to the top. Then smear polymer clay over the limbs. A realistic woody feel for the bark of the tree limbs can be achieved by indenting or cutting slightly into the tree surface using the curved, sharp end of a sculpting tool. Create palm branches using techniques previously described for making cycads.

When making dead trees, there is no need to sculpt leafy branches (which minimizes the effort). A dead-branch effect can be achieved simply by inserting metal coat-hanger rods into the dowel trunk. Then coat the dowel and metal branches with polymer clay. Use sculpting tools to create a desired effect on the bark of this dead tree (figure 7–4).

Generally, due to the weight of sculpted trees, a wire segment should extend downward from the base of the tree trunk that will become rooted (epoxy-bonded) into the base of the diorama for added support. But paint each tree separately prior to joining it to the diorama.[5]

Bronze Paint-up Finish

Creating realistic skin colors or patterns on your dinosaur kit or sculpture can be a real challenge and lots of fun to achieve. Just as challenging to achieve is a bronze look on your dinosaur or other prehistoric figure. So let's begin with bronzing, a technique that will make your sculpture appear weighty and more expensive. Though there are numerous colors (or patinas) that are applied on actual bronze castings, a technique used on Bob's *Edmontosaurus* with juveniles will be described here. This sculpture is approximately 1/12 scale and sculpted out of polymer clay. This sculpture was not molded (figure 16–14).

The first step is to prime all figures and the base in flat black. Several light spray-coats

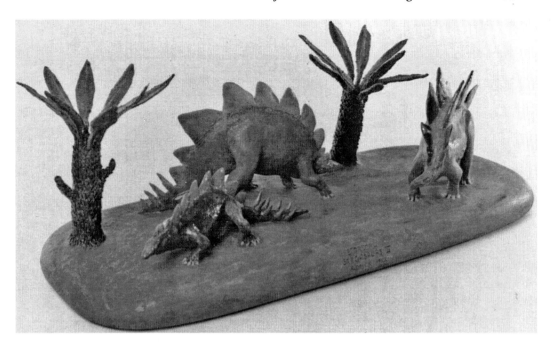

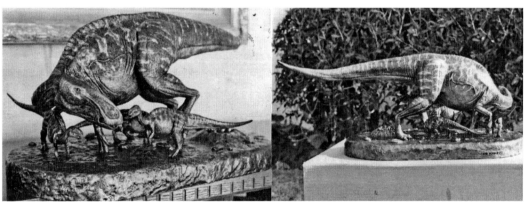

Top: (Figure 16–13): This view of Allen A. Debus' 1993 diorama, "Historical Stegosaurs II" (1992), featuring three more significant, popular, turn-of-the-20th-century views of how the genus *Stegosaurus* was thought to have appeared in life (after — left to right — Richard Lydekker, Charles R. Knight and J. Smit), also showcases two examples of foliage sculpted using techniques described in the text. A sculpting tool with sharp end curvature, applied using a succession of downward strokes, was used to inscribe the spiny looking tree bark. Leaves were impressed onto wire mesh fronds (Debus). *Bottom:* (Figure 16–14): Two views showing Bob Morales' one-of-a-kind, late 1990s sculpture titled "*Edmontosaurus* and Young," painted in faux-bronze-tone finish as described in the text. The largest dinosaur figure visible is 30″ long (See figure 16–2.) (Morales).

of primer were applied. Each coat was allowed to dry to the touch before applying another coat. Then Testors Model Master spray paint enamel (Black Metallic) was applied in two light coats.

Now the dry brushing began. Testors Model Master enamels, in the ½-oz. bottle, were applied. Sable Brown Metallic was dry-brushed onto the entire surface of all figures and

the base. On the dinosaurs' undersides a heavier coat of the Sable Brown was applied so this color would reach in between all scales, bumps and skin folds. Simple Metallic Gold was mixed 50/50 with the Sable Brown Metallic. Then this lighter shade was dry-brushed over the underside of the figures to bring out details on the belly and other lower areas. This lighter color was lightly dry-brushed over the facial areas as well as other protruding areas of the body, such as hips, spine, knees and any areas where highlighting was desired. More gold enamel was added to this already mixed color and also some silver to lighten the color even more.

The light camouflage patterns on the *Edmontosaurus'* bodies were painted (not dry-brushed) onto the desired areas. The final skin color was a 50/50 mixture of Copenhagen Blue Metallic and the previously used Sable Brown Metallic. This color was then very lightly dry-brushed onto the underside of each of the camouflage blotches or striping.

A small amount of non-metallic enamel can be mixed with silver or gold to colorize the metallic pink color. This was painted into the mouth and eyes. Green was added to silver, then dry-brushed onto foliage into the mouth of the adult *Edmontosaurus*. Finally, after all paint was thoroughly dried (24 hours), the sculpture was sprayed with Krylon

(Figure 16–15): Bob Morales painting his 19"-long ***Metriacanthosaurus*** in a tiger stripe pattern, as suggested in a painted restoration by Gregory S. Paul. The hardened polymer-clay prototype was molded and reproduced as a model kit. Interestingly, Bob designed this sculpture with two jaw features; modeler hobbyists could choose from a closed mouth appearance or an open-mouth design (Morales).

Workable Fixture to seal in the colors. If the finish looks a bit too glossy, apply a very light coat of Blair Spray Dull for the final touch.

As with any spray paints or bottle paints, only use with good ventilation and always read the labels for warnings. Remember, the enamels used in polymer clay will generally be slow-drying. Avoid applying enamel paints on model kits of dinosaurs cast in vinyl, as drying may take years!

But there's a far easier way to achieve the faux-bronze finish effect. You can omit dry-brushing techniques entirely and rely on spray paint cans, held and wielded two-fisted over your model. After spray-priming the model with a gray tone, try spraying Color Décor CDS —10 Wrought Iron Black Spray Enamel, followed by Rust-Oleum Brilliant Metal Finish to highlight portions of the sculpture, which will gleam in the sunlight. Then let it air dry, preferably outside. The finish will look quite nice! (See, for example, figure 12–7.)

When it comes to painting, it's usually "each to his own." Zallinger's brilliantly painted Age of Reptiles mural aside, opinions vary on the coloration of certain dinosaurs. *Anchiornis*, as learned in chapter 13 and thanks to geochemists, has taught us the proper coloration in one particular instance. There's no single set of instructions we can provide. Allen has achieved pleasing results, for instance, by mixing and swirling oil paints with various shades of Testors Military Flats enamels. But several of the references cited in the endnotes may facilitate your diorama painting ventures.[6] Further tips on painting a *Tylosaurus* sculpture will be outlined in chapter 18.

Conclusion

While throughout this book the authors have suggested materials and approaches that rely principally on polymer clay and other necessary items (such as wire and hard wood), you may also utilize many other kinds of substances to enhance your diorama modeling.[7] For instance, modelers of every persuasion rely on white glue, which can be spread onto a wooden base, upon which sandy grit and pebbles can be distributed — thus creating the impression of a sandy or rocky setting. There are also air-drying (not polymer or oil-based) clays (e.g., DasPronto) that can cover or smooth out edges or other features along the base of a diorama. These will tend to shrink and crack, however, upon drying. We can't predict whether it would be more costly to simply use Wonder Putty vs. Milliput (plumber's putty) for such mending purposes or the air-drying kind instead. Spackle, Polyfilla, Wood Putty and other household materials manufactured to repair cracks and holes in plaster wallboard, which may be purchased at any hardware store, may also find a happy role in your dino-diorama building. However, discussion of these many kinds of non-polymer clay materials, and generally the intricate practice of diorama building, is well beyond the scope of this book.

Think innovatively and you'll quickly get the hang of it![8] (See figure 16–15.)

17

Molding Prehistoric Animal Sculptures

Dinosaurs persist in human imagination even though their physical remains tantalize us in the fossilized state. Many of us must agree that one of the most spectacular ways of "bringing 'em back alive" is to reanimate dinosaurs in sculpture. But don't quit there, as others may be envious of your artistry. Why not mold the sculpture and reproduce your dinosaur in the form of resin casts for others to enjoy?

And why wouldn't you replicate a sculpture, especially after all the meticulous trouble you've gone through to marvelously recreate the visage of a prehistoric creature? Surely others would love to have copies of your craftsmanship, and wouldn't you care to oblige? But here a serious word of caution is in order. Are you absolutely certain this is something you want to do *yourself*? Read what we have to say and then think about it, *seriously*, for this is a big step.

Many individuals know how to sculpt expertly, yet haven't the foggiest notion of how to mold their pieces. If you are committed to molding the sculpture yourself, this implies you will be mixing resin chemicals to make casts from the mold at home (in your garage or basement) as well. Before converting portions of your domicile into a mad scientist's laboratory, we must forewarn you of what's in store.

First, you require knowledge concerning how to mold three-dimensional objects that are sometimes complexly configured, and later you must possess the wherewithal for casting said objects from a mold that is hopefully of sufficiently high quality. Second, while sculpting the polymer clay prototype need not be too costly in terms of materials used, the economics of purchasing merely the basic equipment and supplies needed for replicating your artistry quickly escalates. Top-of-the-line molding equipment can be quite a costly investment. And it most certainly can be messy (as well as time consuming), working with sticky, gooey chemicals that emit smelly vapors while curing. We aren't trying to completely dissuade you from performing this part of the operation; you *must* make an informed decision, though. And try to visualize beforehand what your spouse would be observing (and smelling). Are you both onboard with this? If you are, this chapter will help get you started.

Here, tips are offered on how Allen and Diane proceeded with such a home laboratory, crunching out cast after cast of various homemade resin Hell Creek Creations.[1]

To begin with, we lacked sufficient knowledge concerning how to mold anything, let alone complex sculptures that might have require cutting beforehand. None of these early

sculptures had been designed at critical armature building stages for any eventual cutting that would facilitate molding; many were bonded to wooden bases rather than crafted as free-standing objects, thereby obviating molding. Hard coat-hanger wire, resistant to cutting, had been used throughout the entire armature. And yet, moving into a new realm where our creations could be replicated into a product line (such as Bob Morales' were at Lunar Models) seemed enticing. Well, Allen happens to be a chemist and is no stranger to safely working with chemicals and lab equipment, so we decided to move forward, intrepidly.

There are relatively few resources out there (besides, today, possibly the Internet) offering detailed explanations on how to make molds. So, like anything else in life, the very best thing to do is to gain some hands-on experience actually doing it. Then practice! And so, our paths led to a company situated in Easton, Pennsylvania, named Polytek Development Corporation. A venture there in October 1995, for a two-day hands-on training course, opened doors for Allen and Diane, adding a new dimension to their small business, named Hell Creek Creations, which had been formed in August 1995.

You may be anxious about molding, apprehensive about refining your molding skills given the great variety of products you could experiment with at great expense before honing techniques for casting a detailed dinosaur sculpture. The friendly Polytek crew guides you, as a trainee, in making a mold of one of your own sculptures — in this case Allen's *Dimetrodon grandis* (1995), made in polymer clay. To Diane, pulling fresh casts from the mold seemed like a live-birthing experience (but without the pain). One of our casts was even placed on display in Polytek's lobby exhibit case.

The 14-inch-long *Dimetrodon grandis* was sculpted in September 1995. As described in *Dinosaur Memories*, [2] it was not intended to convert this sculpture into a model kit comprising half a dozen or more individual pieces that would later be glued together by hobbyists. Rather, the goal was to create a stately mantelpiece item, which would be sold as a distinctive-looking, finished and stained piece, mounted on an eye-catching, nicely fashioned wooden base including a metal plaque. Post-casting assembly should be minimal to nil. However, on rare occasions, upon request, the sculpture was also sold to hobbyists in unfinished, fresh-out-of-the-mold form with an unstained wooden base and unattached plaque.

The *Dimetrodon* finback prototype was sculpted using methods described in chapter 12, incorporating a section of old window-screen mesh for the prominent sail. This creation was not without its challenges, however.

Polytek's instructional staff had never before seen such an unusual prehistoric item brought into a training session and at first were unsure about how to mold it properly. They considered cutting the *Dimetrodon* into several pieces, an option that was rejected after it was explained that very stiff coat-hanger wire had been used to reinforce the armature, with wire mesh used inside the sail. Then, a two-piece mold concept was floated that would not involve any cutting, which turned out to be the winning formula.

Essentially, the *Dimetrodon* was enclosed within a tough, hard exterior mold known as a mother mold. Then, using plasticine clay to segment off the top portion from the bottom portion of the sculpture, both top and bottom halves of the model were molded in two separate pours, creating a snug, two-piece silicone mold (figure 17–1). Resin could be mixed and then be poured through the feet of the mold, which was positioned upside down,

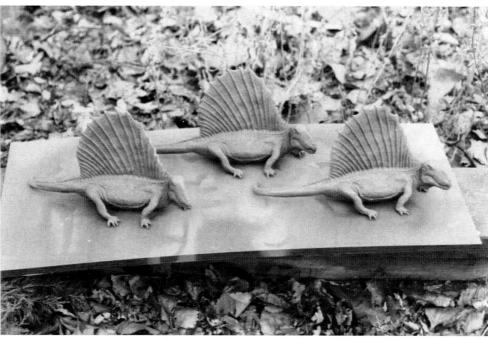

Top: (Figure 17–1): One of two Hell Creek Creations *Dimetrodon grandis* molds used for replicating Allen A. Debus' 14"-long sculpture (1995) (also see figure 17–2) (Debus). *Bottom:* (Figure 17–2): Three Hell Creek Creations *Dimetrodon grandis*, freshly cast in resin (circa 1996) from the mold shown in figure 17–1, awaiting faux-bronze finishing and mounting onto their stately, stained wooden bases. The *Dimetrodon* assembly-line process was carried out fully as a home basement (or "garage") operation. Diane Debus carried out the lion's share of the routine casting and assembly (Debus).

creating hardened casts. This technique will be demonstrated in the case of a Hell Creek Creations tyrannosaur sculpture, below. One finback mold was made during Polytek class time and then later a second mold (also from the same prototype — yes, which actually survived the first molding process and still exists today). Once properly made, each Polytek materials mold can be used to produce about 30 to 40 resin casts before it begins to noticeably degrade and tear, causing defects in subsequent casts.

The finished *Dimetrodon grandis* sculptures were certainly well received; a photograph of this sculpture was even published in a lavish coffee table book called *Dinosaur Imagery: The Lanzendorf Collection — the Science of Lost Worlds and Jurassic Art* (2000).[3] The home basement operation was in full swing, with Diane apportioning aliquots of part A with part B on a tared electronic balance, making casts from the molds when purchase orders were received, cutting and staining wooden bases (figure 17–2). Then on weekends through the summer and fall of 1996, Allen mounted each piece on its base, applied the bronzed plaques, sanded off unwanted resin flashing with sandpaper or a Dremel tool (while wearing respiratory gear and goggles) and finished each piece with faux-bronze luster. It was very involved work, yet considering all the trouble it had been to reach this operational stage, it certainly seemed worthwhile!

Several months later, in order to experiment using techniques learned during the training, putting everything together constructively, a Hell Creek Creations tyrannosaur polymer clay sculpture was made, for purposes of molding. Let's outline the steps demonstrating how this mightiest of dinosaurs can be resin-replicated using standard Polytek products, ultimately as a two-piece mold. As in the *Dimetrodon* example, it was not necessary to cut the polymer clay prototype.

Making a Mother Mold Out of Polytek's Polygel #75

First position your beast standing upright on a suitably large section of plastic-faced particle board. Next, for protection, cover the oven-baked tyrannosaur with plastic foil (to keep any goop off of it) and build a plasticine wall or dome completely enclosing the sculpture. After completing this plasticine dome, carefully divide the dome through the top and along the sides by wedging in (embedding) sections of aluminum metal cut with a tin snips (See figure 17–3.)

Now spray one side of the dome, including aluminum strips exposed along that side of the dome, using Polytek's mold release lubricant, Polyease 2300. If this isn't done, the plasticine may stick to the Polygel 75 mother mold coating. Also spray the plastic-faced particle board to avoid sticking.

Mix up a batch of Polygel 75 (parts A and B) in a clean, one-gallon size, plastic mix bucket using a clean spatula. This material thickens very quickly after mixing, so be prepared to quickly (within minutes) lather it onto the dome side sprayed with Polyease 2300. You want to cover the entire side of the dome and create a lip along the border of the dome over the plastic-faced particle board (figure 17–4).

After each mix, as it cures, Polygel heats up significantly. So be careful to avoid a burn: keep it off your skin and clothes. Also, after use immediately wash your spatula in rubbing alcohol. Always discard mix buckets after one use.

Remember to spray the second side of the dome with Polyease 2300 after removing

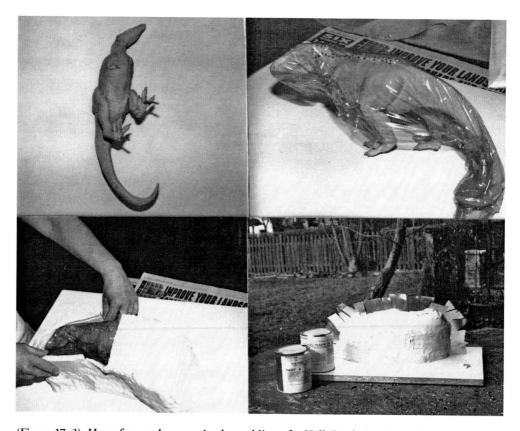

(Figure 17–3): Here, four early stages in the molding of a Hell Creek Creations *Tyrannosaurus rex* polymer-clay prototype are illustrated as described in the text. *Top left:* The Hell Creek Creations 12.5"-long tyrannosaur, showing steel wire pegs protruding from the feet, which facilitate anchoring not only during the prior sculpting phase, but also during the molding operation which is about to commence. You will require a battery-operated balance in order to accurately measure relative amounts of materials that will be mixed to form the mother mold and silicone mold rubber. It is inadvisable to measure relative proportions by volume. *Top right:* Plastic wrap will temporarily protect the *T. rex* from contact with Polygel. *Lower left:* Carefully build up a "brick layering" of Plasticine clay surrounding the model. The plasticine will not harden in the air, but it should not physically touch the model. You need to completely cover the top of the sculpture. Here Diane is nearly halfway through with the Plasticene "roof." *Lower right:* Each aluminum section or wedge (not aluminum foil) should rest against adjacent strips. These strips only need to penetrate about midway through the Plasticine roof layer. Do not harm your model by pushing the strips through the entire thickness of the Plasticine layer. These aluminum strips now roughly divide the Plasticine dome into separate sections. These strips will further separate the two coatings of Polygel 75 after it is applied to each side of the dome (Debus).

the aluminum strips. Then repeat the steps to coat the second side of the dome using Polygel 75. Polytek materials should always be sprayed, mixed, or allowed to cure in a well-ventilated area, such as outside.

Transition — Preparation of the Tyrannosaurus for Molding

After the sturdy Polygel mother mold shell has cured and hardened, without opening or moving the shell, first use a hand drill to anchor it into the underlying plastic faced

particle board and through the lip. Next, remove the mother mold, remove the plasticine dome, and remove the plastic foil from the dinosaur. Now, reusing the plasticine previously comprising the inner dome, build up a plasticine bed covering all of the dinosaur's underlying and inner surfaces (figure 17–5).

The (top) temporarily exposed surface of the sculpture will eventually form the bottom of a two-piece silicone mold.

Making a Two-Piece Silicone Mold

Polytek's PolySil 71–10 silicone-based mold rubber was used, which cures fully into a pink, flexible, rubbery substance within 24 hours, after mixing the component parts A and B. First, the mother mold is fastened down into its former position in the plastic-faced par-

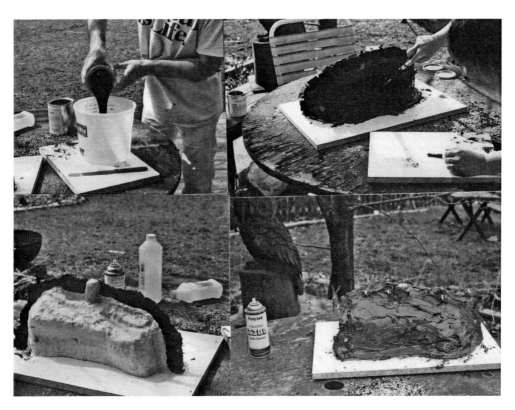

(Figure 17–4): The next four stages in the molding of a Hell Creek Creations *Tyrannosaurus rex* polymer-clay prototype. *Top left:* Mixing parts A and B of the soon-to-become-sticky-and-viscous Polygel 75. *Top right:* Slathering on mixed Polygel 75 using a store-bought spatula on one side of the dome. Be sure to leave a margin of Polygel on the particle board around the Plasticine perimeter to drill screws into for later anchoring. *Bottom left:* After the Polygel 75 sets (hardens) on one side, the aluminum strips can be removed. Next, repeat the performance on the uncoated side. Notice the Plasticine plug at center of the dome, through which uncured, liquefied silicone mold rubber will soon be poured. Also, notice the Polygel 75 lip along the top margin of the Plasticine dome. *Bottom right:* To maintain the relative positions of sculpture and mother-mold shell, fasten the mother mold into the plastic-faced, flat particle board using a hand drill and screws through the mother mold's perimeter. Then bolt the two halves of the mother mold together before moving or opening the shell (Debus).

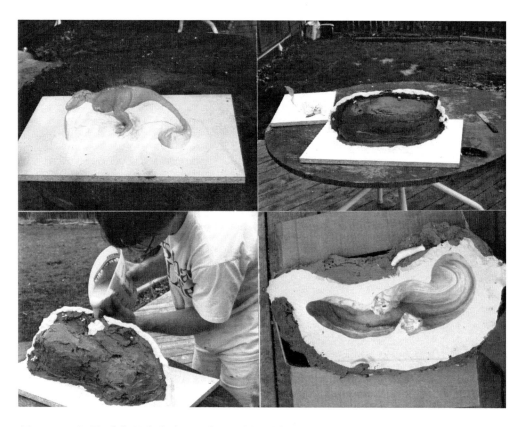

(Figure 17–5): *Top left:* Unbolt the mother mold and free your dinosaur. Then recycle the Plasticine clay, by making a bed covering the underside of the dinosaur. The shape of this bed will determine the shape of the second half of the two-piece silicone mold. Use a sculpting tool to smooth the curve of contact between sculpture and Plasticine so that the two pieces of silicone mold will fit together along a smooth seam line. Also, note the lower half of bed (especially near the tail). Gently contoured surfaces will allow the second half of mold to fit more securely to the first half. *Top right:* Tyrannosaur on its plasticine "bed" is now enclosed within the mother mold, awaiting addition of liquid silicone that will cure within the cavity. Rely on plasticine to prevent leakage from the mother mold. *Bottom left:* After the mother mold has been reattached over the dinosaur "bedding," and bolted down securely to the particle-board base, the two components that will form the pink silicone mold rubber may be mixed and poured through the opening created after removing the Plasticine "plug" shown in the previous figure. After mixing the mold rubber according to Polytek's instructions, pour this liquefied rubber into the mother mold opening. Fill the interior of the shell entirely with liquid silicone. *Bottom right:* Here, the Plasticine bed as shown at top left has been removed. Polyease 2000 now *must* be sprayed into the cavity, or else the second pour will permanently bond to the first piece and your dinosaur will become entombed within the silicone. Several additional Plasticine plugs should be attached to the sculptures' surface (e.g., tip of tail, on the chin and along the belly), extending to the surface so that air can be properly vented later when the resin is poured into the vacated, empty silicone mold (Debus).

ticle board bolted together with screws. Mold rubber is mixed and poured into the shell through the pour hole, smothering the top exposed part of the tyrannosaur.

Don't worry if you misjudge the quantity needed to fill the interior of the mother mold on the first pour. Provided you avoid spraying Polyease 2300 lubricant into the cured PolySil 71–10 surface, subsequent pours will bond perfectly as they cure. Call Polytek for estimates of correct quantities needed for your project before purchasing their chemicals. Reduce the required mold volume by laying your plasticine dome closer to the dino-

saur's body lines. This way, less silicone rubber is needed to fill the interior of the mother mold shell.

After a 24-hour curing time, unscrew the mother mold from the plastic-faced particle board, disassembling and inverting it. Fit it snugly into a sturdy corrugated box so that it is upright, steady and level. Entirely remove the exposed plasticine bed from the tyrannosaur's underside and spray the mold cavity and the underside of the tyrannosaur thoroughly with Polyease 2300. (You must spray with Polyease 2300 lubricant, because you do not want your forthcoming *second* pour of silicone to bond to the first piece of the mold.)

Now, with the mother mold shell stabilized, immobilized in an upside-down position, fill the mold cavity using a fresh mix of PolySil 71–10. Once more — caution!— Polyease 2300 must be sprayed into the cavity *before* this second pour, or else the second pour will bond permanently to the first piece and your dinosaur will be entombed inside its cushy silicone mold.

You should have two or three vertically aligned plasticine plugs protruding from the "top" (really the bottom — from tip of tail, chin and belly, upward) in this second pour, serving as air vents later so that pressure from entrapped air bubbles won't prevent resin from reaching these areas of the mold while casting (pouring in the resin to make casts). These plasticine plugs will be removed after the second mold piece has been cured in place (figure 17–6). Twenty-four hours later, peel the pink PolySil mold away from the mother mold after removing the bolts. Don't worry, as the mother mold and pink dinosaur pink mold will not bond.

Separate (unbolt) the halves of the mother mold to free the inner pink rubber silicone mold. Remove the plugs and separate the second poured mold piece from the first. Now carefully remove your original dinosaur from the first (lower) silicone mold piece.

(**Figure 17–6**): **Showing the bottom of the two-piece flexible silicone with dinosaur removed, resting within the sturdy, screwed-together, darker mother mold. Note the foot holes and air vents for pouring resin into the mold. The vent at lower right connects to the end of the dinosaur's tail (Debus).**

Top: (Figure 17–7): A special tool used for cutting mold rubber (Debus). *Middle:* (Figure 17–8): Another view of the mold-cutting knife (Debus). *Bottom:* (Figure 17–9): Opened silicone mold pieces used to cast replicas of Hell Creek Creations' *Spinosaurus* diorama (shown completed and finished in figure 12–7). While this particular mold was produced at Mike Evan's Texas company, Alchemy Works, all castings were produced at the Debus home "garage" operation (Debus).

When casting (using Polytek 15–3X Liquid Plastic, parts A and B), you can fill the mold cavity by pouring through the open foot holes and air vents.

To ease casting production, the mother mold with silicone rubber pieces may now be suspended upside down in a sturdy framework supported on four wooden legs. (For example, see figure 17–1.)

Now you are ready to mix resin and begin casting! (The Hell Creek Creations tyrannosaur models and others were successfully cast using the aforementioned 15–3X, but note that Polytek has a wide variety of resins to choose from, more so than when Allen and Diane visited their training center 17 years ago. *Talk to the friendly Polytek folks before you start!*)

Molding more complex designs may require cutting of the original piece, and molding each separately. Such resin casts can be sold in model-kit form. The Hell Creek Creations tyrannosaur was mounted over a simple resin cast base (molded separately from the tyrannosaur as a one-piece mold — not shown here) on which an embossed *Pteranodon* had been engraved; the assembly was in turn bonded onto a sanded, nicely stained, oval-shaped wooden base.

Incidentally, there is a knife you may purchase from art supply stores for use in the event that a mold (rather than the polymer clay object) itself requires cutting. This tool facilitates sectioning, such that the mold may later be rejoined (clamped back together) after cutting, preventing spillage of liquid resin from the mold. Don't cut a rubber mold without having this specialty knife handy (figures 17–7 and 17–8).

Molding and Casting Beyond *T. rex*

Following the early Hell Creek Creations experiences with molding and casting original sculpted models, other opportunities came along. It was apparent that homemade "gravity pours," such as described above, were not ideal for this work because tiny pits and bubbles sometimes formed on the surfaces of resin casts. If minimal in nature they could be filled with some

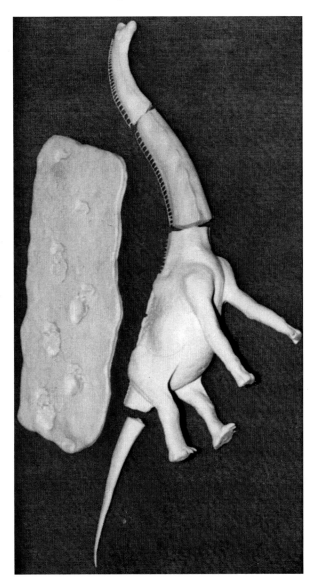

(Figure 17–10): A final resin casting of Bob Morales' 1/35-scale, 28"-long, 16"-tall *Brachiosaurus* (1999), seen in prior stages of development in figures 7–7, 16–4. While the mold was produced by Mike Evans' Alchemy Works, resin replicas were exclusively sold through Bob's company, Dragon Attack! (Morales).

putty, but all too frequently some pieces also had to be discarded, thereby wasting expensive resin chemicals. However, there are individuals — Mike Evans of Alchemy Works, in particular[4] — who owned the expensive equipment needed to perform pressure casting, which would eliminate such surface imperfections. Also, molds such as manufactured by Alchemy Works can be cured using the highest grade professional, industrial equipment to reduce sponginess in the silicone molds so that bubbles would be eliminated on the surfaces of cast replicas.

In fact, Mike asked Allen to sculpt a miniature replica of his historical *Hadrosaurus* created by Benjamin Waterhouse Hawkins in 1868 (figure 10–1). In turn, Mike agreed to mold this custom creation so he could make his own resin replica of the prototype, offering in return the mold for Hell Creek's home use. Mike's mold was exceptionally well done, very solid — not in the least spongy. Later, we also relied on Mike to prepare molds of, first, a diorama — a *Spinosaurus* sculpture that included an embossed crocodylian swimming through a swamp toward a plesiosaur dispatched by the spinosaur (figure 12–7) — then both a *Brontops* (figure 14–5, bottom) and, later, an *Agathaumas* (figure 19–2). Bob has relied on Mike's talents in producing many more molds and castings as well.

While in the case of the Hell Creek Creations *Spinosaurus*, the mold was delivered for home use (i.e., gravity-pour casting), Mike retained both the *Brontotherium* and *Agathaumas* molds at his Texas location, such that orders for those (filled through the resulting, higher-quality pressure casts) would be placed through his shop rather than the Hell Creek garage operation. So for these two creations, Alchemy Works became an invaluable middle man. Meanwhile, at the Hell Creek Creations headquarters, a homemade mold of a Hawkins-esque, 19th-century-style Laelaps (i.e., *Dryptosaurus*) was made in-house in 1997, complementing the *Hadrosaurus* piece, which was used to fill several orders.

Due to the complexity of the *Spinosaurus* model design, it became essential to cut the polymer clay prototype. Although Mike Evans did the eventual cutting (and molding) of this sculpture himself, Allen had accurately identified locations for each cut that would result in the minimal number of separate piece molds (figure 17–9). (Techniques for cutting baked polymer-clay prototype sculptures are described in chapter 15.) Thus, the *Spinosaurus* (one of the very first such sculptures showing this dinosaur with the crocodylian head morphology) became the second Hell Creek Creations model kit. (The Hawkins *Hadrosaurus* design was Hell Creek's first model kit, that is, sold with different individual cast pieces to be bonded together by hobbyists.) In all cases, Alchemy Works returned the prototype polymer clay sculptures, which were then finished on individual display bases. The Hell Creek Creations *Agathaumas* was molded in Texas as a simple, one-piece, soft mold, opened (i.e., cut) to release the prototype and all subsequent casts using the special knifing tool as previously mentioned. (See figure 19–1.)

So — do it yourself, or let the experts help you? That remains the question. Certainly the techniques outlined here will work either with or without the professional equipment (pressure casting, etc.). If you just want to gain some experience trying this out on your own without going "industrial," it's a lot of fun prying those casts out of the mold and making them available to others! You may become obsessed, however, and unless you are well versed in molding and casting techniques, we highly recommend taking a hands-on training course where you can practice with the actual materials (figure 17–10). Finally, sculptors may shortly be able to avail themselves of computerized 3-dimensional printing technology — at your local libraries — in lieu of molding techniques discussed here.

18

A Painting Primer

Near the end of chapter 16, techniques were outlined for applying a simple faux-bronze finish to a sculpted dinosaur or prehistoric animal. Here are several extra tips on how to go about painting oven-baked, polymer-clay prehistoric animals or resin casts, beyond simpler bronzing. (If you are painting a resin casting, then it should be washed with liquid detergent beforehand, whereas baked polymer clay sculptures need no pre-washing.)

Success in painting a model has more to do with color selection than with techniques. This is so because if the colors are not sufficiently realistic, then no amount of technique is going to be effective in achieving a satisfying result. Let's begin with some basics. Model Master enamels and Testors enamels are preferred, both gloss and flat colors (the flat colors are Model Master, and the gloss colors are all Testors). For painting dinosaurs and other extinct creatures, such as pliosaurs, plesiosaurs, flat colors work very well for skin tones and patterns. Gloss colors are used for the inside of the mouth, the teeth, eyes, nostrils, and a mix of gloss and flat are used to achieve a semi-gloss for claws and horns.

For a specific hands-on example, Bob Morales' 1/20-scale *Tylosaurus* model was selected. For a larger model such as this, we can consider applying a variety of colors, skin tones, patterns and detailing (figure 18–1).

For this particular project, Bob chose Model Master colors, including rust, black, and white, all flat colors. It is suggested that you wear rubber surgical gloves. These aren't expensive, and can be purchased at your local grocery or drug store. Also, purchase a can of paint thinner, and have a variety of shapes and sizes of paint brushes available, some that are small or even tiny, for small details such as eyes and teeth. Some paint brushes that are pointed, blunt, or wide would be helpful. It is also suggested that you avoid purchasing cheap hobby brushes, as the bristles of the brush can come loose and will end up adhering to your paint finish. Some like to spray primer over a model before doing the final paint-up, and that's okay. Alternatively, simply ensure that the paint finish is sufficient and thorough. (This will also prevent any diminishing of the sometimes very fine details of the model that is being painted.)

It is recommended that you use enamels. But you can of course experiment with acrylics (water-based) or even lacquers or urethane (solvent-based) to see the different effects that may be achieved. But please *always* read the precautions and warnings on the paint container labels! You are also strongly advised never to use enamel paints on *soft vinyl* model kits. If you do, the paint takes an inordinately long time to dry, sometimes even up to weeks

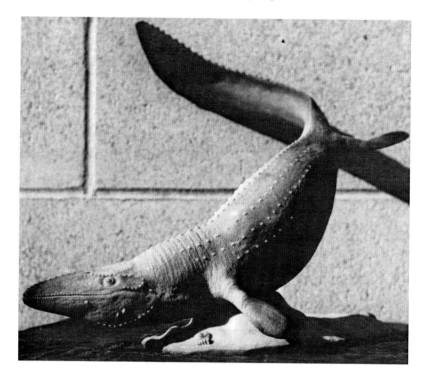

Top: (Figure 18–1): Bob Morales's oven-baked, polymer-clay, 1/20-scale Cretaceous mosasaur, *Tylosaurus* (2000). This prototype was molded, and resin casts will be subjected to painting, as described in this chapter. Bob made two versions of the jaw; here you see the closed-mouth version, but compare this with figure 18–6 (Morales). *Bottom:* (Figure 18–2): With the amount of detail inside the mouth of Bob's 1/20-scale *Tylosaurus* model kit, it was necessary to first paint inside the mouth and throat, and then the teeth afterward. In this photo, touch-ups are being done on the teeth after the lower jaw was glued in place. Later, matching color was used in the area where the lower jaw attached to the head (Morales).

or months, with the paint remaining tacky to the touch. Acrylic or other water-based paints work best on vinyl model kits, as they tend to dry much faster.

Because of the details within the mouth and throat of Bob's *Tylosaurus* model, the inside of the mouth was painted before the jaw was attached to the head section. Don't discard the color that was used for the mouth; you'll need it later to paint inside the nostrils. Then, the teeth were all painted (figure 18–2). The mouth color is a mix of gloss red, white, yellow and a touch of brown, with the most paint being white to achieve a lighter shade of this pinkish kind of mouth color. The teeth are gloss white with a touch of yellow and brown added so that it would not be a pure white. Animals in the wild and in the sea tend to have yellowed or stained teeth from the food they eat. So beside this off-white gloss mixed color, after the teeth dry, a thin wash of brown mixed with black may be painted on the root areas of the teeth. Again, this wash should be quite thinned (using the paint thinner for enamel or water for acrylic) so as not to be too opaque. Also, make sure that the teeth are thoroughly dried before adding this "stain" color.

Using an extra, empty paint bottle that has been emptied of most of the paint from use, for this particular model, Bob's mode of attack involved pouring in some rust color, perhaps up to a third of the bottle's capacity. To this was added about _ of this amount of the flat black, which produced a type of reddish or rust brown, but not so bright since the black helps to tone down the strength of the rust color. This mixed color was painted liberally onto the entire top side of the model, along the top of the head, neck, body and tail (figure 18–3). Care was taken to thin out the paint just a tad with paint thinner, but not so thin that it would run down freely along the side of the model. Also, thinning down the paint some will help the paint to flow into the multitude of small nooks and crannies

(Figure 18–3): **Start painting from the top or back of the model, beginning with the darkest color. It's a good idea to allow the first coat to dry for about an hour as this will make it easier to see small areas where paint did not cover. Holding the model under both artificial and natural outdoor lighting will help you to see areas where paint touch-up is needed (Morales).**

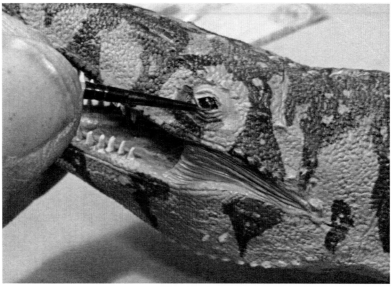

Top: (Figure 18–4): The final steps in the painting process included adding about 50 percent white to some of this dark color, used for the skin patterns, making a much lighter shade, which was then dry-brushed in a very miserly amount over the surface where these dark patterns were painted. Don't despair if some of this lighter color makes its way onto the darker colors; it will hardly be noticeable. *Bottom:* (Figure 18–5): Final steps included painting the eyes and the nostrils, and doing any paint touch-ups that were needed (Morales).

on the surface of the model. Sometimes, the paint is already sufficiently thinned, right out of the bottle, however. A stiff paint brush was used, which is helpful in pushing mixed paint into tight areas, including the little wrinkles and skin folds. Keep a rag handy at all times. Be sure and work in a *well ventilated* area so that you are not inhaling fumes from the enamel paint or the paint thinner (which is very flammable, so be extra careful). Have a

Top: Here is the finished painted *Tylosaurus* model, posed on its seafloor display base. After envisioning a skin pattern, flat black was mixed with a small amount of rust to achieve a very dark brown. A small, pointed brush was used so that fine, crisp lines could be painted as shown. Where patterns on the skin are concerned, there really is no limit to what can be done, so use your imagination, or page through wildlife books or those on marine life for ideas. Color choices also are unlimited, but try to stay within what may be perceived as a believable pattern scheme, and choice of colors (Morales). *Bottom:* (Figure 18–7): Another *Tylosaurus*, shown chasing a shark, outfitted with a different skin coloration pattern. Contrast the closed mouth here with the open-mouth configuration shown in figure 18–6. Bob made two versions of this sculpture (Morales).

small paint brush handy also, to tend to those unreachable little crevices. Be sure to get thorough coverage with your paint. You can always do touch-ups afterwards, especially after the paint has been dried, when it will be easier to see whether you missed any spots.

Next, after pouring about half of this initial (aforementioned) color into another bottle, some white was added, and some more rust (you will want to keep some of the first mixed color, for touch-ups later). Be sure and place the caps back on the paint bottles when you are not using them, and be sure to tighten the caps so that your paints won't dry out quickly. Paint a little bit of the color as mixed on top of the cap, so that you'll be able to see what color is inside that particular bottle.

The dorsal area and sides of the plesiosaur were painted darker than the belly. You may envision a relatively rapid change of shading, or a more gradual lightening, from belly to dorsal side. It's really up to you. A very abrupt and pronounced division between darker back, neck and tail areas, and the lower areas of the belly, neck and tail is also an option.

Next, very dark brown patterns were applied (flat black with a small amount of rust added), keeping a more or less uniform pattern on both sides of the model (figure 18–4). After these patterns were thoroughly dry, white was added to some of this same color, to achieve a color that was less dark. This lighter color was then dry-brushed over the surface of the patterns to bring out the details of the numerous scales and other bumps and spines covering the model. You can also add a little yellow and a tiny bit of brown to this lighter color so that it is not a pure white color. Dry-brushing means that most of the paint is removed from the paint brush bristles before moving the paint brush over the surface.

Next, because details of the mouth and teeth were already finished, the eyes and nostrils were painted (figure 18–5). Here again, it is always advisable to rely on photos of modern aquatic reptiles and mammals for ideas on how to paint the eyes of your model. Using a small or very small pointed paint brush for this, carefully start at the eyeball, gingerly working your way out to the inside of the eyelid area. Try not to go outside of the edge of the eyelids, and don't have too much paint on the brush. A solid gloss black makes the eyes look very realistic and shiny, much like the eyes of a reptile or like some birds, but you can always paint the eyes another color over this black (after allowing this gloss black to dry thoroughly), for example a glossy burnt orange, which can be achieved by mixing equal amounts of red, orange and brown together. Using the very tip of the small paint brush, carefully dab the point directly in the center of the eyeball until the desired size of this part of the eye is achieved.

Avoid smearing color on inner edges of the eyelid. You can always use more gloss black for touch-up. This will take some practice, but if it doesn't turn out right the first time, wipe this color away quickly, using a turpentine-dampened cloth, then allow it to air dry. Once you have carefully and successfully painted the eye color, leaving the gloss black intact around the edges of the eyelid, allow this color to dry for at least an hour before painting in the final detail, which will be the tiny black pupil, or center of the eye.

Last, if you are inclined, use some of the same color that was used for inside the mouth to carefully paint inside the nostrils, using a small pointed brush. Have a paint rag ready in case you get some of this pinkish color outside of the nostril.

Don't get discouraged or impatient if it doesn't turn out perfectly the first time. Your techniques will improve the more you paint models. Just wait and see! (See figures 18–6 and 18–7.)

By all means, have fun!

19

What to Do If Your Model Cracks and Other Eventful Matters

Appropriately, we've saved the topic of damage to your sculptures for last. Polymer clays like Super Sculpey bake to a hard finish, yet they can still fracture even if you've carefully followed our instructions for building armatures and baking your pieces.

You may notice fractures developing in your sculptures as your model cools. These may be hairline cracks up to one millimeter wide. Such cracks can be repaired at minimal expense and loss to the appearance of your handiwork. Cracks resulting from cooling will be minimized or obviated if your baking temperature does not exceed 275° F, and if you've filled the sculpture's interior with Styrofoam or aluminum foil. Always allow your sculpture to cool *slowly* in the oven after it's turned off; crack the oven door while leaving the sculpture inside to allow slow cooling for about the first 15 minutes of cooling.

Even months after your model has been baked, fractures and/or breakage may occur. Changes in humidity throughout the year or other factors may be at fault. This need not happen. Take heart, dinosaur sculptors; properly baked Super Sculpey dinosaurs are durable and have been known to survive earthquake damage as well as guerrilla warfare waged by marauding cats and parrots. If it isn't possible to find a means of displaying your dino-pets while keeping them out of harm's way, this chapter will be of interest to you.

If your sculpture has not yet been painted, and other adhesives haven't already been applied to the body or base, you can repair most cracks using small amounts of Spackle, Milliput (which is a kind of plumber's putty often used by fine-scale modelers), or pre-mixed tile grout. Smear or push it into the cracks using a spatula or flat-edged dental tool. Then carefully scrape off excess material with the sharp end of a knife (or a dental tool, which you can obtain online). Allow the Spackle or grout to harden for several hours. Then lightly sand over the seam using finely graded sand paper. (You should hold the sandpaper using your fingers, *not* rely on a bulky electric sander.) Although this may be overkill, for added bonding strength, brush on a light coating of Super Glue or Duco Cement over the hardened spackle or grout after sanding.

Fractures that occur after painting are trickier because you must also retouch the repaired area with paint. (Spackle and pre-mixed tile grout have a whitish color.) Lightly sand the damaged areas with fine sandpaper. Paint over the area only after any adhesive that is applied has hardened.

Your polymer clay first-aid kit should include a ready supply of Super Glue, Duco

Cement, Milliput and aspirin for other kinds of breakage, such as snapped horns, spines or broken teeth. Your sculpture will need the adhesive to alleviate its suffering. *You* may need the aspirin to steady your nerves as you calmly survey the extent of the damage.

Yes, we feel your pain! Don't worry — sculptures do get fixed, even those that have been snapped or cut during a molding process (and your headache will disappear, eventually). In fact, such occurrences eventually happen to *everyone* who uses Super Sculpey. However, these problems are avoidable, and there are always inventive ways (perhaps beyond those discussed above) to repair the damage.

There are means of preserving your sculptures in more permanent forms before their inevitable decline. First, photograph them for posterity; create a portfolio of your work. Second, if you are inclined to invest further in the hobby, reproduce your work in more durable materials such as plastic resin, as we outlined in chapter 17. And, particularly as you develop your talents, it may make sense to protect your work and good name through other, legal means.[1]

Replicas of your originals can be cast in resin. However, making a mold (unless you can do this yourself) may cost up to 10 times the expense incurred in making the prototype, that is, depending on the size of the original sculpture. Yet, in order to cast a sculpture, the original piece may have to be cut into several pieces. Afterward, the cut original can be glued together using Super Glue. If you are making a Super Sculpey base for a sculpture that will be reproduced, remember while you sculpt to place a sheet of aluminum foil in between your Super Sculpey base and the underlying wooden support. Some prehistoric animals can simply be replicated from relatively inexpensive, single piece molds (with resulting one-piece casts) (figures 19–1 and 19–2).

Up to 30 replicas can usually be made from each mold, at typical production costs of $30 of resin per piece, depending on the size and how much resin was used. If you wish to pursue the commercial opportunities further, consult advertisements in magazines such as *Finescale Modeller* or *Modeler's Resource* —now strictly an online 'zine. And we must reiterate that resins can be dangerous, messy and smelly to work with, so unless you are handy or already experienced in the art of mold-making and casting, or willing to learn the trade from scratch, it may be best to leave this activity to an expert.

And now, a final word.

YOU — THE DINOSAUR SCULPTOR!

Have we motivated you? If you've read this far, perhaps we have!

Don't get discouraged after your first few sculpting attempts. Unless you are already an experienced artist, accomplished sculptor or model designer, your very first efforts may seem dismal. You may make mistakes. Don't give up so easily. There's time to learn from those errors. Remember: no sculpture is perfect. Even the authors have experienced artist's remorse, which is that "Why couldn't I have done better?" feeling. We've striven to show you how to *begin* projects, without emphasizing that everybody's work must be absolutely perfect — whatever that term means when it comes to paleoart — all of the time. And do not be intimidated by processes described or photos that you see here. You'll get the hang of it, if you haven't already. (And, yes, some minimal math is sometimes involved.)

This book is intended as a guide for beginners to learn from, with perhaps a few extra tips or reminders for yeomen sculptors. Our premise is that many of you already have the

(Figure 19–1): One-piece silicone rubber mold produced by Alchemy Works from the 6.5"-long Hell Creek Creations *Agathaumas*, shown in figure 19–2 (Debus).

ability to sculpt realistic-looking prehistoric animals, and that once you get going, you'll find it really enjoyable, all the while further developing and enhancing your skills. Sometimes it only takes a bit of well-intended, hands-on, friendly coaching to gain impressive results. Even if you are ambitious, start slowly and methodically. We've demonstrated in words and visuals — hopefully boosting your confidence along the way, how and where, through research and reading, to build the essential knowledge base, to build armatures for a variety of fascinating prehistoric creatures, how to sculpt flesh onto wire "bone," how to cloak extinct animals in fur and feathers, how to mold and cast prototypes, how to paint and finish your creations, and how to accentuate them in realistic diorama settings. Our goal was to interest you in the field of paleosculpture and show you how to get started. But as stated in a previous chapter, in order to start you need to "just do it." And where you go with it is entirely up to *you*— fellow dinosaur sculptors!

You can do this!

Don't worry even if you consider yourself clumsy when it comes to the intricate handling of fine-scale objects. Just start sculpting, practice faithfully, and soon you may find that you have acquired surgeon's hands. You will heighten your brain and muscle memory, increasingly doing things the right way as you improve. Remember, any mistakes made can usually be repaired if you use polymer clay. And you're allowed to change your mind on pose, posture, alterations in tail or arm positioning, etc., even in midstream.

However, no matter how excited you may be about your chosen design, Do Not attempt to finish it all in one sitting. Whether you're a morning person or a burning-midnight-oil person, our advice is to work in no longer than two- to three-hour sessions so

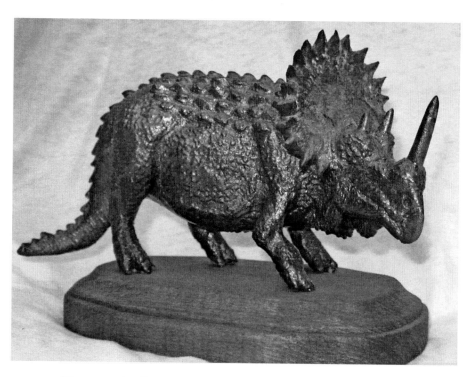

(Figure 19–2): Allen A. Debus' *Agathaumas* sculpture (2002) (Debus).

that you don't tire and spoil something that was done expertly during your most productive period. Take a rest after each session, and stage the project so you can get back to the next stage tomorrow. If you stay at it too long, you run the risk of becoming frazzled — trying to do things that were easily performed only an hour or two before. Or you may dim that artistic spark. Don't quench it — give it a rest. After hours of probing into small crevices, seemingly inaccessible but to the tiniest flea, with bulky fingers, sculpting and dental tools or paintbrushes, you've earned a break! If you don't have too much time at any one sitting to race through a sculpt to completion, keep in mind that polymer-clay sculptures can remain in unbaked, in-progress status for many weeks as you poke along. Just cover your creation with plastic wrap to keep dust off of it in between sculpting sessions.

You can vastly improve your ability, especially with the first several models you make. It is embarrassing for the authors to be reminded of our earliest creations, which now seem so rudimentary in nature — *even though we learned from those creations.* Rather than throwing the old efforts away in the garbage, keep some to gauge your improvement, which can be considerable in a one-year period of part-time sculpting. (Well, by "royal decree," Allen's first, primitive efforts eventually were forever banished from the premises.) You will be thrilled to see just how skilled you have become in such a short time by following our guidelines! (Also, the old sculptures will keep you humble.)

It may take a while before you develop your distinctive style, that look that identifies the paleoartist without the need for a written signature. Such artistry transcends the history of science, for even if the level of accepted fact should progress, the work of art retains lasting appeal. Few paleoartists (Benjamin Waterhouse Hawkins and Charles R. Knight among them) ever achieve that level. In fact, one can only hope to achieve such skill through years of practice. Yet, some of you may get there quickly! How?

Get in tune with your creativity. Getting a good night's sleep will help you resolve sculptural problems. Rely on those midnight flashes of inspiration for solving difficulties and designing new pieces. While probing for new ideas or themes to tackle in paleosculpture, stimulate your mind with music (whatever suits you), be it Mozart or Led Zeppelin. Great ideas may pulse through you during aerobic exercise! Give your imagination free rein! In fact, Free is the Key. We realize this may sound rather like the "Zen of Paleosculpture," but that's how it is.

In sculpting dinosaurs, you only need hold yourself accountable for any progress that is (or isn't) made. You, the dinosaur sculptor, hold the keys to success within your desire and fortitude to produce a work of art conjured from your imagination.

There is no shortage of prehistoric genera and theories concerning these organisms to choose from. And our lifetimes are too short for us to tackle them all. The established number of dinosaur genera has grown considerably, trending toward one thousand. There may have been hundreds more (some of which may never be discovered), lying in fossil tombs all around the world, awaiting the paleontologists of future generations. And don't forget about those ancient nondinosaurian aquatic reptiles, pterosaurs, birds, pelycosaurs, therasids, mammals, fish, exotic invertebrates, etc., which we've only touched on, that you can bone up on in the references cited in the endnotes.

Paleontologists relish the intriguing possibility that the fossil record represents 99.9 percent of all terrestrial organisms that ever lived. (As Dr. David Raup—retired from the University of Chicago—stated, to a first approximation, all species are extinct!) Yes, fewer than one out of 1,000 species that have ever lived are now alive in the present. We're privileged to be among the 0.1 percent, and, therefore, you're bound to find willing subjects for sculpting projects among the 99.9 percent. (So there's no need to redo what's already been done expertly.)

Free is the key! The realm of paleontology sometimes extends beyond the concrete and factual levels into sheer speculation, or even flights of fantasy. Consider, for example, the fossil beings of life's unknown future and even of parallel worlds. Over a century ago, as stated in our introduction, British geologist Charles Lyell speculated that at some long-distant future epoch, creatures bearing close anatomical resemblances to inhabitants of our geologic past such as the *Ichthyosaurus* may re-evolve. Few took the idea seriously, and the idea was caricatured famously in the aforementioned cartoon sketched by Henry de la Beche.

Nearly a century and a half later, Australian geologist Dougal Dixon carried things further by creating illustrations (and sculptures) of an entire host of organisms that could possibly evolve in the world, "after man," 50 million years hence. Today, the term *parallel worlds* bears obvious connotations of the world of physics or even science fiction (but to no lesser degree of time travel, which all paleontologists began to specialize in, through their reconstruction of the deep past, years before physicists considered the theoretical possibilities).

However, paleontologists and artists have pursued the ramifications of what sort of dinosaurian creatures would be alive today in a parallel universe, having split from our own 65 million years ago; a universe where the dinosaurs were somehow spared their final eradication. Is it possible that highly intelligent creatures, such as Dale Russell's fascinating "Dinosauroid," might have evolved, or, alternately, other kinds of dinosaurs as conceived by Dixon in his 1988 book *The New Dinosaurs*? These speculative cases should be of even

keener interest to the reader, because the living form of these parallel-world dinosaurs has also been captured in sculpture.

Let your imagination run wild, then rein it in to produce a design that is do-able and visually exciting. As outlandish as Dixon's and Russell's examples may seem to us, they are still scientifically founded creations, because they exemplify evolutionary principles and hypotheses. They clearly represent an ingenious union of scientific fact and fantasy. There may be other similar themes for you to explore.

For instance, how would the evolutionary missing links of dinosaur ancestry be expected to appear? Sculpt Proavis, the (hypothetical) bird ancestor (actually first depicted by Gerhard Heilmann in his book *The Origin of Birds*, 1926), or perhaps intermediate stages (thus far unknown to science) in the evolution of duck-billed, horned and plated dinosaurs. Based on what is known about Mesozoic paleogeography, speculate about other kinds of dinosaurs that may someday be discovered on the Antarctic continent.

Now the stage is set for you — the dinosaur sculptor — to emerge. Go to it. We trust your results will be absolutely breathtaking!

Glossary

In this glossary, we are not defining every dinosaur and prehistoric animal name mentioned in this book. Instead we encourage sculptors to begin their researches in earnest, beyond our written pages, especially harvesting information from the Internet and the many informative books and dinosaur encyclopedias that have become available since publication of our first edition of *Dinosaur Sculpting*. No doubt future paleosculptors will use our new book closely in tandem with Internet access. So instead, here, the emphasis is on sculpting terms that we use casually and/or repetitively within, and an assortment of scientific terms that may seem unfamiliar to laypersons.

Anchoring— Stabilizing an in-progress sculpt, usually by temporarily or permanently inserting the wire end of a sculpted leg into a sturdy substrate such as wood.

Armature— The sculpture's sturdy metal skeleton, which will support filler such as Styrofoam and aluminum foil to bulk out the body, and over which layers of clay will be added.

Avetheropods— A broad clade comprising Theropod dinosaurs such as allosaurs, tyrannosaurs and even the most bird-like forms.

Baggie trick— Placing a plastic sandwich baggie over the clay and impressing skin textural details through the plastic with a sculpting tool (fig. 1–5).

Ball-tipped sculpting tool— A steel sculpting tool terminating in a tiny spherhical shape (fig. 1–3, 3rd and 4th tools from left).

Cast— For our purposes, a replica made in resin formed in the mold of a polymer clay sculptural prototype.

Clade— Any established category of organisms thought to be closely related to one another and sharing a recent common ancestor.

Coelurosaurs— A subset clade of Avetheropods, comprising theropod dinosaur genera such as tyrannosaurs and more bird-like forms.

Dry-brushing— Applying minimal amounts of wet paint using a brush that is not saturated with liquid paint. The brush is tacky with the color of choice and may be stroked or "dusted" over certain body areas of the sculpt so as to suggest tinges of coloration.

Eumaniraptoran—	A clade comprising the most bird-like looking dinosaur genera, such as *Deinonychus*, *Velociraptor* and *Troodon*. The group is characterized partly by having long arms and rather dexterous fingers. This is the "brainier" clade thought most closely related evolutionarily to modern birds.
Filler material—	Usually bulky Styrofoam, or crumpled-up, aluminum foil, which may be used to fill out abdominal or other body areas of an in-progress sculpture before adding outer layers of polymer clay.
Free-standing—	In regards to an in-progress armature or sculpture, not permanently anchored into a base during the sculpting stages.
Genus—	An organismal classification, one taxonomic level above the specific, usually corresponding to common dinosaur names. For instance, *Stegosaurus* and *Moropus* happen to be generic names.
Imagetext—	A mind-melding linkage of visual with verbal information, sometimes inferred by the viewer, in consequence of experiencing paleoimagery.
Integument—	Skin or hide.
Maniraptorans—	The clade of proportionally longer-armed theropods including therizinosaurs, oviraptorids, "Ostrich-mimics" such as ornithomimosaurs, and bird-like forms such as eumaniraptorans.
Multiple-figure, simple-base—	A sculptural composition involving two or more prehistoric animal figures arranged in a diorama display and set upon a no-frills, non-sculpted (usually stained but otherwise bare) wooden base.
One-of-a-kind piece—	Any completed sculpture not intended to be reproduced through a molding process, such as described in chapter 17.
Ornithischian—	In common parlance, the "bird-hipped" clade comprising numerous dinosaur genera, which are usually quadrupedal and herbivorous.
Ornithopod—	In common parlance, the diverse grouping of duckbill hadrosaur, iguanodontian and hypsilophodont dinosaur genera.
Osteoderm–	Bony growths such as stegosaurian plates and ankylosaur armor embedded into dinosaur skin.
Peg—	A feature sculpted onto the end of a foot, facilitating the stages in sculpting a more or less free-standing sculpture (fig. 6–10).
Plasticine—	A clay that will not harden when exposed to air, and that is not a polymer-clay type.
Polymer clay—	A manufactured clay that upon baking at preferred temperatures will harden in an oven, but will not harden without application of heat upon exposure to air.

Pre-baked parts— Usually smaller parts or adornments of the dinosaur or other prehistoric animal, such as teeth, horns, plates, or spikes, that can be baked and embedded into the still unbaked clay body of the animal. These may be sharpened accordingly before joining them to the sculptural prototype.

Propatagium— A wing membrane existing in modern bats, and thought to be present in pterosaurs, that grew between the neck and upper arms.

Prototype— The original of any sculpture, prior to its reproduction through a molding process.

Pterodactyloidea— A large clade of short-tailed pterosaurs that thrived during the Late Jurassic through the Late Cretaceous periods.

Pubic retroversion— In certain theropod genera, a derived feature in which the pubic bone shifted evolutionarily rearward so as to superficially resemble that of a bird-hipped dinosaur.

Rectrices— Flight feathers on the tail of a bird attached to the rearmost bone (the pygostyle).

Remiges— Flight feathers attached to the arm or wing bones of a bird.

Rhamphorhynchoidea— A large clade of long-tailed pterosaurs that thrived from the Late Triassic through the Late Jurassic periods.

Saurischian— In common parlance, the "reptile-hipped" clade (although including theropods evincing pubic retroversion), comprising numerous dinosaur genera, such as the often bipedal and carnivorous theropods and the quadrupedal and herbivorous sauropods.

Scratch coat— An inner layer of polymer clay scratched prior to pre-baking such that additional, external layers of polymer clay will adhere more tightly to it. It may be necessary to create this inner layer in order to cover abdominal filler such as Styrofoam or aluminum foil (fig. 8–8).

Sculpt— Simply an abbreviation or nickname for "sculpture."

Sexual dimorphism— In nature, the phenomenon in which males and females of to the same species may have overtly distinguishing anatomical or skeletal traits (e.g., relative sizes) that differ statistically.

Single-figure, simple-base— In contrast to the multiple-figure, simple-base design, this is the most simple kind of means for displaying a sculpture. The sculpt may simply be mounted on a sanded, nicely stained wooden base. This kind of exhibition would not be considered a diorama.

Skeleton— Either the real bony fossilized remains of a prehistoric vertebrate, or the wire frame of a sculpted, restored prehistoric animal (the armature).

Spinal tap technique— Embedding the bases of individual pre-baked parts of a prehistoric animal (such as osteoderm plates) into and along the

as-yet-unbaked backbone area of an in-progress sculpt, such that the positions of each piece are clearly marked for future reference when it is time to join these parts to the body.

Striate— Using a sharp-ended sculpting tool to scratch or score the clay, either to create a scratch coat in an inner polymer-clay layer, or to create the illusion of skin detail in the outer dermal layer of a prehistoric animal sculpture.

Tetanurans— A large clade of more derived theropods including, for example, tyrannosaurs, spinosaurs and avetheropods, but not inclusive of ceratosaurs.

Texturing cup— A homemade device permitting the sculpting of scaly skin detail on a sculpt (figs. 6–16 and 6–18).

Thyreophoran— Usually referring to armored, ornithischian dinosaurs, including stegosaurs and ankylosaurs.

Vertebral wire— The main wire corresponding to the fossilized backbone in a prehistoric vertebrate that runs from the neck through the tail in a sculpt. This wire is often logistically positioned underneath where the animal's real backbone would have existed and is the sturdiest weight-bearing armature wire in the sculpture. Filler elements and wires corresponding to limbs (or tail and head) are mechanically bonded to the vertebral wire.

Chapter Notes

Introduction

1. Readers may be interested to learn that the two principal authors of this book (Allen and Bob) do not share similar opinions on the nature and meaning of the fossil record and evolution. (These authors simply agree to disagree.) While Allen, a staunch evolutionist trained in the physical sciences, has sprinkled current interpretations of paleontological and other associated evidence throughout this book, reflecting what has been gleaned about Earth's past and its inhabitants through the scientific process, Bob's contrasting, more theologically-oriented, personal beliefs are stated here:

Before we begin, I would like to point out that my co-author has expressed his views concerning lots of now-extinct animals, and also the idea that animals have evolved, including the idea that some dinosaurs have evolved into what we call birds today. This has led some artists to depict feathered dinosaurs, in art and in literature. Since ample room has been used to state dogmatically that some particular groups of animals gave rise to other groups of animals, to paraphrase my co-author's writings, I say that I strongly disagree with the idea that any organism can and has evolved into a basically different *kind* of animal, such as the idea of a theropod dinosaur changing into a bird, an amphibian turning into a reptile, or an ape changing into a human being. No indisputable evidence exists for these ideas, even though claims are made quite frequently to the contrary, and no one has ever *observed* these major changes taking place. The abundant evidence for stasis in my opinion speaks loudly of the idea that life forms remain basically the same over time, meaning that while there is certainly variety among the basic kinds (referred to by some as "micro-evolution"), such as different varieties of dogs, cats, horses and even in human beings, no macro-evolution has occurred, that is, the change of one basic kind of organism into another basic kind of organism. We certainly do not see any evidence for macro-evolution in today's animal kingdom, nor among human beings. Even the late scientist Dr. Stephen J. Gould recognized that there was no evidence in the fossil record for gradual evolution, and in fact even admitted that what he called "curious mosaics" like *Archaeopteryx* (where transitional forms are concerned) do not count as missing links. That is to say that animals such as *Archaeopteryx* apparently did not qualify as transitional forms. Dr. Gould did however believe in another form of evolution, called *punctuated equilibrium*, which is a very rapid morphological change (geologically speaking) from one kind of animal into another. But this is an argument from lack of evidence, that since we don't see gradual evolution preserved in the fossil record, then it must have occurred so quickly that the evidence was not preserved in the fossil layers. In my opinion, that is total speculation and is also, again, an argument from lack of evidence. Oftentimes, evolutionists point out the similarities between, say, chimpanzees and humans. But very rarely are the vast number of *dissimilarities* mentioned, and they *are* vast in number. The reason I am stating this is because I believe that there is not one example of an actual feathered dinosaur, but instead mis-interpreted fossil finds (perhaps remnants of collagen fibers, a precipitate of some sort, preserved keratin, etc.; and yes, I know that feathers are made of keratin, but this doesn't prove that remnants of feathers are present), and unfortunately there have been examples of fossil fakery (for example, *Archaeoraptor liaoningensis,* in the Nov. 1999 *National Geographic)*. A second reason I am stating this is because I believe that, as in a court of law, both sides of the issue should be addressed. In fact, Charles Darwin himself, in his book *On The Origin of Species,* stated this view in very similar terms. One doesn't need to be a scientist to take the time to study the evidence for (macro-)evolution, or lack thereof, and also evidence which supports stasis among the basic kinds of organisms. The evidence presented in the fields of biology, genetics and information theory seem to indicate that macro-evolution is not possible, and again, macro-evolution has never been observed. Also, careful study of the evidence for both a young earth, and possibly an ancient earth and universe, should be done. The commonly used radiometric dating methods are highly questionable at best, and totally unprovable at worst, especially considering

the fact that one can use five different radiometric dating methods and achieve five very different ages for a rock, for example. How do we know any of the dates are right? And lava flows that are known historically to have occurred in the last few hundred years have been dated using various radiometric methods, and dates in the millions and even hundreds of millions of years have been arrived at. The problem evident in this less-than-exact "science," I hope is clear. However, this is a book on sculpting dinosaurs, so I will soon conclude my comments, and welcome you to send me your comments and questions. I have studied the evidence for both sides (evolution and creation) and have no doubt that the belief in macro-evolution is no less a religious belief than is creation, also known as "abrupt appearance," which we see in the so-called Cambrian Explosion, for example. And the same dilemma applies to the idea of a very ancient earth and universe; if the earth and universe are billions of years old, we can never prove that; we were not there. For any evolutionist to state that "evolution is science and creation is religion," that is a false or at least incorrect statement. Both views ultimately must be taken by faith. And both the evolutionists and the creationists are looking at the same facts, the same evidence. The difference is not in these, but the difference is in our *interpretations* of the evidence. In my opinion, based on the preponderance of evidence, although there is certainly *variation* among the basic *kinds* of organisms, no macro-evolution has ever occurred and is not occurring today. And the earth is really quite young, in the several thousands of years old, not millions or billions, also supported by the preponderance of evidence. And finally, all life, the earth and the universe show clear evidence of being intelligently designed, and created by that very intelligence whose identity is stated in my dedication at the beginning of this book. Okay, having said that, let's move on.— Bob Morales

2. Allen A. Debus, Bob Morales, and Diane E. Debus, *Dinosaur Sculpting: A Complete Beginners' Guide* (Bartlett, IL: Hell Creek Creations, 1995).

3. A *Prehistoric Times* subscription and back issues may be ordered from Mike Fredericks at 145 Bayline Circle, Folsom, CA, 95630–8077. Search the *Prehistoric Times* Web site for additional information: *www.prehistorictimes.com*.

4. Gregory S. Paul's *The Princeton Field Guide to Dinosaurs* (Princeton University Press, 2010), is fortified with a wealth of invaluable dorsal and lateral skeletal reconstructions of most dinosaur genera.

Chapter 1

1. Stephen A. Czerkas, "Skin," in *Encyclopedia of Dinosaurs*, ed. Philip J. Currie and Kevin Padian (New York: Academic Press, 1997), 669–675.

2. Personal communication from David Thomas, circa 1993.

3. Mike Fredericks, interview with Sean Cooper, *Prehistoric Times* 56 (Oct./Nov. 2002): 10.

Here, Cooper discourages use of the Baggie Trick, or "plastic wrap technique." He advises rather that "the trick is to make a gentle impression in the clay rather than gouging like you would if raking or plowing a field. It's tedious work but you don't end up with all the little Super Sculpey 'boogers' so to speak. What few you do end up with can usually be brushed away with a paint brush by whisking in the direction your texture flows. After that, brushing a light coat of rubbing alcohol will usually dissolve the rest. And finally, after baking the sculpey, lightly go over the finished sculpture with a real fine sand wool to remove any left over imperfections."

4. David Norman, *Dinosaur!* (New York: Prentice Hall, 1991); Sylvia Czerkas and Everett C. Olson, eds., *Dinosaurs Past and Present*, vols. 1 and 2, (Seattle, WA: Natural History Museum of Los Angeles County in association with University of Washington Press, 1987).

5. Without elaborating here, Stout's rules include: "Keep your day job; Never stop doing your science homework; Study paleobotany; Study geology; Never stop doing your art homework; Be a good business person; Know (and keep) your rights; Use archival materials; Don't bite off more than you can chew; Always do your best work" (William Stout, "The 10 Rules of Being a Paleoartist," *Prehistoric Times* 86 [Summer 2008]:10–11). Gurney's include: "Learn from animal analogues; When it comes to feathered dinosaurs, avoid the spiky look; Look for unusual behaviors; Pose sculpted dinosaur models, i.e. prior to initiating a painted canvas restoration; Avoid the 'dry lake bed' look — add foliage; Place the animals in a real setting; Use special effect illusions; Separate the light from shadow; Use a five foot eye level" (James Gurney, "James Gurney's 10 tips for Realistic Dinosaurs," *Prehistoric Times* 91 [Fall 2009]: 10–12). It is important to note that both Stout and Gurney are noted primarily for their two-dimensional painted restorations of dinosaurs, and some of their rules would be most germane to paintings rather to sculptural restorations. Yet both Stout and Gurney are top-notch sculptors as well; their *philosophies* should be taken to heart and put into practice by every paleosculptor!

Chapter 2

1. William E. Swinton, *Dinosaurs* (London: British Museum of Natural History, publication no. 542, 1969), 38–39; also see Allen A. Debus and Diane E. Debus, *Paleoimagery: The Evolution of Dinosaurs in Art* (Jefferson, NC: McFarland, 2002), 243, note 3, citing an interview with paleoartist Michael Skrepnick.

2. Kathryn M. Northcut, "The Making of Knowledge in Science: Case Studies of Paleontology Illustration" (PhD dissertation, Texas Tech University, May 2004); Vincent Campbell, "The Extinct Animal Show: The Paleoimagery Tradition and Computer Generated Imagery in Factual Television

Programs," *Public Understanding of Science* 18 (2009): 199–213.

3. William J.T. Mitchell, *The Last Dinosaur Book* (Chicago: University of Chicago Press, 1998), 77–85.

4. Martin J.S. Rudwick, *Scenes from Deep Time: Early Pictorial Representations of the Prehistoric World* (Chicago: University of Chicago Press, 1992), 36.

5. Ibid., 216–217, 225.

6. Allen A. Debus, "Sorting Vertebrate Iconography in Paleoart," *Bulletin of the South Texas Geological Society* 44, no. 1 (September 2003): 5, 10–24; Allen A. Debus, "Images out of Deep Time," *Trilobite Tales* 20, no. 2 (Feb. 2003): 12–17; Allen A. Debus and Diane E. Debus, *Paleoimagery*, 67–72.

7. Martin J.S. Rudwick, *Worlds Before Adam: The Reconstruction of Geohistory in the Age of Reform* (Chicago: University of Chicago Press, 2008).

8. Stephen J. Gould, Preface, "Reconstructing (and Deconstructing) the Past," in *The Book of Life: An Illustrated History of the Evolution of Life on Earth* (New York: W.W. Norton, 1993), 15; Gould reiterates this position in an essay, "The Power of Narrative," in *The Richness of Life: The Essential Stephen Jay Gould*, ed. Steven Rose (New York: W.W. Norton, 2007), 127–142.

9. Rudwick, *Worlds Before Adam,* 98.

10. Ibid., 119.

11. Hawkins, quoted in Steve McCarthy and Mick Gilbert, *The Crystal Palace Dinosaurs: The Story of the World's First Prehistoric Sculptures* (London: Crystal Palace Foundation, 1994), 35.

12. Personal communication, August 27, 1991.

13. Louis Guillaume Figuier, *The World Before the Deluge* (London: Cassell, 1867).

14. Allen A. Debus, "Reframing the Science in Jules Verne's *Journey to the Center of the Earth*," *Science Fiction Studies* 33, no. 100, part 3 (Nov. 2006): 405–420.

15. Rudwick, *Scenes from Deep Time*, 219.

16. Ibid., 219.

17. Sylvia Massey Czerkas and Donald F. Glut, *Dinosaurs, Mammoths and Cavemen: The Art of Charles R. Knight* (New York: E.P. Dutton, 1982); Henry F. Osborn, "Models of Extinct Vertebrates," *Science*, Friday, June 24, 1898, 841–845. Here, Osborn refers to a "Catalogue of Casts, Models, Photographs and Restorations of Fossil Vertebrates, issued by the Dept. of Vertebrate paleontology, American Museum of Natural History, April 1898."

18. Allen A. Debus and Diane E. Debus, *Paleoimagery*, 83–96; Clayton,Hoaglund, "They Gave Life to Ancient Bones," *Scientific Monthly*, February 1943, 114–133.

19. See for example, Henry N. Hutchinson, *Extinct Monsters: A Popular Account of Some of the Larger Forms of Ancient Animal Life* (London: Chapman and Hall, 1893), x.

20. Allen A. Debus, "Henry Robert Knipe: A Neglected Paleo-popularizer" (parts 1 and 2), *Prehistoric Times* 97 (Spring 2011): 46–47, and 98 (Summer 2011): 46–48.

21. H.F. Osborn, *The Origin and Evolution of Life: On the Theory of Action Reaction and Interaction of Energy* (New York: Charles Scribner's Sons, 1918); Allen A. Debus, "When a 'Dinosaur Book' Isn't: Henry Fairfield Osborn's *Origin and Evolution of Life* (1917)" (parts 1 to 3), *Fossil News: Journal of Avocational Paleontology* 16, no. 1 (Jan. 2012): 6–9; no. 2 (Feb. 2012): 4–8; and no. 3 (March 2010): 2–5. Osborn didn't grasp the concept of a Darwinian evolutionary principle that Stephen J. Gould later named "exaptation" in 1981. Osborn's "orthogenesis" is not congruent with exaptation (also sometimes misfortunately termed *preadaptation*), which has great bearing on, for example, the origin of flight in Mesozoic birds. See Stephen J. Gould, "Not Necessarily a Wing," in *The Richness of Life: The Essential Stephen Jay Gould*, ed. Steven Rose (New York: W.W. Norton, 2007), 143–154.

22. Othenio Abel, *Lebensbilder aus der Tierwelt der Vorzeit* (Jena: Gistav Fischer, 1927).

23. W. Maxwell Reed, *The Earth for Sam: The Story of Mountains, Rivers, Dinosaurs and Men* (New York: Harcourt, Brace, 1930).

24. Charles H. Sternberg, *Hunting Dinosaurs in the Bad Lands of the Red Deer River, Alberta Canada* (orig. published by the author, 1917; Edmonton: NeWest, 1985), 130–176.

25. Charles R. Knight, *Before the Dawn of History* (New York: McGraw-Hill, 1935).

26. Charles R. Knight, "Parade of Life Through the Ages," *National Geographic* 81, no. 2 (Feb. 1942): 141–184.

27. Francis B. Messmore, "The History of the World a Million Years Ago," *Dinosaur World* 1, no. 3 (Oct. 1997): 27–32.

28. Ibid., 32.

29. More recent examples include the Prehistoric Gardens in Port Orford, Oregon, Ontario's Le Monde Prehistorique, and Germany's Saurierpark. See Allen A. Debus and Diane E. Debus, *Paleoimagery*, 190–207.

30, Jeff Rovin, *From the Land Beyond Beyond: The Making of Movie Monsters You've Known and Loved* (New York: Berkley, 1977), 56.

31. E. Hamilton, "The Isle of Changing Life," *Thrilling Wonder Stories* 16, no. 3 (June 1940): 33–43, 127–128. H.P. Lovecraft tackled this theme too.

32. Lincoln Barnett, "The Pageant of Life," in *The World We Live In*, ed. Henry R. Luce, 88–106 (New York: Time, 1955).

33. Kerry Heckenberg, "The King of the Sea and Other Stories of Prehistoric Life at the University of Queensland," *reCollections: A Journal of Museums and Collections* 5, no. 1.

34. Ibid.

35. Allen A. Debus and Diane E. Debus, *Paleoimagery*, 70–71. Another fine similar example (of unknown origin) appears as a clipping in an old prehistoric-life scrapbook compiled by my father in 1935, appearing in vol. 1, p. 32, of his "Monsters of the Prehistoric Past." Allen A. Debus, "The Original

Dinosaur Scrapbooks," *Prehistoric Times* 96 (Winter 2011): 29–31.

36. Allen A. Debus, "Time's River Metaphor in *Journey to the Beginning of Time*," *Mad Scientist* 23 (Spring 2011): 28–32; Josef Augusta, *Prehistoric Animals* (London: Spring Books, 1956).

37. Gary Williams, "Prehistoric Journeys of Karel Zeman," *Dinosaur World* 1, no. 3 (October 1997): 49–52.

38. Stephen J. Gould, *The Book of Life*, 19. Benjamin Waterhouse Hawkins viewed his work for Sydenham's Crystal Palace Exhibition as an artistic manifestation of the Almighty, claiming that he summoned "from the abyss of time and from the depths of the earth, those vast forms and gigantic beasts which the Almighty Creator designed with fitness to inhabit and precede us in possession of this part of the earth called Great Britain" (Adrian J. Desmond, *The Hot-Blooded Dinosaurs: A Revolution in Palaeontology* [New York: Dial, 1976], 19).

39. Michael Magee, *Who Lies Sleeping?: The Dinosaur Heritage and the Extinction of Man* (Selwyn, England: AskWhy?, 1993); James Lovelock, *The Vanishing Face of Gaia: A Final Warning* (New York: Basic, 2009). Such concerning matters increasingly became popularized in 1950s science fiction as well.

40. Desmond, *Hot-Blooded Dinosaurs*.

41. Robert T. Bakker, "Dinosaur Renaissance," *Scientific American* 232, no. 4 (April 1975), 58–78; David E. Fastovsky and David B. Weishampel, *The Evolution and Extinction of the Dinosaurs*, 2nd ed. (Cambridge: Cambridge University Press, 2005), 378. The earliest use of the term *dinosaur renaissance* known to this author is within a short article published in *This Week Magazine* (July 27, 1958, 9) concerning the proliferation of mass-produced plastic dinosaur toys. A paragraph declares, "We're in a Dinosaur Renaissance."

42. A. Debus and D. Debus, *Paleoimagery*, 234–242. In particular, one colorful, stylistic book that launched the lively new era in paleoart in public view was *The Dinosaurs: A Fantastic New View of a Lost Era* (New York: Mallard, 1981), illustrated by William Stout. Stout's artistry has the essence of Disney's "Rite of Spring" movement in *Fantasia*, although conveyed in words, vignettes and static drawings, engaging audiences with its downright quirkiness and highly original visual perspectives. *The Dinosaurs* was clearly inspired by the then-recent researches of Bakker, Ostrom, Horner, Peter Dodson (who served as scientific consultant for this production) and other contemporary, progressively minded paleontologists. As stated on the book jacket, here was a scientifically accurate "story more fantastic than fantasy itself."

43. Gregory S. Paul, "Drawing Dinosaurs," *Geotimes* 51, no. 1 (Jan. 2006): 22–26.

44. Vincent Scully, *The Great Dinosaur Mural at Yale: The Age of Reptiles* (New York: Harry N. Abrams, 1990), 16.

45. Michael J. Benton, "Scientific Methodologies in Collision: The History of the Study of the Extinction of the Dinosaurs," *Evolutionary Biology* 24 (1990): 371–400.

46. Allen A. Debus, "Dewey McLean's Volcanic Greenhouse Theory," *Fossil News: Journal of Avocational Paleontology* 17, no. 2 (March/April 2011): 5–9; Allen A. Debus, "When Volcanoes Were in 'Vogt,'" *Fossil News: Journal of Avocational Paleontology* 17, no. 3 (May/June 2011): 5–7, 11–12; Loris Russell, "Body Temperature of Dinosaurs and Its Relationship to Their Extinction," *Journal of Paleontology* 39, no. 3 (May 1965): 497–501. Also see Fastovsky and Weishampel, *Evolution and Extinction of the Dinosaurs*, 377, referring to a 1947 paper by Edwin H. Colbert, "Rates of Temperature Increase in Dinosaurs," *Copeia* 2: 141–142.

47. Notably, this has been the mantra of Montana paleontologist John R. Horner, who has often collaborated with paleoartist Douglas Henderson, professing and supporting ideology of understanding dinosaurs as living, sociobiologically attuned organisms. Also, this was a rousing theme stated in William Service's "Welcome to the Mesozoic Era," in *The Dinosaurs: A Fantastic New View of a Lost Era*. Service stated, "We are going to look into the lives of the dinosaurs and of their kin, not their extinction." *The Dinosaurs* probed into how "dinosaurs lived: how they moved, ate, dueled, drank and even made love."

48. A. Debus and D. Debus, *Paleoimagery*, 152–156, "Portraying Paleocatastophe."

49. Allen A. Debus, "That First Intelligence" (parts 1 and 2), *Prehistoric Times* 99 (Fall 2011): 46–48, and 100 (Winter 2012): 46–48; Allen A. Debus, "A Mastermind of Godzillean Proportions," *G-Fan* 94 (Winter 2011): 58–60.

50. Although clearly associated by the mid–1950s both in popular culture and scientific meditations, the themes of environmentalism and pivotal (now viewed as "catastrophic") episodes recorded in geological history became increasingly linked from the 1980s through the 2000s.

51. The term *disaster porn* is indexed within Max Page's *The City's End: Two Centuries of Fantasies, Fears, and Premonitions of New York's Destruction* (New Haven: Yale University Press, 2008).

52. Peter D. Ward, *Out of Thin Air* (Washington, D.C.: Joseph Henry, 2006); Robert A. Berner, *The Phanerozoic Carbon Cycle* (Oxford: Oxford University Press, 2004).

53. Peter D. Ward, *Under A Green Sky: Global Warming, The Mass Extinctions of the Past, and What They Can Tell Us About Our Future* (Washington, D.C.: Smithsonian Books, 2007); Peter Ward, *The Medea Hypothesis: Is Life on Earth Ultimately Self-Destructive?* (Princeton, NJ: Princeton University Press, 2009).

54. Allen A. Debus, "The First Ingtelligence, Parts 1–2," n49.

55. Mike Fredericks, "The PT Interview with Mark Rehkopf," *Prehistoric Times* 94 (Summer

2010): 10. This philosophy is echoed by paleosculptor David Silva, who in a *Prehistoric* Times interview with Mike Fredericks stated, "My goal is to express the creature's essence through dynamic movement. The intent is to make my depictions about 90% accurate and the other 10% fantasy. It gives it life and adds a certain majestic quality that expresses something beyond skeletal restorations and scientific studies. I want people to see these creatures and immediately know what they were all about. There's a character to these animals that I really enjoy conveying" (*Prehistoric Times* 102 [Summer 2012]: 11). Also see Hans C.E. Larson's review of *The Dinosauria* (2nd ed., 2004); he states, "Dinosaur research is often synonymized with science fiction or Hollywood" (*Science* 307 [Jan. 28, 2005]: 520).

56. Dale A. Russell, "The Mass Extinctions of the Late Mesozoic," *Scientific American*, Jan. 1982, 65.

57. For the best synopsis of the relevant scientific, science fictional and cultural background inspiring this new sculpture, see Allen A. Debus, "That First Intelligence" (parts 1 and 2), *Prehistoric Times* 99 (Fall 2011): 46–48, and 100 (Winter 2012): 46–48; John C. McGloughlin, "Evolutionary Bioparanoia," *Animal Kingdom*, April/May 1984, 24–30; Dale A. Russell and Ron Seguin, "Reconstruction of the Small Cretaceous Theropod *Stenonychosaurus inequalis* and a Hypothetical Dinosauroid," *Syllogeus* 37 (1982); Allen A. Debus, *Dinosaurs in Fantastic Fiction: A Thematic Survey* (Jefferson, NC: McFarland, 2006), 146–147. Also see note 46, this chapter.

58. Dana Cain and Mike Fredericks, *Dinosaur Collectibles* (Norfolk, VA: Antique Trader, 1999), 112.

59. Allen A. Debus and Diane E. Debus, "A Short History of the Hell Creek Creations Prehistoric Animals Resin Line," in *Dinosaur Memories: Dinotrekking for Beasts of Thunder, Fantastic Saurians, "Paleo-people," "Dinosaurabilia," and other "Prehistoria"* (San Jose: Authors Choice, 2002), 577–594.

60. Allen A. Debus and Diane E. Debus, *Paleoimagery*, 94–95, 208–211.

Chapter 3

1. Allen A. Debus, "Historical Dinosaurs: Episodes in Discovery and Restoration," *Earth Sciences History* 12, no. 1 (1993): 60–69; Allen A. Debus and Steve McCarthy, "A Scene from American Deep Time," *The Mosasaur* 6 (May 1999): 105–115. Several of the Dinosaur Society articles were cited in the bibliography of the 1995 edition of *Dinosaur Sculpting*.

2. Combining sculpting and casting skills (per chapter 17), it would be possible to conduct a keen science experiment estimating the masses of various kinds of dinosaurs when alive. The technique, which involves immersing a miniature replica of the dinosaur of known relative scale under water to obtain its volume, was improvised by Edwin H. Colbert in 1962 ("The Weights of Dinosaurs," *American Museum Novitates* 2076: 1–16). A non-porous, scale model of uniform composition and density, cast from a mold, must be made from the polymer clay prototype. The casting should ideally be formed under pressure to eliminate air bubbles using techniques such as Mike Evans employs at Alchemy Works (see chapter 17, note 4, for Mr. Evan's contact information.) The calculation and experimental method are summarized on a Web site created by Tim Culp and Harry J. Wolf of the Woodrow Wilson Biology Institute (http://www.accessexcellence.org/AE/AEPC/WWC/1995/estimating.php). The mathematical formula for determining the mass of the actual live dinosaur is: (volume of model) X (scale3) X (estimated density of live animal) = (mass of actual animal in life).

3. Your goal might be to create your own household "museum" populated with prehistoric animal sculptures representing Earth's past ages. Or maybe you yearn to publish a book illustrated with your original sculptural dioramas. One example of such a book is Ellis Owen's *Prehistoric Animals: The Extraordinary Story of Life Before Man* (London: Octopus Books, 1975), featuring Arthur Hayward's many splendid sculptural renderings. Hayward designed and sculpted prototypes of many of the Invicta dinosaur series of prehistoric animal toys and also several prehistoric creatures animated by Ray Harryhausen.

Chapter 4

1. Tim Brierton, *Stop-Motion Armature Machining* (Jefferson, NC: McFarland, 2002); Tim Brierton, *Stop-Motion Puppet Sculpting* (Jefferson, NC: McFarland, 2004). While neither of Brierton's books discusses the sculpting of dinosaurs, the 2004 book has a chapter outlining how to construct a basic human-shaped armature for a sculpted miniature. Also, to this end, there was an interesting video posted online at Youtube showing paleosculptor Arthur Hayward creating a flexible stop-motion movie dinosaur armature for Ray Harryhausen's *One Million Years B.C.* (www.youtube.com/watch?v=cYxuEEbDpxw).

Chapter 5

1. The giant dino-monster name "G-Fantis" was conceived a decade ago by John D. Lees, editor of the illustrious *G-Fan* magazine.

Chapter 6

1. Cladistics is a system allowing paleontologists to infer probable evolutionary relationships based upon morphological similarities or shared derived features, which when relying on Occam's razor and detailed diagnoses of fossil evidence results in parsimoniously constructed *cladograms*. Cladograms represent falsifiable hypotheses and are not considered "trees of life."

2. George Olshevsky, "*Bruhathkayosaurus*: Big-

ger than *T. rex?*," *The Dinosaur Report*, Winter 1994, 12–13.

3. David E. Fastovsky and David B. Weishampel, *The Evolution and Extinction of the Dinosaurs*, 2nd ed. (Cambridge: Cambridge University Press, 2005), 322.

4. Amina Khan, "*T. rex* Cousin Had 'Shaggy' Feathers," *Chicago Tribune*, April 5, 2012, section 1, 15; for further background on evolutionary relationships among tyrannosaurs, Stephen L. Brusatte, Mark A. Norell, Thomas D. Carr, et. al., "Tyrannosaur Paleobiology: New Research on Ancient Exemplar Organisms," *Science* 329, no. 5998 (Sept. 17, 2010): 1481–1485; James Clark, "Becoming *T. rex*," *Science* 326 (October 16, 2009): 373–374; Paul C. Sereno, Lin Tan, Stephen Brusatte, Henry J. Kriegstein, Xijin Zhao, and Karen Cloward, "Tyrannosaurid Skeletal Design First Evolved at Small Body Size," *Science* 326 (October 16, 2009): 418–422.

5. A compelling photo of the "Wyrex" skin appears on page 548 of Donald F. Glut's *Dinosaurs: The Encyclopedia*, Supplement 4 (Jefferson, NC: McFarland, 2006). However, according to Phil Hore, *Gorgosaurus* skin was smooth, not pebbly: "Skin impressions, rare on a dinosaur (and more so on a theropod), were later reported by Phil Currie on the specimen. Unlike most reptilian hide, the fossil skin is supposedly smooth, resembling the softer skin of a bird's torso" (Phil Hore, "Gorgosaurus-Albertosaurus," *Prehistoric Times* 100 [Winter 2012]: 14–18).

6. Beginning sculptors should know, however, that use of stamps is generally frowned upon. See David Silva, "PT Interview," with Mike Fredericks, *Prehistoric Times* 102 (Summer 2012): 12, for example, where Mr. Silva states, "Try not to use texturing stamps (because it looks unnatural)." Stamps do have their place, but they're at best a rudimentary means for creating the illusion of real dino-hide; the Texturing Cup technique described in this chapter is much preferred. Silva also urges sculptors to "make their own tools when you can.... There are no short cuts for hard work ... (and) caffeine is your friend."

7. Tyler Keillor, "Sue: Sculpting a Skeletal *T. Rex* from Scratch!" *Prehistoric Times* 43 (Aug./Sept. 2000): 6–7; Darren McDonald, "How to Make Your Own *T. rex*," *Prehistoric Times* 99 (Fall 2011): 28–29; James O. Farlow, Matt B. Smith, and John M. Robinson, "Body Mass, Bone 'Strength Indicator,' and Cursorial Potential of *Tyrannosaurus rex*," *Journal of Vertebrate Paleontology* 15, no. 4 (Dec. 27, 1995): 713–725.

Chapter 7

1. Ricardo N. Martinez, Paul C. Sereno, et al., "A Basal Dinosaur from the Dawn of the Dinosaur Era in Southwestern Pangaea," *Science* 331, no. 6014 (Jan. 14, 2011): 206–210. Previously, *Eoraptor* was viewed as an ancestral theropod. But here, the authors state, "Not only does *Eoraptor* lack all of the aforementioned theropod attributes in *Eodromaeus*, but it exhibits features previously seen only among

basal sauropodomorphs." Another new, 3-foot-long genus, the 230-million-year-old *Pampadromaeus* discovered in Brazil, possesses many features later seen in sauropods. See Steve Brusatte's article, "Dinosaur Paleontology: The Year in Review 2011," *Prehistoric Times* 100 (Winter 2012): 54.

2. Based on the evidence they've considered, paleontologists Stephen L. Brusatte and Michael J. Benton prefer this process for proliferation of the dinosaur clades during the Late Triassic (230 to 200 million years ago), rather than a replacement founded on a more warlike and prolonged competition between early dinosaur clades — viewed as somehow superior — and other contemporary creatures. Under an opportunistic replacement or "historical contingency" scenario, dinosaurs fortuitously acclimated themselves to niches vacated by other vertebrates that had suffered extinction (Brusatte, Benton, et al., "Superiority, Competition, and Opportunism in the Evolutionary Radiation of Dinosaurs," *Science* 321 [Sept. 12, 2008]: 1485–1488). Other researchers believe that heightened volcanic eruption and concomitant release of greenhouse gases 201 million years ago may have resulted in a mass extinction that contributed to a preferential unleashing of dinosaurian clades (Richard A. Kerr, "Did Greenhouse Gasses [*sic*] Unleash the Dinosaurs?" *Science*, July 21, 2011, http://news.sciencemag.org/sciencenow/2011/07/did-greenhouse-gasses-unleash-th.html.

3. Gregory S. Paul, "How the African *Brachiosaurus* Became *Giraffatitan*," *Prehistoric Times* 97 (Spring 2011): 20–12.

4. David E. Fastovsky and David B. Weishampel (with illustrations by John Sibbick), *The Evolution and Extinction of the Dinosaurs* (Cambridge: Cambridge University Press, 2005), 237. Also see P.M. Sander and M. Clauss, "Sauropod Gigantism," *Science*, Oct. 10, 2008, 200, and Roger S. Seymour, "Sauropods Kept Their Heads Down," Letters, *Science* 323 (Mar. 27, 2009): 1671. In particular, Seymour states, "The high (metabolic) cost of high browsing makes it energetically more reasonable to keep the head down and move the neck horizontally rather than vertically." In a picture caption to Seymour's letter, the editors note, "Sauropods may not have used their necks to lift their heads high, at least not for long periods of time."

5. Tracy Ford, "How to Draw Dinosaurs: Bipedal or Tripodal Sauropods?" *Prehistoric Times* 98 (Summer 2011): 18–20.

6. According to some paleontologists, *Seismosaurus* may be a junior synonym of *Diplodocus*.

7. For a detailed study of how the most spectacular *Brachiosaurus* skeleton was discovered and eventually reconstructed and mounted during the early 20th century, see Gerhard Maier's *African Dinosaurs Unearthed: The Tendaguru Expeditions* (Bloomington: Indiana University Press, 2003).

8. Gregory S. Paul, "Big Sauropods — Really, Really Big Sauropods," *The Dinosaur Report*, Fall 1994, 12–13.

9. A.D. Stewart, "Quantitative Limits to Paleogravity," *Journal of the Geological Society* 133, part 4 (April 1977): 281–291.

10. Stephen A. Czerkas, "Discovery of Dermal Spines Reveals a New Look for Sauropods," *Geology* 20 (Dec. 1992): 1068–1070.

11. Another excellent resource is Gregory S. Paul's aforementioned *Princeton Field Guide to Dinosaurs.* David Norman, *Dinosaur!* (New York: Prentice Hall, 1991); Gregory S. Paul, "The Science and Art of Restoring the Life Appearance of Dinosaurs and Their Relatives — A Rigorous How-to Guide," in *Dinosaurs Past and Present*, vol. 2, ed. Sylvia Czerkas and Everett C. Olson (Seattle, WA: Natural History Museum of Los Angeles County in association with University of Washington Press, 1987), 5–49.

12. See Michael Skrepnick's restorations on the cover of *Science* 293, no. 5531 (August 3, 2001). Lawrence M. Wittner, "Nostril Position in Dinosaurs and Other Vertebrates and Its Significance for Nasal Function," *Science* 293, no. 5531 (August 3, 2001): 753, 850–853.

Chapter 8

1. Anthony Beeson, "*Scelidosaurus* in Art and Science," *Prehistoric Times* 88 (Winter 2008): 44–45.

2. In his philosophically satisfying essay, Kenneth Carpenter discusses the "genus and species problems" in vertebrate paleontology, stating, "The paleontological concept of species is problematic because it is based on osteological characters. The situation is made worse by the fragmentary nature of most specimens. It is no wonder then that there is no agreement as to whether a particular taxon is a valid species, let alone a valid genus" (Carpenter, "Species Concept in North American Stegosaurs," *Swiss Journal of Geoscience*, DOI 10.1007/s00015–010–0020–6, Aug. 21, 2010, *http://link.springer.com/article/10.1007/s00015–010–0020–6/fulltext.html*, 8 pp.

3. Plate geometry in *Stegosaurus* was first discussed by Charles Whitney Gilmore in "Osteology of the Armored Dinosauria in the United States National Museum," *Memoirs of the United States National Museum* 89 (1914).

4. Carpenter, "Species Concept," 6.

5. Tracy Ford, "How to Draw Dinosaurs: Were Stegosaurs Bipedal?" *Prehistoric Times* 88 (Winter 2008): 18–19; Allen A. Debus, *Prehistoric Monsters: The Real and Imagined Creatures of the Past That We Love To Fear* (Jefferson, NC: McFarland, 2010), 125–132, 135.

6. Gregory S. Paul's skeletal reconstruction may be found on page 36. But also seek out Paul's valuable *Princeton Field Guide to Dinosaurs* (2010) for additional visual references.

Chapter 9

1. David E. Fastovsky and David B. Weishampel, *The Evolution and Extinction of the Dinosaurs,* 2nd ed. (Cambridge: Cambridge University Press, 2005), 178.

2. Jeffrey Kluger, "Kosmo the Dino," *Time* 176 (Oct. 11, 2010): 44–45.

3. William Stout, *The Dinosaurs: A Fantastic New View of a Lost Era*, narrated by William Service (New York: Mallard Press, 1981).

4. Czerkas and Olson, *Dinosaurs Past and Present,* Vol. 1, 48, 53, 55–59, Vol. 2, 5–6, 11, 13, 17, 39–40. In the case of ceratopsians and their evolutionary ancestral lineage, another valuable reference is Peter Dodson's *The Horned Dinosaurs: A Natural History* (Princeton: Princeton University Press, 1996). Also see relevant figures in Gregory S. Paul's *Princeton Field Guide to Dinosaurs* (2010).

Chapter 10

1. The *Thescelosaurus* specimen in question, named "Willo," was discovered in 1993 in South Dakota. *Thescelosaurus* was a pony-sized, 13-foot-long, Late Cretaceous dinosaur, representing a clade of more derived ornithopods known as euornithopoda, thought to be ancestral to Iguanodontia. This doubtful yet fascinating evidence of a fossilized heart purportedly supported the warm-blooded dinosaur concept because it appeared to be four-chambered with evidence of an aorta. Such a heart would have invested dinosaurs, potentially, with an "intermediate to high metabolic rate." However, the fossilized "heart" has been reinterpreted by some as an iron-stone concretion instead. Regardless, even if the object in question isn't a genuine cardiovascular feature or organ (which as of 2012 it doesn't appear to be, after all), such a conclusion would not falsify the theory that certain ornithopods may have been to some degree warm(er)-blooded as opposed to reptilian cold-bloods. Usually paleontologists find logic, evidence and reason for warm-bloodedness in derived saurischian theropods, as opposed to ornithischians. For more on this specimen, see Paul E. Fisher, Dale A. Russell, et al., "Cardiovascular Evidence for an Intermediate or Higher Metabolic Rate in an Ornithischian Dinosaur," *Science* 288 (April 21, 2000): 503–505; Rachel K. Sobel, "A Dinosaur with Heart," *U.S. News and World Report*, May 1, 2000, 59; Tim Friend, "Debate over Dinosaur 'Heart' Gets Blood Pumping," *USA Today*, October 3, 2000, Science, 8D-8E; Erik Stokstad, "Doubts Raised About Dinosaur Heart," *Science* 291 (Feb. 2, 2001): 811; Steve Brusatte, *Prehistoric Times* 100 (Winter 2012): 55. Although beyond the scope of this book, an excellent discussion concerning background on the question of warm- versus cold-blooded dinosaurs may be found in chapter 15 of David Fastovsky's and David Weishampel's *The Evolution and Extinction of the Dinosaurs* (2nd ed., 2005), 347–382.

2. Paleoartist Mark Hallett's restoration of the skull of *Iguanodon* in Czerkas and Olson, *Dinosaurs Past and Present*, vol. 1, p. 105, will steer you correctly in sculpting the appearance of iguanodont heads.

3. Reconstructions by Paul, found in Czerkas and Olson, *Dinosaurs Past and Present,* vol. 2, page 42, as well as in Paul's *Princeton Field Guide to Dinosaurs,* will provide accurate indication of the proper ratio of body width to length in duckbills.

4. For considerably more concerning historical considerations and proper restoration of *Iguanodon* see pp. 160 to 169 in David Norman's *Dinosaur!* (New York: Prentice Hall, 1991).

5. David E. Fastovsky and David B. Weishampel, *Evolution and Extinction of the Dinosaurs,* 2nd ed. (Cambridge: Cambridge University Press, 2005), 192; chapter 10 in this text, concerning Ornithopods, will be an invaluable starting point for paleosculptors.

6. Hallett, in Czerkas and Olson, *Dinosaurs Past and Present,* vol. 1, 105–107, 110 (see note 2).

7. Paul, *Dinosaurs Past and Present,* vol. 2, 1987; Czerkas and Olson, *Dinosaurs Past and Present,* 41–43 (quote is from p. 42).

8. David J. Varricchio, Anthony J. Martin, Yoshihiro Katsura, "First Trace and Body Fossil Evidence of a Burrowing, Denning Dinosaur," *Proceedings of the Royal Society* Vol. 274, No. 1616 (2007): 1361–1368, doi:10.1098/rspb.2006.0443. But also see chapter 11 for more on this creature, herein.

Chapter 11

1. Curtis Morgan, "More Crocs, and More Nervous Gulps," *Chicago Tribune,* Section 1, Wednesday, April 25, 2012, 18.

2. Raul Martin's North American scene was reproduced in *National Geographic* 216, no. 5 (November 2009): 130–131. Martin's dramatic Sahara scene was available in poster form during the early 2000s. Ferguson's *Deinosuchus* painting (American Museum neg. #337265) was recently reproduced in Debus and Debus, *Dinosaur Memories,* 266.

3. Mel White, "When Crocs Ruled," *National Geographic* 216, no. 5 (November 2009): 128–139.

4. William Mullen, "These Crocs Are Bad to the Bone," *Chicago Tribune,* Friday, November 20, 2009, section 1, 12.

5. Eric Buffetaut, "The Evolution of the Crocodilians," *Scientific American,* October 1979, 130–144; Robert L. Carroll, *Vertebrate Paleontology and Evolution* (New York: W.H. Freeman, 1988); Allen A. Debus, "Super-Crocs!," chapter 14 in Debus and Debus, *Dinosaur Memories,* 262–279.

6. Paul Sereno, "Strange Crocs of the Sahara," *National Geographic* 216, no. 5 (November 2009): 140–141.

7. Fastovsky and Weishampel, *Evolution and Extinction,* 91.

8. Carroll, *Vertebrate Paleontology*; Robert Bakker restored *Euparkeria,* which was published in Desmond's *Hot-Blooded Dinosaurs,* 86.

9. Bakker, *Dinosaur Heresies,* 294.

10. Phil Hore, "Plateosaurus," *Prehistoric Times* 97 (Spring 2011), 14–17, 54–55.

11. Paul, *Dinosaurs Past and Present,* vol. 2, 29.

Also see two skeletal reconstructions of adult prosauropods, in Peter M. Galton, "Basal Sauropodomorpha — Prosauropoda," chapter 15 in *The Dinosauria,* ed. David Weishampel, Peter Dodson, and Halszka Osmolska (Berkeley and Los Angeles: University of California Press, 1990), by page 321.

12. Peter M. Dodson, consultant, *Encyclopedia of Dinosaurs: A Visual Guide to Prehistoric Life with over 140 Dinosaur Profiles* (Lincoln, IL: Beekman House, 1990), 176–177, 219–220. Note that Franczak's therizinosaurs are restored in quadrupedal stance, which goes against the grain of current thought.

13. In their *Evolution and Extinction of the Dinosaurs,* Fastovsky and Weishampel state that during the Late Cretaceous, therizinosaurs "by the chewing standards of their ornithopod brethren were mighty primitive. While speculation has analogized their behavior with mammals as diverse as sloths and the enigmatic, extinct, long-armed and heavy-clawed chalicotheres, these dinosaurs remain fundamentally mysterious. Was there something about the rise of angiosperms that fueled this unusual radiation?" (p. 408).

14. David J. Varricchio, Anthony J. Martin, and Yoshihiro Katsura, "First Trace and Body Fossil Evidence of a Burrowing, Denning Dinosaur," *Proceedings of the Royal Society.*

15. Phil Hore, "Tenontosaurus," *Prehistoric Times* 98 (Summer 2011): 38–41. Hore comments humorously on how "boring" *Tenontosaurus* seems from a pop-cultural perspective.

16. Weishampel, Dodson, and Osmolska, *Dinosauria,* 540; Sylvia J. Czerkas and Stephen A. Czerkas, *Dinosaurs: A Global View* (New York: Mallard Press, 1991), 172; Paul, *The Princeton Field Guide to Dinosaurs.*

17. Debus and Debus, *Paleoimagery,* Chapter 28, "Hypsilophodon — A 'Super' Dinosaur," 180–184.

18. Paul, *Dinosaurs Past and Present* vol. 2, 37.

19. An excellent resource on armored dinosaurs for dinosaur sculptors to consult is Paul's *Princeton Field Guide to Dinosaurs,* 227–229. Here Paul includes many skeletal reconstructions, showing both dorsal and lateral views, as well as restorations suggesting inferred soft tissue musculature. Paul republished several of his armored dinosaur reconstructions and restorations in this amply illustrated and accessible volume, which is indispensable for all dinosaur sculptors; Kenneth Carpenter, "Skeletal Reconstruction and Life Restoration of *Sauropelta* (Ankylosauridae: Nodosauridae) from the Late Cretaceous of North America," *Canadian Journal of Earth Sciences* 2 (1984): 1491–98; Gregory S. Paul, "Fat, Really Fat Ankylosaurs," *The Dinosaur Report,* Spring 1995, 6–7; Carpenter's and Paul's skeletal reconstructions and restorations of *Euoplocephalus* may be found on page 313 of Robert L. Carroll, *Vertebrate Paleontology and Evolution* (New York: W.H. Freeman, 1988), and the cited issue of *The Dinosaur Report.*

20. Josef Augusta, *Prehistoric Sea Monsters* (London: Paul Hamlyn, 1964).

Chapter 12

1. For present purposes, we're striving to lessen your reliance on costly materials that could be employed for sculpting and modeling. So our discussion emphasizes what can be made, to the greatest extent possible, using relatively inexpensive materials such as polymer clay, wood, wire, and aluminum foil. But for those who would care to consider a truly advanced technique for making Pelycosaur sails, please refer to chapter 6 in Ray Rimell's *Building and Painting Model Dinosaurs* (Waukesha, WI: Kalmbach Books, 1998), 80–83. Ray's illustrated method using latex rubber may also be applied to the making of spinosaur sails. It has the advantage of being able to form ultra-thin, rubbery sails that would even appear slightly translucent. Although Rimell's book does not address how to sculpt original dinosaurs from scratch, *Building and Painting Model Dinosaurs* remains an excellent resource explaining advanced techniques for building and painting realistic dinosaur dioramas — once the dinosaurs have already been sculpted, cast from molds and purchased. We will address basic dinosaur molding techniques and fundamental considerations (emphasizing polymer clay, although not exclusively) for building original dinosaur dioramas in subsequent chapters of this book, however.

2. *Suchomimus*—described in 1998—is now considered a second species of *Baryonyx*, described in 1986. More so than any other modern paleoartist, William Stout has documented shifting views concerning the probable life appearance of *Spinosaurus* (described in 1915), particularly in light of more recent discoveries of related dinosaur genera. See William Stout and William Service, narrator, *A Fantastic New View of a Lost Era* (New York: Mallard Press, 1981); Donald F. Glut, *The New Dinosaur Dictionary* (Secaucus, NJ: Citadel Press, 1982), 226; William Stout interviewed in *Prehistoric Times* 44 (Oct./Nov. 2000): 37. Also see Tracy Ford's "How to Draw Dinosaurs — Sails in the Mesozoic," *Prehistoric Times* 50 (Oct./Nov. 2001): 14–15.

3. Jack Bowman Bailey, "Neural Spine Elongation in Dinosaurs: Sailbacks or Buffalobacks," *Journal of Paleontology* 71, no. 6 (1997): 1124–1146; Allen A. Debus, "Dinosaur World Interviews Dr. Jack Bowman Bailey of Western Illinois University," in *Dinosaur World* 5 (Summer/Fall 1998): 65–71.

4. Allen A. Debus, "Sculpting Twilight Zone Dinosaurs," *Modeler's Resource* 31 (Dec./Jan. 2000): 58–61.

5. Donald F. Glut, *Dinosaurs: The Encyclopedia*, supplement 1 (Jefferson, NC: McFarland, 2000), 119.

6. *Megalosaurus'* sail-like feature seems to have originated with a skeletal reconstruction attributed to "Meyer," possibly yet not confirmed to be Hermann von Meyer, appearing (later) in H.N. Hutchinson's *Extinct Monsters* (London: Chapman and Hall, 1893), figure 13, 78, which may have been based in part upon then-recent discoveries of related genera, *Ceratosaurus* and *Allosaurus*. However, Meyer's/Smit's speculative megalosaur reconstruction was bedecked with proportionally long neural spines. Meyer's reconstruction led to J. Smit's life restoration of a peculiarly long-necked megalosaur (with a second restored "specimen" posed in kangaroo-like stance)—Hutchinson, *Extinct Monsters,* plate 6. In Smit's 1893 restoration, the longer neural spines have been translated into a humplike feature situated along its dorsal region. The mien of Smit's restoration then seems to have been swiped, albeit in different pose, by artist C. Whymper, as published in Henry R. Knipe's *Nebula to Man* (New York: J.M. Dent, 1905), plate 20. Whymper's "megalosaur," with long neck and a humpy-looking torso, (also posed with legs in kangaroo posture) more closely resembles a carnivorous plateosaur. Then in his 1981 *Fantastic New View,* Stout published his restoration of a sailback *Megalosaurus.* Consensus opinion, however, favors that megalosaurs resembled the better-known allosaurs, lacking humps or sails. Also see Allen A. Debus, "Notes on the Hump-Backed, High-Spined *Megalosaurus* of Yesteryear," *Prehistoric Times* 104 (winter, 2013), pp. 41–43.

7. Other more recently described theropod dinosaurs purportedly sporting short fins or sails in life include *Icthyovenator* and *Concavenator.*

8. Kevin Padian, "The Case of the Bat-winged Pterosaur: Typological Taxonomy and the Influence of Pictorial Representation on Scientific Perception," in *Dinosaurs Past and Present*, vol. 2, ed. Czerkas and Olson, 65–81; Adrian J. Desmond, *The Hot-Blooded Dinosaurs: A Revolution in Palaeontology* (New York: Dial, 1976), 157–183; Dr. Peter Wellnhofer, *The Illustrated Encyclopedia of Pterosaurs* (New York: Crescent, 1991).

9. Desmond, *Hot-Blooded Dinosaurs.*

10. Donald F. Glut, *Dinosaurs: The Encyclopedia*, supplement 4 (Jefferson, NC: McFarland, 2006), Appendix 1: Pterosaurs, 583–633.

11. Ibid., 614.

12. Wellnhofer, *Illustrated Encyclopedia*, 149–151.

Chapter 13

1. Mark Norell, *Science*, Sept. 16, 2011, 1590.

2. Phil Hore, "*Archaeopteryx*—Birds of the Mesozoic," *Prehistoric Times* 99 (Fall 2011), 14–18; Xing Xu, Hailu You, Kai Du, and Fenglu Han, "An *Archaeopteryx*-Like Theropod from China and the Origin of Avialae," *Nature* 475 (July 28, 2011): 465–470.

3. Glut, *Dinosaurs*, supplement 4, 118.

4. Henry Fairfield Osborn, *The Origin and Evolution of Life* (New York: Charles Scribner's Sons, 1918), 229; Richard O. Prum, "Dinosaurs Take to the Air," *Nature* 421 (Jan. 23, 2003): 323–324.

5. Interestingly, Hore (*Archaeopteryx*—see note 1) mentions that some paleontologists suspect there are traces of leg feather impressions on the *Archaeopteryx* Berlin specimen, which despite preser-

vational hazards were, in life, elongated, indicating that perhaps this first known fossil bird was also a 4-winged "tetrapteryx" like *Microraptor*.

6. Luis M. Chiappe, *Glorified Dinosaurs: The Origin and Early Evolution of Birds* (Hoboken, NJ: John Wiley & Sons, 2007).

7. Formerly, such nests and eggs were attributed to ceratopsian *Protoceratops*, of which hatchlings sans eggs are nonetheless known from other apparent nesting sites. Also see Lynne Clos, "Nesting Behavior and Parental Care in Non-avian Archosaurs," *Fossil News* 16 (Sept./Oct. 2010): 2–11, 15.

8. Donald F. Glut, *Dinosaurs: The Encyclopedia, supplement 6* (Jefferson, NC: McFarland, 2010), 318.

9. Allen Debus coined the term *feather revolution* in *Paleoimagery* (Jefferson, NC: McFarland, 2002), 241.

10. Xiao-Ting Zheng, Hai-Lu You, Xing Xu, and Zhi-Ming Dong, "An Early Cretaceous Heterodontosaurid Dinosaur with Filamentary Integumentary Structures," *Nature* 458 (March 2009): 333–336.

11. One could conceivably use a series of cut paintbrush bristles to make upright *Psittacosaurus* tail feathers.

12. Jerry Finney, "How to Sculpt Prehistoric Animals," *Prehistoric Times* 13 (July–Aug. 1995): 30–31.

13. Allan Smith, "Birds of a Feather ... *Bambiraptor*: A Model-Build-Up," *Prehistoric Times* 65 (April/May 2004): 44–45.

14. Most recently, juvenile non-avian dinosaurs were found with feathers, further indicating how wings evolved (D.K. Zelenitsky et al., "Feathered Non-avian Dinosaurs from North America Provide Insight into Wings Origins," *Science* 338 (Oct. 26, 2012): 510–514.

Chapter 14

1. *Walking with Prehistoric Beasts* (2001), produced by Tim Haines and Jasper James, is currently available in *The Complete Walking With Collection, 5 Disc Set* (2006), BBC Video, www.bbcamerica.com. This collection also includes *Walking with Dinosaurs* (1999).

2. Allen A. Debus, "Triumph of the Leapin' Lizards," chapter 6 in *Prehistoric Monsters: The Real and Imagined Creatures of the Past that We Love to Fear* (Jefferson, NC: McFarland, 2010), 108–158; Allen A. Debus, "Why Not the Mammals?," chapter 5 in *Dinosaur Memories: Dino-trekking for Beasts of Thunder, Fantastic Saurians, Paleo-people, Dinosaurabilia, and other Prehistoria* (Lincoln, NE: Authors Choice Press, 2002), 85–110; Allen A. Debus, "The Lost Chapter: Sculpting Prehistoric Mammals," *Prehistoric Times* 31 (Aug./Sept. 1998): 45–47; David Rains Wallace, *Beasts of Eden* (Berkeley: University of California Press, 2004); Michael Benton, *The Rise of the Mammals* (London: Quantum, 1991).

3. Sean Cooper, interviewed by Mike Fredericks in *Prehistoric Times* 56 (Oct./Nov. 2002): 9–11.

4. John Fischner, "Prehistoric Mammals: Famil-

iarity Breeds Intimidation," *Prehistoric Times* 38 (Oct./Nov. 1999): 45.

5. Robert L. Carroll, *Vertebrate Paleontology and Evolution* (New York: W.H. Freeman, 1988); William Berryman Scott, *A History of Land Mammals in the Western Hemisphere* (New York: MacMillan, 1937); Bjorn Kurten, *The Age of Mammals* (New York: Columbia University Press, 1971); R.J.G. Savage, illustrated by M.R. Long, *Mammal Evolution: An Illustrated Guide* (New York: Facts on File, 1986); Zdenek V. Spinar, illustrated by Zdenek Burian, *Life Before Man: The Fascinating Story of the Evolution of Living Things on our Earth* (New York: Crescent, 1981).

6. This theme is prevalent throughout the writings of Stephen J. Gould. For instance, see Gould's *The Richness of Life: The Essential Stephen J. Gould*, ed. Steven Rose (New York: W.W. Norton, 2006). Following the great Late Cretaceous mass extinction, mammals were able to invade many vacated niches via a process commonly referred to as adaptive radiation. Paleomammals spread further and broader into arboreal, aerial (bats!), oceanic, and terrestrial ecological settings. And through geological time, especially during the Paleocene and Eocene epochs, mammalian species rapidly attained greater body masses than their furred Mesozoic forebears — as did some lineages of ancient birds.

7. On the other hand, there is no direct fossil evidence for such a magnificent horn. Sheer speculation? See Allen A. Debus, *Dinosaur Memories*, 150–151, 155. For more on fossil rhinos, see chapters 4, 8 and 9 in *Dinosaur Memories*, pages 67–77, 145–156, and 157–176, respectively.

8. Cooper interview, *Prehistoric Times*.

9. Charles R. Knight, *Animal Drawing: Anatomy and Action for Artists* (1947; reprint, New York: Dover, 1959); also see Edouard Lanteri, *Modelling and Sculpting Animals* (1911; reprint, New York: Dover, 1985).

10. In regard to fossil horses, one may consider slicing bristles or stiff fibers from a paintbrush, then epoxying them standing upright along the neck to create a mane.

11. For example, see Allen A. Debus, "A Plio-Pleistocene Primer: Glyptomaniac with Big Birds," chapter 11 in *Dinosaur Memories*, 191–220.

12. Alan J. Turner, illustrated by Mauricio Anton, *The Big Cats and Their Fossil Relatives* (New York: Columbia University Press, 1997).

13. For example, throughout the span of the Cenozoic Era, there were hyaenodonts, massive dire wolves, cave bears, creodonts (e.g., the 10-foot-long *Sarkastodon*), and 7-foot-long "bear-dogs" as well.

14. Erik Trinkaus and Pat Shipman, *The Neandertals: Changing the Image of Mankind* (New York: Alfred A. Knopf, 1993).

Chapter 15

1. At this stage, matches and fire could be involved, so take the necessary precautions to avoid

burns. Children should *not* perform this particular step! Adult supervision is absolutely required. This is an advanced trick that takes some practice; many past experiences have fortified our confidence with this technique. But only do this isolated from other flammable sources. (If you're skittish about this step, then do *not* perform it. No problem if you choose not to. Instead, simply attach the Styrofoam chunk using thin gauge wire to the vertebral wire and add thin lumps of polymer clay over this assembly.) Here again, make sure there is sufficient ventilation to avoid breathing in any toxic fumes. (Refer to figure 15–9.) The matches will be used for lightly shaping and prepping the carved Styrofoam. After lighting a match, while holding the foam piece in one hand, move the flame quickly over its surface. In this way two things can be done: you will harden the surface of the Styrofoam, and create realistic indentations and depressions that may appear on the creature. In doing this, the Styrofoam contour is being optimized for subsequent sculpting. Be careful not to hold the flame on the surface of the foam unless you want to create holes or craters in it. Also, too long an exposure to the open flame will burn it. As beforehand, occasionally hold the piece up against your reference illustration to determine whether any refinements are necessary.

Chapter 16

1. Lev Grossman, quoting Edmund Burke in "Into the Void: *Prometheus* Dives into a Dangerous Genre — the Space Opera," *Time*, June 11, 2012, 58.

2. Allen noticed one such impressive model built along these lines at G-Fest #18, July 2011. Also see Ray Anderson's "Simulating Water with Plastics," chapter 7 in *The Art of the Diorama* (Waukesha, WI: Kalmbach, 1994), 50–55.

3. David E. Fastovsky and David B. Weishampel, *The Evolution and Extinction of the Dinosaurs*, 2nd ed. (Cambridge: Cambridge University Press, 2005), 402–405, figs. 16.10 and 16.11. Here paleoartist John Sibbick has restored several plants that grew during the Mesozoic. Also, Zdenek Burian was a master at restoring lush jungle Late Paleozoic, Mesozoic and Tertiary landscapes.

4. Ray Rimell creatively suggests how to convincingly add many kinds of real plants to your diorama that will seem like paleo-foliage. Many of the materials he relies on may be purchased in hobby stores. See Ray Rimell, *Building and Painting Model Dinosaurs* (Waukesha, WI: Kalmbach, 1998), 68–79.

5. Ron Lemery has recently contributed an informative series of articles to *Prehistoric Times*, titled "The Art of the Diorama," which would well worth be checking into. For instance, he has written articles on how to make miniature trees using electrical wire and Poly Fill ("Frozen Moments," *Prehistoric Times* 92 [Winter 2009]: 34); "Frozen Moments," *Prehistoric Times* 93 (Spring 2010): 36; "Bonsai Anyone," *Prehistoric Times* 97 (Spring 2011): 36; "Pine Trees,"

Prehistoric Times 95 (Fall 2010): 36. Also see Michael Rusher, "Mini-Mesozoic! Creating Realistic Foliage in Miniature," *Prehistoric Times* 24 (May–June 1997): 12–13; David Alden, "Dinosaur Dioramas," *Prehistoric Times* 24 (May–June 1997): 46–47. Techniques described in these articles do not rely on polymer clay.

6. For example, recently, Steven B. DeMarco, Ron Lemery and Sean Kotz have contributed articles to *Prehistoric Times* magazine, offering tips and suggestions on how to realistically paint prehistoric animal resin castings as well as the dioramas they're intended to inhabit. Here are a few selections worth reading for ideas on advanced painting techniques: Steven B. DeMarco, "Patagonian Scene," *Prehistoric Times* 96 (Winter 2011): 60–61; Ron Lemery, "The Art of the Diorama — Frozen Moments," *Prehistoric Times* 94 (Summer 2010): 36; Ron Lemery, "The Art of the Diorama — Frozen Moments," *Prehistoric Times* 96 (Winter 2011): 36–37; Steven B. DeMarco, "Patagonian King," *Prehistoric Times* 97 (Spring 2011): 60–61; Steven B. DeMarco, "One Horned Army," *Prehistoric Times* 99 (Fall 2011), 37; Ron Lemery, "The Art of the Diorama — Brontotherium," *Prehistoric Times* 98 (Summer 2011), 36; Sean Kotz, "Stomping Grounds: Painting David Silva's Styracosaurus," *Prehistoric Times* 98 (Summer 2011): 37; Steven B. DeMarco, "Tusks!" *Prehistoric Times* 96 (Fall 2010): 60–61; Steven B. DeMarco, "Tales from the Glypt," *Prehistoric Times* 91 (Fall 2009): 56–57; Steven B. DeMarco, "All Fur and Horn," *Prehistoric Times* 100 (Winter 2012): 56–57; Steven B. DeMarco, "Texas Assassin," *Prehistoric Times* 101 (Spring 2012): 36–37.

7. Ray Rimell and Ray Anderson both address the pleasing art medium of lighted "box dioramas" along with use of heterogeneous materials in creating dioramas. A dino-diorama may be staged within the cavity of an old, gutted wooden television box frame, for instance. Anderson specializes in historical themes and doesn't discuss dinosaurs or polymer clay. Rimell, *Building and Painting Model Dinosaurs*, 68, 75–79.

8. Ron Lemery's "three rules of dioramas" are worth citing here: "(1.) Keep it tight; (2.) Keep it focused; (3.) Keep it clean. The first rule means not making your piece any larger than it has to be. This saves on waste as well as shelf space. The second warns against having a display that is too busy, so that there is no focal point of interest. You want to avoid the eye wandering all around the scene, trying to find a place to rest. The third rule is more Zenlike. It's hard to explain and harder to do. It doesn't mean not to have any junk or garbage showing. Just try to keep it very clean. Meaning very, very well done." Ron Lemery, "The Art of the Diorama — Frozen Moments," *Prehistoric Times* 96 (Winter 2011): 36–37.

Chapter 17

1. Diane E. Debus and Allen A. Debus, "A Dinosaur's Molding Tale," *Modeler's Resource* 18

(Oct./Nov. 1997): 10–13; Allen A. Debus and Diane E. Debus, "A Short History of the Hell Creek Creations Prehistoric Animals Resin Line," chapter 35 in *Dinosaur Memories*, 577–594.

2. Debus and Debus, *Dinosaur Memories*, 578–580.

3. John Lanzendorf, *Dinosaur Imagery: The Science of Lost Worlds and Jurassic Art—The Lanzendorf Collection* (San Diego: Academic Press, 2000), 2–3.

4. Here it is appropriate to provide contacts for Polytek and Alchemy Works: Polytek Development Corp., 55 Hilton Street, Easton, PA, 18042; 1–610–559–8620; Alchemy Works, 1350 Southwest Asbury Blvd. # 736, Burleson, TX, 1–817–471–9096.

Chapter 18

1. Tess Kissinger, *Copyrights, Contracts, Pricing a Ethical Guidelines for Dinosaur Artists and Paleontologists* ([PLACE]: The Dinosaur Society, 1996).

Bibliography

Bakker, Robert T. *The Dinosaur Heresies.* New York: William Morrow, 1986.

Brierton, Tom. *Stop-Motion Puppet Sculpting: A Manual of Foam Injection, Build-up, and Finishing Techniques.* Jefferson, NC: McFarland, 2002.

Carroll, Robert, L. *Vertebrate Paleontology and Evolution.* New York: W.H. Freeman, 1988.

Chiappe, Luis M. *Glorified Dinosaurs: The Origin and Early Evolution of Birds.* Hoboken, NJ: John Wiley, 2006.

Choniere, Jonah N., et. al. "A Basal Alvarezsaurid Theropod from the Early Late Jurassic of Xinjiang." *Science* 327 (Jan. 29, 2010): 571–574.

Choo, Brian. "Segnosaurs: Oddballs of the Dinosaur World." *Dinonews* (Newsbulletin of the Dinosaur Club, Western Australian Museum, Perth) 7 (March 1994): 10–14.

Clos, Lynne. "Nesting Behavior and Parental Care in Non-avian Archosaurs." *Fossil News: Journal of Avocational Paleontology* 16 (Sept./Oct. 2010): 2–11, 15.

Cooley, Brian. "Sculpting Dinosaurs." *Alberta* 1, no. 1 (1988): 119–130.

Currie, Philip J. *Dinosaur Imagery: The Science of Lost Worlds and Jurassic Art— the Lanzendorf Collection.* San Diego: Academic Press, 2000.

Czerkas, Sylvia J., and Everett C. Olson, eds. *Dinosaurs Past and Present,* vols. 1 and 2. Seattle: Natural History Museum of Los Angeles County in association with University of Washington Press, 1987. (This work contains many superb, informative articles, especially those by Kevin Padian and paleoartists Gregory S. Paul, Stephen Czerkas, and Mark Hallett.)

Czerkas, Sylvia J., and Stephen A. Czerkas. *Dinosaurs: A Global View.* New York: Mallard, 1991.

Czerkas, Sylvia Massey, and Donald F. Glut. *Dinosaurs, Mammoths and Cavemen: The Art of Charles R. Knight.* New York: E.P. Dutton, 1982.

Debus, Allen A. "Sculpting Twilight Zone Dinosaurs." *Modeler's Resource* 31 (Dec./Jan. 2000): 58–61.

Debus, Allen A., and Diane E. Debus. *Paleoimagery: The Evolution of Dinosaurs in Art.* Jefferson, NC: McFarland, 2002.

Debus, Allen A., and Steve McCarthy. "A Scene from American Deep Time." *The Mosasaur* 6 (May 1999): 105–115.

Debus, Allen A., Bob Morales, and Diane E. Debus. *Dinosaur Sculpting: A Complete Beginners' Guide.* Bartlett, IL: Hell Creek Creations, 1995.

Debus, Diane E., and Allen A. Debus. "A Dinosaur's Molding Tale." *Modeler's Resource* 18 (Oct./Nov. 1997): 10–13.

Desmond, Adrian J. *The Hot-Blooded Dinosaurs: A Revolution in Palaeontology.* New York: Warner, 1975.

Dixon, Dougal. *After Man: A Zoology of the Future.* New York: St. Martin's, 1981.

_____. *The New Dinosaurs: An Alternative Evolution.* Topsfield, MA: Salem House, 1988.

_____, B. Cox, R.J.G. Savage, and B. Gardiner. *The Macmillan Illustrated Encyclopedia of Dinosaurs and Prehistoric Animals: A Visual Who's Who of Prehistoric Life.* New York: Macmillan, 1988.

Fastovsky, David E., and David B. Weishampel. *The Evolution and Extinction of the Dinosaurs.* 2nd ed. Cambridge, MA: Cambridge University Press, 2005.

Glut, Donald F. *Dinosaurs: The Encyclopedia.* Jefferson, NC: McFarland, 1997. Supplements 1–7, 2000–2012.

Goodwin, Mark B., and Dan S. Chaney. "Molding, Casting, and Painting." In *Vertebrate Paleontological Techniques,* vol. 1, ed. Patrick Leiggi and Peter May, 235–284. Cambridge: Cambridge University Press, 1995.

Gould, Stephen J., ed. *The Book of Life: An Illustrated History of the Evolution of Life on Earth.* New York: W.W. Norton, 1993.

Groman, James. "Creating a Sculpture of Godzilla." *Modeler's Resource* 44 (Feb./March 2002): 40–42, 47.

Horner, John R., and Don Lessem. *The Complete T. Rex.* New York: Simon and Schuster, 1993.

Knight, Charles R. *Animal Drawing: Anatomy and Action for Artists.* 1947. Reprint, New York: Dover, 1959.

Lanteri, Edouard. *Modeling and Sculpting Animals.* 1911. Reprint, New York: Dover, 1985.

Li, Quangur, et al. "Plumage Color Patterns of an Extinct Dinosaur." *Science* 327 (March 12, 2010): 1369–1372.

Lucas, Frederic A. "The Restoration of Extinct Animals." In *Annual Report of the Board of Regents of the Smithsonian Institution for the Year Ending June 30, 1900*, ed. Richard Rathburn, 479–493. Washington, DC: Government Printing Office, 1901.

Norman, David. *Dinosaur!* New York: Prentice Hall, 1991.

_____. *The Illustrated Encyclopedia of Dinosaurs.* New York: Crescent, 1985.

Ostrom, John H. *Osteology of Deinonychus antirrhopus, an Unusual Theropod from the Lower Cretaceous of Montana.* Bulletin 30, Peabody Museum of Natural History, Yale University, July 1969.

Paul, Gregory S. *The Princeton Field Guide to Dinosaurs.* Princeton: Princeton University Press, 2010.

Perkins, Sid. "Dressing Up Dinos." *Science News* 177, no. 3 (Jan. 30, 2012): pp.22–25.

Rainger, Ronald. *An Agenda for Antiquity: Henry Fairfield Osborn and Vertebrate Paleontology at the American Museum of Natural History.* Tuscaloosa: University of Alabama Press, 1991.

Rimell, Ray. *Building and Painting Model Dinosaurs.* Waukesha, WI: Kalmbach, 1998.

Rovin, Jeff. *From the Land Beyond Beyond.* New York: Berkeley, 1977.

Rudwick, Martin J.S. *Scenes from Deep Time: Early Pictorial Representations of the Prehistoric World.* Chicago: University of Chicago Press, 1992.

Salas, Maximo. "Sculpting Dinosaurs in 1/35 Scale." *FineScale Modeler,* March 1995, 46–48.

Scully, V., R.F. Zallinger, L.J. Hickey, and J. H. Ostrom. *The Age of Reptiles: The Great Dinosaur Mural at Yale.* New Haven: Peabody Museum of Natural History, 1990.

Stout, William, edited by Byron Preiss and narrated by William Service. *The Dinosaurs: A Fantastic New View of a Lost Era.* New York: Mallard, 1981.

Telleria, Robert. *The Visual Guide to Scale Model Dinosaurs.* San Francisco: Blurb, 2012.

Weishampel, David B., Peter Dodson, and Halszka Osmolska, eds. *The Dinosauria.* Berkeley: University of California Press, 1990.

Wellnhofer, Peter. *The Illustrated Encyclopedia of Pterosaurs: An Illustrated History of the Flying Reptiles of the Mesozoic Era.* New York: Crescent, 1991.

Index

Numbers in *italics* indicate pages with illustrations.